PRACTICAL GUIDE TO
DRAWING

PRACTICAL GUIDE TO
DRAWING

Vicenç B. Ballestar
Jordi Vigué

WATSON-GUPTILL PUBLICATIONS/NEW YORK

First published in the United States in 2002 by
Watson-Guptill Publications,
a division of VNU Business Media, Inc.,
770 Broadway, New York, N.Y. 10003
www.watsonguptill.com

Original title: Guía Práctica de Dibujo
© 2002 Gorg Blanc, S.L.
Via Augusta, 63
08006 Barcelona, Spain

Library of Congress Control Number: 2002103626

ISBN: 0-8230-4088-7

Idea and concept: Jordi Vigué

Editor-in-chief: Virgin Stanley
Painting exercises: Vicenç B. Ballestar
Photographs: Estudi Enric Berenguer
Photographic archive: Archivo Gorg Blanc, S.L.
Photographic collaborations: Jordi Vigué, Vicenç B. Ballestar,
Ramón de Jesús Rodríguez, Photo Stock
Graphic design: Paloma Nestares
Photographic documentation: Marta Albalat
Publishing coordinator: Miquel Ridola
Translators: Mark A. Lodge and Catalina Girona

Models: Josep Costa, Montserrat Planella, Sergio W. Hurtado,
M. del Pilar Doménech, Alejandra Barra,
Sílvia Coromines, Renata Brahim, Verónica Blanchet

Printed in Spain
Gráficas Iberia, s.a. Barcelona

1 2 3 4 5 6 / 07 06 05 04 03 02

As the title suggests, this volume strives to serve as a guide, a tool, or possibly a road to learning how to draw.

Drawing can be a hobby, a pastime, or simply an interest. This book takes these aspects of the art form into account, but our motives in creating it are actually more ambitious: drawing expresses a way of seeing and feeling things. An artist never presents pure, objective reality. Whether he or she is drawing a landscape or a portrait, the final work has always passed through the filter of the artist's feelings.

Besides offering innumerable technical tips, explaining various methods, and providing a large amount of advice, this guide shows you how to see things through an artist's eyes, how to cultivate your feelings, and how to express them. A person cannot pretend to be an artist; it is something you are or are not. Any artistic work, such as a drawing, always portrays the person who created it. This is the concept that guided the making of this book, and it has become the leitmotiv of all the people who collaborated in its production.

This book deals with all drawing techniques, and the exercises include a wide variety of subject matter, so that nothing is left out. It is our hope that this thorough treatment will give readers everything they need to become real artists.

Since everything is clearly explained in the book, there is little left to say in this introduction. Only two things come to mind. The first is a piece of advice: if you have artistic talent, remember that becoming a real artist inevitably involves patience and perseverance. The second is a word of thanks: we are grateful to you for having chosen us as your companions on this fascinating adventure. I am sure that you will never regret having undertaken it.

Jordi Vigué

CONTENTS

ELEMENTARY SHAPES 9 — **1**
- The triangle and the circle 9
- The square 10
- All forms are based on these shapes 11
- A clean stroke 12
- Step by Step: Apples and Kettle 13

HOW TO EXECUTE A PRELIMINARY SKETCH 17 — **2**
- The medium and the stroke 17
- Hardness and pressure 18
- Ways to apply line in a preliminary sketch 19
- The nature of the stroke 20
- Step by Step: Mountain Landscape 21

SKETCHING THE FIGURE 25 — **3**
- How to start sketching 25
- Gesture drawing 26
- Importance of the initial structure 27
- Learning how to calculate proportions 28
- Step by Step: Female Torso 29

SKETCHING THE STILL LIFE 33 — **4**
- Starting to sketch 33
- Correct as you work 34
- Framing the structure of your drawing 35
- Elementary shapes 36
- Step by Step: White Still Life 37

DRAWING AND COMPOSING THE LANDSCAPE 41 — **5**
- Methods for sketching the landscape 41
- Composing visually 42
- The importance of blocking in the composition 43
- Calculating scale and distance 44
- Step by Step: Landscape with a High Horizon 45

FROM SKETCHING TO MODELING THE FIGURE 49 — **6**
- Building complex shapes from simple shapes 49
- How to suggest volume 50
- Contrasting lights and darks for luminous effects 51
- Illuminating the subject 52
- Step by Step: Female Torso in Three-Quarter View 53

MODELING WITH LINES 57 — **7**
- Shading in linear strokes 57
- Hatching 58
- Shading a sphere and a cube 59
- Different ways to draw shadows 60
- Step by Step: Drapery and Orange on a Plate 61

RURAL LANDSCAPES AND COUNTRY HOUSES 65 — **8**
- Architecture and nature 65
- Structure and terrain 66
- Synthesis of planes 67
- The importance of light 68
- Step by Step: Tree and Ruins 69

PROPORTIONS OF THE HUMAN BODY 73 — **9**
- The canon 73
- The importance of line 74
- Sizes and proportions 75
- Joints 76
- Step by Step: Standing Male Nude 77

ACHIEVING TONAL BALANCE 81 — **10**
- The importance of tonal differences 81
- Balancing subject and background 82
- Common errors in handling contrasts 83
- Maintaining equilibrium 84
- Step by Step: Onions and Tomatoes 85

LIGHT AND SHADOW IN A SEASCAPE 89 — **11**
- How to sketch a seascape 89
- A study of waves 90
- Alternating light and dark 91
- Opening up light spaces 92
- Step by Step: Seascape 93

BIRDS 97 — **12**
- From the basic shape to the details 97
- Plumage 98
- Line quality 99
- The legs 100
- Step by Step: Two Macaws 101

SKETCHING WITH PATCHES OF COLOR 105 — **13**
- Proportion as a starting point 105
- Sketching with color tones 106
- Applying quick patches of color 107
- Some tips 108
- Step by Step: Reclining Woman 109

NATURE STUDY: TREES
113

14

Trees **113**
The structure of trees **114**
Contrasts and highlights **115**
Avoiding detail **116**
Step by Step: Trees in the Foreground **117**

GESTURAL FIGURE DRAWING
121

15

Movement **121**
Drawing in flat strokes **122**
Using your fingers and a brush **123**
Drawing with sanguine dust **124**
Step by Step: Academic Figure Study of a Male and Female Nude **125**

EXPLORING STILL LIFE THEMES WITH
"SOFT" TECHNIQUES **129**

16

Charcoal **129**
Sanguine Conté crayon **130**
Chalk **131**
Water-soluble pencil **132**
Step by Step: Still Life with Ceramic Vessels **133**

THE URBAN LANDSCAPE 1
137

17

The importance of perspective (1) **137**
Perspective in artistic drawing **138**
The vanishing point and lines of perspective **139**
Helpful hints **140**
Step by Step: City Street Scene **141**

LIGHTING THE FIGURE
145

18

From synthesis to tonal values **145**
Defining the figure's volume with light **146**
Foreshortening **147**
Foreshortening an elbow **148**
Step by Step: Seated Female Figure **149**

METALLIC AND SHINY SURFACES
153

19

Effects of light **153**
Metallic objects **154**
Rusty and old metals **155**
Polished metal **156**
Step by Step: Cauldron with Fruit **157**

THE URBAN LANDSCAPE 2
161

20

The importance of perspective (2) **161**
Drawing on a plane **162**
Constructing buildings in artistic perspective **163**
Different types of perspective **164**
Step by Step: Rural Landscape with Church **165**

THE FACE: EYES
169

21

The position of the eyes on the face **169**
An artistic rendering of an eye **170**
The depth of the gaze **171**
The expression of the eyes **172**
Step by Step: A Woman's Glance **173**

HORSES
177

22

Anatomical sketch **177**
The horse's head **178**
The importance of foreshortening **179**
The line over the sketch **180**
Step by Step: Horses Grazing **181**

CHIAROSCURO
IN THE STILL LIFE **185**

23

Interpreting still life through shadow and light **185**
Working with maximum values **186**
Soft shading, accentuated volume **187**
Drama in a drawing **188**
Step by Step: Classical Still Life **189**

EXPLORING LANDSCAPE THEMES
WITH "HARD" TECHNIQUES **193**

24

The clean drawing **193**
The hard finish **194**
Hard techniques with graphite pencil **195**
Fountain pen, reed pen, and ballpoint pen **196**
Step by Step: Japanese-Style Landscape **197**

THE FACE: NOSE AND MOUTH
201

25

Drawing the nose **201**
Drawing the mouth **202**
Relating facial features **203**
Partial portrait **204**
Step by Step: Female Face **205**

NATURAL TEXTURES
209

26

Vegetables **209**
A pumpkin **210**
Reflections and highlights in a still life **211**
Varied textures **212**
Step by Step: Still Life with Grapes,
Tomatoes, and Lemons **213**

NATURE STUDY: SKIES
217

27

Different skies **217**
Clouds and skies **218**
How to sketch clouds **219**
Blending, creating highlights, and opening up whites **220**
Step by Step: Cloudy Sky **221**

HANDS AND FEET
225

28

Very simple shapes **225**
Anatomical structure **226**
Hands in a contemplative pose **227**
The foot **228**
Step by Step: Woman Fastening Her Shoe **229**

FLOWERS
233

29

Understanding complex shapes **233**
From structure to detail **234**
The importance of texture **235**
Contrasts between leaves **236**
Step by Step: Roses **237**

STUDYING TERRAIN IN THE
LANDSCAPE
241

30

Different points of view **241**
Different terrains **242**
Rain-drenched textures and mud **243**
The texture of muddy ground **244**
Step by Step: Muddy Landscape **245**

CATS AND DOGS
249

31

The proportions and anatomy of the legs **249**
Outline and sketch of a cat **250**
The harmony and proportion of a dog's body **251**
A dog's head **252**
Step by Step: A German Shepherd **253**

THE FACE: COMBINING FEATURES
257

32

Sketching the face **257**
Sizes and proportions **258**
Volume and relationships between the features **259**
Highlights and tones **260**
Step by Step: Portrait of a Young Woman **261**

TRANSPARENT GLASS SURFACES
265

33

Reflections **265**
Glass containing liquid **266**
Reflection and refraction **267**
Sharp contrasts in the highlights **268**
Step by Step: Beer Steins and Mug **269**

ATMOSPHERE IN
THE LANDSCAPE **273**

34

Suggesting distance with tonal gradation **273**
Atmospheric effects **274**
Alternating areas of atmosphere **275**
Defining grounds and distance **276**
Step by Step: Atmospheric Landscape **277**

THE CARICATURE
281

35

Establishing proportion to understand form **281**
Exaggerating the features **282**
Satire in the portrait **283**
Different options **284**
Step by Step: Richard Wagner **285**

COMPOSING
STILL LIFES **289**

36

Thematic combinations **289**
Contrasts between elements **290**
Interpreting a subject with a clean line **291**
Interpreting with shadows **292**
Step by step: Majestic Still Life **293**

SENSUALITY
IN THE NUDE **297**

37

The source of sensuality **297**
Interpreting a model's pose **298**
The importance of line in expressing sensuality **299**
Eroticism and suggestion **300**
Step by Step: Female Nude **301**

LARGE MAMMALS
305

38

Movement and rhythm of the joints **305**
Connecting lines **306**
Summarizing shapes **307**
Where to place the details **308**
Step by Step: A Leopard **309**

PORTRAITURE
313

39

Framing the figure **313**
Creating a well-proportioned structure **314**
Contrasts and blendings **315**
Highlights **316**
Step by Step: Portrait of a Woman **317**

1

ELEMENTARY SHAPES

THE TRIANGLE AND THE CIRCLE

Perfect geometric shapes don't really exist in nature. Nature's shapes appear to be complicated, and are difficult to take in at first glance. Elementary shapes, on the other hand – those that humans created as the basis for geometry – are extremely easy to sketch. These are the indispensable basic elements for drawing, since any form in nature, complex though it may seem, can always be broken down into geometric shapes.

How do you go about creating a drawing? Well, simply start from the most elementary shapes, those that are so simple that anyone can grasp and represent them. Anyone can imagine and draw, however roughly, a square, triangle, or circle. With these basic shapes as a foundation, the most complex of drawings can be executed.

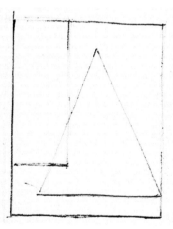

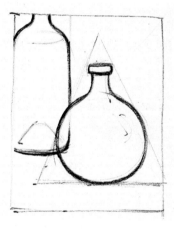

1. Observe the simplest shapes we know, beginning with the rectangle – the foremost shape, acting as a frame within which anything can be projected – and the triangle. Look at this simple sketch. Anyone could draw it! Shapes in nature are always easier to grasp if you begin with schematic drawings such as this one.

2. Here, the rectangle is used to define the form of a straight-sided bottle simply by cutting away both upper edges of the geometric shape; the triangle serves as a frame within which to draw a circle for the form of a rounded vessel. These simple shapes constitute the basis of many of the still life exercises later in this book.

3. Let's try something simple. First, draw two circles as a starting point. Then draw a rectangle above one of them and modify its shape until you get the vase. It is now easy to further define its form by shading in one side in the shape of a quarter-moon.

THE SQUARE

Many forms can be drawn inside a square, and by extension, a rectangle can be adapted to numerous representations too. With practice, you'll be able to sketch these elementary shapes confidently; there's no need for great precision here. Gradually, you'll recognize more quickly how shapes can be blocked in, and will see that it's not so difficult to represent complex elements after all.

1. A square is easier to draw than a circle, and almost any form can be blocked into it, even a circle itself. This makes it easier to conceive any shape, regardless of how complex it is. As an extension of the square, the rectangle can serve as an excellent box within which to block in a difficult shape. When dealing with such a shape, try to draw with precision from the start. If the forms are exact from the beginning, the entire process of execution will prove easier later.

2. It's easy to draw this shape within the square. If it had been done without the box, the shape would certainly have been imperfect, as well as more difficult. The advantage of drawing in charcoal is that it is easy to correct. Any error can be eliminated easily with a finger or a cloth. Lines must be drawn with resolution and with a steady hand. Don't worry if it's not perfect. If you make a mistake, correct it or start over.

3. Thus, correction after correction, shapes are sketched and then perfected until the desired result is obtained. Don't worry if you have to correct errors repeatedly. The important thing is to learn how to break an object down into its elemental shapes, block it in, then refine and polish it.

ALL FORMS ARE
BASED ON THESE SHAPES

The synthesis of forms – combining elements to create a whole – is fundamental to learning how to draw. The first stages of a drawing should always be aimed at reducing the shapes of your subject to their most elementary linear schemes. Although moving from the linear to a more advanced stage can seem difficult, it's really rather simple. The exercise on this page is done in Conté crayon and charcoal, two different but highly compatible mediums.

1. Many types of fruit can be sketched using elementary circular shapes, from which more complex forms can be developed. In this case, all forms have been drawn on the basis of circles, although the pear could have been blocked into a triangle. Draw a grid on your paper to use as a guide in arranging the various shapes in your composition.

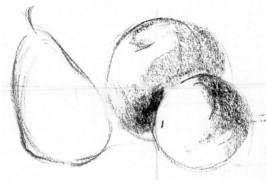

2. With the flat side of a Conté crayon, a first roughing out is done to suggest volume. It's important to make sure the forms you've drawn on the paper reflect the correct shape of the fruit. Just as with charcoal, Conté can be used to either draw lines or color in areas. This feature, characteristic of dry mediums, facilitates the synthesis of forms.

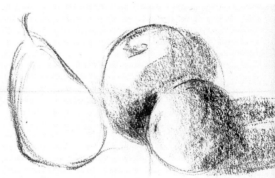

3. Charcoal is then used to reinforce the Conté and better define the fruits' volume. The fusion of the two mediums is beautiful and allows for sharp contrasts. Note that only the areas that should be darker (to indicate shadows) cover the Conté color. Don't worry if your drawing isn't perfect on the first attempt. With practice, your results will improve.

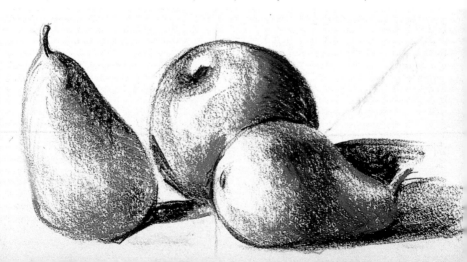

A CLEAN STROKE

The intrinsic importance of line in drawing means that it must be of high quality, from the earliest stages of your work and thereafter, no matter what your subject, whether an apple or a skyscraper. A clean stroke is essential to obtaining the best results, with the fewest visual ambiguities possible. It will become even more important once you have gained a greater mastery of drawing as a whole. This section presents exercises to help you practice clean strokes.

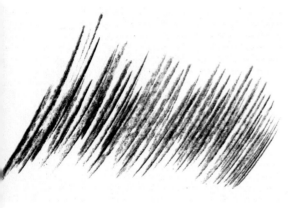

1. Drawing a straight line is a good deal more difficult than it seems, but the more you practice, the better results you obtain. Most importantly, try to develop a sure hand. In attempting to do so, it's best – and easiest – to begin by using the flat edge of the charcoal stick to make your mark. Then try repeating the same exercise, this time holding the charcoal as if it were a pencil. As dull as this might seem, to grow your artistic skill and confidence, practice drawing straight lines to pass the time between other activities.

2. Another important stroke is the wrist technique, as it allows you to fill in a wide area quickly. The drawing instrument – charcoal, in this case – is held like a pencil. The wrist is swung back and forth, while the fingertips control the pressure of the charcoal on the paper.

3. Line allows you to transmit any gesture onto paper such that all sorts of representations can be achieved. Don't hesitate to doodle, as this is good practice for you to develop your hand's firmness and sureness of stroke and your composure in moving the medium along the paper.

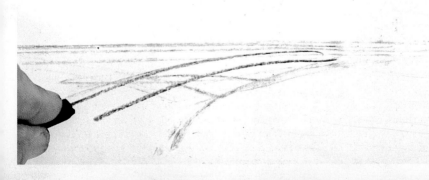

MATERIALS

Charcoal, Drawing paper,
Cloth, Eraser

Apples and Kettle

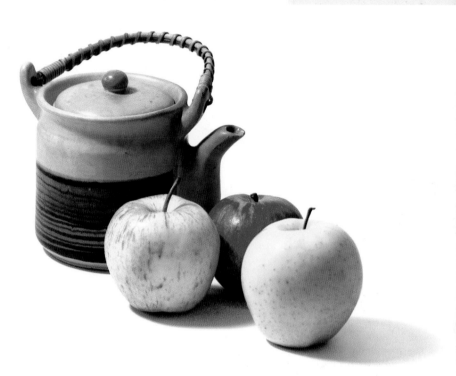

In this exercise, key aspects of drawing will be put into practice. This still life is a good preparation for more complex themes. For this reason, you should follow the procedure slowly and carefully from the beginning. Some stages may seem a little difficult, but there's no need to worry. If you begin with a sound base, everything that follows will be much easier. Therefore, the greater care you take in the first steps, the simpler it will be to continue and the better your results will be.

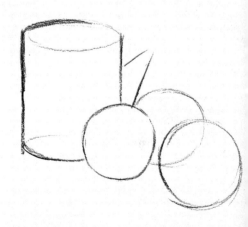

Step 1. The primary aim of this demonstration is to help you comprehend the basic shapes of the various objects that make up a still life, and then represent their underlying structures to create a compositional whole. In this preliminary sketch, the shapes are very simple; draw them by mentally reducing the real, complex forms you see into the fewest possible lines before transferring them onto paper. Through close observation, imagine the apples in terms of their elementary shapes – three circles overlapping one another – and the kettle behind them as a shape based roughly on a rectangle.

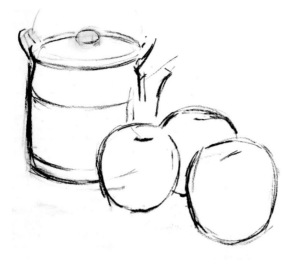

Step 2. Here, the simple, geometrically based shapes established in the previous step are gradually refined to resemble recognizable forms that relate to the real objects shown in the photograph. It's easy to make this transition in your drawing if you work attentively. The precision of your line is important, so don't hesitate to make corrections as often as necessary. For example, if any of the apples you have drawn isn't as rounded as it should be, or the sides of the kettle aren't properly vertical, they must be corrected.

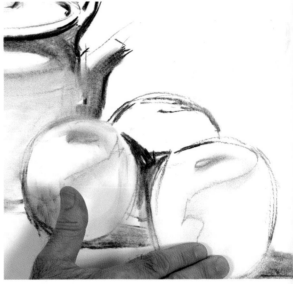

Step 3. Though it may seem too soon to work on representing three-dimensional volume, you should always challenge yourself somewhat, executing each drawing so that it has a complete and finished effect. In this case, fill in the appropriate areas with charcoal, then spread the color with your finger, grading the tones to help define the forms you've drawn.

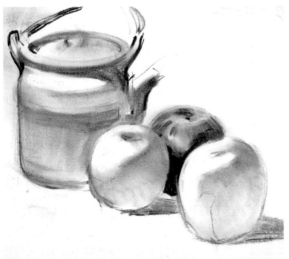

Step 4. By using your finger as a pencil, you can blur and blend lines together to create a variety of tones (gradations of light and dark). The lighter areas are achieved through the white color of the paper itself. These areas should be kept clean; if smudged during work, you can clean them with an eraser.

Step 5. Now that the light areas have been cleaned with the eraser and other areas have been blended, the drawing seems somewhat subdued. This is the time to reinforce its forms through more lines, some applied with greater pressure, others hardly touching the paper. Pay attention to the rhythm of your strokes, sometimes using the tip of the charcoal, and sometimes the flat edge. Aim to make the drawing dynamic by exploiting all the possibilities the medium offers.

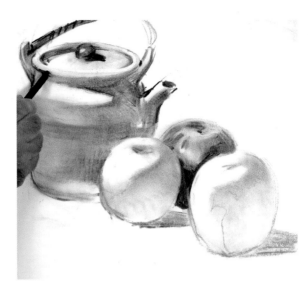

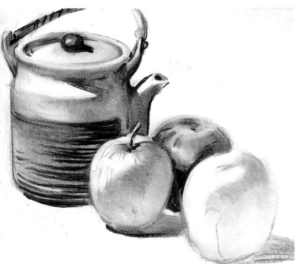

Step 6. Here, you can see the addition of various contrasts; note the great difference between the tones of the kettle, the apple in the background, and the one on the right. In your mind, reconstruct the exercise from the first step to weigh the importance of beginning correctly. If you observe closely, you will see that the shapes have hardly varied from the initial schematic drawing based on circles and a rectangle.

Step 7. To balance the overall tonal quality of the work, add some more dark tones, being careful not to make them excessively dark. Repeat the previous operation with the eraser to clean areas that should be lighter. If the eraser becomes dirty, rub it against a cloth or on another sheet of paper to clean it. Don't use a dirty eraser, as it will embed the charcoal in the pores of the paper, making it impossible to remove.

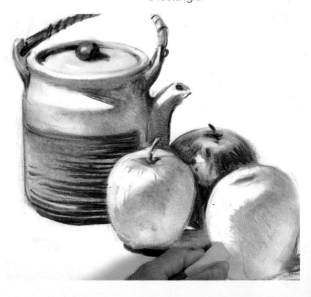

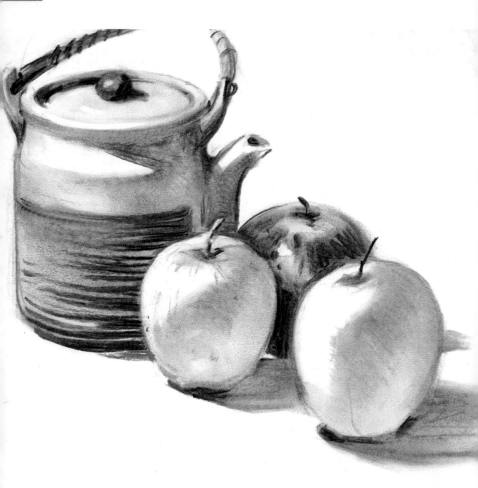

Step 8. Finish the drawing by adding more dark tones, this time with clean, barely blended strokes. The combination of blended areas with unblended ones creates a realistic effect. (This will be covered in more depth later.)

SUMMARY

• Any subject can be broken down into elementary shapes.

• All shapes existing in nature, complex though they may be, can be blocked into geometric shapes.

• The rectangle is like a box in which anything can be stored.

• A great many shapes can be blocked inside a square, even a circle.

• Inside a simple shape, it is very easy to draw another, more complex one.

• Your strokes must be steady.

• The object must be blocked into an elementary geometric form and then refined and polished.

• The synthesis of shapes is an important step in mastering drawing.

HOW TO EXECUTE A PRELIMINARY SKETCH

THE MEDIUM AND THE STROKE

Making a preliminary sketch is an important step in constructing a drawing correctly. This stage is essential to any drawing, no matter how simple or complex your subject. Through practice, the technical aspects of sketching will gradually become imperceptible and natural to you.

Various sketching techniques help you establish the objects in your subject in the proper location on the paper. In drawing, correction is constant; it allows you to refine the precision of each stroke by itself and in relation to other lines in the drawing. With practice, the sketch will become more and more precise from the first stages.

1. A sketch is a quick drawing that helps you grasp the basic forms of the subject from the outset. Any medium will do. Soft vine charcoal gives you a very malleable, contrasting line, and works on almost any type of paper. This sketch was drawn with a two-inch-long piece of charcoal, combining flat strokes with others made with the point of the stick.

2. Another medium appropriate for a sketch is Conté crayon. Although denser than vine charcoal, it is used in a similar fashion. The lines it produces are generally harder and more defined, and it is often used in combination with other mediums, such as charcoal or white chalk. Here, the strokes have a gestural quality, giving the drawing liveliness.

3. Different sketching procedures provide the drawing with various qualities of tone, color, and line. The quality of the stroke contributes to the vitality of the final drawing. Here, colored and graphite pencils were used.

Hardness and Pressure

In executing a sketch, it's important that you understand the characteristics of the medium you are working with. Through practice, you'll acquire certain definite preferences; try a variety of mediums to discover those you like best. Some give hard and clean results, while others give soft and malleable effects.

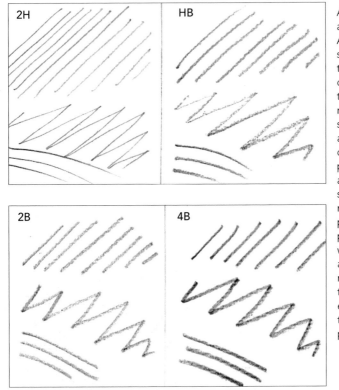

A hard pencil provides a defined, clean line. Applying it with pressure leaves a definitive, "engraved" mark on the paper, such that if correction is necessary, the line will still be visible even after erasing. When drawing with such pencils, you need not apply too much pressure, as their maximum darkness is preestablished. Hard pencils are marked with the letter H, accompanied by a number. The higher the number, the harder the graphite and the finer the line it will produce.

The pencils most appropriate to artistic work are those marked with a B. As the number printed next to the B rises, the line produced will be softer and greasier, and the tonal variation will be richer.

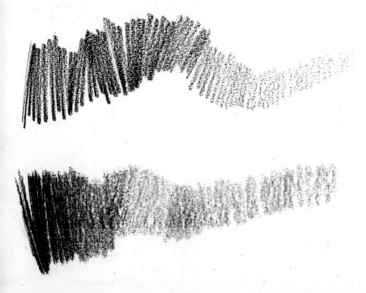

In addition to its maximum darkness, the pencil's hardness determines its gestural capacity. For some work, it will be important to use a pencil that produces soft, malleable effects; in other cases, the drawing may call for hard, precise lines. At left are results achieved with a hard versus a soft pencil.

Ways to apply line in a preliminary sketch

When you begin a drawing, aim to make your strokes definitively. The preliminary sketch will be successful if it is based on a sound, linear foundation. The best way to comprehend this is by practicing. The exercises on this page were drawn in soft vine charcoal and compressed charcoal, although any medium could have been used.

1. *Right*: At first, hold the stick of charcoal flat between your fingers to apply it to the paper; this method lets you draw lines with assurance. In this preliminary sketch of a tree, the direction of the strokes helps determine the tree's internal structure. Lines drawn with the stick held flat are very basic, but facilitate the definition of form.

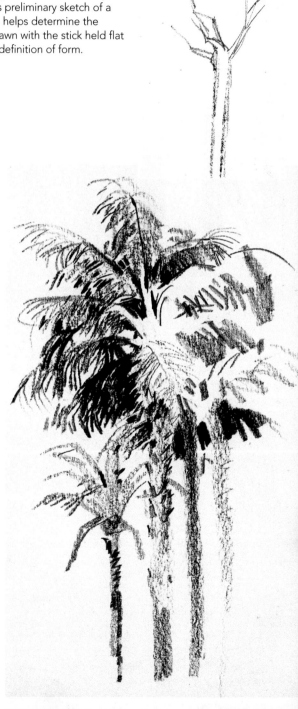

2. *Above*: When the sketch has acquired more body, the necessary contrasts can be added. Here, the details are left unfinished. In many cases, the final drawing will not go beyond a simple sketch.

3. *Right*: An exercise such as this one is very helpful for studying a subject and transferring it to paper. The lines in this sketch are not all identical; there is a great variety of intensities and gestural intent. The thickness of the lines is purposeful: the thicker lines and even those that are applied with hardly any pressure all combine to create a harmonious whole.

THE NATURE OF THE STROKE

The stroke is an extension of your artistic intent, just as the voice is an extension of thought. Some strokes are like whispers, whereas others can become exclamations, or even poetry. The nature of your stroke is what allows you to express yourself through drawing, and the medium you use will contribute to that expression. Thus, it's important to choose a medium that lets you express yourself best.

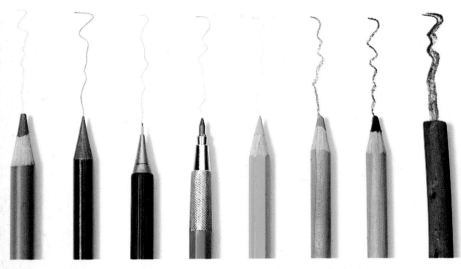

Every medium has its own character and, depending on how an individual artist uses it, can produce surprising results. Even the simplest medium has many possibilities. The stroke is the most elementary expression of the medium, and the quality of the sketch and the definitive drawing greatly depend on it.

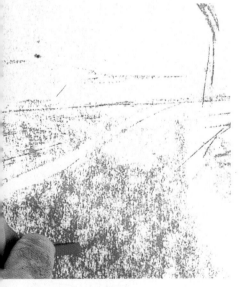

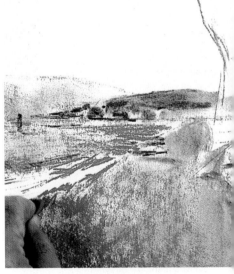

1. A typical Conté crayon is rectangular, with hard edges. Many types of line can be drawn with it; delicate lines will result from using the edges of the stick, whereas wide strokes will result by applying the flat side to the paper. The gesture of the stroke will depend on the texture or grain of the paper.

2. Contrasts and fairly well defined forms can be established in an initial sketch. The direction and quality of your strokes will determine the final results of the drawing. Here, some areas have been executed with great pressure and others with a softer touch, as appropriate to the subject.

Mountain Landscape

MATERIALS

Pastels: blue, burnt sienna,
and white
Orange-toned paper
Cloth, Eraser

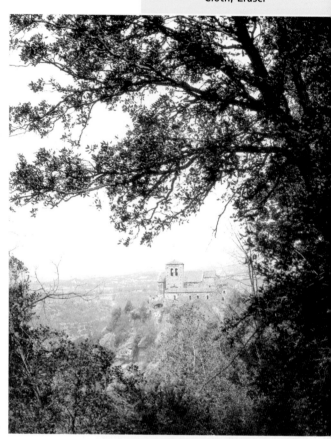

A sketch can serve many different purposes. It is, for example, a means for gaining a better understanding of your subject, for mapping out the placement of all the elements in a composition, or studying tonal or color relationships. As an artist, you must learn to evaluate how far to develop any drawing and determine the point at which it best expresses your intent. This exercise, with a landscape as its subject, should help you grasp some of the basic approaches to executing a preliminary sketch.

Step 1. Executing a good sketch requires strong observation skills. This is probably the most difficult obstacle to overcome, not only here, but in any exercise you may carry out. Looking at the photograph, draw the principal lines of the scene in sienna, seeking the underlying structure of the foreground tree and the main volumes of the landscape. Represent these elements schematically, with no details whatsoever.

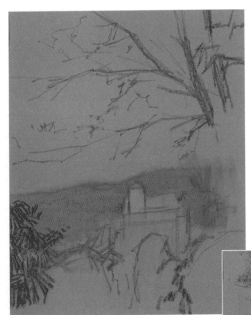

Step 2. The first lines established the basic structure of the sketch. Now reinforce these lines in blue. This is the same process you would use in a sketch with only one color, where the initial outlines serve to provide a framework and the later ones strengthen it. Note that the forms are kept rough throughout. Here, work on the background has begun; with fingers covered in blue pastel, the profile of the farmhouse and its various shapes are outlined.

Step 3. The kinds of strokes applied vary as the work progresses, as does the amount of pressure used. The denser areas of foliage in the foreground are suggested using the side of the pastel held flat against the paper, while in the middle ground the medium is held like a pencil and applied in short strokes.

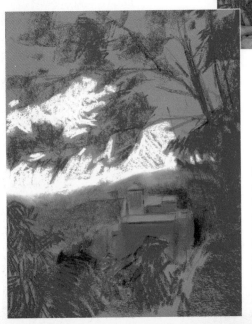

Step 4. The foreground vegetation is completed in blue, interpreted as a series of areas of different intensities but with no detail whatsoever. The building is further refined with blue along the rooflines and a lighter tone of the same color extended onto the façade with the fingertip, taking care to stay within the outlines. White is applied to the sky in loose strokes so the color of the paper can be seen in between.

Step 5. More sienna is now applied. This intense earth color combined with the blue provides dark tones. The strokes are drawn directly and spontaneously, differentiating the middle ground from the background. Applying the pastel with pressure deposits dense accumulations of pigment on the paper, creating an impasto effect. Stop for a moment and observe the great variety of strokes and their nature. They change throughout the drawing, acquiring a specific intensity in each area.

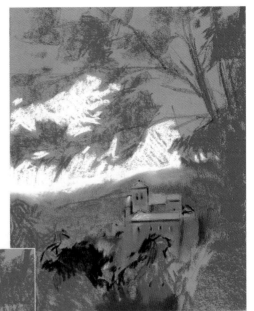

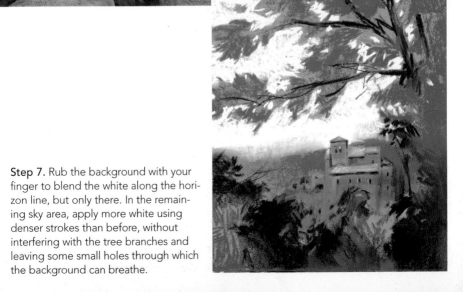

Step 6. The importance of each area is defined by the kind of stroke applied. The foreground is given a more gestural impact, whereas the background remains relatively subdued. A common error is attempting to provide equal amounts of detail at every depth of the picture plane. This should be avoided at all costs.

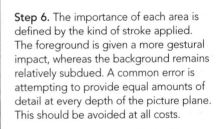

Step 7. Rub the background with your finger to blend the white along the horizon line, but only there. In the remaining sky area, apply more white using denser strokes than before, without interfering with the tree branches and leaving some small holes through which the background can breathe.

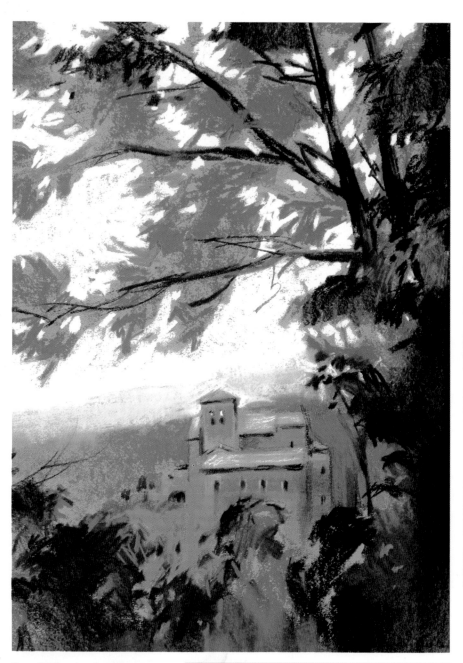

Step 8. The sketch might have been considered finished after the previous step, but it still seemed to need the addition of some small contrasts, such as some quick strokes of sienna on the trees in the foreground. The resulting dark tones clearly separate the foreground from the more distant areas. At this point the drawing appears finished, demonstrating how a sketch can certainly be the final objective in and of itself.

SUMMARY

• A preliminary sketch is essential for any subject.

• A preliminary sketch is a quick, perceptive study that helps you understand your subject.

• Various procedures can be used to create a sketch, providing different tonal, color, and stroke qualities.

• For a sketch, it is very important that you know the medium you've chosen and its possibilities.

SKETCHING THE FIGURE

HOW TO START SKETCHING

In this chapter, we will apply sketching techniques to the figure, one of the most universal painting motifs. The sketch allows the artist to study the body's proportions, weights, and balances, and is a means for establishing a basic structure that will facilitate rendering the rest of the figure, no matter how complex.

We'll begin with a female nude, focusing on the torso and drawing it set in uncomplicated poses. Although the human figure requires far greater attention than the still life or the landscape, no matter what your genre, you must first define the subject's main shapes.

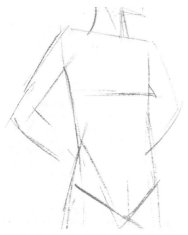

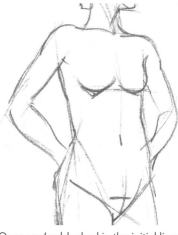

1. The first part involves getting down the most significant lines. Pay close attention to the initial structure of your subject; then, holding the Conté crayon against the paper, make resolute strokes.

2. Once you've blocked in the initial lines correctly, developing the work further will become easier. Here the lines were drawn using the tip rather than the flat length of the stick; the rectangular forms must now be made more sinuous, reflecting the body's anatomical structure.

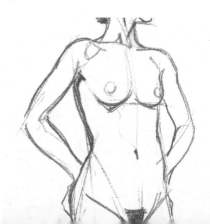

3. During this phase it's important to thoroughly study the lines you have already drawn, deciding which ones are most relevant to the sketch. This procedure is complex and cannot be mastered in a single lesson. Here, note how the contour of the left-hand side of the body has been reinforced, lending it greater prominence.

GESTURE DRAWING

The figure is one of the most interesting subjects to draw, and as with everything else, the more you work at it, the better the results. You can start by drawing from photographs before trying to work from a live model. It's important to use a loose stroke, even if the result bears little similarity to the model. It all boils down to educating your eye and coordinating it with the strokes your hand makes.

1. Whereas the last exercise involved a more calculated approach, based on a rectangular structure you used to flesh out the forms, this exercise involves capturing forms through the gesture or movement of the hand; graphite is the best medium for this method of drawing, because it allows you to easily vary the thickness of your lines. Draw the contours and outlines with the tip of the stick and create the shaded areas by holding the medium on its side. Highlights can be created in these areas using a rubber eraser.

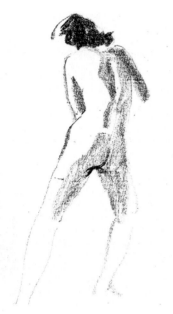

2. A shaded area can be used to suggest the continuity of a line. Observe the figure's left leg: there is no line below the shadow, although its shape is perfectly intuited. In a sketch, this suggestive approach allows you to solve complex areas easily.

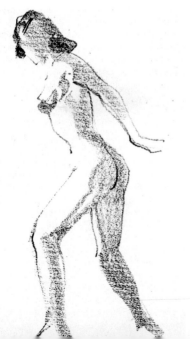

3. Gestural drawing lets you easily create a very basic rendering of the body, and is a good method for developing your ability to draw the figure with confidence. Note how the contrast between dark strokes and light areas suggests three-dimensional form. For practice, first try copying these or other drawings, then use photographs; whenever possible, however, work directly from a live model.

IMPORTANCE OF THE INITIAL STRUCTURE

Basic geometric shapes can be used to represent any part of the body, as this preliminary sketch of a female torso reveals. A sketch like this one provides a sound structure that allows you to better understand and establish the figure's proportions. Here we'll focus on individual parts of the figure rather than the entire body, which is covered later.

1. Through practice you're learning how basic shapes can be used to represent everything in nature. Fruit and other elements that make up a still life can be rendered from these geometric schemes; the same holds true for the human body. This exercise demonstrates how to draw a female breast. The main shape is a circle, here drawn with the tip of a Conté crayon. The circle is drawn faintly and quickly several times until the right degree of roundness is obtained; then the line is gone over.

2. Once a correct foundation has been achieved, the lines are reinforced by applying more pressure on the stick. The underlying sketch lines will be virtually absorbed by the more intense lines.

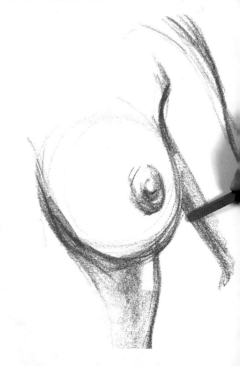

3. The anatomical form is gradually made more realistic through continual adjustments. The first lines have not been erased; they are still there, although they are barely noticeable, as the overlying strokes are more prominent. A reinforced line will lend importance to a concrete area.

LEARNING HOW TO CALCULATE PROPORTIONS

Sketching the figure within a construction frame like the one used below helps you judge the measurements of your subject's various components so you can calculate their proportions in relation to one another. Note how spaces have been left between the first lines and how the forms are outlined progressively with ever more definitive strokes.

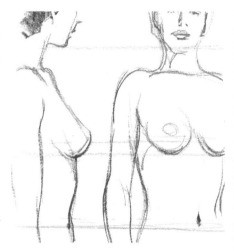

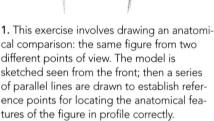

1. This exercise involves drawing an anatomical comparison: the same figure from two different points of view. The model is sketched seen from the front; then a series of parallel lines are drawn to establish reference points for locating the anatomical features of the figure in profile correctly.

2. Once the basic structure has been adjusted sufficiently, a more precise drawing is done, defining perfectly the female forms of both figures.

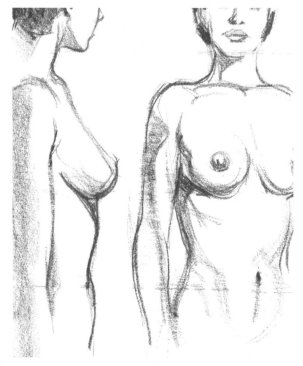

3. The sketch is almost finished; all that remains is to define the forms by drawing over them with a light stroke, which should be executed in a dynamic and spontaneous manner.

Female Torso

MATERIALS

Conté crayon
Drawing paper
Eraser, Cloth

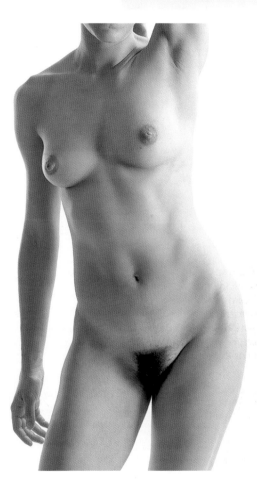

The sketch is one of the most fundamental approaches to understanding and articulating the figure. As we've already said, it is essential to begin with an initial construction sketch. Carefully study the first steps of this demonstration, in which the sketch lays the groundwork for the subsequent development of the figure drawing.

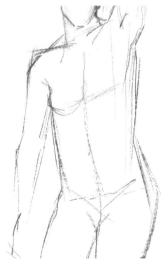

Step 1. To draw a construction frame, it's important to take into account the body's curvature, in this case the line of the back, which changes direction at the hip. This point marks the axis from which the sketch and the subsequent drawing can be developed. Close observation of the frame reveals that three main lines define the breadth of the body: the shoulders, the thorax, and the hip. These three points, together with the axis line of the back, provide the reference points for drawing as well as the main outline of the shape of the body.

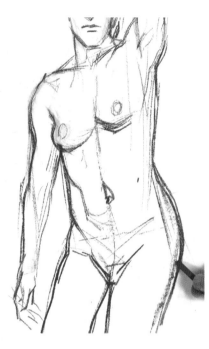

Step 2. Once these lines have been established, you can draw in the main contours of the body more confidently. A free, more calligraphic type of stroke is achieved by drawing with the tip of the Conté crayon. The construction lines remain visible throughout the process as new lines are drawn over older ones to correct and adjust the forms.

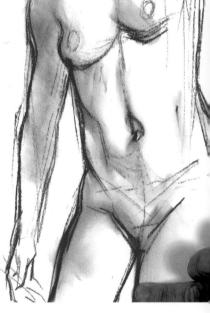

Step 3. The preliminary sketch has been finished; the main lines have been adjusted and given more definition. Now, with the fingers, some of the color is spread into the interior of the figure. These tones help suggest volume.

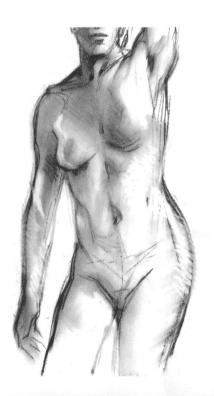

Step 4. The sanguine color is spread easily over the paper until almost the entire area of the figure has been filled in. The highlights on the body are brought out with the eraser, thereby beginning the process of creating tonal balance, a fundamental technique that will be used in subsequent exercises.

Step 5. Tonal work continues; dark shadows are established by applying color densely in the appropriate areas, such as the one below the breasts and the one on the arm hanging at the model's side. These zones provide a source of color that will be extended with the fingers. The eraser is used to bring out the highlights. Rather than simply follow the process illustrated in these images, you should constantly compare the progress of your drawing with the photograph of the model shown on page 29.

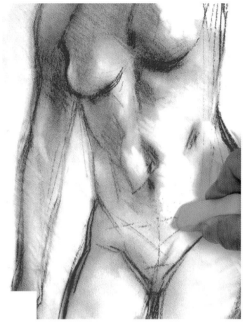

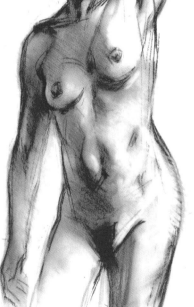

Step 6. Part of the contour and certain details are gone over using the tip of the Conté stick. Note the dark zone in the abdomen and how it lessens the importance of the curved line of the hip.

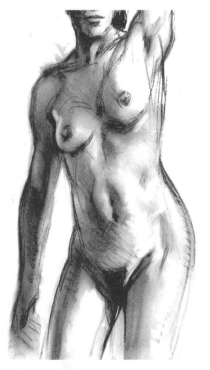

Step 7. Contrasts are made increasingly more intense; care must be taken to ensure you don't lose sight of the model as a whole. Volume and shadows can also be developed in a sketch, but they should not be overly prominent if you want to retain the work's original freshness.

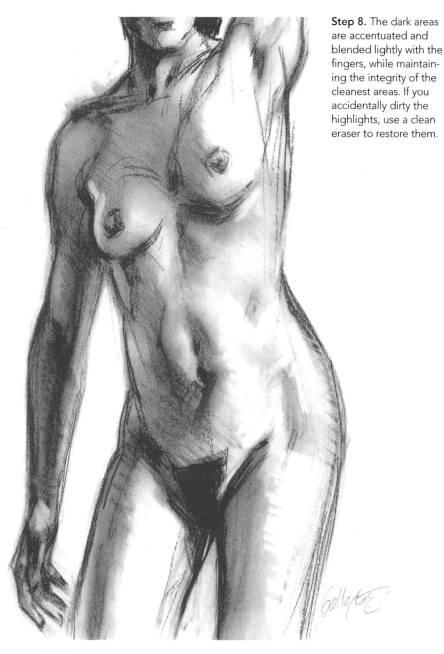

Step 8. The dark areas are accentuated and blended lightly with the fingers, while maintaining the integrity of the cleanest areas. If you accidentally dirty the highlights, use a clean eraser to restore them.

SUMMARY

- The figure can be constructed from a series of boxlike structures.

- Volumes can be drawn as simple linear forms.

- Draw loosely to educate your eye and coordinate it with the strokes your hand makes.

- Elementary shapes can be used to draw any representation of the human body.

- By summarizing a shaded area you can suggest the continuity of a stroke.

- The secret of a well-drawn sketch lies in combining shaded areas and lines.

- Once your framework is correct, reinforce it with a bold line.

- Dark, intense lines are used to lend prominence to a specific area of the sketch.

- Establishing a preliminary structural sketch allows you to correct and adjust your subject's measurements.

4

SKETCHING THE STILL LIFE

STARTING TO SKETCH

The sketch is as indispensable to the still life as it is to the other great painting motifs, landscape and the figure. The procedure demonstrated for drawing a still life is slightly more intricate than that for the figure, but is still based on the use of elementary shapes. Many novices take the advice offered in this section for granted; however, doing so may bring unsatisfactory results.

The importance of the preliminary sketch as the cornerstone of a future work has been stressed from the first pages of this book. Some of the guidelines and rules that apply to motifs as complex as the figure are also valid for the still life.

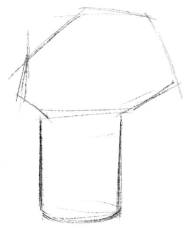

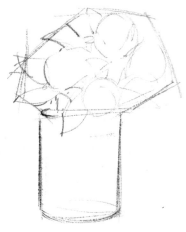

1. Don't be daunted by the apparent difficulty of a complex shape. Although flowers may seem hard to draw because the space they occupy isn't always easy to comprehend, they can be boxed or blocked into a simple geometric shape.

2. First we draw the main masses and then proceed to more specific features. The geometric shape that encloses the whole is subdivided into other smaller and more concise shapes, within which the individual elements of the subject will be drawn.

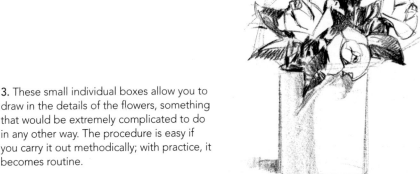

3. These small individual boxes allow you to draw in the details of the flowers, something that would be extremely complicated to do in any other way. The procedure is easy if you carry it out methodically; with practice, it becomes routine.

CORRECT AS YOU WORK

You must continually correct a drawing as you proceed. This advice may sound obvious, but it is a fundamental rule for learning how to draw. It is worthwhile to spend more time on blocking in and making corrections to your sketch if you want to use it as the basis for a later work. This exercise, a drawing of two pears, is meant to help you hone your powers of observation.

1. We begin with two simple circles, but it's not merely a question of drawing their circumferences. Their proximity to each other in space and to the viewer is indicated by the angle of the table they rest on. If the two pieces of fruit were on the same level, it would mean that they were at the same height as the viewer's eyes, and therefore the surface of the table would not be visible.

2. While sketching the fruit, continually make corrections in your efforts to be accurate. Execute the first lines that define the more intricate shapes faintly as you aim to approximate the pears' forms. This way they can be corrected easily without leaving marks.

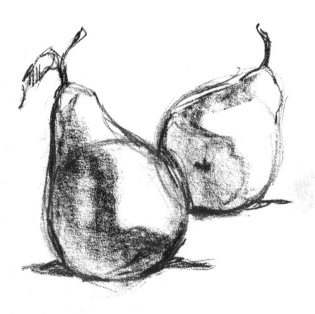

3. This exercise requires keen visual skill. Learning to see teaches you how to draw. Close observation helps you reduce the subject to its most basic shapes on paper. Using a sepia Conté crayon, the outlines of the shadows are drawn in with a studied stroke. These strokes, which are more akin to patches, define the volume of the fruit. Some correction will also be required here, therefore the first lines should be faint, allowing you to adjust them to the desired shape.

FRAMING THE STRUCTURE OF YOUR DRAWING

Reality is very complex; thus, in attempting to represent it on paper, you must decide which elements you want to include. Making such choices is part of the initial phase of your work. Next comes framing – setting up the underlying structure of your drawing and determining the arrangement of all its components on the paper. This still life has been framed in a way that leaves out significant portions of the objects, creating an abstract quality.

1. This preliminary drawing establishes the frame of the subject, that is, what's to be included in the work. You don't have to set up a complicated still life; the important thing is to find a suitable part of the arrangement to represent. The emphasis here is on achieving a balance of forms. Note the importance of the space that surrounds the two objects. In this case, the framing will be sustained by a new artistic value: the "weight" of the dark areas.

2. The darkest areas are indicated first, thereby establishing the highlights. This task is executed using a stick of compressed charcoal, a denser, less malleable medium than vine charcoal that makes it easy to create bold contrasts. It permits a gestured and consistent stroke while allowing the white of the paper to remain visible.

3. The entire background is darkened; in this way the highlights on the objects acquire a new relevance. Note that the darkness of the background extends only to the edge of the table, perfectly defining this surface. A finger is used to blend some of the tones and thus soften the harsh contrast.

ELEMENTARY SHAPES

The best way to understand forms is by studying them in terms of simple geometric shapes. This task is more difficult than it at first seems, but with regular practice you'll use this technique almost unconsciously. The following exercise examines a theme that has been explained from the first chapter of this book, and that will be reiterated in various sections throughout the book.

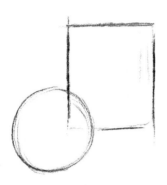

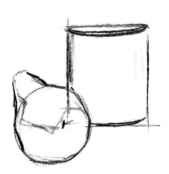

1. The basic elements of a still life must be studied with care. These two shapes, which are easy enough for anyone to draw, will provide the groundwork for many exercises that follow. Now that you've had some practice making different kinds of strokes, you should be able to draw in a looser, more spontaneous manner. The circle superimposed over the square indicates from the outset the position of the two objects in space.

2. The process appears to be childishly simple, but don't allow yourself to get overconfident. Often beginners make the mistake of believing that its simplicity means this initial phase can be bypassed. But doing so leaves the final result to chance. The preliminary structure forms the foundation of the drawing; without a correct preliminary sketch, the subsequent work will not turn out well.

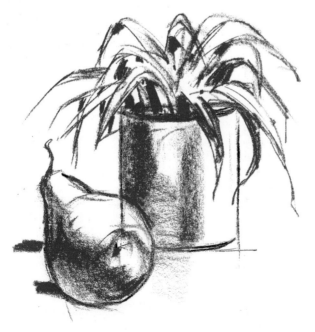

3. The simple preliminary sketch was enough to guide the result at left. Here, a Conté crayon was applied without any blending, emphasizing the gesture of the stroke. For the shadows on the pear and the flowerpot, the stick was applied flat against the paper, whereas the intense shadows on the leaves were rendered with the tip of the stick.

White Still Life

MATERIALS

Charcoal
Drawing paper
Eraser

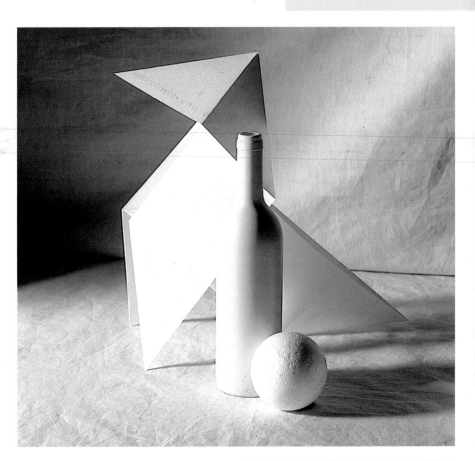

This exercise summarizes everything you've learned thus far. The two main points to bear in mind are the synthesis of forms and your ability to break them down into their basic geometric shapes as you sketch them. The elements of the still life shown here are very simple. This, along with a monochromatic approach, will help you study these drawing concepts further.

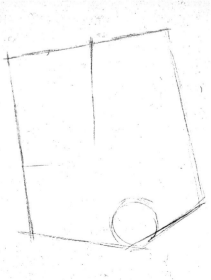

Step 1. Closer scrutiny of the subject reveals a certain degree of complexity. The first step involves enclosing the main shapes within a geometric structure. Although these lines only approximate the space occupied by the objects, they help you establish their placement on the paper.

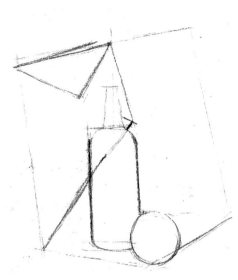

Step 2. Following the rule of working from the general to the specific, draw the preliminary shapes. By beginning with the diagonal line of the paper bird, you establish the location of the bottle, which is indicated by a rectangular shape. It's important to study proportions; to draw each partial structure, you must keep in mind the position of the other objects in the composition.

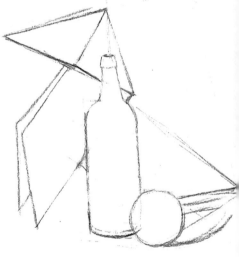

Step 3. The first outlines of the objects are sketched faintly. Then the forms and their proportions undergo a continuous process of correction. Once these lines have been consolidated, they are intensified a little. When the preliminary outline is complete, the shapes are closed up, and the next phase of work begins.

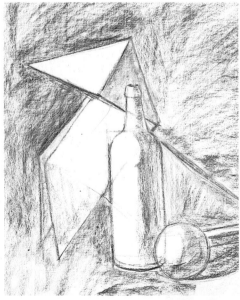

Step 4. The background is darkened and the main shadows are added by applying the charcoal flat against the surface of the paper. The brightest areas of the objects are left white. Once the drawing's structure has been sufficiently defined, the work of applying tones can begin. Establishing this preliminary structure is essential to proceeding to the next phase.

Step 5. The charcoal is spread using your fingers over the background until a uniform surface is obtained. Care must be taken to avoid erasing the main lines of the drawing. If you do happen to make this mistake, redraw the lines; remember that this is only the preliminary structure of the drawing.

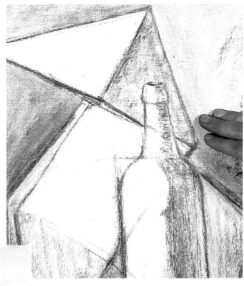

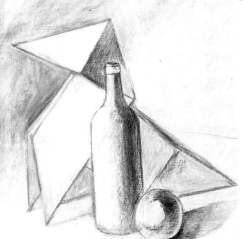

Step 6. Using the eraser to clean the brightest areas produces a velvety visual effect and makes the whites appear softer than they were at the beginning. Once the light areas have been cleaned, the dark areas are intensified. Note how the light areas make the dark areas appear even darker.

Step 7. Clean, sharp edges between tones can be achieved by placing a sheet of white paper over your drawing as a mask where needed and making careful strokes with the eraser. The eraser must be clean and should not drag the paper mask.

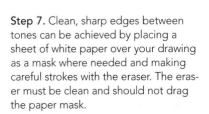

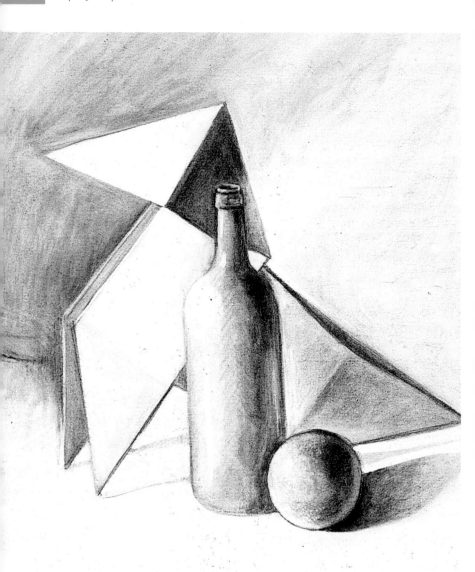

Step 8. Not all the boundaries between tones should be articulated with the mask, only those that are really necessary. The eraser is applied in different areas, opening up little highlights here and there over the bottle and the sphere. The exercise is finished. This result was only possible because the first steps were followed.

SUMMARY

• The sketch paves the way toward more advanced work.

• The subject can be blocked into a geometric form.

• The secret of making a good sketch is to start with the main masses and end with the details.

• The details must be sketched within previously defined sub-divisions.

• Establishing an initial structure simplifies the drawing of complex forms.

• The work must be corrected continually throughout the entire process.

• The first strokes must be applied faintly.

• Framing is a technique used to select the part of a subject you wish to represent.

5

DRAWING AND COMPOSING THE LANDSCAPE

METHODS FOR SKETCHING THE LANDSCAPE

The landscape is an enjoyable genre, and it lets you compose with greater freedom than other pictorial motifs, possibly because errors are less apparent in the landscape than in a figure or still life. Nevertheless, landscape subjects require special attention to the way masses and forms are distributed.

From the outset, the landscape requires a good preliminary framework, something that is essential for its later development. This exercise shows how easy it is to render a landscape. You will also learn about the fundamental aspects of line and composition.

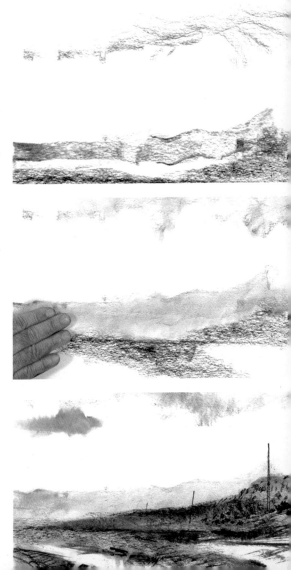

1. A simple horizontal line could already be a landscape, as it divides the picture space in two and thus determines the observer's point of view. The aim of this first step is to define the planes of background, middle ground, and foreground. These basics are established by applying the charcoal flat against the paper; to give a sense of depth, the clouds and mountains in the background must be fainter than anything in the foreground.

2. An effect of depth is achieved by altering the contrasts of the background. Here, this is done by spreading and blending the charcoal with the fingers. You can create an atmospheric effect by softly rubbing your hand over the area. The two main planes, the background and foreground, have now been established.

3. Through a continual process of adding dark patches in the foreground, the differences in the height and the surface of the terrain are defined. The lightest areas are highlighted with the eraser.

COMPOSING VISUALLY

Once you have chosen your subject, you have to decide which part of it you want to record on paper. In other words, you don't draw everything you see, but select a fragment of it. To do this you must study the scene careful-ly and imagine how you will synthe-size its components. Whereas the pre-vious sketch was executed by means of a speedy application of dark patch-es, this one will be carried out using wash, a technique that offers highly satisfactory results, although because this is a drawing exercise, we will keep the process simple.

1. For this landscape, besides paper and pencil, you'll need watercolor paints – sienna, blue, and green – a brush, and a container filled with water. The subject is first sketched in pencil, defining the main forms with faint lines. Special emphasis has been given to the curve of the path, which, to avoid symmetry, is not drawn exactly in the center.

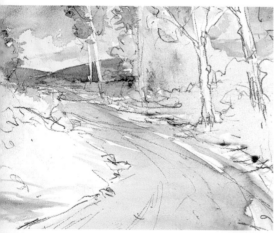

2. The brush is dipped in water and loaded with a touch of sienna; the path is painted with a simple stroke. Then the other elements are paint-ed, leaving the highlights and other light areas unpainted. Different intensities of a color result from the proportion of paint pigment to water on the brush. You should let one color dry completely before applying another one to an adjacent area so that the two don't mix; how-ever, since this is a drawing exercise, it's not important if this happens.

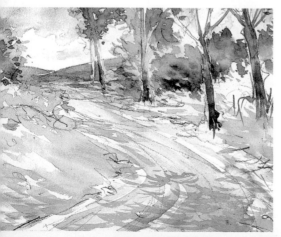

3. When the washes are completely dry, reapply the same colors to each of the main compositional areas. Superimposing paint layers this way lets you deepen and intensify colors as needed, in much the same way you can create tonal differences with charcoal.

THE IMPORTANCE OF BLOCKING IN THE COMPOSITION

This exercise demonstrates two fundamental aspects of composition: blocking in and creating the illusion of depth. The relationships among the different planes are so crucial to rendering a landscape convincingly that, without establishing a suitable preliminary structure, the work would end in a jumble of tones. By taking this into account, you can draw landscapes that convey spatial depth effectively and are visually pleasing, too.

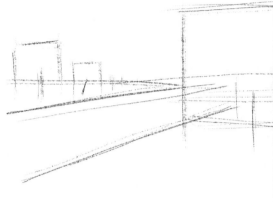

1. With the tip of a stick of charcoal, we establish the horizon line. This provides a linear structure that indicates the depth of each plane and allows you to block in the main masses of the landscape. The various elements are blocked in using geometric shapes; a rectangle indicates the position of a tree that is to appear in the right foreground.

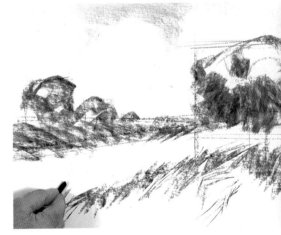

2. Having the preliminary structure in place facilitates sketching in the masses that represent the different planes of the landscape and the dark areas of the trees. The stroke is now more gestural and the charcoal is applied flat against the paper. Note the different textures that suggest the grass on either side of the path and define the densest parts of the trees.

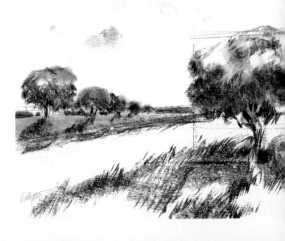

3. Contrasts are developed on top of the preliminary structure and blended with the fingers. At this stage the only concern is with laying the groundwork for the final contrasts, so not much detail is required here. These shadings help further define the different planes of the landscape and reinforce the sense of depth.

CALCULATING SCALE
AND DISTANCE

Most landscape compositions have reference points that give the viewer an idea of the relative distance between one element of the scene and the next. Some don't, especially those that intentionally place the viewer before a nature scene devoid of references to size to create a romantic impression. But in a realistic drawing, such references provide the information that is paramount for the observer to gain an idea of scale.

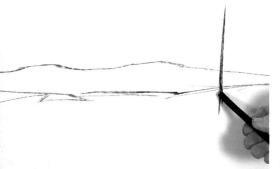

1. Once the lines defining the height of the horizon and the differences between the landscape's main planes are drawn, the first unit of measurement, which eventually will become a tree, is established; all other compositional elements will be scaled according to it. Such calculations help you draw distant objects in proportion to those in the middle ground and foreground.

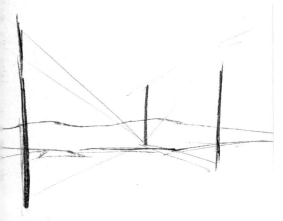

2. Lines defining the position and height of the scene's other two trees are drawn as reference points. Several very faint lines are sketched from these points to the horizon line. Anything drawn between these lines should be the same height. This method gives you a rough idea for calculating distances and defining the planes in the landscape, in accordance with the size of the objects represented.

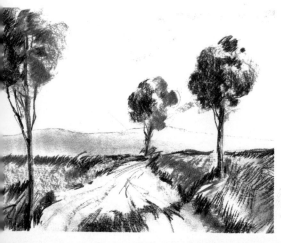

3. Now the drawing has a very convincing depth. The most important point to remember is that the areas nearest to the viewer require more contrast than those in the background. Likewise, foreground surfaces should have detail, while distant ones should be more vague.

Landscape with a High Horizon

MATERIALS

Compressed charcoal
Eraser
Drawing paper
Cloth

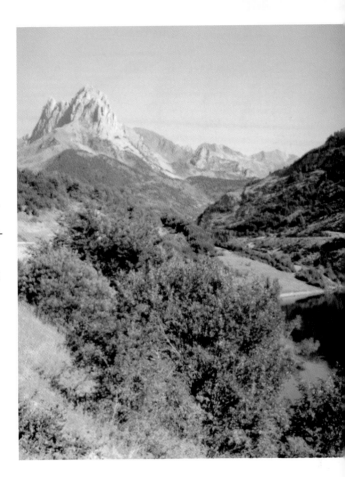

This step-by-step demonstration is meant to help you practice blocking in your subject, sketching it, and achieving a suitable representation of depth in a landscape drawing. Although the subject is complicated, the exercise should be relatively easy if you follow each step carefully. This stage doesn't involve rendering details; that will come later. As always, you must begin with the main masses and work toward the more specific features.

Step 1. Look carefully at the photograph and you'll be able to see the landscape as a synthesis of volumes and masses. To start, we draw the horizon line and the main masses of the mountains. Below this area, the trees of the foreground are superimposed over the rocky terrain of the middle ground. The aim here is to record only an impression of the whole, so keep your lines simple.

Step 2. The atmospheric effect in the most distant plane is achieved by blending the tone with a fingertip, spreading the compressed charcoal over the area. Unlike soft vine charcoal, the compressed variety cannot be erased easily, but it is easy to spread. The craggy faces of the mountain are sketched with very soft tones.

Step 3. The mountains on the right are drawn with very dark tones, the intense strokes applied with the tip of the charcoal. It's important to let the white of the paper remain visible between the lines. The sensation of distance has now been accomplished, thanks to the well-defined structure of the underlying sketch and the use of different tones.

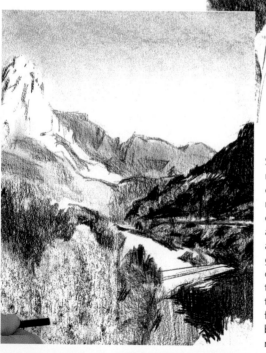

Step 4. The white areas of the mountains in the foreground are cleaned up with the eraser; the result is an even more pronounced contrast between the rocky faces and the most brightly illuminated areas. As you can see, the work progresses from the general to the specific. This rule must be followed throughout the process, including the elaboration of textures and surfaces. The area that will eventually become the foreground trees is now shaded.

Step 5. We return to the mountains in the background, strengthening the contrasts, taking care not to leave them as dark as the dark areas in the foreground. These tones are produced by applying more or less pressure with the tip of the stick of charcoal. The dark shading in the foreground superimposes the previous shadings. To render the texture of the vegetation, tonal differences are created.

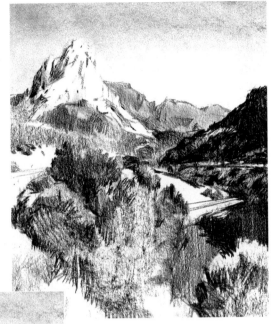

Step 6. Even though the contrast in the foreground has been increased, it isn't as dark as the mountain at right; this tonal difference helps to create the effect of depth. The three main planes of foreground, middle ground, and background have now been defined. The eraser is used once again to delimit the areas of vegetation and to enhance the contrasts.

Step 7. Now that the main contrasts of the landscape have been perfectly defined, we turn our attention to the most important details, and darken the areas of greatest contrast.

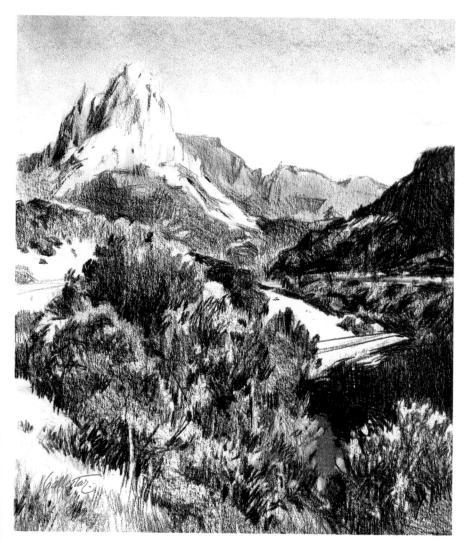

Step 8. With the stick of compressed charcoal held like a pencil, the details of the fore-ground are drawn, going around the highlights. Don't add specific detail to all areas of the work; it's best to limit it to just a few areas and only suggest it elsewhere.

SUMMARY

• Errors in a landscape are not as apparent as they are in a figure or a still life composition.

• Landscapes require special attention to the distribution of masses and forms.

• Avoid symmetrical compositions, as they won't hold the viewer's attention.

• The lines of the preliminary sketch lay the groundwork for further development.

• The horizon line suggests depth and indicates the spectator's point of view.

• The effect of depth is obtained by altering the contrast between the planes in the distance.

• The blocking-in technique requires you to see your subject as a synthesis.

• It is essential to establish a relationship between the planes of a landscape.

• A landscape composition usually has reference points that give the viewer an idea of the relative distances between objects.

FROM SKETCHING TO MODELING THE FIGURE

BUILDING COMPLEX SHAPES FROM SIMPLE SHAPES

The human figure is one of the most attractive subjects to draw, and it offers a wide range of possibilities that can result in works of outstanding beauty. Drawing the nude requires that you take many factors into account, such as proportions, composition, and the "modeling" of forms. Modeling refers to the depiction of a three-dimensional form based on different tonal gradations.

The simplest volumes derive from basic shapes, like those used to draw the fruit in the still life exercises. Once you have mastered how to apply these elementary shapes to depicting the figure, you can move on to the subject of lighting and the techniques used to render the figure's volumes.

1. To draw a female breast, first recall how to render an apple. As you look at your subject, block it in as a basic shape, in this case a circle. Next, observe how the light falls on the fruit and shades the part of the apple in shadow, which is located on the side opposite the direction of the light. This crescent-shaped shadow suggests the fruit's volume.

2. Now turn the apple into a female bust by continuing the line, seamlessly integrating the previous shape into the drawing of these breasts. The shaded area that suggested the volume of the apple continues to do so with the breast. The previously shaded area is then softly extended into the lower area of the torso.

3. With the groundwork laid, you should not find it very difficult to complete. The contrasts are intensified in accordance with the volume of each zone. The luminous white area highlights the shading that models the breast. The volume of an object is always heightened by these kinds of contrast.

HOW TO SUGGEST VOLUME

In order to suggest volume, you must know the direction from which the light falls on your subject. The relative depth or flatness of an object, or its complete lack of volume, depends on the type of lighting and how the artist chooses to interpret the subject. By understanding how shadows work, you will be able to represent more intricate gradations.

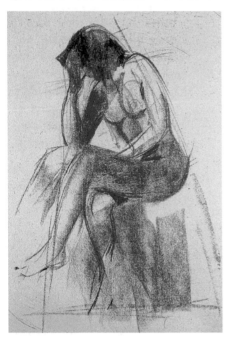

1. This figure has been left unfinished deliberately so that you can see the drawing's initial structure and the tonal process. The modeling here is very rudimentary; in fact, there is barely any modeling at all, only the initial tones produced by applying the Conté crayon, held flat on the paper, using varying degrees of pressure.

2. The approach used in this second example (below) is simpler, using just a single tone of shading executed with the stick held flat to the paper. The shadow drawn along the figure's length clearly indicates that the light source is above and to the left of the body. This method is very useful for sketching works destined for further elaboration.

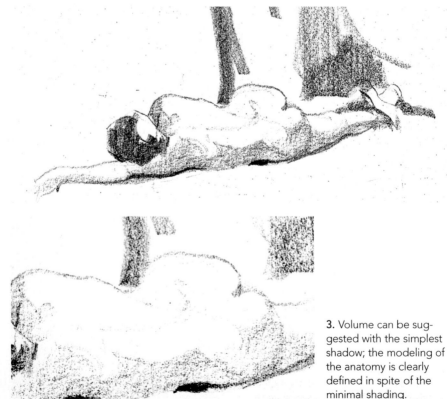

3. Volume can be suggested with the simplest shadow; the modeling of the anatomy is clearly defined in spite of the minimal shading.

CONTRASTING LIGHTS AND DARKS FOR LUMINOUS EFFECTS

The nude, as we have seen, can be modeled using dark-and-light contrasts in a variety of ways, depending on the artist's intent. The example described at the start of this theme evokes highly rotund volumes; the second only roughly suggests three-dimensional form, while the third relies more on light than shadow to define the anatomy. The exercise shown below uses watercolor pencil, a medium that requires a certain amount of experience, but that produces excellent results once it has been mastered.

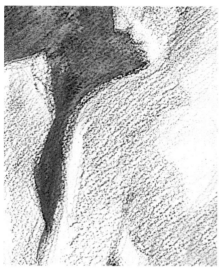

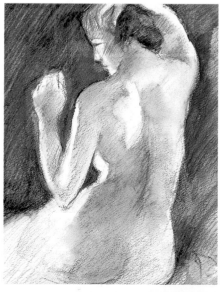

1. On the facing page, we saw how a shadow was rendered from a simple stroke. Now we'll do the same, this time with watercolor pencils. First the outline of the body is established, then is silhouetted by applying watercolor pencil around its shape. A paintbrush dipped in water is applied over this background area to create a wash. The figure is then shaded with the pencils; highlights are left uncolored.

2. A wet brush is now applied over the areas of the body that have been drawn with ochre and sienna, saturating the pencil-rendered tone and making it denser. To achieve convincing volume, the highlights must be left unpainted from the outset. However, it's also possible to lift off some of the tone through successive dabs of a brush dampened in clean water; just remember to clean the brush before each and every dab.

3. Wetting the entire area in which colored pencils have been applied makes the color more intense, thereby transforming the previously soft highlights into areas of great luminosity. Compare the highlight on the left side of the body and the one on the left arm with the same highlights in the previous step. The increase in the intensity of these highlights has been produced through the so-called effect of simultaneous contrast.

ILLUMINATING THE SUBJECT

Light from different sources can vary greatly in intensity; for example, natural light at midday is not the same as that from a powerful spotlight. To explore the importance of illumination in artistic interpretation, let's study the effects of three different kinds of lighting on the same model. Trace the three profiles reproduced here and add the shadows that indicate the figures' volume.

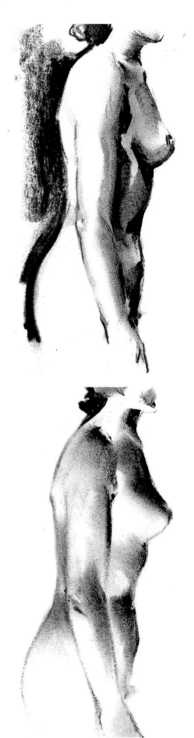

1. *Left*: Strongly lighting the model from behind results in virtually no perceptible volume of the figure's back. The intensity of the light is such that the only way to describe this part of her profile in a drawing is to darken the background. The front of the figure, on the other hand, has very strong contrasts. The shadows around the most prominent areas call for the darkest tonality your medium allows. In this example, the sense of volume is not very pronounced.

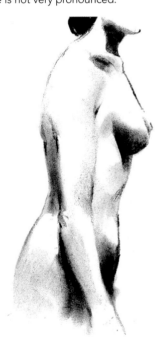

2. *Above*: This profile is illuminated with a somewhat diffuse overhead lighting, the type most often used in interiors. The volumes are accentuated and the modeling clearly defines the anatomy. Still, some areas are very dark, especially that below the breast and the soft curve defining the abdomen.

3. *Left*: This profile is illuminated from below; compare it with the previous example. The shadows are located in different areas over the body, which acquires a markedly sculptural appearance. A highly dramatic effect is obtained by alternating strong highlights with dark shading.

Female Torso in Three-Quarter View

MATERIALS

Colored pencils: red, sienna, yellow ochre, and black
Drawing paper, Eraser

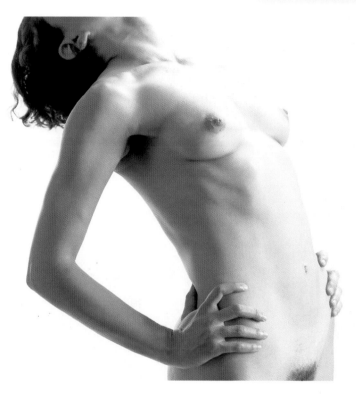

Unlike the earlier demonstration using watercolor pencils, this step-by-step exercise does not require the use of water. Hence, the result will be more akin to a drawing executed with lead pencil or Conté crayon. Note how, following the first step, in which the main outlines of the subject are drawn, the exercise focuses on successively building tonal gradations, a process that can be likened to developing a photograph.

Step 1. First, using red, make a careful sketch that contains only the most essential lines of the subject. Then go over the figure's contour with a single, clean stroke. It is important to remember that lines can only be erased easily when they are drawn faintly; a strong, dark line is almost impossible to erase. This technique is a very gradual process, starting with sharp, definite lines and building intricate shadows from there.

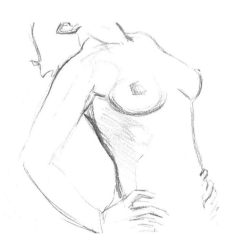

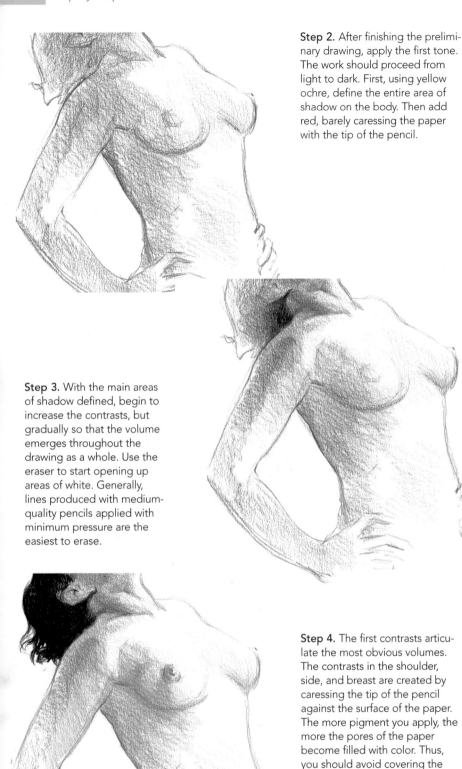

Step 2. After finishing the preliminary drawing, apply the first tone. The work should proceed from light to dark. First, using yellow ochre, define the entire area of shadow on the body. Then add red, barely caressing the paper with the tip of the pencil.

Step 3. With the main areas of shadow defined, begin to increase the contrasts, but gradually so that the volume emerges throughout the drawing as a whole. Use the eraser to start opening up areas of white. Generally, lines produced with medium-quality pencils applied with minimum pressure are the easiest to erase.

Step 4. The first contrasts articulate the most obvious volumes. The contrasts in the shoulder, side, and breast are created by caressing the tip of the pencil against the surface of the paper. The more pigment you apply, the more the pores of the paper become filled with color. Thus, you should avoid covering the entire white surface; tonal values, or gradations, are achieved by applying increasingly darker layers of shading, something that would be impossible to do if the pores of the paper were completely filled in.

Step 5. Using sienna, add shading to indicate the shadows on the side of the body. This shading should not be uniform, as the aim here is to express the figure's curvature. Just as the white of the paper is used to create the brightest highlights, the areas rendered in medium tones can be interpreted as "reserved" areas between much darker tones.

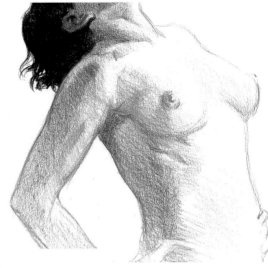

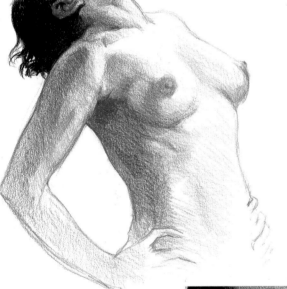

Step 6. Next, apply a dark red down the side of the figure in shadow; the body now gains a pronounced volume. Return to the breast, darkening the nipple down to the base, leaving the modeling of this area fairly complete.

Step 7. The maximum contrasts are what really lend volume to the body. Note how areas of medium tones that have been established gradually from the start of this exercise are left intact. Now, using the tip of the pencil rather than applying it sideways against the paper, outline several areas of the anatomy. Subsequently, you will open up some highlights that contrast clearly with the medium and dark tones.

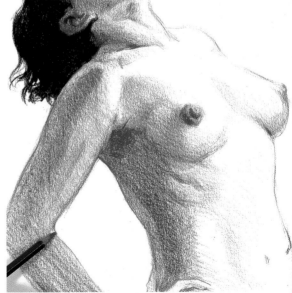

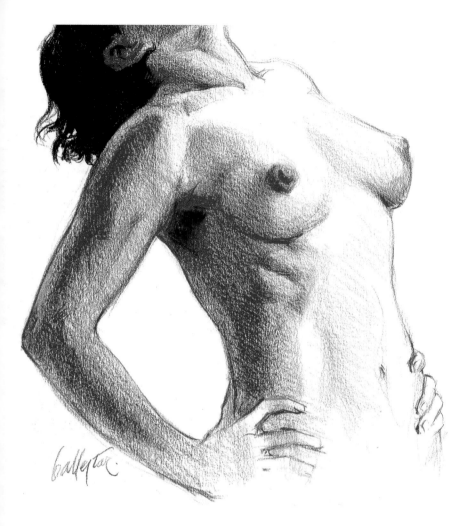

Step 8. The tones applied now are more intense; using burnt umber, we heighten the darkest shadows in various areas. Since this is the last step, it's not so important if the pencil saturates the pores of the paper.

SUMMARY

• Modeling is the technique used to suggest volume through tonal gradations.

• The simplest volumes derive from basic geometric shapes.

• Volume is suggested by rendering shadows on the side of the object opposite the direction from which the light source illuminates the model.

• Each area of a given volume is articulated through variations in tonal intensity.

• Volume is determined by the light that falls on the model.

• Subtle gradations can be achieved only once the artist has learned how to see shadows in terms of synthesis.

• The representation of flat shadow is very useful in sketching.

• Contrasts between dark and light allow different interpretations of the nude: soft modeling, synthesis of shadows, and synthesis of highlights.

• Light does not always fall on an object in the same way.

MODELING WITH LINES

SHADING IN LINEAR STROKES

This chapter further explores modeling techniques, by which you can represent three-dimensional volume and relief, thereby giving a sense of realism in two-dimensional formats. When light falls on an object, it creates shadows that define the object's form, as well as causes the object to cast a shadow onto the surface upon which it rests. Shadows involve tonal gradations – gradual transitions from the darkest points to the lightest, or most luminous.

By now you've practiced how to model forms by blending soft mediums like charcoal using your fingers on the paper or brushing water over water-soluble colored pencils. But you can also create tonal gradations with series of parallel and perpendicular lines, or hatching and cross-hatching, techniques often used by artists working in silverpoint and printmaking mediums like engraving and etching. This method lets you create halftones (gradations between black and white) with pen or pencil.

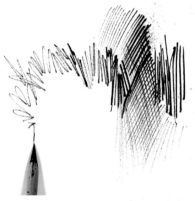

1. The reed pen, made of bamboo cane cut into a bevel at one end, permits a range of shadings. Fully charged with ink, it allows vigorous strokes and very intense blacks; less ink results in subtle halftones. The shadows on these apples have been articulated with parallel strokes whose density (especially on the one at left) has been increased in the darkest zones. Such lines should follow the fruits' curvature to convey their spherical shape.

2. The crow quill pen, which is similar to a reed pen but made of metal, is more sophisticated. The type of tone produced with this pen depends on the amount of pressure applied. Its sharp nib makes it very useful for drawing details and fine lines. The shadings of a drawing executed with such a pen are produced through hatching. In this example, the shading has been produced through a series of thick and thin lines.

3. The quality and intensity of the tones you can achieve with pencil depend on the degree of hardness or softness of the variety of the medium you are using. A soft pencil, like the one used in the example at right, produces very rich and intense tones of gray; to obtain similar results with a hard pencil, you'd have to follow a somewhat more methodical procedure.

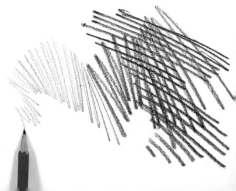

HATCHING

Hatching is a technique in which close parallel or crossed lines are used for shading or for building up an area of uniform tone. By following this exercise, you should gain useful practice in hatching technique such that you'll be able to render tonal gradations skillfully, regardless of what your subject is or how complex it may be.

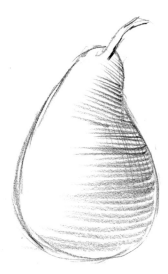

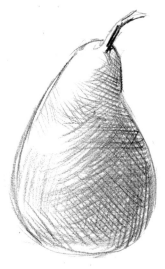

1. It's important to indicate the direction in which the light falls on the object from the outset. At first you should draw the lines indicating shadowed areas horizontally. Once you have acquired more confidence, you can draw them in any direction.

2. The depth of tone increases with successive applications of hatched lines. At this stage, the lines should not be drawn in parallel but crosshatched, so as to form a mesh that will be adapted to the shape of the object being represented.

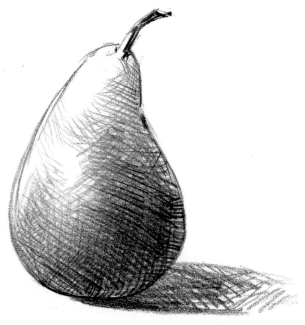

3. The hatching becomes increasingly dense, heightening the darkest area of the shadow in the pear's curvature, as well as the shadow it casts. At this stage, short strokes are easier for rendering the shape of the shadow on the object. As your drawing progresses, making shorter strokes gives you greater control over the area you are working on.

SHADING A SPHERE AND A CUBE

So far, you've seen how to shade curved surfaces; here you will see some of the ways a straight-sided object can be articulated through shading. The three examples below, using a sphere and a cube, show how different light sources affect the kinds of shadows you would use in depicting these objects. The shadows were drawn with subtle hatching in soft pencil.

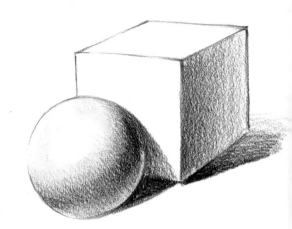

1. Although this study of light is similar to that carried out on a figure, this subject is far more complex because the perfect shapes of these objects call for an intricate treatment of the light. In this case the subject has been lit from the side, with the light source coming from the left. This type of lighting produces especially intense shadows. Unlike the shading of the sphere, the side of the cube in shadow is drawn with a vertical stroke.

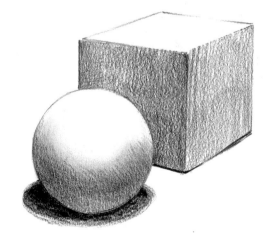

2. A significant change in the shadows occurs when the spotlight is shone directly above the model. The strokes shading the sides of the cube retain their verticality, although there are differences in certain areas.

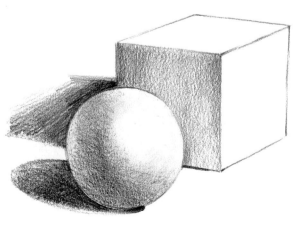

3. The light source, to the right, results in a shadow on the side of the cube adjacent to the sphere. An interesting effect occurs here. The sphere receives the shadow from the cube, and at the same time causes a reflection on the dark face, thereby producing a light area. Beginning with very light tones facilitates this type of work.

DIFFERENT WAYS TO DRAW SHADOWS

Meshing lines permits a rich and varied treatment of shadows. The three illustrations on this page demonstrate some simple approaches to shading and blocking-in. These basic shading techniques are fundamental to achieving realistic forms. As you practice the different methods, note the effects they produce in your representations of various three-dimensional objects.

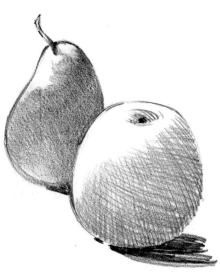

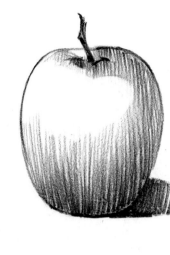

1. Cross-hatching can become the artist's best ally for resolving shadows. In fact, this technique is paramount for capturing subtle transitions; it also allows objects to acquire relief. Note the tonal differences between the pear and the apple.

2. Simple shading with lines going in one direction is especially practical when an immediate solution is required. The beginning of a stroke is located in the darkest area; you gradually reduce the amount of pressure applied to the paper, then lift the pencil off at the end of its trajectory.

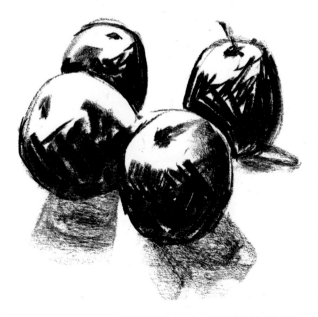

3. Compressed charcoal produces very strong, stark shadows. Strokes applied with this medium are intense and gestural, and are particularly suited to certain types of sketches. However, you can also apply compressed charcoal in series of parallel lines to produce a wide range of tonal shadings.

Drapery and Orange on a Plate

MATERIALS

Pencil, Eraser
Paper suitable for ink
Reed pen, India ink
Cloth

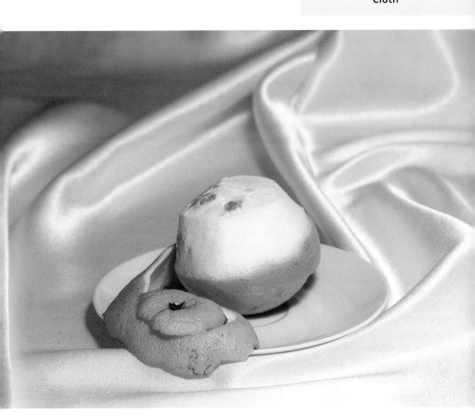

You don't need a very complex setup, although it should contain enough elements to allow you to practice hatching and creating a wide variety of shadows and modeling effects. When you set up your still life, remember to take into account the direction of the light so that you can situate the shadows appropriately; this is essential to the drawing's composition.

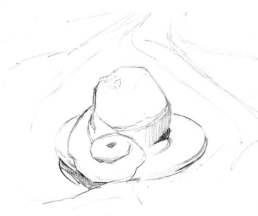

Step 1. The outlines of the objects must be clearly defined in your preliminary sketch. The rough outline indicates the distribution of the elements of this still life. The next phases will entail refining the lines and cleaning up the drawing, ensuring that it contains no errors. It's not easy to correct with ink; you can either accept the error or laboriously scrape the ink off with a knife.

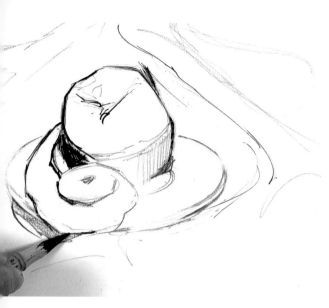

Step 2. First draw the subject in pencil, then begin drawing with ink. Before you start using ink over the preliminary drawing, load the reed pen with India ink and draw some strokes on a separate piece of paper to test the lines. The technique is not very different from any other drawing technique, although you must take care not to place your hand over recently applied ink.

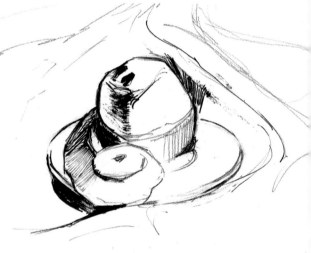

Step 3. Here, the first strokes have been drawn over the pencil lines, and shading has begun. Whether you produce an absolute black or a shade of gray will depend on how closely together you draw the lines.

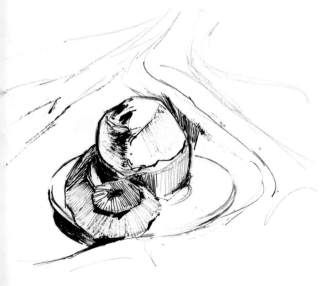

Step 4. Ink makes it possible to create a balanced combination of patches and clean lines. By applying loose strokes, you can carry out a certain degree of correction during the drawing process. Note the fine lines that suggest the spiral shape of the orange peel. Next, the first lines indicating the brightest area around the orange are drawn. Dark areas, such as the shadow cast by the plate, can be rendered completely black.

Step 5. The almost black shadow of the orange peel is achieved by superimposing lines. This is an artistic interpretation, as the dark areas of the subject are not nearly as intense. With the reed pen loaded with just a little ink, the shadows that define the folds of the fabric are begun. This stroke gives way to very faint shades of gray.

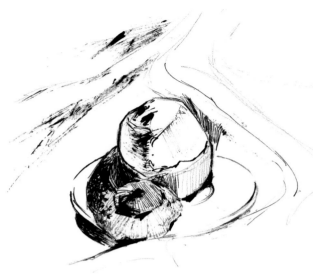

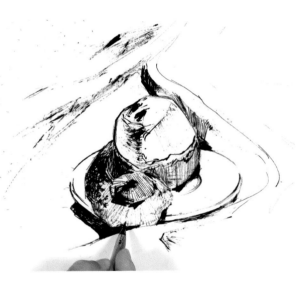

Step 6. The most intense contrasts are those that define the luminous forms. Compare this step with the previous one: the dark areas below the plate have been accentuated noticeably, which makes the peel look much brighter.

Step 7. With the shading of the skin of the orange sufficiently dark, the drapery comes next. The first, very soft, lines lay the groundwork for a second, darker application. This work brings out the brightest part of the fold. The prolonged lines from the start become ever shorter and crosshatched.

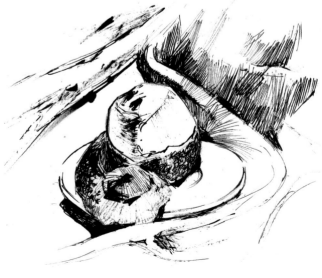

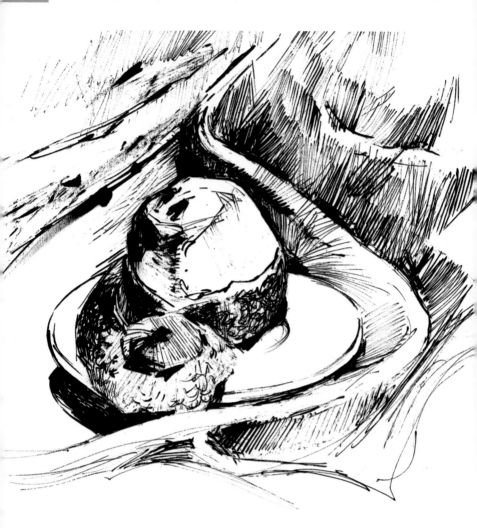

Step 8. This drawing is somewhat akin to a sketch, given that the main emphasis is on the gesture the pen-and-ink technique allows. The fabric is finished with a soft shading, which is crosshatched in certain areas. The shaded patch lends greater prominence to the highlights on the orange.

Summary

- Modeling techniques make it possible to depict subjects in terms of their three-dimensional volume.

- Many different values of gray can be obtained by using simple parallel lines and crosshatched lines.

- Correctly executed, a series of parallel lines can produce any gradation of shadow called for.

- Drawing a stroke so that it follows the contour of the subject's surface helps define its shape.

- Pen-and-ink techniques allow for precise and flexible drawings.

- From the outset, the shading of objects in a drawing must define the direction of the light source.

- Shading can be used to lend relief to an object.

- India ink applied with a reed pen allows the artist to draw very intense and gestural lines.

Rural Landscapes and Country Houses

Architecture and Nature

A cottage in a landscape is a romantic setting. This motif is a bit of a departure from the landscape in its strictest sense, and is far removed from the urban landscape. Nonetheless, regardless of type, all landscapes call for a similar approach and can be interpreted in a variety of ways. This exercise sets forth some of the basic notions for representing a subject within a natural setting.

Every genre can be subdivided into many subjects. So vast is the range of possible subjects in any given general category that it is easy to overlook certain motifs that can provide an excellent source of creativity.

1. Knowledge of artistic perspective is often necessary for "constructing" a landscape drawing. Even though the lines of perspective are drawn freehand, without the aid of a ruler, the drawing must be technically sound, as the correct use of perspective is essential to representing reality convincingly. This preliminary sketch has three fundamental lines: the horizon line, the line indicating the base of the house, and the line that indicates the roof. These lines, also called vanishing lines, converge at one point on the horizon, known as the vanishing point.

2. A preliminary sketch helps you draw realistic architectural structures that lend depth to the landscape in a way that's different from depth achieved by establishing foreground, middle ground, and background. The building in this exercise has a technical perspective, and the planes infer a spatial depth.

3. A good preliminary sketch lays the groundwork for this type of result. Close observation reveals that there haven't been many changes since the first lines of the sketch were drawn; the end result of this landscape has been achieved with just a few contrasts.

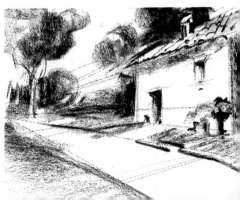

STRUCTURE AND TERRAIN

Even though the buildings in these few exercises are very simple, their structures are governed by the laws of perspective. In subsequent sections this subject will be examined in greater depth. We'll start now to explore some of the most basic concepts of perspective, which should make it easier for you to continue later.

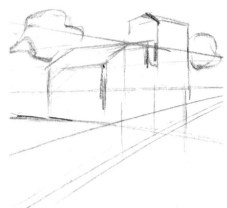

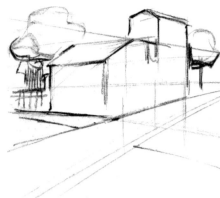

1. Building structures greatly influence the shape of the surrounding landscape, but the observer's point of view is equally important. Unlike the previous exercise, this one has an added difficulty: two sides of the building are visible. Therefore, the two visible planes require two vanishing points, which in this case are situated off the paper, meaning you'll have to rely on a rough calculation of the perspective.

2. Once the lines of the building have been correctly situated, the "construction" work can proceed with relative ease. It's important to ensure that the lines of the walls are all vertical. The vanishing lines – those that lead to the horizon line – represent the horizontal lines of the subject; the vertical lines define the height of the walls.

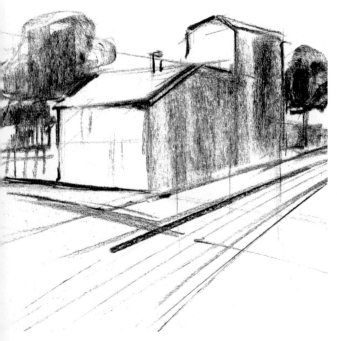

3. Only a few elements are needed to render the building and the slope of the terrain. The stick of charcoal is held flat against the paper to create the different areas of light and shadow on the house. This basic technique is explained in more depth in the final exercise in this section.

SYNTHESIS OF PLANES

It's not always necessary to rely on mathematical perspective in constructing a drawing; some subjects are more easily rendered using your powers of observation. This means knowing how to reduce a subject to its most basic shapes, something that is achieved through synthesis, or summarizing. The following exercise begins with a careful analysis of the subject's main forms and masses.

1. The main lines and masses are drawn with a sanguine Conté crayon; flat strokes are used to facilitate the synthesis of each element. Even though there is a perspective, there are few references to it, and it's not necessary to indicate a vanishing point. The lines of the top and bottom of the house converge at a point outside the confines of the paper. There are three very evident planes: the ground, the wall of the house, and trees.

2. The planes are shaded with one application of compressed charcoal; to distinguish them as separate entities, each is rendered in its own specific tone. The darkness of the trees sets off the brightness of the country house's façade.

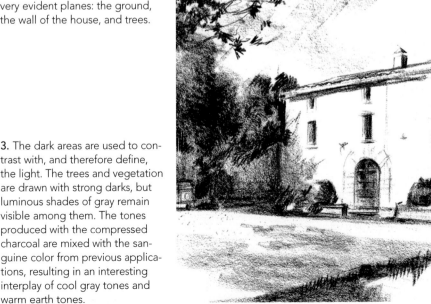

3. The dark areas are used to contrast with, and therefore define, the light. The trees and vegetation are drawn with strong darks, but luminous shades of gray remain visible among them. The tones produced with the compressed charcoal are mixed with the sanguine color from previous applications, resulting in an interesting interplay of cool gray tones and warm earth tones.

THE IMPORTANCE OF LIGHT

As in all drawing subject matter, the question of light is fundamental. In landscape, the textures and geographic features of the terrain, as well as the sense of depth, are defined in accordance with the light that falls on them. Although this is an open landscape, the light lends each element its own value. In fact, the illumination is as important as the subject itself. Before you carry out this exercise, be sure to study the steps carefully. Then develop your drawing gradually, working on all areas at the same time as you build the composition.

1. For this exercise, use a graphite pencil. A soft lead, such as a 9B, allows a wealth of gray tones that can even reach black, which you can't achieve with a hard pencil. Begin by sketching the outline of the landscape, then add a range of gray tones to differentiate the most important planes: the ground, the house, the trees, and the mountainous background. Here, these first shadings have been executed with vertical lines, leaving the brightest areas empty.

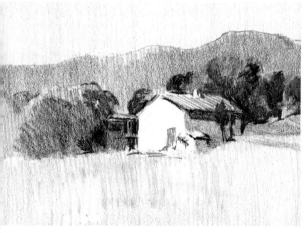

2. These initial tones provide the foundation upon which you can build a greater variety of tones. Remember: always work from light to dark. In the previous step, the soft shading in the sky made the mountains look too light. Therefore, here they are darkened a bit. The trees are drawn with deep darks, thanks to which the mountains gain importance. One side of the house is left completely white, while the other is shaded with another tone of gray.

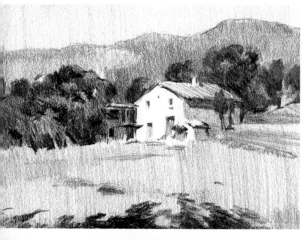

3. Note the synthesis of the drawing: a scale of tonal values, ranging from a maximum dark value to a maximum light value, represents each plane. The textures and surfaces have been described through contrasts; note especially how they are used to suggest the grass in the foreground, the dense foliage of the trees in the middle ground, and the mountains and sky in the background.

Tree and Ruins

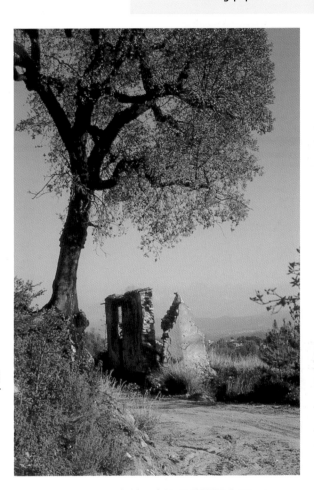

The combination of a landscape and the ruins of a house make this a highly attractive motif. Ruins have long provided artists with a source of inspiration, and they still deserve attention nowadays. This exercise covers a number of important questions, ranging from composition to the intensity or value of gray tones in each area. As you will see, this drawing doesn't call for a methodical use of perspective, but relies instead on an atmospheric perspective achieved through the placement of the different elements.

Step 1. First, draw the main lines with very light shadings, produced with a medium to soft pencil, such as a 2B. The foreground and the tree are drawn with simple, faint lines. The initial structure of the building in the background is represented by emphasizing the shadows on the left wall.

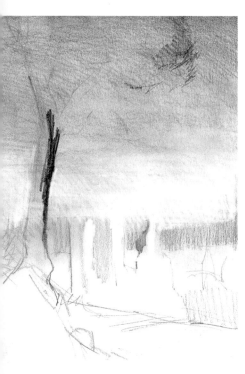

Step 2. Lightly shade the area of the sky with a soft pencil, and then blend it with your fingers. Next, begin to further articulate the tree by darkening the profile of its trunk. At the end of this simple phase, you have already established an important division between the two grounds.

Step 3. Work continues on the trunk using a 6B pencil, which can produce extremely dense tones. But the trunk is not drawn uniformly; one area is rendered with lines that suggest the texture of the bark. The smaller branches are drawn with darker tones. The leaves are begun and the shadows on the ruins are darkened.

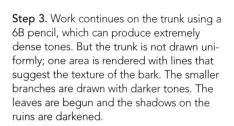

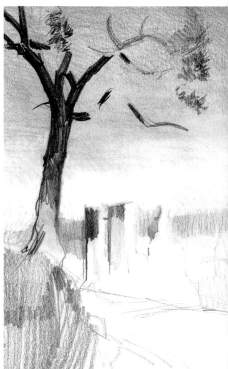

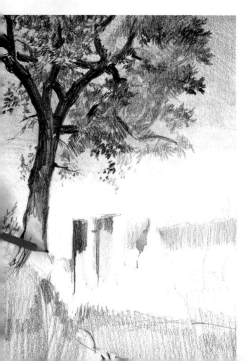

Step 4. Short, meticulous strokes represent the foliage of the treetops; individual leaves vary in tonal intensity according to their distance from the viewer. The gray sky is visible through gaps in the foliage. The entire lower half of the landscape is darkened with a halftone, which provides the foundation for the final work. Note at this stage that the middle ground remains largely untouched.

Step 5. The medium tones in the vicinity of the ruins are darkened, while certain areas are left white. The area of background between the ruins and the tree is shaded with an intense dark tone, which provides a reference for all the blacks in this zone.

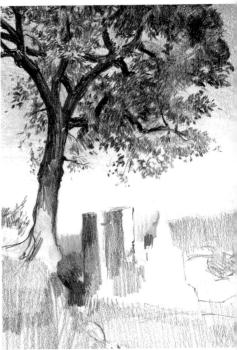

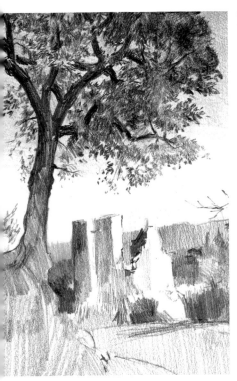

Step 6. Returning to the tree, a dark patch is established to integrate the previous dark areas in the lower part of the trunk. The slanted strokes in the trunk suggest its texture. In the treetop, contrasts are strengthened in some areas, giving the tree a pronounced volume. The intense shadows of the ruins are drawn using the previous dark area as a reference tone.

Step 7. In the final stages of the drawing, work continues on the tree. It's important to let the previous shadings "breathe" through these new applications. The ground on which the tree stands is drawn with great meticulousness. The darkening of the areas in shadow makes the white of the wall more prominent, thanks to the effects of contrast.

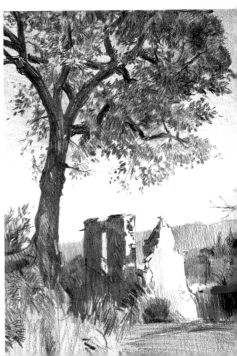

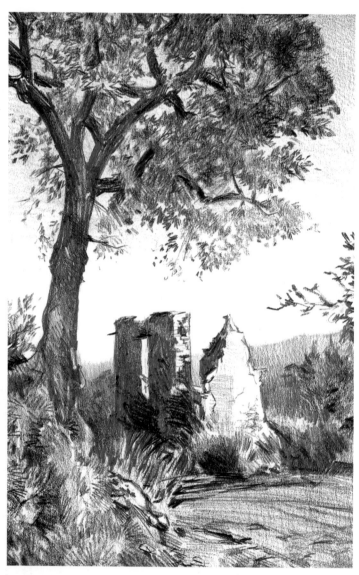

Step 8. Having achieved the right balance of contrasts, the only remaining task is to draw the details of the foreground. The grass is suggested by the dark areas surrounding it. Here, the light areas gain importance, as they form the foundation of the textures and surfaces in the foreground.

SUMMARY

• Some basic notions of artistic perspective are essential for "constructing" a landscape convincingly.

• The lines in this type of perspective are drawn freehand.

• The most important lines are the horizon line and those of the walls of any buildings.

• All lines of perspective converge at the horizon, the vanishing point.

• A correctly drawn structural sketch can help you develop realistic-looking architecture.

• Architectural motifs are not difficult to draw provided you begin with a solid foundation.

• Building structures affect the shape of the surrounding landscape.

• Only a few elements are required to describe the architecture and the slope of the terrain.

• The different planes, or grounds, in a landscape acquire depth according to the light that falls on them.

• Textures and surfaces are interpreted through contrasts.

PROPORTIONS OF THE HUMAN BODY

THE CANON

Throughout history, artists have used canons – standards of measurement – to draw the proportions of the human body. The first canon, established by the ancient Greeks, used the height of the head as the basic unit that was then applied to the rest of the body.

Correctly drawn proportions are essential to a balanced rendering of the human anatomy. This is accomplished with a canon, a formula devised for calculating the size of one part of the body in relation to the others. The canon has varied throughout history, in accordance with each period and each culture.

2. *Right:* The pencil is used to transfer the figure's measurements to paper. The proportions are only approximate, but they let you establish harmonious relationships among body parts.

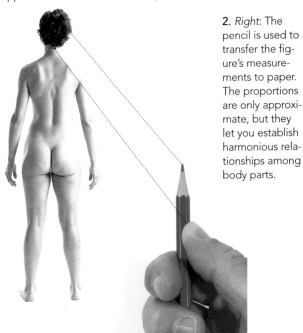

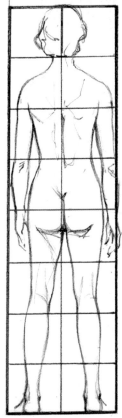

1. *Above:* While looking at the model, hold a pencil upright so that its tip appears level with the top of her head, then move your thumb down so it appears level with the top of the neck. The distance between the tip of the pencil and your thumb represents the height of the head, the basic unit of measurement; the figure's overall height is established as consisting of eight of these units, as you can see at right in step 3.

3. You can draw a relatively accurate representation of the body by creating a frame or grid. Draw a vertical line to indicate the body's axis of symmetry. Divide it vertically into eight equal parts, and make the frame the width of two heads.

THE IMPORTANCE OF LINE

Measurements are necessary for drawing a correctly proportioned figure. The proportions are harmonious relations that allow the drawing to be adapted to the canon. On the previous page you saw how this was done using a rectangular frame measuring eight units by two; we'll continue with that exercise to further develop the figure. The intensity of the stroke plays an important role in this process.

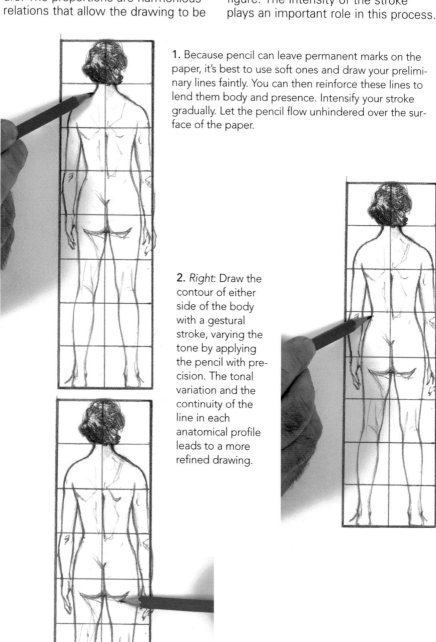

1. Because pencil can leave permanent marks on the paper, it's best to use soft ones and draw your preliminary lines faintly. You can then reinforce these lines to lend them body and presence. Intensify your stroke gradually. Let the pencil flow unhindered over the surface of the paper.

2. *Right*: Draw the contour of either side of the body with a gestural stroke, varying the tone by applying the pencil with precision. The tonal variation and the continuity of the line in each anatomical profile leads to a more refined drawing.

3. There are always areas where lines need to be drawn with more pressure. This may appear obvious, but it's something you can master only through practice. The perfectly refined line is more complicated than that used to render a figure through shading.

Sizes and Proportions

Regardless of pose and attitude, the figure must conform to a canon, which makes it possible to gauge sizes and proportions and record them in a drawing in correct relation to one another. Similarly, your rendering of the figure's features must correspond to the age, build, typology, and gender of the model.

1. In the previous exercise we used a frame based on the head as a unit of measurement to draw a specific type of female figure. By varying these proportions, you can attain a radically different result. For example, basing the height of the model on nine heads instead of eight would result in a more stylized, attenuated drawing of the figure.

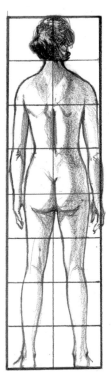

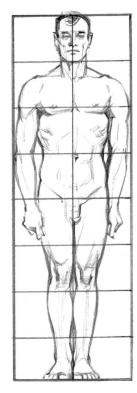

2. *Left*: The eight-head formula is also appropriate for the male figure, although notice in the example at left that the horizontal measurements are wider.

3. Even the proportions of a figure in action, such as the one at right, remain the same. To draw this example requires some knowledge regarding the movement of limbs and joints, which we will begin to explore on the following page.

JOINTS

It's essential to draw the extremities of your model in the correct proportion. The joints connecting limbs can be especially troublesome for the beginner; the exercise below should help clear up some of your doubts concerning this subject. Follow this example to learn how to draw a shoulder and an elbow.

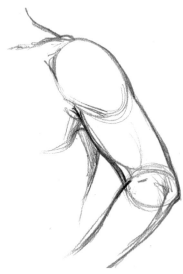

1. Even the most complex areas begin with a simple structure. These simple elements can be used to draw the anatomy and joint of the arm. The most essential aspect is to learn how to draw the joint between the upper arm and the lower arm, but it is also worth knowing how to draw the shoulder from a ball-and-socket ellipse, which will also be used to bring out the muscles of this area.

2. If you've drawn the structure shown at left adequately, it will be quite easy to draw the anatomical contour of this arm. The initial lines provide a support over which you can draw a more defined outline, molding it to human anatomy. As you can see in this step, the drawing has changed very little from the preliminary structure. The line must be clean, and should be able to accommodate the basic shapes.

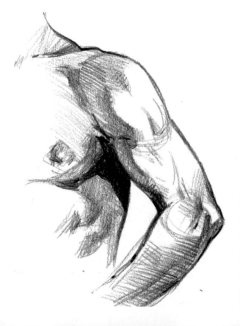

3. A correctly articulated sketch is fundamental to attaining a satisfactory result. Once this has been achieved, you can add some tonal values to create the desired degree of naturalism. The shadows on the figure suggest the volume of the musculature. Note how the final result was obtained; some areas of the paper were left unshaded, and an eraser was used to bring out the highlights.

Standing Male Nude

MATERIALS

Drawing paper
Graphite pencil
Eraser

The proportions of the human body are governed by a series of elements that are interrelated by invariable measurements. But there are many different body types, each with variations in proportions that must be adapted to their corresponding canon. The human figure must be understood first and foremost as a whole, not as a haphazard puzzle. This exercise demonstrates how to achieve harmonious proportions in a figure drawing. It will give you practice in studying volumes, an equally important aspect of drawing.

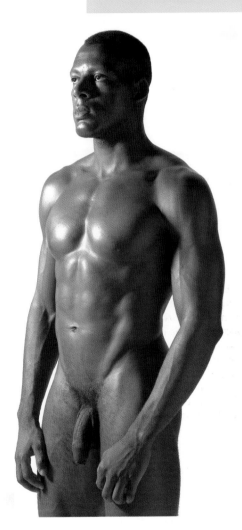

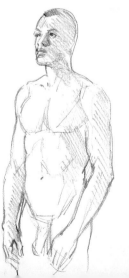

Step 1. Let's first study the model's pose. The three-quarter profile implies a reduction of the forms delimited by this position. There are a number of basic lines and elements to bear in mind: the line of the model's shoulders, the distance between them and the hips, and the head as a standard of measurement for the figure's overall proportions. Once these forms have been established in the initial sketch, certain parts are shaded to create an approximation of the body's volume and its darkest areas.

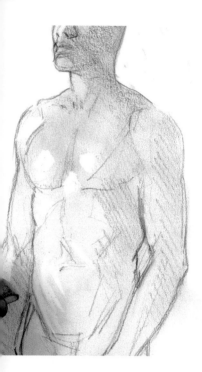

Step 2. The initial tonal value of the figure is established with a soft shading, which will gradually be darkened as work begins on the highlights. The most important highlights are "opened up" from this uniform base tone with the eraser. The eraser is essential for this task, because the stroke it produces is cleaner than the result achieved by reserving the area; that is, shading around the highlight.

Step 3. The tone continues to be darkened until the densest shadows are identified. The stroke continues to be soft. This time, some areas are reserved – left unshaded.

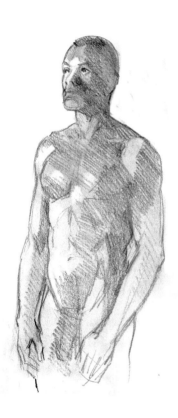

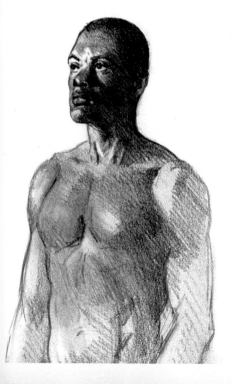

Step 4. The aim now is to search for the darkest tones, using the head as the point of reference. The darkest area of the head is where the most intense black is: the side of the face, the jaw, the shape of the nose, and the neck. Note how some nearby areas are left reserved.

Step 5. With the previous tones as a reference, the main volumes of the torso are searched out with dark shadings. The volume of the trapezius (here, the triangular area between the base of the neck and the shoulder) is resolved by leaving the shape of the collarbone light. The dark areas of the pectoral muscles are now very prominent.

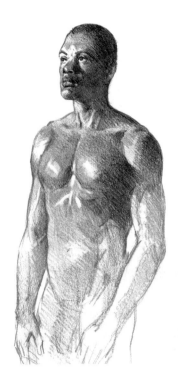

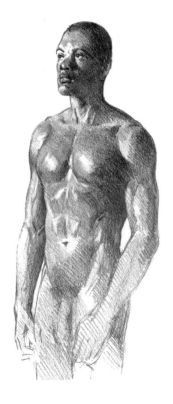

Step 6. Now for the abdomen, where a number of gradations are created to define the volumes. The division between the abdominal muscles is drawn with the corner of the eraser. Darkening the arm brings out the brightest part of the body.

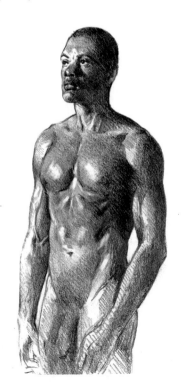

Step 7. With the tonal values consolidated, maximum contrasts are introduced. This is carried out by gradually intensifying the halftones, the softest shadows, and, last of all, the darkest shadows. Before continuing, the highlights are gone over once again with the eraser.

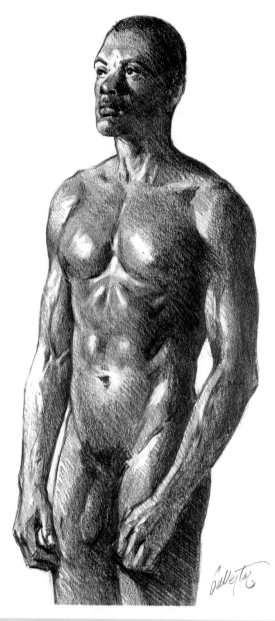

Step 8. The shape of the body is refined. The intensity of the dark shadows is now absolute, although the halftones are left untouched. The modeling of the lower half of the body is brought to a finish, taking care to ensure that the planes are clearly differentiated.

SUMMARY

- The canon is a formula used to draw the human figure.

- Correctly drawn proportions are paramount for rendering the human body in a convincing manner.

- The height of the head is the unit of measurement of the canon.

- The canon of a human body is eight heads high by two heads wide.

- The model's real measurements must be adapted to the scale of the paper.

- Working within a gridlike structure, it is possible to draw the body with a certain degree of accuracy.

- The measurements of the figure are indispensable for obtaining a proportioned drawing.

- The sizes and proportions of the figure must be correct for the canon to function.

- The features of figures vary according to their age, build, and gender.

10

ACHIEVING TONAL BALANCE

THE IMPORTANCE OF TONAL DIFFERENCES

A value, or tonal, drawing is nothing less than a series of light and dark contrasts. Imagine a black-and-white photograph in which the white becomes gray and the black is lightened so that contrasts disappear. In drawing, exactly the same can occur if you lose sight of the relationship between tones.

A good balance of tones is required to achieve pictorial rhythms that lend your subject plausibility and depth. It's especially important in integrating your subject with its background.

1. A "hard" drawing is one with extreme contrasts between dark and light and few, if any, tones in between. Conversely, a "soft" drawing is one with little or no contrast between lights and darks. In this section we'll explore how to achieve the kind of tonal balance that makes for a successful drawing.

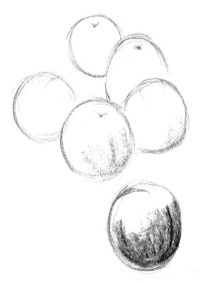

2. *Top left and above*: Compare these two sketches and note what a difference even the simplest shading makes in your perception of the fruits' depth.

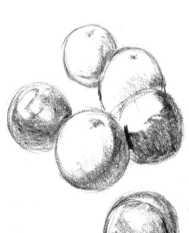

3. *Left*: Adding some new shades of gray produces an effect of balance. The fruits now clearly stand out on the paper, as if they were three-dimensional objects floating in space, without any points of reference. Contrast is fundamental to this effect.

BALANCING SUBJECT AND BACKGROUND

Bear in mind that your subject is not just the objects (figure, still life, etc.) you see in front of you; rather, it consists of those objects within the context of the surroundings they inhabit. This means that you must take a great deal of care in how you relate one component to the other tonally, especially if you wish to convey a sense of three-dimensional depth.

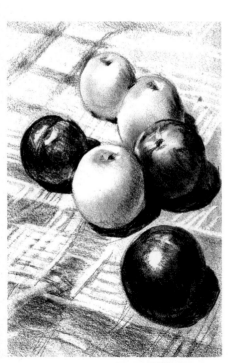

1. Continuing from the last step of the preceding exercise, let's now try to create a balance between the background and the subject. Darkening the background causes the previous dark shadings on the fruit to lose prominence, making the tone appear faint. The highlights, reserved as the white of the paper, appear brighter because of the gray shadings that surround them.

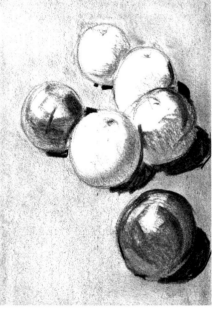

2. *Above*: The most intense shadows, those the fruits cast on the table, are accentuated; their darkness modifies the tones of the drawing as a whole. Now the shadings on the fruit must be darkened. Once this has been accomplished, the highlights appear especially brilliant.

3. Here, the fruits are shaded with varying intensities of tone, and in the background the pattern of a tablecloth is established. In some areas where shading is increasingly darkened, white highlights are opened up with the eraser, creating luminous highlights that suggest the fruits' roundness.

COMMON ERRORS IN HANDLING CONTRASTS

Learning how to interrelate background and subject through tones and simultaneous contrasts all boils down to distinguishing between what is a wise move and what is an error. It's easy to make mistakes when attempting to interpret reality. Even though your preliminary structure and sketch may be correct, there is a series of problems that must be solved.

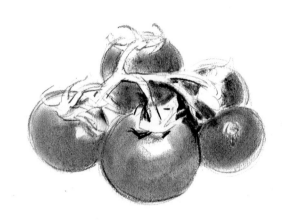

1. A common drawing error consists of darkening the main subject without taking into account its effect on the background. The result is invariably an imbalance of tones. One practical piece of advice to help you avoid this: never establish the darkest areas at the start of the drawing.

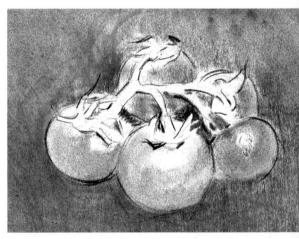

2. Another common error is to shade the background with too dark a tone, thereby setting up a contrast with the subject that makes it appear lighter and minimizes any modeling of form you may have achieved. If you were to compensate for this by adding more tone, your drawing would become too dark. The best approach is to begin with the light tones and darken them gradually, working on all areas simultaneously.

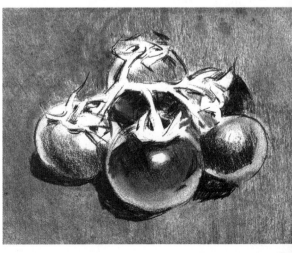

3. Here is another common error made by inexperienced artists when building tones. In an attempt to compensate for the dark areas, the shadows cast on the background are so hard that the balance of contrasts, so essential for achieving a good drawing, have been nullified. Let's examine these errors and see how the artist should have proceeded in order to avoid them.

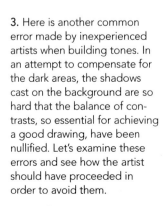

MAINTAINING EQUILIBRIUM

The counterbalance of tones is what characterizes a good drawing, and is what makes it possible to represent three-dimensional space convincingly. The tonal difference between one area of the composition and another is crucial to achieving this. In this section we'll look again at the errors shown in the last exercise.

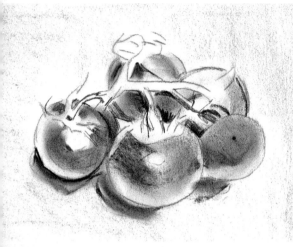

1. In the first error on the preceding page, no attention was paid to the background when the tomatoes were shaded in gray. Here, a simple shading is used to set off the highlights, which will be opened up with the eraser. These areas provide a clue as to the first shadows cast by the tomatoes, which, although apparently incorrect, are left until the next phase to be solved.

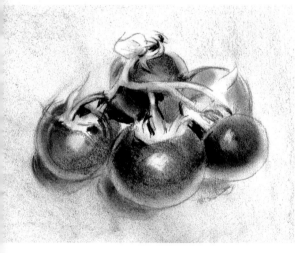

2. By intensifying the dark areas on the tomatoes, the shadow they cast is perfectly balanced. To strengthen the different tones, the dark areas must be intensified gradually, and at the same time. This allows you to adjust new shadings by using the previous ones as a tonal reference.

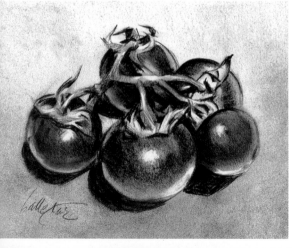

3. The aim of balancing the tones is to seek the absolute black; the darkest tones are used to set off lighter ones. Compare this stage with the last and note how, in the light areas between the tomatoes and their cast shadows, the halftones acquire an intense brightness thanks to the dark tones surrounding them.

Onions and Tomatoes

MATERIALS

Drawing paper
Charcoal, Conté crayon, Chalk
Cloth, Eraser

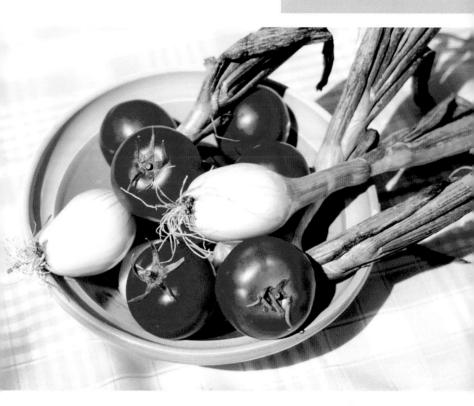

The main aim of this exercise is to study the effects of light produced by simultaneous contrast. We'll see how important the interrelation of background and model is in drawing. Indeed, it would be impossible to conceive a drawing without having this in mind at every stage of work. The still life setup for this demonstration is uncomplicated, which should make it easier for you to focus on contrast relationships and how they're used to integrate model and background.

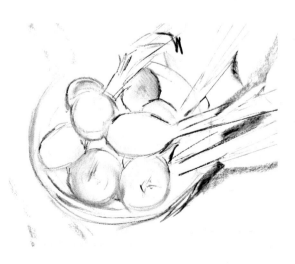

Step 1. From the beginning, the preliminary sketch must contain all the elements that will facilitate the integration of the background and the model. There is a significant amount of space around the model in the sketch. Although it is now white, this space will form part of the drawing in the same way the tomatoes and onions do.

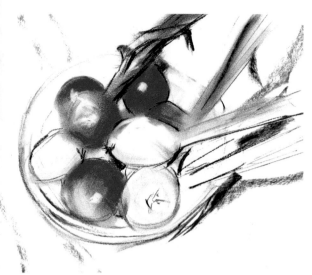

Step 2. Several red areas are shaded in to study their effect on the white areas of the surrounding space. These establish the brightest highlights, which are accentuated by cleaning them up with the eraser.

Step 3. Here you can see what happens when the darkest contrasts are applied. The charcoal is used to create a very dark, intense shadow between the tomatoes. This tone defines its shape with complete accuracy and will be used to gradate the intensity of the red tones in this area. The contour of the plate is then drawn with the Conté crayon. In addition to outlining its shape, the line begins to integrate the plate with the foreground.

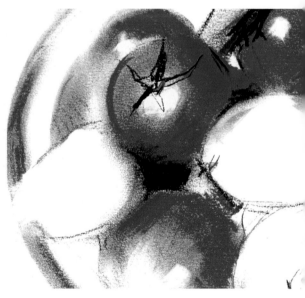

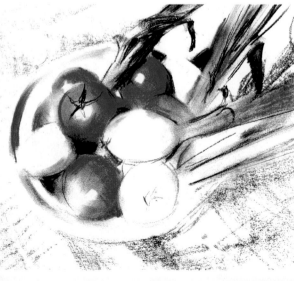

Step 4. Some simple touches of sanguine lend a new tonal dynamic to the whole. These hues define the drawing and bring out the brightest highlights of the onions. The background is roughed out with charcoal and light areas are opened up with the eraser.

Step 5. All the tones of gray must be increased simultaneously, rather than worked on one area at a time. Here, the tonal possibilities of the charcoal and the Conté crayon are combined. The red tones are intensified, making them more dominant, and are used to outline the border of the tomatoes. After some further work, the eraser is once again used to open up the highlights defined in the preceding step.

Step 6. Now work proceeds on the densest darks in the shadows, from which simultaneous contrast arises. The black tones make the red tones appear more saturated and the whites acquire a profound brilliance. The cloth is used to reduce the presence of the gray tones on the tablecloth, heightening luminosity in this area.

Step 7. With the tones defined and corrected, the volumes are further modeled, details are drawn, and the brightest highlights are brought out in each area. Some areas are blended with the fingers. Then the contrasts are accentuated once again in order to outline any shapes that had gotten lost. White chalk is used in other areas to draw the highlights.

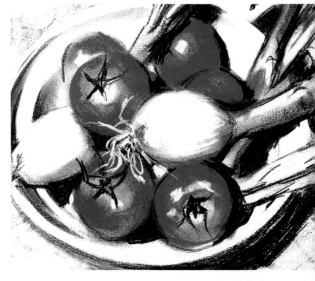

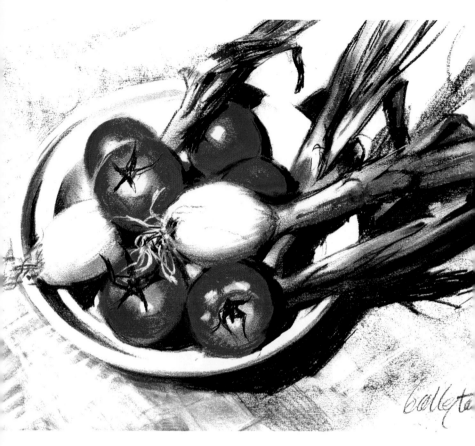

Step 8. The last task consists of reinforcing the strongest contrasts, done directly with the charcoal. These intense tones demarcate the lightest areas and lend them more prominence through the effect of complementary, or simultaneous, contrast.

SUMMARY

• Balance between the tones in a drawing establishes rhythms that lend the subject plausibility.

• The lightness or darkness of a gray with respect to white varies in accordance with the tones of the whole.

• A subject exists in the context of its surroundings.

• Applying a dark gradation over a dark background results in a subtler contrast.

• Contrasts between dark and light areas underscore the presence of both; this is known as simultaneous contrast.

• Dark areas make highlights appear brighter.

• Never begin a drawing with the darkest areas; remember to always work from light to dark.

• Avoid darkening the background before taking into account the tones of your subject.

LIGHT AND SHADOW IN A SEASCAPE

HOW TO SKETCH A SEASCAPE

In drawing, you should always develop your subject from a preliminary sketch. The seascape is no exception: the main volumes of the scene must be correctly distributed. When the subject is a calm sea, one such volume might consist of a dramatic sky, as can be seen in this example. In this chapter, we'll explore some possible ways to depict marine subjects.

1. This preliminary sketch indicates just the basic elements of the scene: the horizon, the land located in the distance, and the rough shapes of the clouds.

2. Now the first contrasts in the sky in relation to the clouds are established. A dark shading near the horizon creates a contrast with the background. The water area is filled in with a light gray; reflections on the surface of the water can be created with an eraser.

3. The dense contrasts of the clouds are rendered by combining various light and dark tones; an eraser is used to create the clouds' texture. The eraser is very useful when you're drawing in negative – that is, removing areas of tone. Contrasts in the sea are emphasized; highlights and the texture of the ripples on the water are created with the eraser.

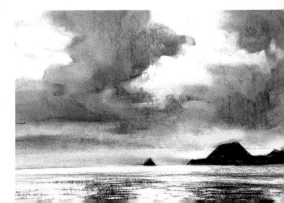

A STUDY OF WAVES

It is difficult to draw a wave from nature because of its constant movement and ever-changing forms. For this reason, at first it's easier to approach this subject by working from a photograph. Eventually, with close observation of the way water moves and of different wave formations, you will be able to draw waves from nature.

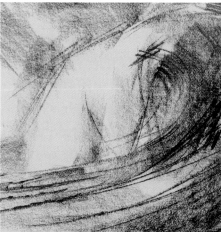

1. Working on green-toned paper, the first thing sketched is the basic structure of the wave. This consists of its shape as a whole and its general lines of movement. In this wave there are two planes, one sloping and the other curved. The curved plane culminates in the crest.

2. The crest becomes more defined as the area around it is darkened with charcoal. With the charcoal held flat on the paper, a wide range of grays is created in the wave's structure, especially on the inside face. This shading will later be intensified to make the foam look brighter.

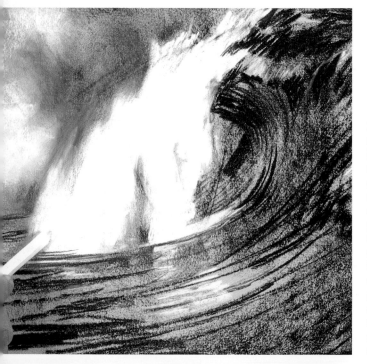

3. The wave takes shape when the highlights are added. Dense applications of white chalk blend with the green paper, creating new tones that give the drawing great realism. Above the wave, in the background, the shades of the charcoal and the chalk blend to create a dynamic and violent image.

ALTERNATING LIGHT AND DARK

When drawing an extensive expanse of sea, you have to omit certain details and sketch each area like a background, since there are usually no geographic points of reference. This exercise shows you a simple but beautiful way of dealing with this theme. Note how the tones are used here: the closer the water is to the viewer, the stronger the contrasts are in those areas.

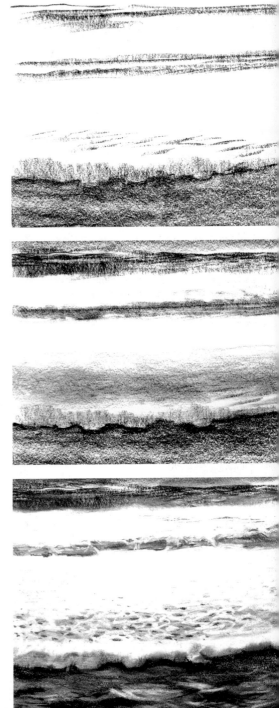

1. This first sketch establishes the various grounds using a simple set of horizontal lines. Pay attention to these grounds, since each one will be dealt with independently.

2. Using the flat side of a charcoal stick, a dense barrier is created in the background. This line should not be uniform; although it is horizontal it has several openings that reveal the cream-colored background of the paper. In the next plane, white chalk is applied with enough pressure to cover the grain of the paper. In the foreground, the white forms a gradation with the paper's color so that the main shading maintains a fresh appearance.

3. Now to articulate the foreground. Texture is given to the sea by sketching alternately with white chalk and charcoal. The crest of the main wave, which is completely white, is highlighted with a direct application of white chalk.

OPENING UP LIGHT SPACES

Opening up highlights or light spaces with an eraser is common practice in all drawing techniques. It is especially useful for rendering seascapes, as it allows you to create highlights and reflections on complicated waves. With sufficient practice, this exercise will help you to create drawings as spectacular as the one shown here.

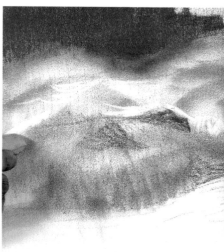

1. This first sketch gives shape to the various grounds of the sea. It should be precise and not overly simple, taking advantage of the scene's abstract quality. The drawing is done plane by plane, starting with the background and progressing to the foreground.

2. After shading in the cliffs in the background, most of the drawing is blended with a finger to create a gray. An eraser is used over this gray base to create highlights; some areas are blurred with a finger, and then more clearly defined lines are opened up.

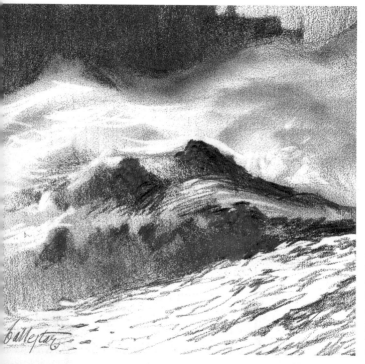

3. Once the most intense white areas have been brought out with the eraser, charcoal is again applied, and excess color is blended with a finger. The eraser, cleaned first by rubbing it on a clean piece of paper, is then used to lift out the final white spaces.

Step by Step

Seascape

MATERIALS

**Blue paper, Chalk
Eraser, Cloth**

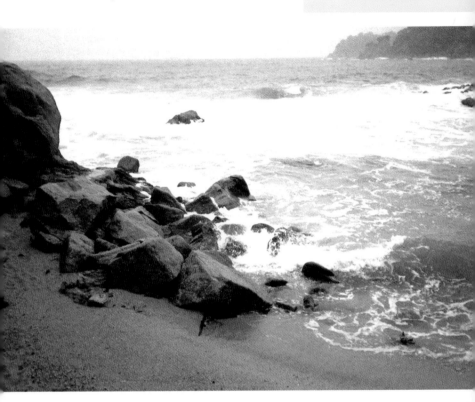

The seascape scene for this exercise is not especially complicated, but it is still important to start by studying its highlights, the areas where the contrasts play a crucial role. The aim is to observe the waves and the effects that can be achieved, here using just a few colors in addition to the blue tone of the paper: blue, white, ochre, sanguine, and dark brown. This limited palette will allow you to capture the texture of the sea under a specific kind of light.

Step 1. The blue paper has been chosen to give the exercise a chromatic base that can serve as a reference point for the tones achieved with the other colors. The first sketch is extremely simple: only a few lines that indicate the horizon, the shore, and the rocks on the left.

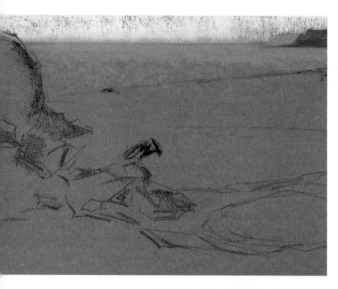

Step 2. Sketch in the lighter blue of the sky without pressing down too hard, so that the color of the paper remains visible through the strokes. Using the color of the paper in addition to the ones you apply to it is a common technique in drawing. With chalk, as with char-coal, you can use just the tip or hold it on its side to apply it to the paper.

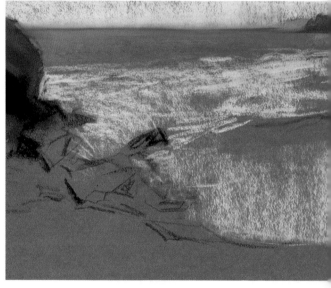

Step 3. Using a shade of blue that is similar to the color of the paper, sketch over the light area of the horizon, thus giving it back part of its original color. Patches of dark brown are applied to the rocks. On these patch-es, draw the highlights of the lightest areas. There are three planes in this scene: the shore, the luminous part of the sea, and the back-ground.

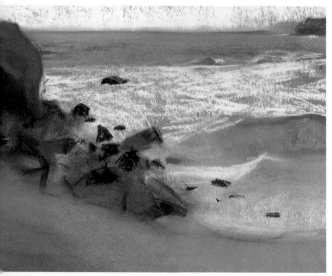

Step 4. Superimpose the tones to create the tex-ture of the water and depict the light on its surface. This will accentuate the contrasts. Darken the white area of the waves with blue, creating a vari-ety of tones. The texture of the water is sketched with white chalk applied using the tip. Each white line is a sparkle of light on the surface of the water. Fill in the fore-ground with ochre and a touch of sanguine, blend-ing the two colors with your fingers.

Step 5. After blending the colors lightly with your fingers, sketch over them again, leaving some areas blurry and undefined and others more clear and crisp. The white highlights are more intense where the waves break against the rocks. With the tip of the white chalk, start drawing the small crests on the waves.

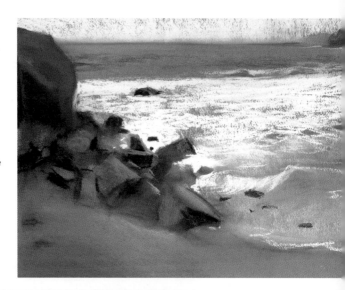

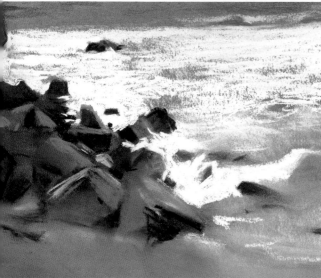

Step 6. The intensity of the white patches is increased by taking advantage of the blurry areas in the background. These direct applications of white create a highly realistic texture, which brings the effects of light on the water to the forefront. Add contrast to the rocky area with intense dark patches speckled with small reflections.

Step 7. After completing the rocky area, draw with blue over the water so that the waves in the foreground acquire more presence. This vivid shade of blue establishes the foreground in relation to the rest of the sea. Next, apply an ochre tone to the sand, and blend it in with your fingers to give it a blurred look.

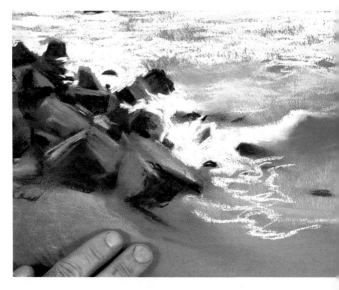

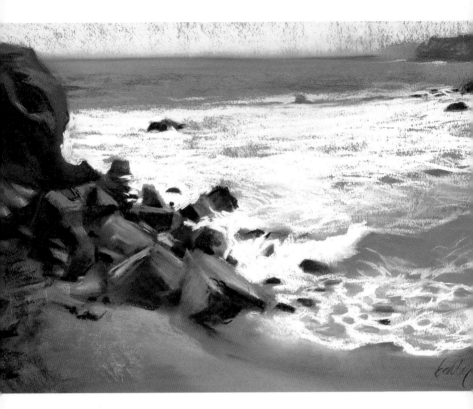

Step 8. Sketch in the highlights with white chalk, paying special attention to the foam in the foreground. Blend some of the colors on the shore with your fingers, then add more white on top.

SUMMARY

• Seascapes offer a wide range of possibilities, both in terms of the subjects to be sketched and the way they can be rendered.

• A great deal of artistic license is allowed in the depiction of marine subjects.

• It is essential to distribute the main volumes correctly in a seascape.

• In an extensive seascape, the horizon and the shapes of the clouds stand out.

• When drawing an expanse of sea, each area is treated as a background.

12

BIRDS

FROM THE BASIC SHAPE TO THE DETAILS

Among animal subject matter, birds are by far the most interesting creatures to draw. Despite their apparent complexity, birds can yield highly aesthetic results. Even though drawing the basic outline of a bird is simple enough to do, you have to be very accurate in capturing the proportions if you hope to achieve a sufficient degree of naturalism. Only with practice will you be able to master this subject.

Most birds can be drawn by beginning with two circles. It is essential to ensure that they are proportionally correct. The slightest miscalculation in the first draft may result in a caricature rather than a naturalistic representation. In addition to their basic structure, birds are very detailed creatures. This two-part exercise demonstrates an approach that can be applied to all birds.

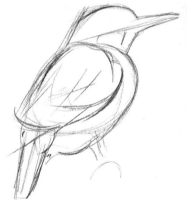

1. Here, the bird's body is sketched as two ovals. Though these shapes are simple, it's important to draw them in correct proportion to each other. The two shapes are nearly identical, but note that the curvature of the breast is slightly more elliptical.

2. After adjusting the essential lines, turn your attention to the details. In this case, the principal anatomical feature – the wings folded back – describe the shape of the animal.

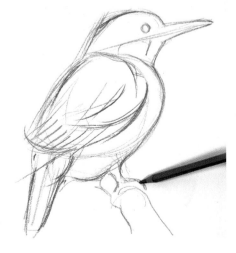

3. With the major shapes defined, you can begin adding some detail to them. Note how articulating the structure of the wing helps illustrate the rest of the anatomy. Observe the subject closely, as each bird has its own particular characteristics.

PLUMAGE

Continuing from the previous exercise, the next step is to render the beauty of the plumage; for this task, you'll use colored pencils. Alhough this process is somewhat complex, it yields highly satisfactory aesthetic results. Start with the lightest colors, but take care not to apply the pencil with too much pressure; this is to avoid filling in the pores of the paper too soon.

1. Begin with the brightest and most luminous color, yellow, with which the foundation is laid for the rest of the work. This color is also used to reserve the white or almost white areas. In other words, uncolored areas of the paper represent the white colors in the subject. The red shaded over the yellow results in orange tones. The direction in which the stroke is applied is important for defining the texture of the feathers.

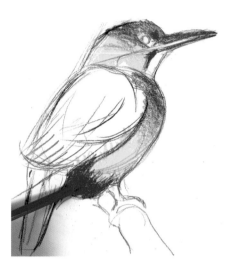

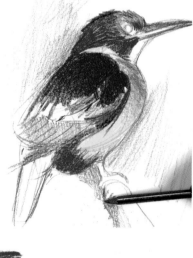

2. Here, color is applied to the head, the breast, and the lower part of the body, allowing some of the underlying colors to breathe through these new strokes. The wing is drawn with short strokes that define the plumage.

3. The short and long strokes that follow the shape of the bird's volume lend a realistic touch to the texture. Rather than opaque color or shaded areas, the colors are drawn in the form of short strokes. Thus blue is drawn over the red lines of the wing with loose and vigorous strokes, controlling the pressure applied on the pencil so as to describe each different texture.

LINE QUALITY

The preceding exercise showed you just one of the many ways you can draw a bird. Birds can also be rendered with a line drawing, a no less complicated approach, as errors in execution are readily visible; with any other technique, such mistakes can easily be concealed with shading. The subject for this exercise is a goose, drawn with a graphite pencil. Aim to draw lines with a sinuous quality.

1. This preliminary sketch also begins with two ovals, but this time they are placed farther apart to leave room for the neck, which joins these shapes. This phase is perhaps the most important; the drawing must be clean, as any error in the initial stages will lead to a poor result.

2. Now draw the anatomical shapes over the preliminary sketch. Simplicity is important here, as is your ability to draw each area of the body in synthesis. Limit your lines to those that best summarize the main aspects of the animal, rather than lavishing the drawing with details. The quality of your line is key; its density indicates the significance of the area represented.

3. This work, which could have been left as it was in the last stage, is enhanced with some areas of shading distributed over the body. The shading must be as synthetic as the line defining the goose. The shading has been executed with a graphite pencil placed flat over the paper, taking advantage of the medium's softness.

THE LEGS

The legs are possibly the most complicated parts of a bird to draw. Every bird has its own individual characteristics; just look at the two previous examples. This exercise shows you how to draw the legs of a rooster. Note the structure and dynamism of their shape, as well as the way line is handled.

1. The structural sketch begins directly at the lower part of the animal. The thighs are connected to the body through the plumage. The legs are left bare, as clean lines ending at the claws. The bird's stance forms an angle between the claw and the leg. The line is left faint and unfinished for the moment until the correct form is found.

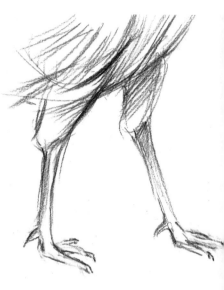

2. The depth between the legs is achieved through a change in the lighting that describes them. A slight darkening of the forward leg gives an idea of the distance between the two. It's important at this stage to keep the lines that describe the claws as simple as possible; they will be refined in the last phase of the drawing.

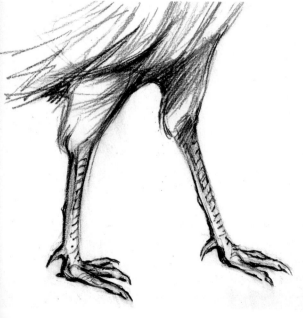

3. Only once the anatomy has been perfectly defined can the lines that describe the legs be finished. Note the texture and the way the stroke is applied. The area where the plumage and the leg connect has been saturated with strokes in the shadows, the only place to call for this treatment.

Two Macaws

MATERIALS
Drawing paper Colored pencils Eraser

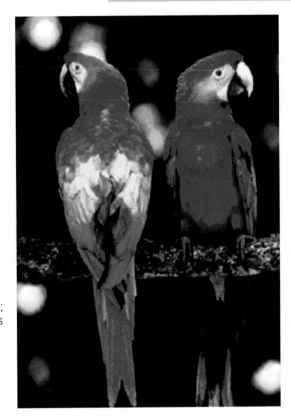

Parrots are an excellent and highly colorful subject to draw. This time we'll work with colored pencils again. The anatomy of this type of bird is relatively easy to draw; its practically fusiform body is composed of very simple shapes. Drawing birds is an especially appealing pursuit, which is why so many artists have specialized in this fascinating theme.

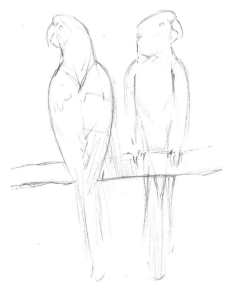

Step 1. Begin with a faint line, taking care not to make too many marks on the paper or press too hard. Colored pencils are a very transparent medium, which means that light tones cannot be superimposed over dark tones, unlike pastel. Therefore, with colored pencils, you must leave the most luminous areas in reserve – in other words, they must be left undrawn and untouched. Only in this way is it possible to superimpose tones.

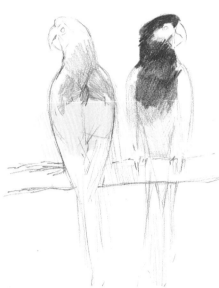

Step 2. The first tones to be applied are the most luminous ones, beginning with a soft shading of yellow that will serve as a base color for the subsequent tones. Now red is applied with an intense shading over the yellow. The direction in which the stroke is drawn is important, as the texture of the plumage is achieved by means of progressively more intense lines. Still, you must take care not to apply the pencil with too much pressure; you must avoid saturating the pores of the paper, which would make it impossible to superimpose subsequent new tones.

Step 3. The intensity of the stroke is a determining factor for attaining the shape of the birds. Each color is applied in a way that defines the modeling of the anatomical forms. Close observation of the volume of the bird's head reveals how the shape is progressively defined. The superimposing of red on yellow produces orangy tones. Blue tones are then added, continuing the extension of the wings. Dark tones are used to shade the background and thus separate the bodies from it.

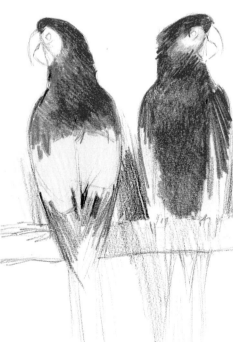

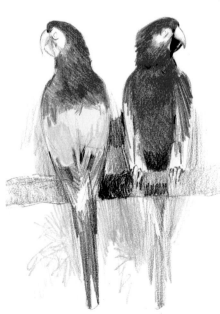

Step 4. As the drawing develops, the colors are consolidated as more layers are added; this turns the top layers into the most luminous areas, which, as can be seen in the middle of the parrot on the left, has been left in reserve. The subtle shading is combined with another, more intense and gestural stroke, which gives further definition to the shape of the breast. The tail of the parrot on the left is executed with dense, straight lines.

Step 5. Compare this step with the previous one. The gradual buildup of color results in greater intensity. Some areas are left barely touched to achieve a greater contrast between the highlights and the dark areas. The combination of colors allows a wealth of new tones and half-tones to be created. The stroke is not always the same, but is adapted according to the birds' shapes and textures.

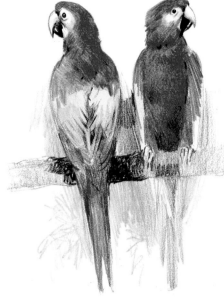

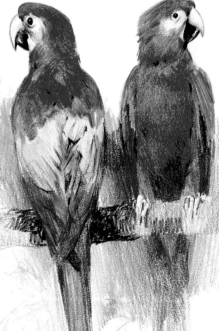

Step 6. With all the luminous areas established, it's time to increase the most intense contrasts. Blue is superimposed over the violet tones, thereby creating a wide range of iridescent-looking colors. The definitive dark tones in the heads of the two macaws lend them vividness and realism. The entire background has been darkened to produce a contrast through color rather than through tonality.

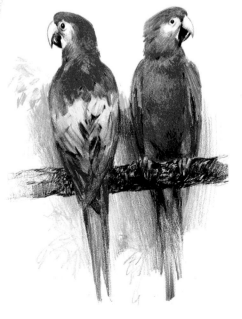

Step 7. The dark areas of the wings are drawn with extreme care so as not to lose any of the underlying color. The shading of the plumage is executed softly until the appropriate tone is achieved. Blue is shaded over yellow to obtain green tones, and some very soft earth tones are added to enhance the yellow tones. The branch on which the birds are perched is darkened, but with some light areas left to define the texture of the bark.

Step 8. The final stage involves heightening the tones to their finished state, now without worrying about saturating the grain of the paper, as there is no need to add any more layers of color. The blue tones are drawn in the same way as the red ones; the intensity is strong, the last strokes applied boldly to heighten the contrast, thus bringing the work to its conclusion.

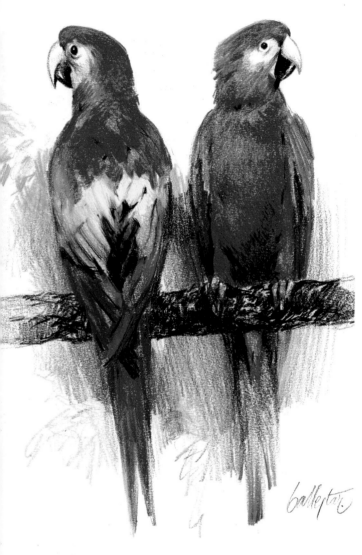

SUMMARY

• Drawing birds calls for a faithful rendering of proportions and a high degree of naturalism.

• Two circles or ovals are the basic shapes used in drawing most birds.

• A correct proportional relationship between the two ovals of the body is essential.

• The proportions in the preliminary sketch must correspond with the bird's specific size.

• Short strokes and long lines that follow the shape of the bird's volume lend the plumage a more realistic texture.

• The wing's structure must contain more detail than the rest of the body to define each part of the bird's anatomy.

• When drawing with colored pencils, the first color used must always be the lightest, which serves as the foundation for the rest of the work.

SKETCHING WITH PATCHES OF COLOR

PROPORTION AS A STARTING POINT

Two essential concepts must be mastered in order to draw figures: synthesis and proportion. These aspects are fundamental even in simple works like the one presented here. You should observe the model analytically, comparing the distances between the body's various forms, transferring them to paper and looking for balance between them.

The human form can be represented and interpreted in so many ways, using any number of different drawing techniques to explore the limitless possibilities of the figure genre. In this exercise, we will combine sketching and watercolor techniques by using watercolor pencils.

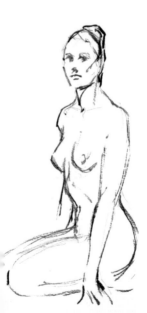

1. *Left*: The initial drawing with watercolor pencils is the same as for a normal graphite pencil, although its feeling on the paper is slightly different. It is important to use a light touch to avoid saturating the paper. The first lines should be just barely visible. Afterward, adjust the sizes little by little, always using schematic shapes and going from the general to the specific.

2. *Right*: This is the result of the previous phase. The essential lines have been established, as well as the proportions, in which the shapes have been carefully developed.

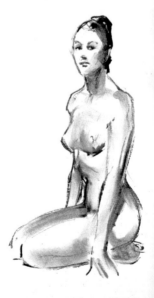

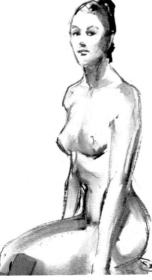

3. Applying the pencil sideways and dragging it gently over the paper, we add the shading. Then we open up the lighter areas with an eraser. Since this drawing with watercolor pencil will later be passed over with a wet brush, we have to use soft tones.

SKETCHING WITH COLOR TONES

After thoroughly studying the proportions and establishing the first tones, we can begin to apply more direct patches of color. The procedure is fairly simple: just moisten a paintbrush and pass it over the sketch. The lines will start to run when the water touches them and loosens and spreads the pigment in the dampened areas.

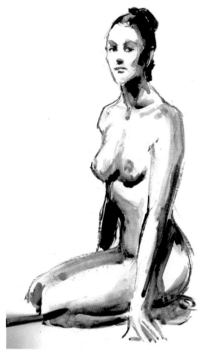

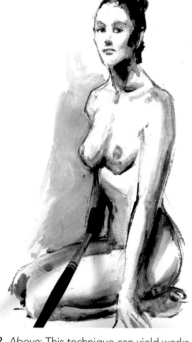

1. *Left*: By applying a wet brush to the previous step, the grays become a wash. When dragging the brush over the drawing of the figure, some of the colors "fuse" completely. If the area was already wet, the result is a gradation that helps us to perceive shapes through their shading and highlights.

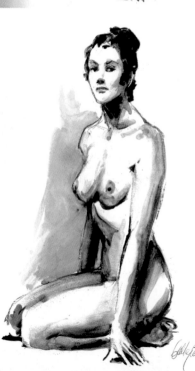

2. *Above*: This technique can yield works of extremely high quality, as can be seen in this illustration. The dark shade on the arm can be lightened by repeated strokes of the brush. We use an earth color to paint the area around the body, and wet it again to clearly define the contour of the figure. This makes the light areas more luminous.

3. *Left*: The technique does not eliminate the entire original sketch. Some lines remain completely visible, and others have been transformed into luminous, almost transparent, tones. The contrast of these tones with the white background creates a vigorous effect and adds volume to the figure.

APPLYING QUICK PATCHES OF COLOR

Drawing is not limited to dry techniques; there is also a great tradition of wash drawings. This approach uses the white of the paper as the absolute light tone; it's not very different from working with graphite or charcoal. The method of application is different, and we must be very careful when blending tones. The complexity of this exercise lies less in the chosen technique than in the anatomical study itself.

1. The first step is a precise sketch that specifies all the areas of the anatomy. After sketching in the first contours, we go over the shapes with more precise lines. The shapes should be summarized as much as possible. Observe the shaded area, for example; the lines are exact and the illuminated area of the shaded side clearly suggests the back muscles.

2. We apply quick patches of well-diluted sepia ink. When drawing with the brush and ink, take care to check the covering power of the color. Dip the brush in water and then in ink, and mix the solution in a separate container, such as a cup or small bowl. If a more transparent color is needed, add more water. We use the brush only to color in the areas in shadow, leaving the lighter areas white.

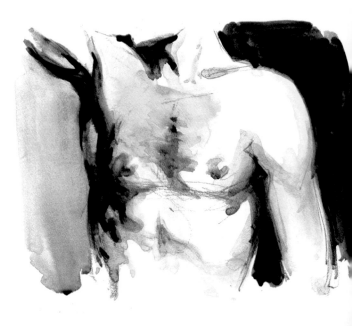

3. Different colors of ink are compatible with each other, and they can even be mixed with watercolors if we want a quick finish, as in this example. Notice how darkening the areas in deepest shadow creates the strong contrast that makes this torso so dramatic.

SOME TIPS

Your subject may determine your choice of drawing method and medium. Some subjects lend themselves to a soft, shaded approach, whereas others, like one shown here, may be better suited to a harder, more direct medium and technique, with the shading represented by flat gray areas. Keep the methods employed in this study in mind as a guide for similar works.

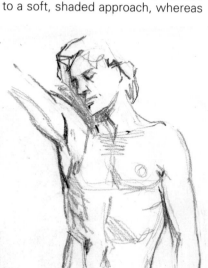

1. The sketch. Start with simple shapes. The initial sketch should be loose; lines can be corrected later as the forms start to develop on the paper. Give each line the attention it deserves, and sketch the entire drawing at once, not piece by piece. The anatomical forms should be clearly defined before you determine the shaded areas.

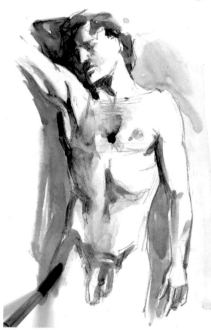

2. Shading. Keep in mind that the lightest lights should be reserved by leaving the paper completely clean in those areas. If you're working on colored paper, the paper's hue should be the lightest tone. In this exercise, the paper is white, so the first tones can be suggested with a very transparent wash.

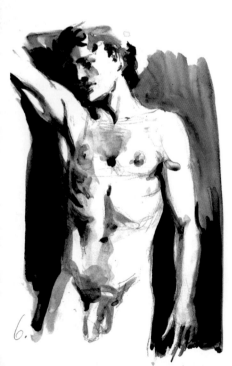

3. Contrasts. When creating the strongest contrasts, keep in mind the medium tones, since these show shades of light. Be careful to keep tonal points of reference in relation to the background. By darkening the background with black, the light on the skin has acquired more prominence.

Reclining Woman

MATERIALS

Watercolor paper
Pencil, Paintbrush, Sepia ink
Eraser, Container of water

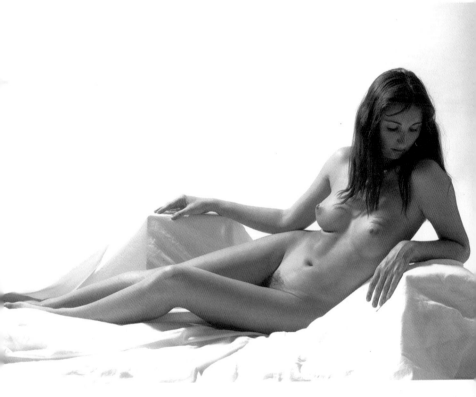

In a drawing of a human figure, patches of color can even define the body almost completely. For this exercise, we have chosen a female figure with accentuated shadows to study how to render the various grounds without too many applications of color. The first steps of this exercise are essential for understanding how to summarize forms.

Step 1. Start with a concise but careful sketch. The basic forms of the figure should be corrected as many times as necessary until you have achieved contours that perfectly reflect the model's anatomy and proportions. Study the shape of the spine and the relationships between all of the woman's physical features. Erase all lines that are not absolutely necessary or that might be confusing.

Step 2. Color in the most important shaded areas using a small amount of well-diluted ink. This is a very important step, since each patch of color enhances an area of light by contrast. It's essential to use a light, transparent tone, as excessively dark patches will prevent you from adding more color in later stages.

Step 3. After applying the patches of color to the body, apply a wash in the background to delimit the figure's contour. The color applied to the body should be completely dry to prevent it from mixing with later applications. The dark, intense background sets off and enhances the lighter areas.

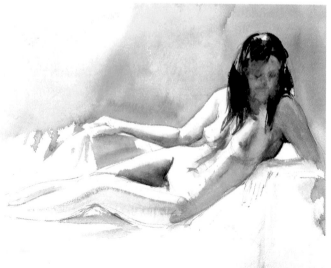

Step 4. Now work starts on the more pronounced contrasts on the body. The wash is now darker, and each application adds small dark areas that give the body shape. Note that too much water can soften the dry washes, creating undesired light spots. Try not to concentrate on any one area for too long.

Step 5. With a small amount of ink on the brush, go over the parts that should be darker than the rest, such as the leg and the breast. When painting these areas, drag the brush down to the lower section in order to blend the new tone with the previous one, which constitutes the base color. A new patch of color gives the hand its final shape.

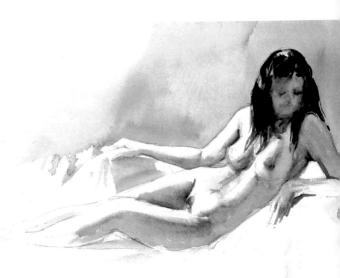

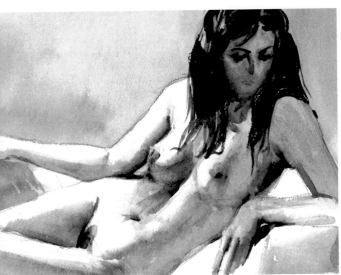

Step 6. Here a more detailed phase of the study is begun. The paintbrush fills in the shapes of the facial features. The increasingly intense contrasts separate the dark areas from the lighter ones, in the leg, breast, and side, for example. Add the eyes and the darker shadows using a brush with a small quantity of lightly diluted ink.

Step 7. The painting is gradually darkened. The shaded areas, which are more and more intense, blend with the lighter tones thanks to repeated brushstrokes. The highlights have been reserved, but contours added where light areas border on dark ones.

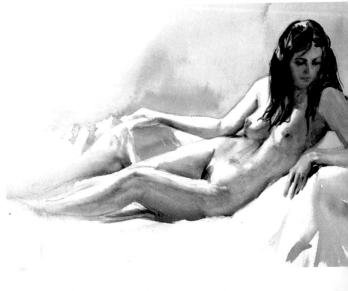

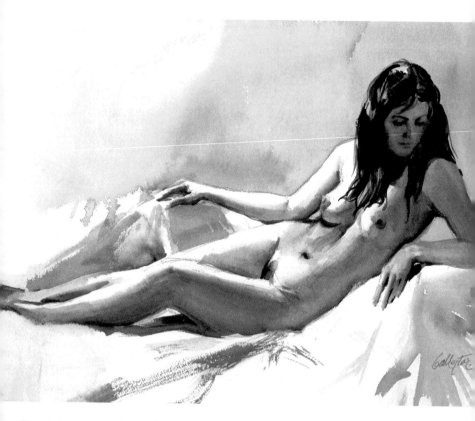

Step 8. Here, the addition of glazes – very transparent layers of diluted color – darkens the general tone by reducing the luminosity of the white paper. This increases the contrasts on the body while avoiding sharp breaks between the various applications of color. Note how the first application of color patches was a decisive step in the development of this exercise.

SUMMARY

- The human figure can be represented using various techniques.

- The figure should be understood in terms of two basic concepts: synthesis and proportion.

- The figure's shapes should be summarized as much as possible.

- When using watercolor pencils, avoid pressing too hard and thus saturating the grain of the paper.

- Drawings with watercolor pencils are later painted over with a wet brush.

- The shaded areas should be precisely outlined.

- Different colors of ink can be combined, and ink can be combined with watercolor.

- The initial sketch should be drawn freely and then corrected as the figure begins to take shape.

- When you begin establishing shaded areas, keep them very light.

- When creating intense contrasts, keep the medium tones in mind.

14

Nature Study: Trees

Trees

Trees, unlike the human body, don't require as strict attention to achieving correct proportions. In fact, their proportions can be approximate, and this allows us to work with a great degree of creative freedom. The technique of applying patches of color is essential to this subject, so trees can be interpreted in an abstract manner.

This chapter focuses on trees and the various techniques you can use to draw them. The approaches included here range from monochrome studies to the most vivid use of color, and all make it possible to capture the subject with satisfactory results.

1. The best way to see a group of trees is by looking at them through squinted eyes to get an idea of the basic volumes. This technique allows you to ignore the details and concentrate on the main differences in tone. In this exercise, we'll start with a monochrome drawing and later add color. Pastel is an extremely flexible medium. In this first sketch the general tones are established by holding the pastels flat against the paper, just as with charcoal.

2. We now start adding more detail to the trees, filling in the principal contrasts. We add shading to the lower part of the drawing to establish the foreground, and finish the foliage in the upper section.

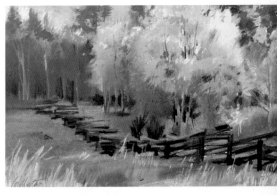

3. We now start adding color on top of the previous drawing. This is a good way to learn how to use pastel, which combines aspects of drawing and painting. Since pastel colors are very opaque, they let you apply lighter tones or colors directly on top of darker ones. Here, we use intense shades of green in the dark areas and then depict the light by applying yellow and orange tones on top of the green.

THE STRUCTURE OF TREES

The structure of a tree depends on its species and its volume – filled out with foliage or bare, for example – which varies according to the time of year. The top of a tree can be rounded, or long and streamlined. A leafy tree can be drawn in many different ways. This exercise will help you understand the volume of a tree and its tonal differences. We will use black and white pastels on cream-colored paper.

1. The starting point is to set up the relationship between the background and the main subject. The background plays an important part in determining the structure of this tree. After establishing the horizon, which defines the plane that depicts the ground, we use black pastel on the background, blending the tone with our fingers. Before we clean our fingers, we color in the shaded area of the tree and then open up the large highlight at the top with an eraser.

2. This simple addition of the white highlighted area helps to define the structure of the tree. We draw with intense strokes, using the tip of the pastel and bringing the color of the paper into play. In fact, the color of the paper is just another tone in the drawing, and it will be completely integrated into the finished work.

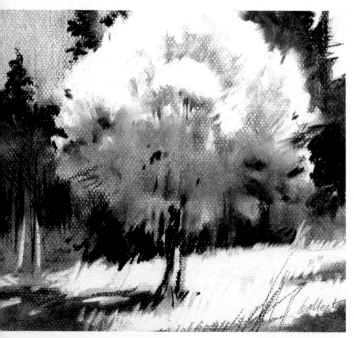

3. The contrasts in the background play an essential role in the drawing. The round shape was defined from the initial stages, but it is not until the background tones are intensified that the contrasts make the shape and texture completely evident.

CONTRASTS AND HIGHLIGHTS

Contrast is an extremely useful tool in any drawing, regardless of its complexity. In this nature study, color contrasts give life to a drawing of a small grove of trees. Nevertheless, in this exercise it is also essential to understand the structure of each individual tree. In this way, as the drawing progresses, it will be the contrasts and lights that differentiate the various trees and provide a sense of depth.

1. The color of the paper provides the foundation for this work, as its hue becomes an integral part of the drawing's overall color scheme. Working on violet paper, we begin by sketching in the trees in red, distinguishing the sky by the use of blue.

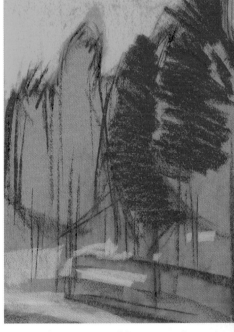

2. Intensifying the red of the trees and adding some orange increases the contrast considerably. This phenomenon is produced by the juxtaposition of complementary colors, which the eye perceives as an extreme vibration; in this exercise, we will take maximum advantage of this effect.

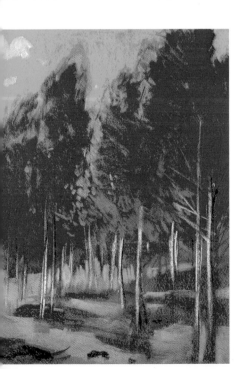

3. With these more intense contrasts, the drawing takes on a chromatically dynamic quality. Since the paper is almost completely covered, the background color is just barely perceptible, but it is there, peeping out through the branches and between the tree trunks, with subtle hints of its hue among the earth tones on the ground.

AVOIDING DETAIL

Continuing with the previous exercise, we will now pay special attention to detail. An excess of detail can spoil even the most interesting drawing. It's easy to forget that details are often merely suggested. Beginners frequently make the mistake of using too much detail and trying to define everything exactly, giving every section of the picture the same importance. With practice, you can learn to distinguish between the essential and the accessory.

1. *Left*: Detail shouldn't be understood as a collection of lines that flood the entire drawing; instead, it involves selecting certain areas and concentrating only on the things that capture the viewer's attention. Here, it would be the highlights in the center.

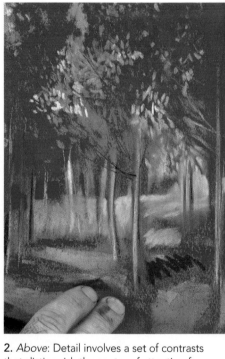

2. *Above*: Detail involves a set of contrasts that distinguish the center of attention from the background. This difference should be subtle, and the areas surrounding the center of attention should also include certain details. Such attention to detail should not extend to the entire drawing, however.

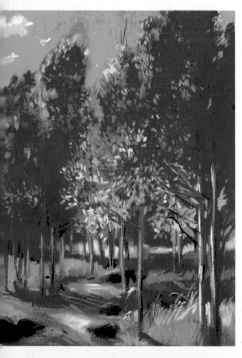

3. *Left*: Using the tip of the pastel, we add the most intense highlights to the composition, pressing down directly on the red of the trees and creating occasional impastos. Just as with black-and-white drawings, the tones balance each other.

MATERIALS

Gray paper
Charcoal, White chalk
Eraser, Cloth

Trees in the Foreground

The objective of this exercise is to learn how to capture in synthesis the trees in a landscape. We have chosen an uncomplicated scene so that the composition is relatively simple. There are three clearly differentiated planes: the ground (foreground), trees (middle ground), and sky (background). The way these three planes relate to one another will determine the final result.

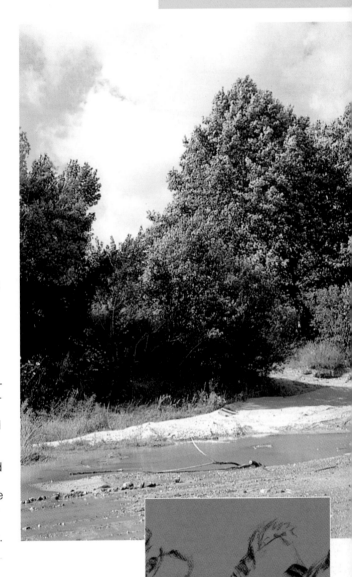

Step 1. We observe the scene through squinted eyes in order to capture its general volumes. With the charcoal held between the fingers, we first draw the structure of the overall scene and then lightly sketch in the volumes of the trees. Once the structure of the drawing is established, we apply dark patches to the lower section, using the flat edge of the charcoal.

Step 2. We now establish the main difference between the sky and the rest of the drawing. Using a small piece of white chalk, we color in the upper section, allowing some of the paper's hue to remain visible. We darken in the contour of the trees with the tip of the charcoal. At this point each structure should be clearly distinguishable. The color of the paper falls in between the white chalk and the charcoal, creating a highly suggestive medium tone.

Step 3. We enhance the main contrasts with lines that separate the trees according to their tone. The lines should be very intense and clearly distinguish the trees from the sky. The dark tones are denser in the shaded areas, and the gray of the paper is integrated with these and the light tones.

Step 4. Note the difference between this step and the previous one. Both the maximum darks and lights intensify each other, and the gray color of the paper is totally integrated in the tonal range. It's important to keep this artistic effect in mind when executing drawings on a colored surface.

Step 5. The white of the sky silhouettes the treetops, but this effect is not harsh or clear cut: in certain areas the black blends with the white chalk, creating grays that enrich the tone of the paper even more. In certain areas in the grove of trees, we use white lines of varying intensity to suggest the texture of the vegetation.

Step 6. In the foreground, the lines are soft and blended with the fingers. The rest of the contrasts are sharper, alternating direct, continuous lines with more precise touches that establish highlights. In the left-hand section, we use a dense, dark patch of tone to make the vegetation in the foreground stand out.

Step 7. We increase the intensity of the black tones. These new applications of black outline the luminous details, which include the elements in the foreground. If necessary, use an eraser to outline certain details. Then we use white chalk to draw in the main points of light. In the foreground, we enhance the contrasts in the ground to create an effect of depth.

Step 8. In this final stage, details are distributed judiciously among the various areas of interest, and contrast is added to the foreground, where some attention is focused on the dead branch.

SUMMARY

• Unlike the human body, trees are not subject to rigid patterns.

• The proportions of trees are approximate, which allows us to work with a great deal of creative freedom.

• When observing a group of trees, squint your eyes to capture the general volumes.

• Since pastel is very opaque, we can apply light tones and colors directly on top of darker ones.

• The background plays an important role in defining the contour of a tree.

• In a study of nature, chromatic contrasts can bring vibrancy to a drawing.

• Juxtaposing complementary colors sets up intense contrasts like those achieved by juxtaposing light and dark tones.

• Details should be understood as a set of contrasts that allow the center of attention to stand out against the background.

GESTURAL FIGURE DRAWING

MOVEMENT

The figure in motion is not rendered in the same way as a static figure. Movement not only calls for different types of strokes, but also lets you capture the figure's expressiveness. Rather than an anatomical study, this exercise is meant to show you how a gestural stroke can be adapted to the shape of the figure. Regardless of how gestured or abstract the stroke is, you must always keep in mind the proportions of the body.

Gestural drawing is an extremely interesting practice, and the figure is perfectly suited to this type of representation, which yields vivid and dynamic results. A gestural stroke can contribute far more than a line to a figure drawing; it can help express personality. This chapter is concerned with showing you how to develop these personal qualities in your work.

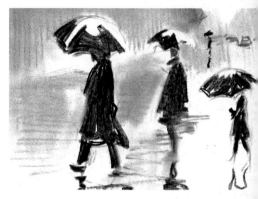

1. Understanding the figure in motion and then capturing it in a gestural rendering requires a great capacity for synthesis and a skillful stroke. In a gestural representation of the body, the act of drawing takes precedence over the subject. Here, a slice of reality is captured with several simple shaded patches – figures drawn with a fast and direct stroke – layered over a previously blended background.

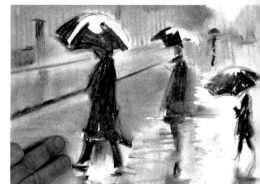

2. The drawing forms a single unit; there's no particular need to make a distinction between the background and the figures. Thus, we can concentrate on the forms and define the urban setting. The background is drawn with the eraser, opening up whites to define the reflections on the wet asphalt. Don't worry if you go over parts of these elements; they can be redrawn later.

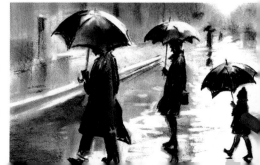

3. The darkest contrasts are heightened against the background, which is blurred once again, and the eraser is used to open up white areas on the sidewalk and the highlights of the street. Darkening the forms against the light background creates a backlit effect. The end result is a highly attractive study of texture and light.

DRAWING IN FLAT STROKES

Although it's common to draw with the flat side of a stick of charcoal, this technique plays an especially important role in rendering the figure. It not only facilitates gestural strokes, but also makes it easy to express subtle contrasts as simple lines rather than through tonal modeling. This exercise shows you how to draw a figure with a gestural stroke, using mostly the flat side of the charcoal stick.

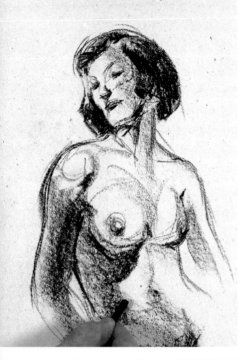

1. The sketch is executed on toned paper with very faint lines, using the flat length of the stick. It's important to keep in mind the figure's spine, which forms the shape of an inverted S from the head down. Once we have built the body structure from basic shapes, we work on the shadowed side of the figure with the charcoal held flat.

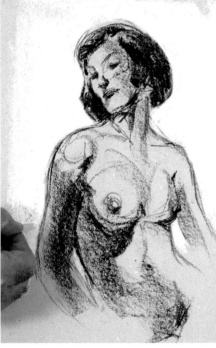

2. We take stock of the work; because we're concerned primarily with immediacy, we will not use any blending. The best approach for achieving a balance between the gray tones and the color of the paper is by creating a white background with chalk. This will allow the tones to acquire more prominence.

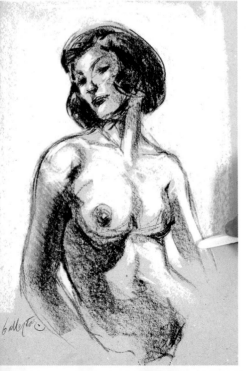

3. To make the tone of the paper more prominent, we draw the interior of the figure with the charcoal held flat, allowing certain areas of the background to integrate completely with the contrasts that have been established. The white shading on the figure must be treated as highlights, leaving the grays as intermediate tones.

USING YOUR FINGERS AND A BRUSH

This exercise combines two interesting drawing techniques: blending tones with the fingers and the use of a brush. Dry mediums such as Conté crayon, chalk, charcoal, and graphite are especially suited to this technique. When you apply one of these mediums to paper, the pigment is deposited as tiny particles, which can be picked up with a brush or with your fingertips and can then be used to create gradations.

1. Conté crayon is not as versatile as charcoal when used in a linear drawing, as the warm contrast between the line and the paper is conspicuous. However, it can be used to achieve very fresh effects when applied appropriately. The profile of this female figure has been drawn with a clean stroke, suitable for continuing on with a very direct approach.

2. A small paintbrush is impregnated with a little dust from the sanguine Conté crayon. You can make use of the particles that have already crumbled off the Conté stick, or file it down. A well-loaded brush affords a very homogenous application, with which we begin to model the body directly.

3. Tones created with the Conté stick and the paintbrush model form in a very particular way, leaving the edges of the line slightly blended, an effect that lends the drawing a fine, velvety finish.

DRAWING WITH SANGUINE DUST

The Conté stick is possibly not as versatile as charcoal, although because it is made with a binder of gum arabic, it adheres much better to the paper than the latter, thereby allowing a better covering finish. With the previous exercise, we'll try a new approach in order to gain a better understanding of this type of blending.

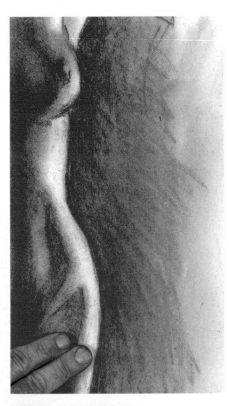

1. The pigment dust we will use here is the byproduct of the drawing itself. In this exercise, started on the previous page, the brushwork made the tone too uniform. Therefore, we will now use our fingers to work the tone in a more intuitive way, removing color in certain areas to achieve a more precise modeling.

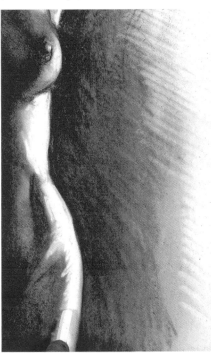

2. An eraser is used to recover the luminosity of the brightest highlights, extracting the soft layer produced by the sanguine dust. The combination of blending and erasing allows an exquisite finish. It all boils down to positioning the highlights appropriately.

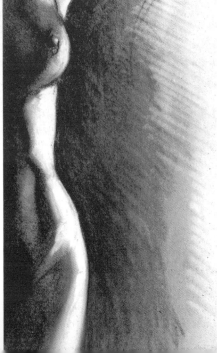

3. Blending is combined with the refining of the highlights, although this isn't done the same way over the entire body. In some areas, such as the hip, transitions between light and shadow are very abrupt, whereas in others, such as the breast, they are diffuse. These blendings between light and shadow can be accentuated with the brush.

Academic Figure Study of a Male and Female Nude

MATERIALS

Paper, Conté crayon
Brush, Eraser
Cloth

The main focus of this exercise is drawing with sanguine dust. The aim is to study the structure of a male and a female figure based on the contrasts between their anatomies. A side-by-side pose allows us to compare the forms of each and to closely observe their respective proportions. Synthesis of the forms will be based on areas of shading.

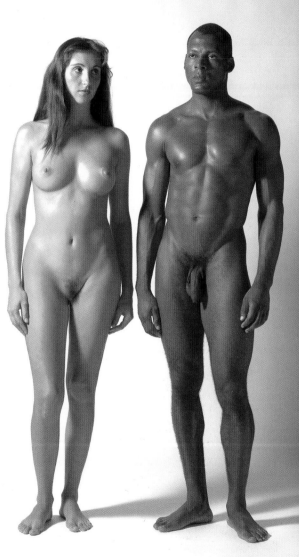

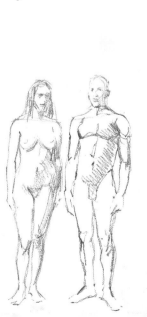

Step 1. First, a quick but detailed sketch of the two figures is executed. The definitive shapes are adjusted by drawing with the tip of the Conté crayon. Closely observe the lines of the shoulders and the hips; the figures are not drawn symmetrically, since their bodies themselves are not. Special attention should be paid to the posture of the man's hip, in which one leg is straight while the other is slightly flexed and relaxed.

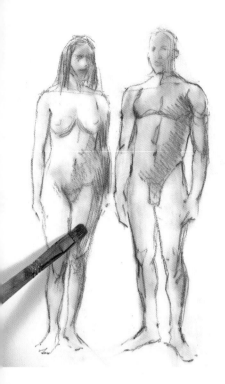

Step 2. The best way to determine the main masses of your subject, eliminating its details, is to look at it through squinted eyes. Here, using a brush loaded with sanguine dust, we shade the figures, pressing down harder in the darkest areas. The drawing is done quickly using gestural strokes.

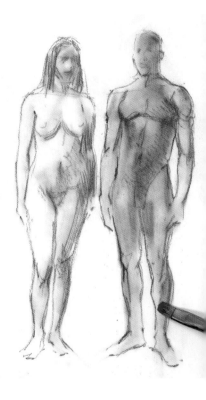

Step 3. Attention is now focused on shading the male figure. The dark tones are increased or reduced with the brush, quickly at first, since there's no need for detail at this stage. Gradually the tones are intensified by using the first dark tonal patches as a point of reference. Strokes drawn with the Conté crayon are then softened with the brush.

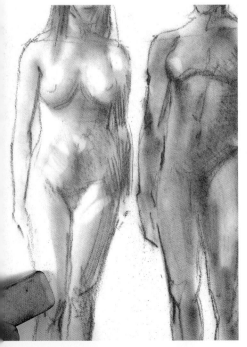

Step 4. The dark shadings on both figures are meant to define the anatomical areas of each, in particular the main muscle masses. Here, after some of the tones applied previously to the female figure have been spread and blended, shapes and volumes are further refined with the eraser.

Step 5. The brush is used on both figures, softening the tones and the profile of the white highlights. Now we draw the darkest contrasts and once again open up white areas with the eraser, especially over the female body. Drawing with the tip of the Conté crayon, we accentuate some of the prominent contrasts and lines. Note how the facial features have been rendered with just a few patches of tone to suggest the details.

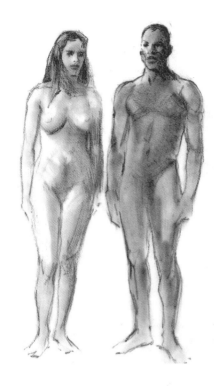

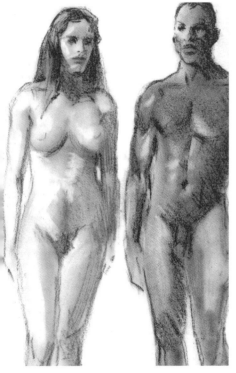

Step 6. In this step we begin to better articulate the forms. The eraser is used to define a large portion of the woman's anatomy, while the Conté crayon is used to limn the man's musculature. Highlights on the skin are now brought out with the eraser.

Step 7. Using the tip of the Conté crayon, we reinforce the strongest shadow areas on the female figure. The drawing has now begun to acquire some detail, and contrasts have become more pronounced, lending definitive shape to the breast and the stomach. Some areas are again cleaned up with the eraser.

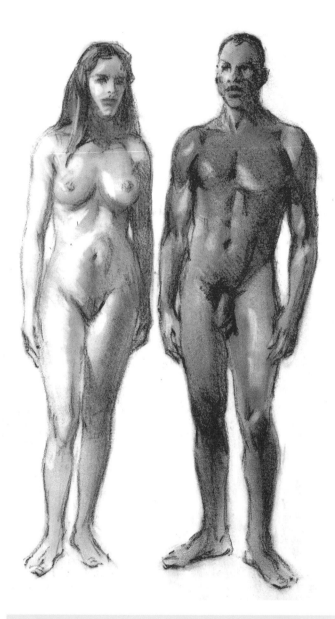

Step 8. More direct drawing techniques are now used to further articulate the anatomical forms of both figures and better describe their volumes. As a final step, the background is cleaned up with the eraser.

SUMMARY

• A gestural stroke gives a drawing a lively, dynamic quality.

• The figure in motion is not rendered in the same way as a static figure.

• Depicting a figure in motion in a way that expresses its action requires a determined type of stroke.

• To render a moving figure, you must know how to see your subject in synthesis and master a gestural stroke in your drawing method.

• In a gestural rendition of the body, the act of drawing takes precedence over the subject.

• A dramatic backlighting effect can be achieved by layering dark forms against a lighter background.

• Soft mediums like charcoal offer very interesting artistic possibilities because, when applied to paper, they deposit pigment particles that can then be dispersed with your fingers or a brush.

EXPLORING STILL LIFE THEMES WITH "SOFT" TECHNIQUES

CHARCOAL

Soft vine charcoal is a very versatile drawing medium because it's so forgiving: you can easily erase mistakes by rubbing a cloth over the paper to obliterate "offending" areas. For this reason charcoal is especially suited to making compositional studies.

Soft mediums facilitate gestural drawing and blending, two techniques that are ideal for modeling the shapes of a still life. In this section, you'll practice some previously explored "soft" drawing techniques, here applying them to still life motifs.

1. This exercise demonstrates the versatility of charcoal and the way it lets you quickly transform a basic outline into a more detailed drawing.

2. The structure of the basic outline can immediately be turned into a more precise and complex work with very little retouching. A cloth is used to erase unnecessary lines. Applying the charcoal with more pressure results in darker lines, which are then blended with a fingertip.

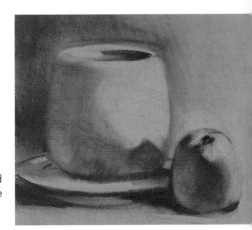

3. The extensive area that has been blended is ready to be worked on. Intense strokes are "drawn" with the eraser, revealing the original color of the paper.

SANGUINE CONTÉ CRAYON

Whereas charcoal facilitates the preliminary study, Conté crayon, which is somewhat denser and more stable, is an interesting medium to use in modeling the forms of your subject. This exercise is a continuation of the previous one. Note how the color of the paper has been used to integrate the two mediums.

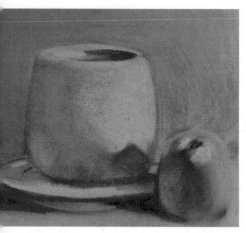

1. We begin with the last step of the previous exercise. The sanguine color will lend the still life a totally different appearance. The Conté crayon, which is dense and opaque, covers even the darkest papers. The previously dark areas are shaded in with the flat length of the stick.

2. The blue areas of the background have now been transformed into highlights and are interpreted as the chromatic atmosphere enveloping the objects. Conté crayon is again applied over the orangish base color of the background, making it more opaque.

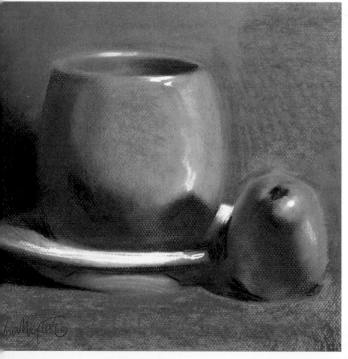

3. Conté crayon is easy to spread; we blend many of the sanguine-colored areas with our fingertips. The objects acquire volume once the definitive highlights are added with charcoal and white chalk.

CHALK

Chalk is not terribly pleasant to the touch, but it's a very versatile drawing tool and allows a wide range chromatic effects. Softer than Conté crayon, chalk is very easy to blend on the paper with your fingertips and even with a brush.

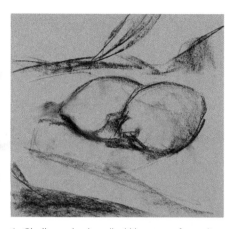

1. Chalk can be handled like any soft medium. This sketch is drawn by holding the stick flat against the surface of the paper. We don't settle for simple lines, but use a crosswise stroke to indicate the first dark areas.

2. Strong contrast is established with a stick of white chalk; holding it flat against the paper, we draw around the lemons, as well as add the bright reflections on them. Blue is used to separate the white background from the lemons, and an earth tone is applied to establish a difference between planes and describe the volume of the fruit.

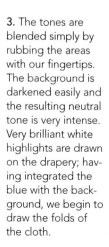

3. The tones are blended simply by rubbing the areas with our fingertips. The background is darkened easily and the resulting neutral tone is very intense. Very brilliant white highlights are drawn on the drapery; having integrated the blue with the background, we begin to draw the folds of the cloth.

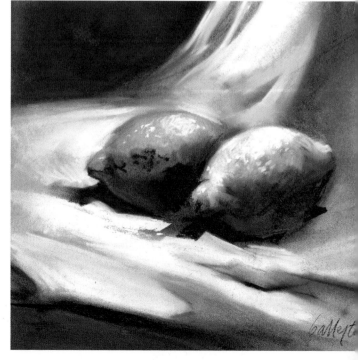

WATER-SOLUBLE PENCIL

In addition to watercolor pencils, there is another type of medium that is very well suited to drawing still life sub-

jects: the water-soluble pencil. This drawing implement is similar to a graphite pencil, but is somewhat more versatile, making it quite easy to create a wide range of gray tonal gradations.

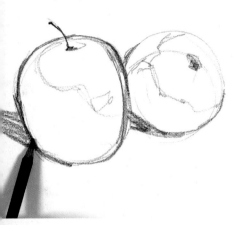

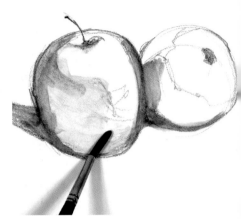

1. This exercise demonstrates why the water-soluble pencil is considered a soft medium. When you first apply it to the paper, the line it produces may appear somewhat hard. However, when water is applied to the pigment with a brush, it behaves like paint, as you can see in the next step.

2. We apply a wet brush on top of the line drawn with the water-soluble pencil, which dilutes the pigment and turns it into a wash. The tones that define the contours of the apple are rendered by controlling the saturation of the wash.

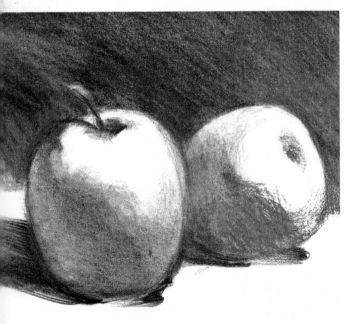

3. The work is completed by combining the possibilities of the medium: the linear qualities of the pencil and painterly ones achieved with the application of water. Reflections and highlights can be lifted out with an eraser. The final result is a highly voluminous effect.

Still Life with Ceramic Vessels

MATERIALS

Medium-grain watercolor paper
Water-soluble pencil, Eraser
Watercolor brushes, Water

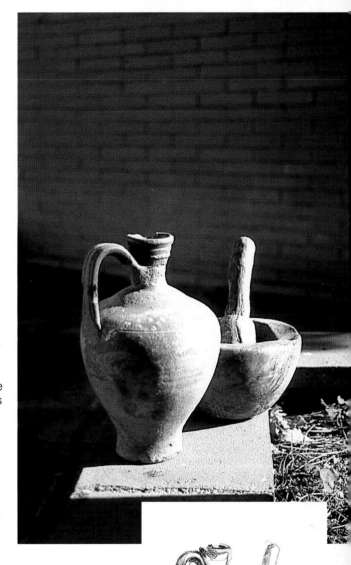

The aim of this exercise is to obtain a variety of gray tones using a water-soluble pencil. The subject is a still life that offers many possibilities in terms of lighting. This technique is very similar to wash, except that you begin with a linear drawing, interpreting the shadows with gradated lines.

Step 1. After drawing the preliminary sketch, we study the main areas of light, beginning with the objects and then proceeding to the straight planes of the ledge. These shadings serve as a gray base for the washes that will follow with the application of water.

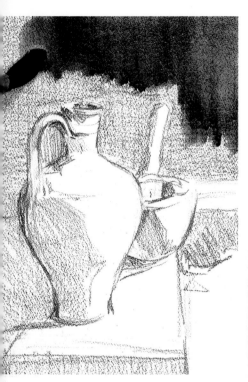

Step 2. We shade the background with the pencil, then pass a wet brush over the area. The water turns the tone into a very dark gray, which we spread easily over the paper.

Step 3. The wash is spread over the entire background, taking care not to overlap the contours of the still life objects. The more sweeps of the brush, the more diffuse the gray tone becomes. Using the same wash technique, we start painting the pitcher, almost "stretching" the color over it.

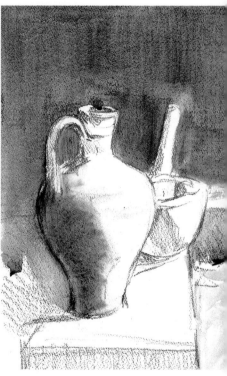

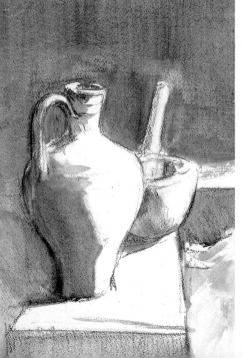

Step 4. Unlike traditional wash, with the water-soluble pencil we can correct areas with far greater ease. The shadow on the pitcher is executed flawlessly. The shadow on the mortar is handled in the same way.

Step 5. After giving the wash time to dry, we go over it in pencil, further defining the different planes. The highlights acquire more prominence thanks to the darkening of certain areas of the background. Even the light gray tones stand out from the background. These tones are drawn again in order to create denser washes.

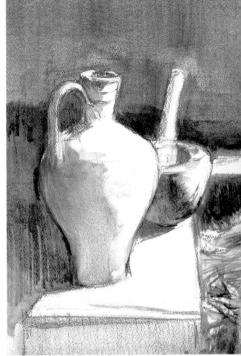

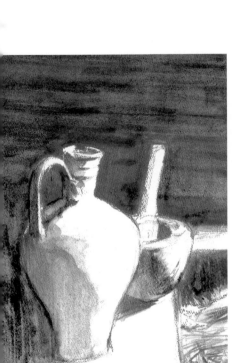

Step 6. We again dampen the darkest areas of the drawing. The darkness of these tones now sets up a major contrast with the lightest areas. Some very interesting tonal values have begun to emerge on the objects.

Step 7. Certain areas are darkened further to establish the maximum contrasts. The background tone now verges on black. The same tone is used to draw the darkest shadow on the pitcher and to darken other areas of the object. We use the eraser to outline the highlights.

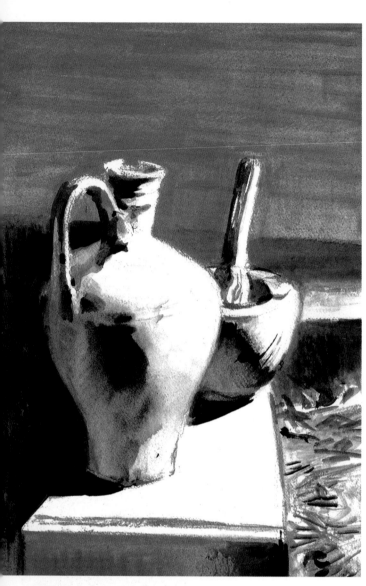

Step 8. In this last phase, we concentrate solely on achieving maximum contrasts. The water-soluble pencil is again applied, depositing more tone on the paper. Water is then applied to create a wash, which is used to redefine the shapes of the most important shadows, modeling the forms of the objects. Note how the reflections and highlights have been created by holding these areas in reserve from the outset of the exercise.

SUMMARY

- Soft mediums facilitate gestural drawing and blending.

- The versatility of charcoal makes it an excellent drawing medium.

- Because charcoal is friable, it can be easily erased.

- Strokes can be made more intense by slightly increasing the pressure on the charcoal stick. This stroke can then be blended with your fingertip.

- Conté crayon is denser and more stable than charcoal, and has great covering capacity.

- Sanguine-colored Conté crayon can produce luminosity on the darkest-toned papers.

- Chalk is softer than Conté crayon and is very easy to blend on the paper with the fingertips or a brush.

- The water-soluble pencil is similar to a graphite pencil but allows a great variety of possibilities.

- A water-soluble pencil makes the same kinds of marks as a regular pencil, but running a wet brush over the strokes drawn on the paper produces a washlike effect.

THE URBAN LANDSCAPE 1

THE IMPORTANCE OF PERSPECTIVE (1)

Not all subjects call for the rigors of technical perspective; nonetheless, a knowledge of the basics is needed for drawing buildings correctly and creating the illusion of depth and distance. In this chapter we lay the foundation for using artistic perspective in later work.

The urban landscape is a noteworthy subject for two reasons: it is easy to find and it offers a wide range of possibilities. Perspective techniques help you set up spatial relationships between the objects in a composition in such a way that gives the illusion of depth. A knowledge of perspective is essential to drawing urban scenes convincingly.

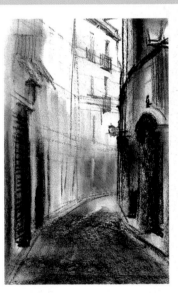

2. *Right*: Doors and balconies are drawn based on the initial scheme. The illusion of depth is created by reducing the intensity of the lines defining elements as they recede into the distance. But this isn't just a line drawing; tones are also important in achieving a sense of depth.

1. *Above*: A winding street like this one is always an alluring subject, as it has an air of mystery. Here, a rudimentary perspective is determined by directing the preliminary lines toward a single point, which in this case is outside the confines of the paper. This type of scheme provides you with a groundwork on which to work with greater ease and accuracy.

3. Note the way tones define the the street's depth, its foreground much darker than the brightly lit background. An important point to remember is that elements in and near the foreground call for more detail than those in the more distant planes, which are rendered simply with dark shadows.

PERSPECTIVE
IN ARTISTIC DRAWING

Artistic perspective can be represented by following a series of very basic rules; in addition to being extremely useful in the drawing process, perspective also lends a high degree of realism to your compositions. This page shows you two very simple ways of establishing perspective.

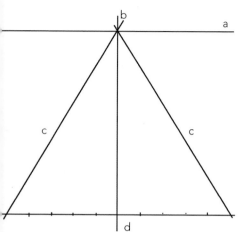

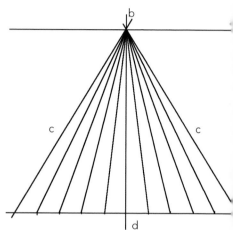

1. This diagram shows how to draw the perspective of what could be a floor between two walls, or a street with building façades on either side. First we draw the horizon line (a), which is always at the same eye level as the viewer; if the horizon line were drawn very low, hardly any ground would be visible. The horizon line in this example is situated at the top. The vanishing point is marked (b), and from it the vanishing lines are drawn (c), which show the breadth of the "street," represented by the marks indicated between the two vanishing lines (d).

2. You can draw as many vanishing lines as necessary. These lines are especially advantageous when you're drawing something more complicated, such as floor tiles or a row of windows.

3. This procedure can be applied to drawing any volumetric object in space. After first establishing the horizon line (a) and the vanishing point (b), we sketch three cubes and draw lines from the vanishing point to their corresponding vertices.

THE VANISHING POINT
AND LINES OF PERSPECTIVE

At this point you may want to refer back to chapter 8, where we introduced perspective from an artistic standpoint, in which your intuition plays an important role. Building from there, let's examine the subject more rigorously. In this exercise we will practice drawing a cube in perspective, this time by using a somewhat more technical approach.

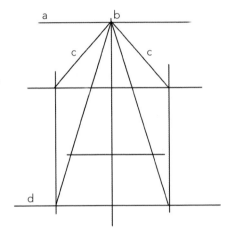

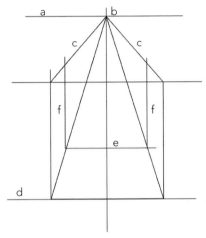

1. Here we'll study how to construct cubes in greater detail. First we draw the horizon line (a) and the vanishing point (b). A perfect square is then drawn in the foreground and lines are drawn from the vanishing point to the square's vertices (c). Now the depth of the object, a six-sided form called a parallelepiped, is defined, and its base is indicated with a horizontal line (d).

2. From the line at the base of the background (e), we draw two vertical lines (f) that extend to the vanishing lines (c); the face of this transparent cube is now almost closed.

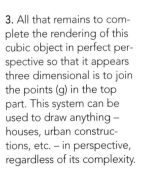

3. All that remains to complete the rendering of this cubic object in perfect perspective so that it appears three dimensional is to join the points (g) in the top part. This system can be used to draw anything – houses, urban constructions, etc. – in perspective, regardless of its complexity.

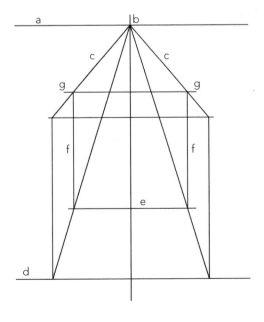

HELPFUL HINTS

Although certain aspects of perspective are governed by strict rules, things are generally not so complicated. The technical hints included here will help you to draw complex elements. Although we have been using a ruler in some of the exercises, you can also draw freehand or use rudimentary tools such as a length of string or a sheet of paper folded down the middle.

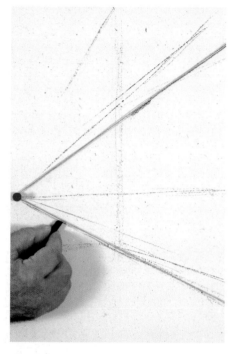

1. With artistic perspective, you should feel free to use whatever means are at hand to apply the system to your subject. When you need to study the lines of a plane, you can resort to this simple procedure, which is fast and reliable: secure a thumbtack directly over the vanishing point in your drawing and attach a length of string to it. Draw the vanishing lines by moving the string accordingly.

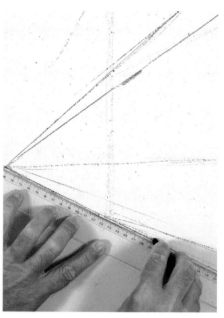

2. Another way of drawing vanishing lines is with a ruler, or any other object that helps you draw straight lines, such as a sheet of paper folded down the middle.

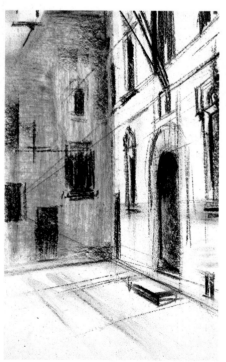

3. Either approach makes it is possible to represent a simple perspective like this one. The openings of the doors and windows must be drawn in accordance with the lines that were used to indicate them from the outset. Here, note how the wall in the background, which is at an angle to the viewer, "blocks" the perspective.

City Street Scene

MATERIALS

Drawing paper
Pencil, Felt-tip pens
Eraser

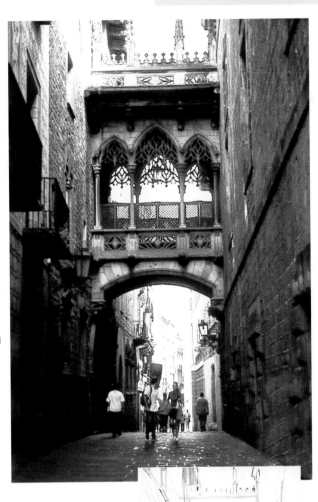

The technical complexity of this urban landscape lies not so much in the perspective as in the drawing medium used, felt-tip pens, which are less forgiving than pencil, charcoal, Conté crayon, or chalk. The perspective is basic, with a single vanishing point. The arch in the middleground opens onto a view of the street as it recedes into the sunlit distance.

Step 1. First we situate the vanishing point and from it, without using a ruler, sketch the basic perspective lines, starting with the main walls and the ground, the cornice on the right wall and the row of balconies on the left. With these first lines in place, we draw in the upper gallery and the arch. After establishing these planes, we begin to sketch the interior of the walls and the Gothic details.

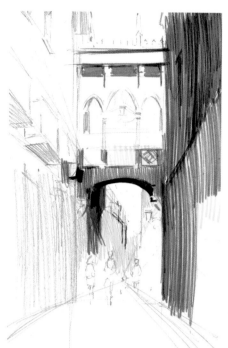

Step 2. The felt-tip pens can be used to create a variety of lines. The stroke applied here conveys the surface of the walls. The vertical lines are elongated and intensified in certain areas, ending at the height of the cornice. The first tones to be added are the light ones; the yellow of the background provides a foundation for the darker tones that will be added later.

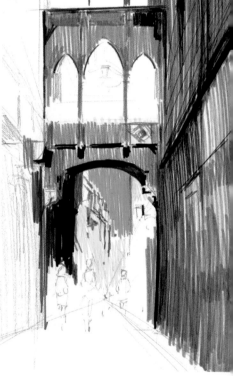

Step 3. Right: Felt-tip pen lets you create more or less closely woven hatching that doesn't completely cover the luminosity of the paper. The ink has a degree of transparency that allows underlying layers to breathe through. The intense blue of the sky is drawn with very dense strokes, with the white areas left in reserve.

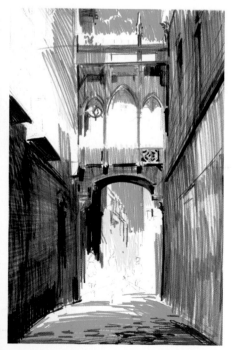

Step 4. This drawing involves a limited range of colors The left-hand wall next to the Gothic arcade is shaded with an intense application of yellow, following the perspective of the wall. The same yellow is used to draw the lower area of the wall. Gray and blue are used to create an area of variegated half-shadow. Horizontal lines are drawn over the ground, leaving some areas reserved for later work.

Step 5. New tones are created on the cobblestone street with yellow. This results in greenish tones, while the areas in reserve are left intact until the last stage of the exercise. We increase the darkness of the left wall, which enhances the effect of depth.

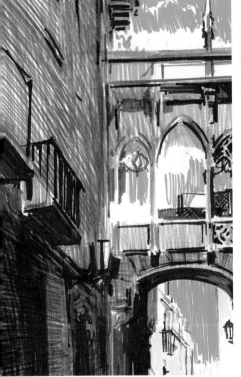

Step 6. Now the entire drawing is filled with line and color. First we focus on the top part of both walls, especially the one on the left. Note the effect produced by superimposing gray shading over the yellow areas. Now, following the lines of perspective, we draw the balconies and the details of the arcade.

Step 7. We continue to focus on the wall, where yellow and orange create an interesting texture of tones and hues. We begin to gradually increase the contrasts until the balconies on the left are completed. We also increase the hues on the ground and sketch several pedestrians.

Step 8. We draw the windows of the left wall with black and meticulously draw the dark areas that define the Gothic architecture of the arcade. With an intense stroke, we draw the shadows on the upper part of the cornice.

SUMMARY

- To establish perspective correctly:

- First, draw the horizon line, which indicates the viewer's eye level.

- Next, draw in the vanishing point.

- Then, draw vanishing lines from the vanishing point.

- You can draw as many vanishing lines as you need.

- Artistic perspective is not overly technical; it lets you give your drawings a sense of distance and depth.

- To create the illusion of depth in a drawing, reduce objects in size and tonal intensity as they recede into the distance.

- The way you handle tones is essential to creating the effect of depth in a drawing.

- Perspective schemes can be drawn freehand, with the aid of a standard ruler, a length of string, or with a sheet of paper folded in half.

18

LIGHTING THE FIGURE

FROM SYNTHESIS TO TONAL VALUES

Throughout the chapters of this book, we have stressed the importance of synthesis and provided demonstrations of it in all the exercises illustrated. The first exercise in this section demonstrates how to establish the preliminary synthesis of the model; the second part of the lesson shows how to develop the sketch using tonal values to express the light on the figure.

You can take any number of approaches to drawing the human body. This chapter features one of these concepts: lighting. Well-chosen lighting can help you draw convincing figures, and will help you understand the important subject of foreshortening. This means depicting a figure from such an angle that the body and limbs are not drawn in their true size, but as they appear to the viewer.

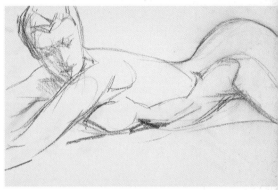

1. The preliminary sketch is executed very loosely, without focusing too much on any specific area. The most important thing at this stage is the line separating the body from the background. Areas of very faint shading indicate the shadows.

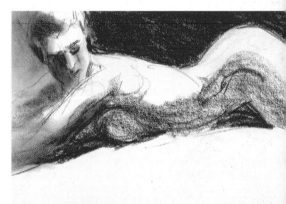

2. The curvature of the back is very important, as is the area of the body resting on the floor. The curved form is executed with simple shading and the most intense areas define the basic volume. The background is colored in with an intense tone that, through strong contrast with the model's back, silhouettes her body.

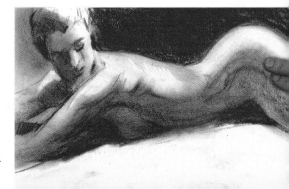

3. The fingers are used to achieve a homogeneous tone in the shadows. The drawing develops and the amount of sanguine applied to the paper is increased. The tone is once again blended with the fingers to lend shape to the body until a perfect fusion between the highlights and the shadows has been achieved.

DEFINING THE FIGURE'S VOLUME WITH LIGHT

Continuing from the last step of the preceding exercise, we will now further refine the drawing by enhancing the figure's three-dimensionality. To achieve this sense of volume, you have to pay close attention to how light and shadow model the figure's forms, which depends on the strength and position of the light source. The technique shown here is intended to produce specific effects; it should never predominate in a drawing.

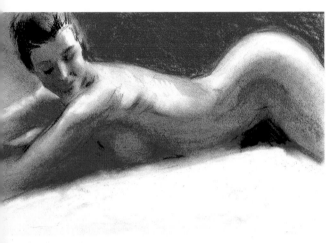

1. The brightest highlights on the figure are opened up with the eraser. Once the tones have been blended, some dark shading is added with charcoal to accentuate the most prominent volumes in the shadows.

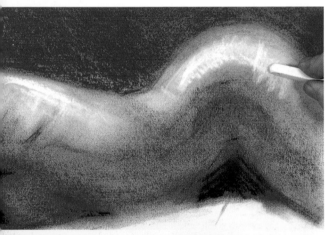

2. The highlights and reserved areas of the last stage are made more prominent with an application of white chalk, with which the tonal differences become plainly apparent. The drawing now has the tonal base necessary for a correct study of light. Care must be taken not to place the highlights just anywhere, but only where they are appropriate.

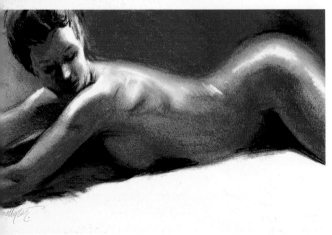

3. When the tones are softened, they result in other halftones. These intermediary areas must be handled with exceptional care, as a badly placed "gray" area will deform the entire figure, creating an ungainly, dented effect.

FORESHORTENING

Foreshortening is one of the most important developments made in drawing since the Renaissance. The technique is based on reducing body sizes and on a special treatment of lighting. In this example, the model is turned in a way that one side of her body is foreshortened. When one part of the body is closer to the viewer than the rest, the canon of the figure undergoes a radical transformation. Note how light is handled here, and how shapes appear to advance toward you.

1. *Right*: The forms closest to the front of the picture plane are drawn based on the general volume of the figure and never independently. Note the interplay of lines and the distance between them, and try to imagine how the figure would look seen from the front in order to be aware of its real position.

2. *Above*: Once the drawing is explicit enough, shadows are added. First the model is separated from the background by darkening the area around her back. Then grays are added to some areas of the body to help describe its position in space. Darks counterbalance the light area of the arm. Various tones establish depth in the limbs: note the wrist, fingers, neck, etc. Careful study of light is essential to successful foreshortening.

3. Further darkening the area behind the model's back helps push this part of her body forward in space. Other tones are carefully added. The modeling of the closest arm must be subtle; the tones are light and contrast with the grays of the rest of the body.

FORESHORTENING
AN ELBOW

The joints of the figure are the most difficult parts to draw. Constant practice and study will help you understand the highlights and most intense contrasts, aspects that allow you to construct the anatomy in a sculptural way. The elbow is the subject of this exercise, while the step-by-step section that follows is dedicated to two other important joints, the knee and forearm, and the treatment of light in foreshortening these features.

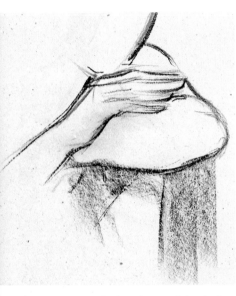

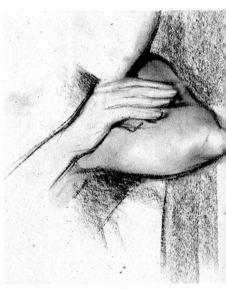

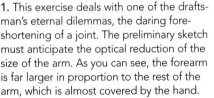

1. This exercise deals with one of the draftsman's eternal dilemmas, the daring foreshortening of a joint. The preliminary sketch must anticipate the optical reduction of the size of the arm. As you can see, the forearm is far larger in proportion to the rest of the arm, which is almost covered by the hand.

2. Following the same procedure used in the previous exercise, the background is darkened to get a better sense of the light areas in the foreshortening. At this stage, the different degrees of depth of the arm are separated. The lighting in the foreground deserves special attention.

3. Gradually darkening some areas sets off the lighter ones, pushing them forward in space. The modeling of each part of the arm is done according to its degree of depth and the light it receives. The darkest areas are accentuated, thereby making the brightest areas appear closer to the viewer.

Seated Female Figure

MATERIALS
Cream-colored paper Sanguine and sepia Conté crayon White chalk, Eraser, Cloth

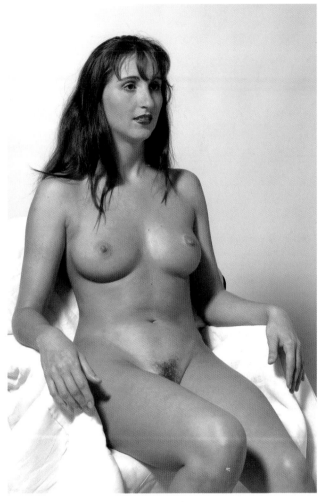

The subject for this exercise is a seated female nude, parts of whose body display a high degree of foreshortening; that is to say, some areas appear to advance toward the viewer. The way the proportions of these projecting areas are depicted in relation to the rest of the body must be supported by an interpretation of lighting that brings the volume of these forms to the fore.

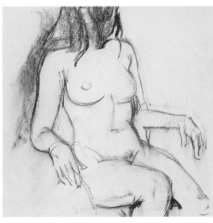

Step 1. Before you attempt to draw this figure, we strongly recommend that you review the most important points entailed in foreshortening a figure. In this case, the leg and the forearm will be drawn foreshortened. Here, the shading at left separates the figure from the background to bring her closer to the viewer.

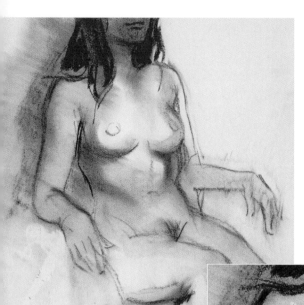

Step 2. The brightest areas are studied by referring to the darks that lend the form depth. The first dark areas are drawn down the side, around the breast, and in the arm. The forms are modeled with an intense blending; care is taken to go around the most important highlights, which are cleaned up a bit with the eraser.

Step 3. The amount of sanguine Conté crayon applied to the figure is enough to establish the first values of the modeling. You must handle lights and darks very carefully so that the interplay between the two tones is definitive; otherwise, if the contrasts are badly executed, the illusion of foreshortening will be shattered. Note that the hair's texture has been accented with sepia.

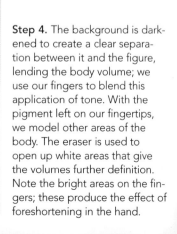

Step 4. The background is darkened to create a clear separation between it and the figure, lending the body volume; we use our fingers to blend this application of tone. With the pigment left on our fingertips, we model other areas of the body. The eraser is used to open up white areas that give the volumes further definition. Note the bright areas on the fingers; these produce the effect of foreshortening in the hand.

Step 5. We work on the fore-shortened leg, studying how the light acts on it so as to produce a suitable effect of depth. First we correct the shape of the knee joint, which appears too rounded. Then we accentuate the dark area of the knee and integrate it with the highlights produced by the light source. The contrasts and volumes of the rest of the body are further refined for tonal balance.

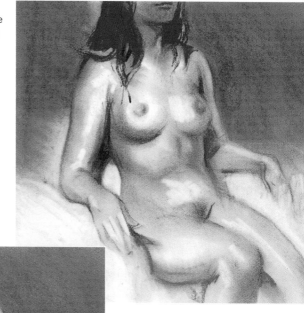

Step 6. We continue darkening the background to establish the drawing's maximum contrast. Next, we tone down the dark areas of the knees and soften the contrasts of the breast and the abdomen with our fingertips. This results in a far better integration of the highlights on the skin. Finally, we use the eraser to restore the luminosity of the hand, the knee, and the breast.

Step 7. Now we begin to highlight parts of the body with white chalk, working on the areas that require the brightest lights. Just as with the sanguine, these whites will be blended and merged with the background.

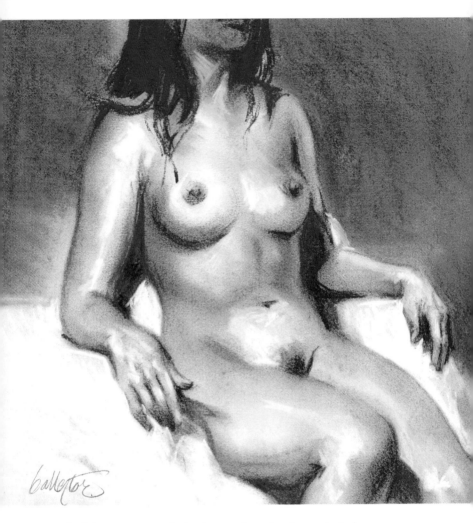

Step 8. All of the contrasts on the body are softened and accentuated. The knee has undergone a notable transformation in terms of illumination, thanks to the way in which the whites were blended.

SUMMARY

• An important technique in rendering the figure is modeling: adjusting tonal values of the body to express light and shadow, and, hence, form.

• Foreshortening – that is, abridging volumes that recede into space to convey depth – depends on a correct interpretation of the lighting.

• The first stage consists of determining the values of the highlights and shadows.

• Special attention must be paid to the line that separates the body from the background.

• The background must produce a strong contrast with the body so that forms near the front of the picture plane appear to project toward the viewer.

• Highlights are applied only where they are absolutely necessary.

• The parts of the body closest to the viewer are drawn based on the figure's overall volume.

• The preliminary sketch must anticipate the optical reduction of sizes in foreshortening.

METALLIC AND SHINY SURFACES

EFFECTS OF LIGHT

In this section, we'll explore how light is used to express the patina and reflective surfaces of metallic objects. Drawing such still-life objects involves more than modeling their forms with tonal values; you must also convey the surface texture of, and brilliant highlights on, the objects represented.

The more closely you study the effects of light on the surface of a metallic or shiny object, the better able you will be to discern the object's texture and convey its reflective qualities in a drawing. With practice, you'll master your powers of observation and the techniques you need to resolve such complex artistic problems with relative ease.

1. Pay close attention to the structure of each object you're drawing so that you see everything as simple, schematic shapes, leaving aside all else for now. Remember: in this initial phase of the drawing process, shape takes precedence. In this still-life study, the preliminary sketch is executed in charcoal on a gray-toned paper, then treated with a fixative to preserve the drawing's basic structure.

2. The first tones indicating light and shadow are added over the clean lines of the initial drawing; shiny, reflective areas are denoted by the absence of shading.

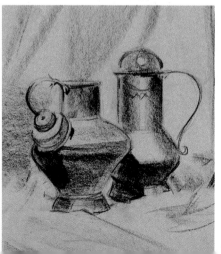

3. Once the first tones of the objects' surfaces have been established, the lightest areas are further articulated by adjusting the shadows. Transitions between shadow and light must not be too abrupt, since we want to capture the subtlety of the objects' craftsmanship.

METALLIC OBJECTS

Representing metallic objects convincingly often means taking an almost superrealist approach to your subject. For this reason, you need to thorough-ly study the surfaces of the reflective objects you're aiming to represent in a drawing. Let's continue with the next phase of this two-part exercise, starting where we left off in the previous step with the basic tonal values of the objects already established.

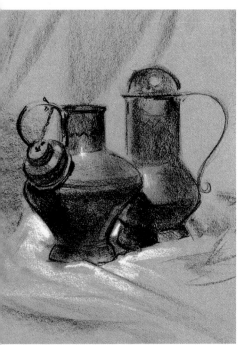

1. Metal objects reflect light according to their structure and how well polished they are. Similarly, highlights, resulting from the light source, greatly help to convey the shapes and surfaces of shiny objects. Here, contrasts established in the previous drawing are heightened to emphasize the light's effect: the objects' profiles are reinforced and the brightest highlights are indicated.

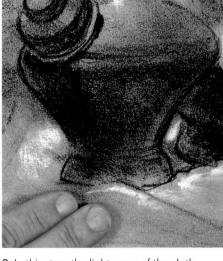

2. In this step, the light areas of the cloth ground are more clearly defined. Tones are softly blended with the fingertips, taking care not to blur the profiles of the two pots or disturb the brightest areas. This helps integrate the lights and darks with the gray color of the paper.

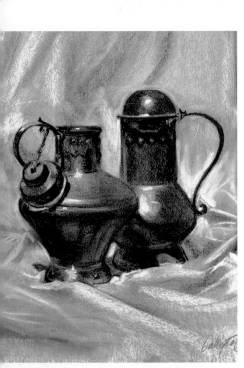

3. The last stage of the drawing involves meticulously working all the tones. The dark areas are intensified; grays are adjusted in the background so as not to dominate those areas; and white highlighting is refined to better describe the objects' reflective surfaces. Finally, the areas that need more pronounced contrast are outlined in black.

RUSTY AND OLD METALS

The appearance of certain kinds of metal is sometimes conditioned by oxidation – rust, tarnish, etc. – or by a characteristic patina, particularly with regard to very old objects. This exercise shows you how to capture, with tonal variations, the evocative surface qualities of an antique, here, an iron from the late nineteenth century.

1. This antique iron is meticulously drawn with a clean line that clearly defines the shape and proportions of each of its parts. As you can see, the drawing is executed in sepia-colored chalk, a medium that's easy to blend and lends a warm appearance to the subject. Only once the preliminary drawing is complete can the ornamental features be added. A fixative is applied to the initial sketch once it's finished.

2. The first tonal values are applied to the drawing, differentiating the vertical plane of the background and the horizontal plane of the table. Don't worry if, when drawing and blending, you accidentally lose part of the contour; it can be redrawn later when the final contrasts are added.

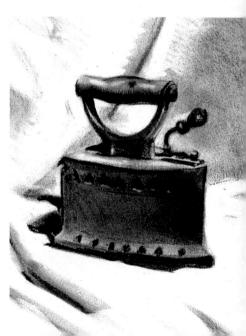

3. The last phase of the work is done with charcoal, intensifying the shadows and the strongest contrasts, such as the area around the main shape of the iron. The iron's curved profile is accentuated with a soft blending of charcoal, thereby leaving the surface almost finished. Finally, highlights are added to very specific areas, such as the handle and the top of the iron.

POLISHED METAL

When you're drawing fruit or other natural objects, you have a bit of leeway in rendering their textures; tonal irregularities in such cases can even enhance the shape and quality of your results. However, when you're drawing polished metal objects like the one in this exercise, there is no such margin for error.

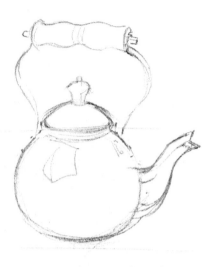

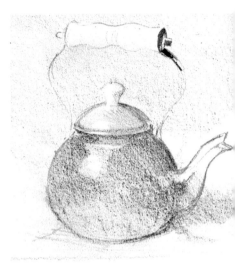

1. The relative complexity of this object's spherical shape calls for utmost care in its rendering. A fast and resolute sketch is the best approach, but it needn't consist of a single line; you can make corrections along the way until the shape looks right.

2. Rendering a polished surface means that you have to pay close attention to getting shapes correct. Here, grays are applied in a soft, faint shading to maintain the teapot's spherical form. The highlights should be equally subtle, although their placement must be definitive.

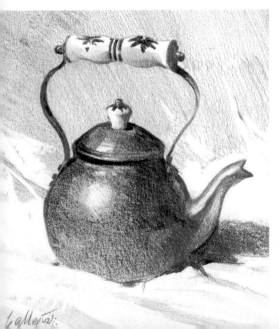

3. The process of adjusting the tones is selective; the deepest are applied in the shadowed areas, while the brightest tones are reserved as the absolute white of the paper, with soft gradations of gray in between the extremes. Finally, the eraser is used the clean up the highlights on the pot's spout.

Step by Step

Cauldron with Fruit

MATERIALS

Gray paper, Eraser
White and sepia chalk
Sanguine Conté crayon, Charcoal
Sepia and sanguine colored pencils

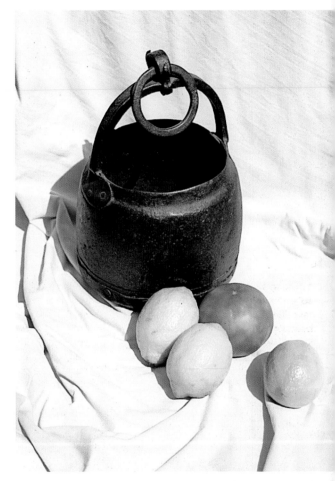

Continuing with the subject of metallic surfaces, this exercise offers an extremely interesting combination of the techniques covered in this and previous chapters. The composition and lighting of this still life are essential and should not be underestimated, as the success of the resulting drawing will depend to a large extent on the preliminary sketch and the care taken in rendering the subject's surface textures.

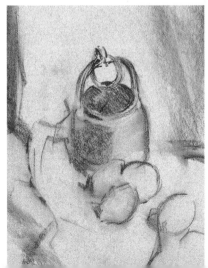

Step 1. The initial shapes and tones are executed in sepia. The cauldron and the fruit form a diagonal – and therefore, dynamic – composition. The cauldron must be drawn with the utmost precision, in correct perspective, while the fruit is relatively simple and thus can be drawn quickly.

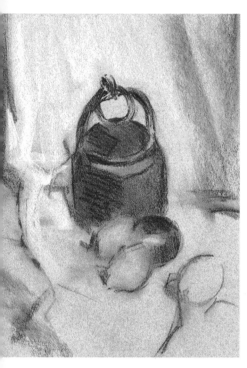

Step 2. Sanguine Conté crayon is applied to the pot to make a preliminary study of the highlights that will guide subsequent work; this layer of color will breathe through much darker ones to follow. White is used to indicate the folds of the drapery in the background, balancing and integrating this area with the reflections on the pot.

Step 3. Next, charcoal is used to shade the cauldron to convey its curve; this area represents the darkest value in the composition. This dark tone is then blended with surrounding ones, creating a wealth of halftones.

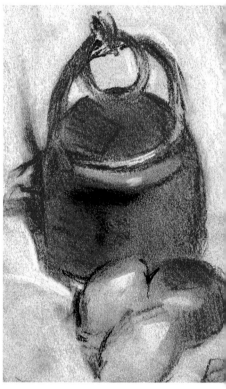

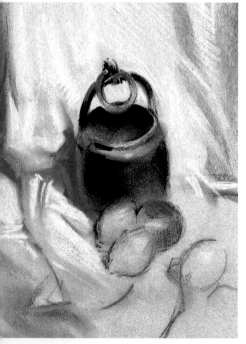

Step 4. The whites of the drapery are heightened for stronger contrast with darker areas, while the gray color of the paper intermediates between tonal extremes. The dark areas of the pot are reinforced with charcoal, which is spread to blend with the underlying sanguine tones and thus enhance the quality of the metallic texture.

Step 5. Contrasts are accentuated to lend greater definition to those shapes that require it. Shadows are also accentuated, starting with those on the drapery and the cauldron. The cylindrical shape of the pot is enhanced by the shadow it casts on the drapery to its left. In the foreground, the form of the orange is articulated in sanguine, the reflection on its surface held in reserve.

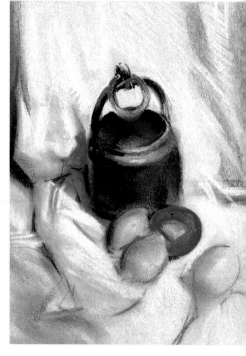

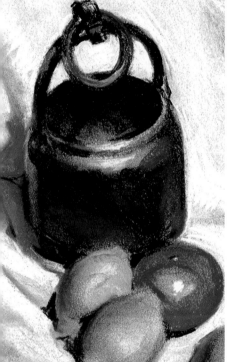

Step 6. Successive shadings in charcoal lend the cauldron surface texture and ever-greater definition. Charcoal is also used to draw the pot's handle and the ring at its summit. Tonal values are added to the lemons to establish their volume.

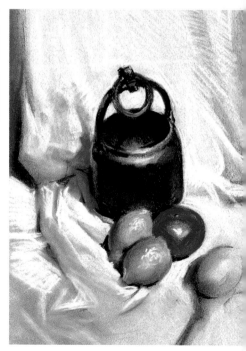

Step 7. The drapery is now given more detail. White chalk is used to express the highlights on the lemons, endowing them with a greater sense of volume.

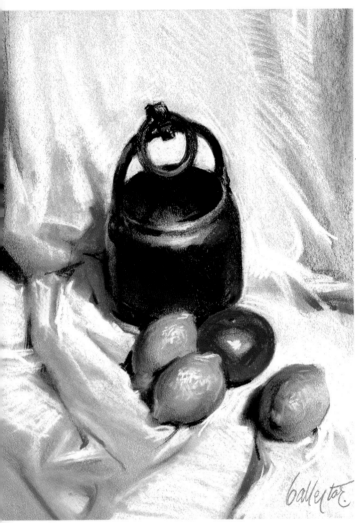

Step 8. Several touches of sepia are added to the cauldron to articulate its metallic surface characteristics. Then, to create an atmospheric background, some areas of the drapery folds there are retouched using the fingertips, slightly stained with sanguine and sepia pigment. Finally, with some delicate work on the lemons to refine their volumes, the composition is complete.

Summary

- To draw a metallic object, you must consider two points: its tonal values and its surface.

- Your first consideration when drawing an object is its shape and recording it with accuracy.

- Don't render the effects of light on a metal object until all of the main forms in the drawing have been resolved.

- White highlights help integrate your drawing with the tone of the paper.

- A metal object reflects light according to how highly polished it is, and according to its shape.

- Highlights, reflected from the light source, help convey the shapes and surfaces of shiny objects.

- If you hope to render the reflective surface of a polished metal object convincingly, there is no room for error.

THE URBAN LANDSCAPE 2

THE IMPORTANCE OF PERSPECTIVE (2)

In this section we return to the simple perspective system used in chapter 17. This aim of this exercise is to draw a checkerboard that you can use as a schematic tool to draw objects and buildings in perspective and to situate any element in space with a real sensation of depth.

The landscape takes on a completely different dimension when buildings are added to it. In an earlier chapter, we examined the basics of perspective. In this chapter, we will develop this theme one stage further. The application of perspective offers a wide variety of creative possibilities and will help you tackle the most demanding artistic challenges.

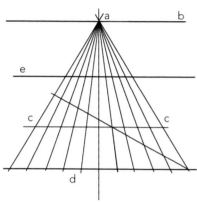

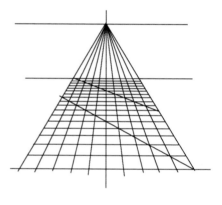

1. The vanishing point (a) and the horizon line (b) result in vanishing lines (c) that allow us to draw the ground plane (d). This plane starts in the foreground and can be extended into infinity. This exercise describes the process for drawing a checkerboard or a mosaic in perspective. The vanishing lines divide the plane into equal parts, as indicated along the ground line. A diagonal line traced through plane (e) marks the cutoff points on the vanishing lines, indicating the exact place through which the horizontal lines parallel to the ground line must pass.

2. The entire plane is drawn with lines that run parallel to the ground line. This process allows us to draw the checkerboard reproduced here. The parallel lines are drawn in a way that they precisely cross each cutoff point indicated by the previous diagonal.

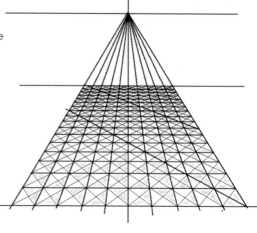

3. This checkerboard can be easily turned into a mosaic in perspective. Each square drawn crosses each one of the diagonal lines that divide them into four. The checkerboard is obtained in a sharp perspective by shading one half of every other square.

Drawing
on a Plane

When drawing an object on paper, you should treat it like the object itself, rather than as a fiction. For instance, when you think of the word "house," you quickly conjure up a picture of it in your mind. This is precisely what you should avoid doing when drawing. As an artist, you have to scrutinize and understand what you're drawing, dispensing with the image that first comes to mind; it all boils down to concentrating strictly on what you see rather than what you imagine. Perspective is extremely useful for analyzing reality. By understanding a shape from its plane, you can draw any object in depth with a certain amount of impartiality.

1. This simple scheme illustrates how perspective is perceived. Here, the viewer stands before a quadrangular base. If from the ground we elevate a plane (the plane of the square) like a transparent window, the viewer's angle of vision will indicate everything that is in his line of sight. These points are indicated on the plane of the square.

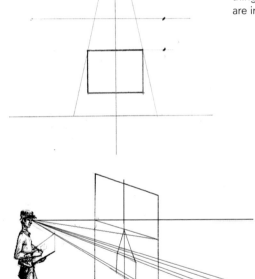

2. This diagram shows what the view in the preceding scheme would look like in reality. The draftsman draws what he sees on the plane of the square; his paper thus becomes the plane he sees before him. All these reference points form a system that allows objects to be drawn in perspective.

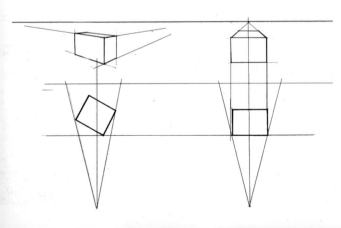

3. If we return to the first scheme, we can see how an object is drawn from different points of view, according to its location relative to the viewer. The distance between the vanishing point and the visible points of the object on the plane of the square give the exact points for sketching the perspective.

CONSTRUCTING BUILDINGS
IN ARTISTIC PERSPECTIVE

This drawing is based on an artistic representation and its perspective will be applied to the drawing's composition. The exercise is divided into two parts: the study of the planes of the urban landscape, and the adaptation of their perspective to the subject. For this drawing, we'll use colored chalk.

1. This drawing is done freehand, without a ruler. Here the perspective has two vanishing points. One is situated in the foreground on the right, outside the limits of the paper, and the other, also on the right, coincides with the buildings in the background of the scene.

2. Over the rough scheme of the perspective, we can draw further lines that better define the structure of this urban landscape. The lines from the buildings on each plane converge at their respective vanishing point.

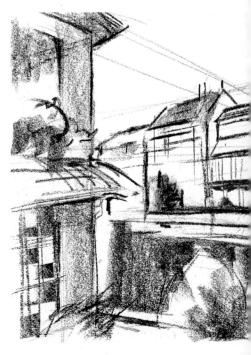

3. The lines of each plane must be drawn with the utmost accuracy, otherwise the drawing will appear strange and distorted. Close and continuous observation immediately reveals any error. When drawing with artistic perspective, corrections should be made constantly until your intuition tells you that the lines are accurate.

DIFFERENT TYPES
OF PERSPECTIVE

In this exercise we will develop the previous drawing in perspective with color. Furthermore, we will apply another type of perspective, the so-called atmospheric perspective, by which the different planes of the picture are expressed with variations in tonal and linear intensity.

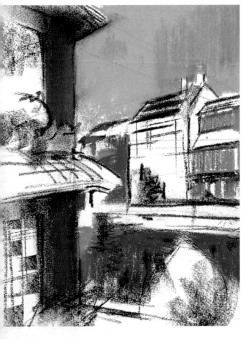

1. The differentiation of planes is essential to expressing perspective. Incorporating color is a highly direct means for doing so, since you can set up contrasts that emphasize this difference. Here, the sky is shaded in using the side of the chalk held flat to the paper. With this plane resolved, we focus on the planes that define the buildings.

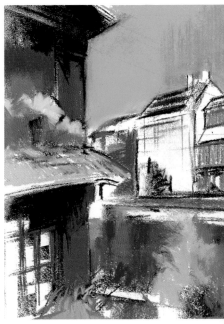

2. Color is applied in strokes appropriate to defining each given plane. For example, the background calls for verticality, whereas the foreground is based on textures, except for the yellow roofing, which is drawn in a way that defines the roof tiles.

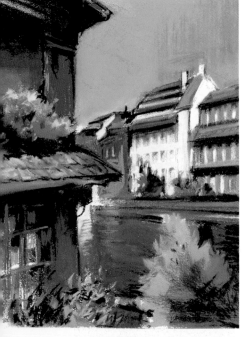

3. The priority of tones should be established for each plane. Contrasts in the foreground are very strong in terms of both tone and color. The colors and tonal differences in the background, on the other hand, are far fainter, making those areas appear to recede in space in relation to the sharper contrasts in the foreground. This is atmospheric perspective.

Rural Landscape
with Church

MATERIALS
Dark blue paper
Pastels
Cloth

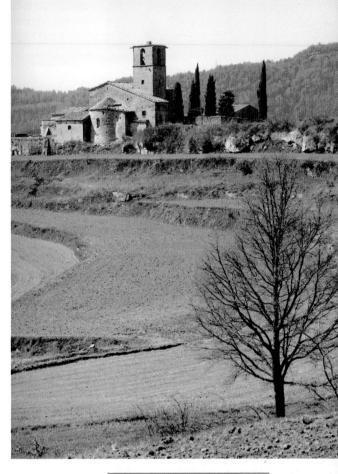

This step-by-step exercise illustrates how perspective is applied to a land-scape. You will see how a number of seemingly technical considerations can be resolved in an expressive and artis-tic way. Before we begin, study the sub-ject carefully so you can understand how the landscape com-bines with the archi-tecture and how the slope of the planes indicates depth.

Step 1. The first step is to study the per-spective of the landscape in three very differ-ent but complementary respects. First, we draw a number of successive planes, with which we can interpret the foreground, the middle ground, and the church in the back-ground. Next, we execute a compositional perspective in the middle ground, accentuat-ing the curve there. Finally, we draw the church, viewing it as a series of cubes.

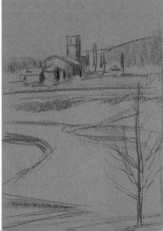

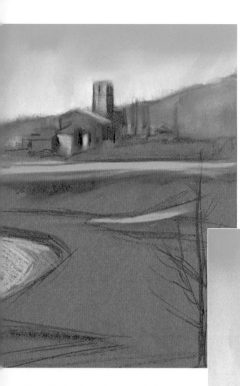

Step 2. Pastel allows you to work quickly, and thus is ideal for sketching. The blue hue of the paper provides an excellent tonal foundation upon which to gradually build pastel color. As you add pigment, however, it's important not to saturate the paper, as it is essential to the work's overall atmosphere. Here, the sky and the mountain are shaded with tones of light blue. Then the clouds are drawn with white, which is blended in the upper section. Finally, the light and dark planes of the church are indicated. By adding a color to each plane, we are able to increase the sense of spatial depth.

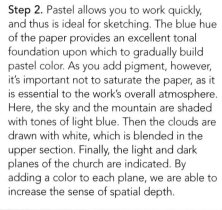

Step 3. To draw the church in correct perspective, you must separate the light areas from the shadows. The dark areas are shaded with tones of umber and the lightest ones are made much brighter. The lines that indicate the depth of the objects are more slanted than the ones that define the frontal planes.

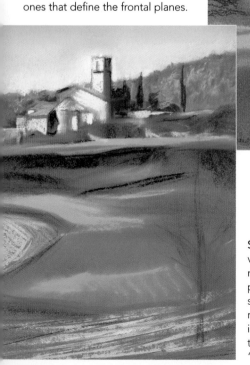

Step 4. The foreground is executed with very loose shading, creating a large, luminous mass that seems to push the rest of the planes into the distance. In atmospheric perspective, contrasts between colors and tones must be stronger in the foreground and increasingly softened as you move toward the background. Some areas must be left to "breathe."

Step 5. After some tonal blendings, we again darken the ever-denser areas in the hill separating it from the plane of the church. The contrasts are intensified and the contours of the shapes accentuated. To the well-established color base we add a variety of intermediate tones to enhance the harmony of the greens and grays of the middle ground. In the foreground we draw a tree trunk, which serves as a spatial reference point for the rest of the planes.

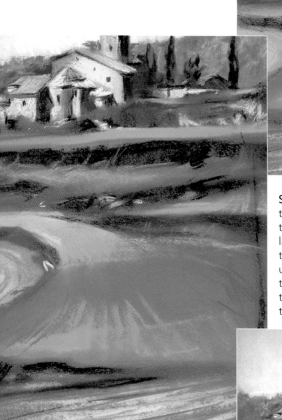

Step 6. From here on the composition is developed with tiny variations focused on rendering the land's various textures. Note how the yellowish greens have been used to convey the curvature of the terrain, and how the browns convey the plot of land that acts as a wall to the hillock.

Step 7. The details are rendered with increasing precision, and impasto-like applications of pure color are added in certain areas, such as the field. The track in the foreground is painted with flesh tones, with touches of yellow and a hint of green. These colors are blended very lightly so as to preserve the identity of each hue.

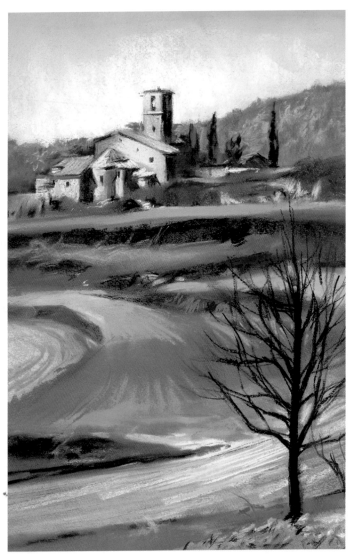

Step 8. Finally, the strongest contrasts are intensified, such as that of the tree in the right foreground and the minute details of the rolling terrain. All these planes are superimposed over one another and, thanks to the use of color and perspective, result in a pronounced sense of spatial depth.

SUMMARY

• With perspective you can create spatial depth in a landscape drawing.

• Perspective helps you analyze reality; by understanding a shape in planar terms, you can draw any object so that it conveys a sense of spatial depth.

• Different angles of vision give other possible views of an object, perceived according to the object's location in relation to the viewer.

• The distance between the vanishing point and the visible points of the object on a square plane give the exact points for sketching the perspective.

• The lines defining each plane of a building must converge at the corresponding vanishing point.

• Vanishing lines must be drawn correctly; otherwise the final outcome will appear unreal and distorted.

• For an accurate perspective drawing, make corrections constantly.

• Atmospheric perspective is achieved through color and tone; sharper contrasts and details come forward in space, while softening these elements toward the background helps them recede into depth.

THE FACE: EYES

THE POSITION OF THE EYES ON THE FACE

Generically speaking, the shape of the face is basically an oval. A simple system of lines imposed on this shape can help you locate, and then draw, each of the facial features in proper relation to one another. In this chapter we'll focus on drawing the eyes. To start, follow the examples included here, then repeat them, altering distances between the lines each time to see how whenever you do so, the face undergoes a complete transformation.

The eyes are the most important parts of the face, as they transmit the subject's emotions and personality. Eyes are not the easiest things to draw; their shape and the intensity of their expression are but a few of the considerations to bear in mind. Their position on the face is another issue that requires careful study.

1. An oval is drawn to represent the general shape of the face, regardless of whether the shape of your specific subject's face is, in reality, rounder, longer, or more rectangular. The basic oval lets you establish guidelines to indicate the face's structure, starting with the axis of symmetry, a vertical line that bisects the shape and is then crossed with a number of horizontal lines drawn to help you situate the height of the eyes, the distance between them and the nose, and the position of the mouth.

2. The first feature to be sketched in is the mouth, indicated by the lowest horizontal line. Next, the nose is drawn with a sinuous line in its lower half. The eyes are then outlined with a very faint stroke.

3. The eyes are an extremely important part of the face, as they give it expressiveness. In figure drawings, especially portraits, the eyes must be treated with great care because they provide clues to the subject's personality.

AN ARTISTIC RENDERING OF AN EYE

At first, beginners often draw the eye as if it were a completely uniform shape, and they give more importance to detail than is really necessary. This exercise demonstrates how to render an eye artistically. The first things to note about the eye are its irregularities, the skin of the eyelid, and the position of the eyebrow. Another important aspect of the eye to have in mind is its depth, represented by shading the socket.

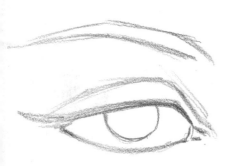

1. The main outline of the eye is drawn as an irregular oval; the tear duct is then drawn by modifying the inner corner of the eye. The eyelid should be seen as a layer of skin that covers the eye. The iris – the colored part of the eye – does not occupy all of the white, although this will depend on the opening of the lid and the expression of your model.

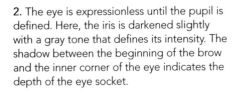

2. The eye is expressionless until the pupil is defined. Here, the iris is darkened slightly with a gray tone that defines its intensity. The shadow between the beginning of the brow and the inner corner of the eye indicates the depth of the eye socket.

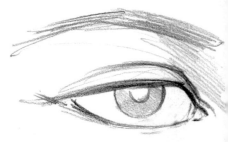

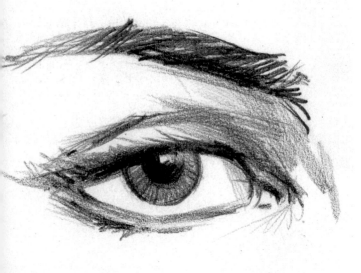

3. The pupil, which is the element that defines the expression of the eye, must always have a highlight to indicate its moistness. As you will see shortly, this highlight helps indicate the direction of the eye's gaze, and the equilibrium between the two eyes. In addition, the darkening of the eye socket defines the depth with respect to the bridge of the nose.

THE DEPTH
OF THE GAZE

The eyes have an expressive force that is probably greater than that of any other part of the body. They convey the full range of human emotions most directly, and personality as well. In this exercise we'll explore the direct gaze and the depth of what it can transmit to the viewer. But it's essential to realize that there's a difference between simply drawing the eyes themselves and rendering the expression they project.

1. When blocking in your subject's eyes, study the position of the head. In this case, it's turned slightly to the left. The position of the head affects the shape of the eyes, as they are situated on the curved plane of the face. This woman has big eyes that reflect serenity and seductiveness. Note how the darkness of the line of the eyelashes is not uniform.

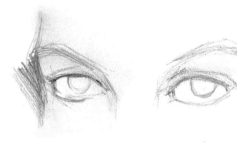

2. The profile of this area of the face is defined by the model's dark hair, which plays up the expression of the eyes. You don't have to know the person you're drawing to capture on paper the sensuality of her look. A soft gray lends shape to the curve of the head and establishes the tonal differences between the face's visible volumes. Shading on either side of the bridge of the nose indicates the eyes' anatomical depth.

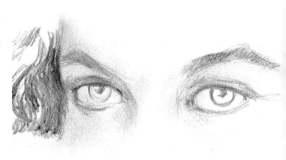

3. The hair is notably darkened. This contrast helps highlight the face. The eyebrows are also darkened to integrate them with the skin. Contrasts are intensified along the line of the eyelids, defining the lashes. A touch of sea green is added to the irises, capturing the model's highly serene and sensual expression.

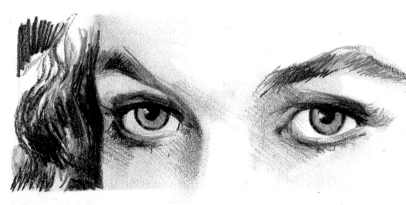

THE EXPRESSION
OF THE EYES

This is an especially appealing aspect of drawing. The study of facial expression requires an analysis of the deep-est human emotions. This exercise demonstrates only three possibilities, and at the same time three possible ways of starting a portrait. Practicing with these examples will pave the way to your being able to create successful renderings of the human face.

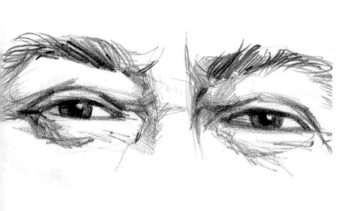

1. This expression is pleasant and reassuring. Even without seeing the whole face you can tell that these eyes go together with a warm smile. The eyes are lengthened because they are half-closed. The lines defining the eye-lids convey the expression; the bright areas of the lids have been opened up with the eraser.

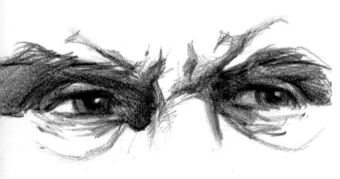

2. This look of irritation is expressed to a great extent by the frown. The eyes are partly hidden by contracted eyebrows, indicating wariness. The dark shadings are intense, with an abundance of tones that accentuate the expression. The substantial darkening of the sockets makes the stare more incisive.

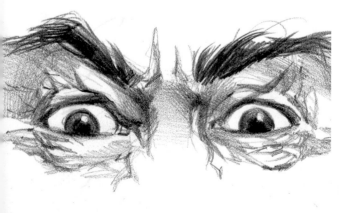

3. This look expresses horror and surprise. The eyes are wide open, showing the whites in the upper area, a characteristic of this expression. The final touches involve accentuating the highlights and drawing in the reflections on the pupils.

MATERIALS

Drawing paper
Colored pencils
Eraser

A Woman's Glance

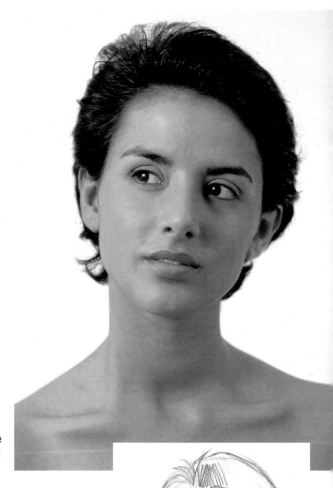

As you have seen throughout this chapter, our eyes reveal some of our innermost psychological traits, and are the face's principal source of expression. In this exercise we will draw the face of a woman whose eyes glance sideways. Rather than attempt to create a portrait, we will limit ourselves to interpreting her eyes and her expression. Therefore, we'll concentrate on just the eye area, leaving everything else sketchy.

Step 1. First we study the structure of the face, then sketch its basic shape as an oval and draw a line down the center to divide the face in two. Then, we draw horizontal lines across this axis to indicate the position of the eyes, the nose, and the mouth; this gives us a first appraisal of the facial features. The eyes are indicated solely by the curves of the eyelid, while the pupils are drawn faintly.

Step 2. We apply the first faint shading using a slanted stroke to establish the curved shape of the face. This uniform shading interrupts the lighted areas. The eyelids are intensified and lend more expression to the gaze. The white areas of the eyes are left open.

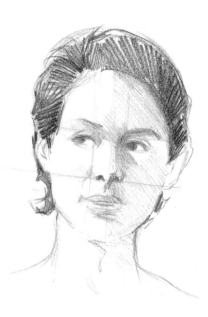

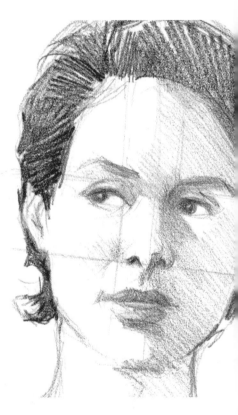

Step 3. After darkening the hair, we must adjust the tones in the areas where the features are to be defined. We begin to darken the eyelids, and use them to draw the shape of the bridge of the nose. Gray is used to tone the eyes. We draw the dark areas of the lips with a clean line. Since this exercise focuses on the eyes, the lower half of the face will be left as it is here.

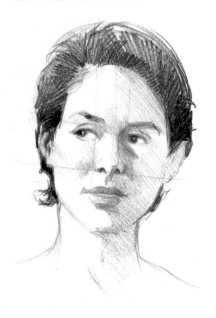

Step 4. The tones are gradually increased in a way that allows errors to be corrected without resorting to the eraser, as colored pencils are always applied from the lightest to the darkest colors. The shading must be soft so as not to fill in the pores of the paper.

Step 5. As you can see, drawing with colored pencils requires a gradual procedure; the light colors and the white areas must be left in reserve from the outset. We apply black in the eyebrows, taking care not to press down too hard; the halftones of the shadows are also reinforced. Little by little the face begins to come to life.

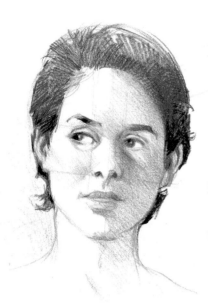

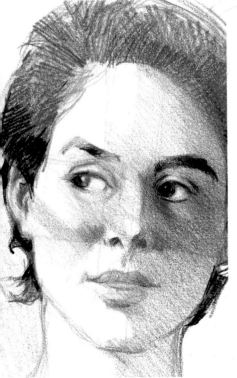

Step 6. Darkening one side of the face makes the model's expression more prominent, and the increase in contrast better defines the volume of her face. Black is used to accentuate the line of the eyelids and the intensity of the stare.

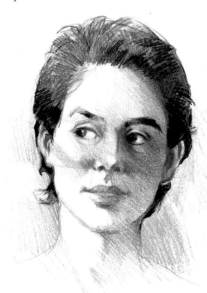

Step 7. We continue working on the face with subtle tones that gradually intensify the previous ones. The eraser is used to clean up the highlights; extreme caution must be taken when doing this.

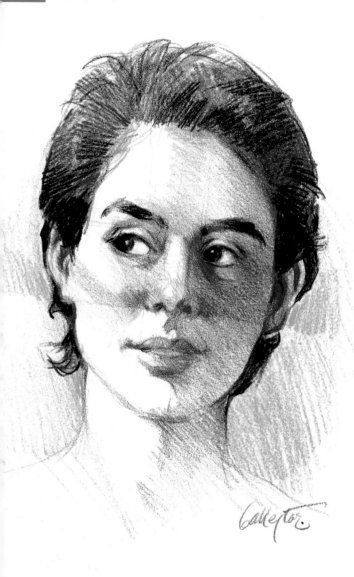

Step 8. The last task consists of darkening significantly the black of the eyes, while leaving the white highlights intact. Some soft shading is added to give shape to the eyelids, thereby lending depth to both eyes; this brings the exercise to its conclusion.

SUMMARY

• The eyes transmit the subject's expression and personality.

• Begin the face with an oval, then draw a vertical line through it to divide it in half.

• From the central axis, draw a series of horizontal lines to indicate the height of the eyes, the distance between them and the nose, and the location of the mouth.

• The eye only becomes expressive once the pupil has been defined. The eye socket indicates its depth.

• The pupil must have a highlight to indicate its moistness; it also indicates the direction of the gaze and the equilibrium between the two eyes.

• All the expressive force capable of captivating the viewer is in the eyes.

• In an anatomical representation, it is essential that you study the position of the head, which affects the shape of the eyes.

• Through the rendering of the eyes we can study the most profound human emotions.

HORSES

ANATOMICAL SKETCH

The anatomy of animals is complex and requires such a thorough study that it can be considered a specialization within the field of drawing. Although this book does't approach drawing from a scientific standpoint, we present some basics of animal anatomy because having some knowledge of it gives you additional flexibility in choosing your subject matter. Becoming familiar with the animal's bone structure will make it easier to represent it from any angle.

The subject of animals is one of the most interesting in the field of drawing. Of all animals, horses have proven to be a special source of inspiration for many artists. We have included a few lessons in drawing them not only for their general beauty, but also because studying horses can provide you with some technical solutions to drawing animals in general.

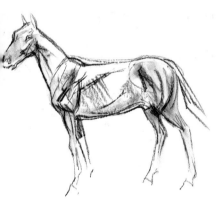

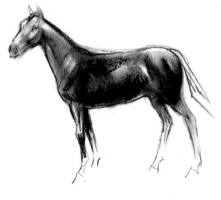

1. Sketching a horse from nature is highly recommended, as it helps you understand the animal's forms. The horse's limbs must relate to one another harmoniously. In this preliminary sketch, the principal muscular masses are evident. A flat, transverse stroke has been combined with lines drawn with the tip of the charcoal.

2. The darker areas are shaded in with the flat side of the charcoal, and the tone is blended with the fingers to model forms and emphasize highlights. The charcoal is again applied flat against the paper to increase the dark tones on the back, abdomen, and hindquarters. An eraser is used to re-create any highlights that have been dimmed.

3. We continue using the fingers to blend the charcoal, and gradually increase the tone in the denser areas. The eraser is used to open up the most intense highlights. It is important to remember that the eraser can be used to "draw" just like any other drawing medium. Cleaner highlights are achieved by rubbing firmly over the charcoal.

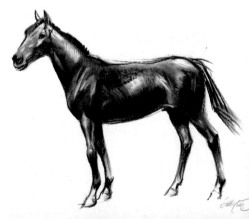

THE HORSE'S HEAD

A horse's head is an ideal subject for drawing, because it offers a great variety of planes and forms. This exercise shows you how to draw the cranial structure of the animal's head, and then how to depict its external appearance and the facial features. Here, graphite pencil is used because it is such a flexible medium.

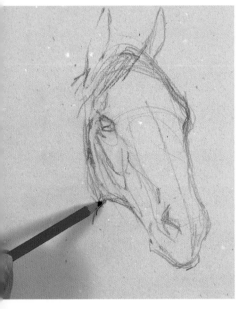

1. The head is blocked into a triangular shape that we gradually adapt to the desired form. The outline is determined by the shape of the forehead and the protuberance of the eye. Drawing an axis of symmetry helps in distributing the forms of the head.

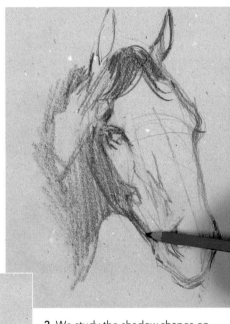

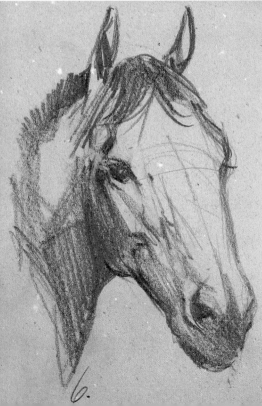

2. We study the shadow shapes on the head, then apply the darker ones, beginning with the side of the face and neck. The strokes should precisely follow the cranial structure. Graphite pencils of varying degrees of hardness are used, starting with a 2B and increasing the gradation in the darkest areas.

3. The finishing touches are left to the artist's discretion. With the pencil we emphasize the intensity of the lines in the previously studied forms. The shading is executed in wide, generous strokes, although the tones are adjusted in each area accordingly. Hence, in the mouth area, we apply only slight pressure, whereas on the cheek we apply strong pressure.

THE IMPORTANCE OF FORESHORTENING

Representing a horse using foreshortening can give you highly realistic results, but it requires a thorough knowledge of the animal's anatomy.

Foreshortening lets you draw the horse as seen from any angle, based on what the eye actually sees. This means that certain real measurements will be significantly reduced while others will appear in their actual size. You can compare this exercise with the one on page 177.

1. In the first exercise in this chapter, the horse is drawn in profile, with its proportions in balance. But if you view a horse from an angle, part of it appears closer to you. When drawing the horse, this difference is solved by shortening the lines that recede into the distance and changing the placement of the legs such that the plane on which the horse is standing is also altered.

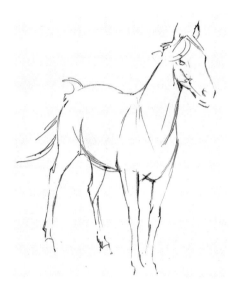

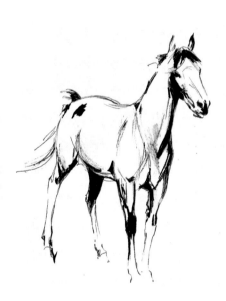

2. The preliminary sketch is done in pencil; then, using a reed pen, we add ink to help describe the forms, as the contrasts created will indicate the direction and intensity of the light. Dipping the pen in a small amount of ink, we begin shading in the darkest areas, in case the ink drips initially. The shading is continued until the ink runs out.

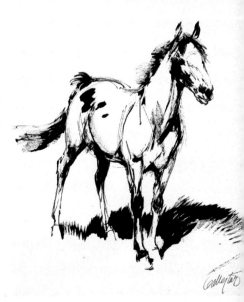

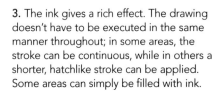

3. The ink gives a rich effect. The drawing doesn't have to be executed in the same manner throughout; in some areas, the stroke can be continuous, while in others a shorter, hatchlike stroke can be applied. Some areas can simply be filled with ink.

THE LINE OVER THE SKETCH

Here we present some exercises combining the preliminary study with a foreshortened sketch. Though sketch-ing horses is not easy, through prac-tice, even copying from other sketch-es, you will gradually gain confidence. The dynamic quality of your resulting drawing depends in great part on the agility of your stroke.

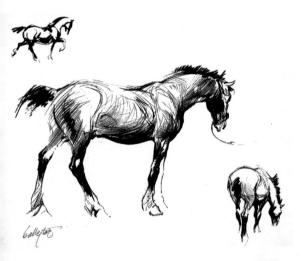

1. Try making sketches similar to these at left. In pencil, we sketch the shapes as general volumes, then gradually define the forms, focusing more on correct proportions than on perfect strokes. We continue by applying ink in search of a more profound gesture in the basic structural lines of the horse. In certain areas, these lines should only be suggested.

2. This sketch was execut-ed in charcoal and ink. First, the horse was roughed out in a gestural, spontaneous way. Then ink was applied in this foreshortened view, seen diagonally from the rear. Note the legs and the way they bend, and the sim-plicity of the lines used.

3. In this example, ink was applied with a paintbrush over a quick sketch of the general lines. Roughing out with the brush en-hances the description of the darker forms, which are extended in clean strokes echoing the horse's clean lines.

Horses Grazing

MATERIALS
Paper suitable for ink India ink, Reed pen, Pencil Eraser, Cloth

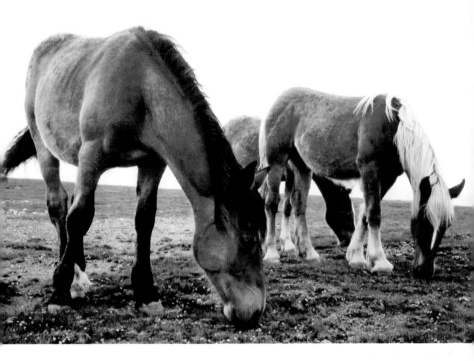

The horse is certainly a popular artistic subject, but is not especially simple to draw. Thus, keep in mind all of the advice given throughout this chapter, from the anatomical study to the animal's bone and muscular structure. This demonstration is an interpretation of an equine subject executed in ink. The first steps are very important, and the ink should not be applied until the elementary forms have been blocked in.

Step 1. The first thing is to determine the proportions of the forms. The horse in the background in the photograph is seen from a less angled point of view, whereas the one in the foreground is slightly foreshortened. Note the reduction of its measurements in the trunk of the body and the hind legs. The initial drawing is executed in pencil so that all necessary corrections can be made in the early stages.

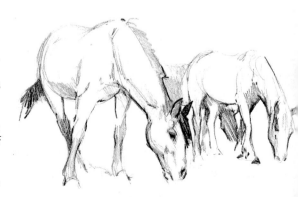

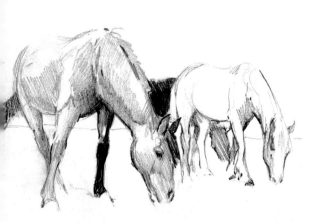

Step 2. Next, we evaluate all the dark areas. Using graphite pencil, we add a variety of tones to serve as a guide for applying the ink later. It's important that the tones be established in pencil first, as inked areas are very hard to correct.

Step 3. We draw the dark areas of the animal in the foreground and study each tonal area in depth. We evaluate the tones of the horse in the background as well, leaving the mane blank for now. In the area of the legs, we indicate what will later be the most intense black in the drawing. The rest of the tones will be established in relation to this darkest area.

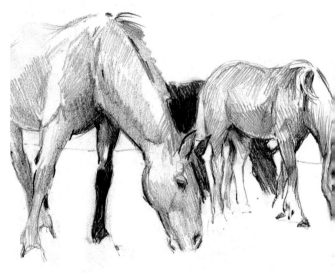

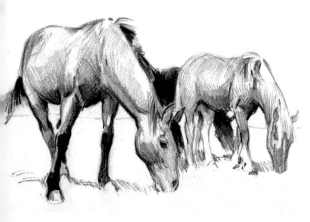

Step 4. We execute an in-depth study of the most intense dark areas, and then apply the strong contrasts in the legs and manes. We complete the lower area of the horses with strong contrasts to achieve volume and a realistic foreshortening.

Step 5. We begin applying ink to the drawing, in which the horses' anatomy has already been established in terms of proportions, contrasts, highlights, and shadows. Ink is first applied in less problematic areas, that is, in the darkest areas. You can thus obtain a clear idea of the tonal limits of the medium and gain a feel for the reed pen.

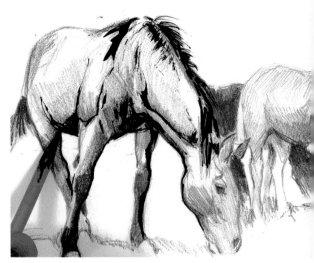

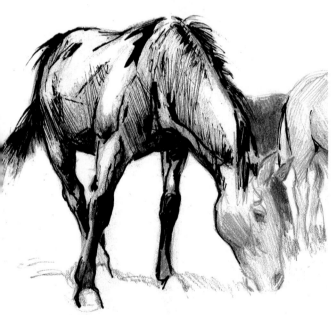

Step 6. As mentioned in the preceding step, it's best to begin applying ink to the darkest areas and proceed to render the finer lines when the reed pen has almost run out of ink. If you need to draw with a fine line immediately after dipping the reed pen in ink, the best procedure is to test the pen on a separate sheet of paper first.

Step 7. The strongest contrasts describe the anatomical forms, the white and lighter areas revealing their volumes. The horse in the background is executed in the same manner as the one in the foreground, although more schematically, with less detail. The ink should be applied very cleanly. If you need to correct something, let the ink dry completely first. Then you can scratch it away with a razor blade.

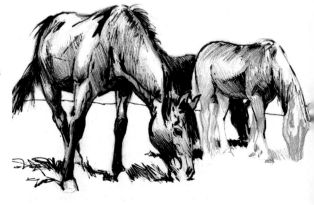

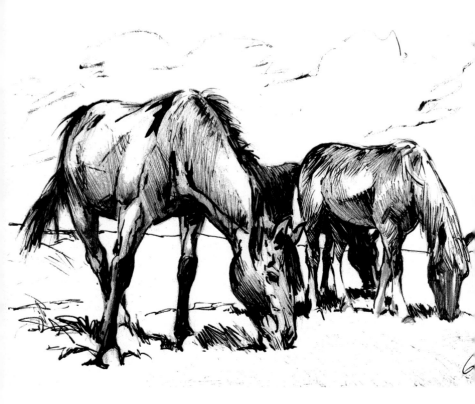

Step 8. With a series of strokes, we complete the dark areas of both animals, in a way that the highlights become more intense.

SUMMARY

• Horses are inspiring subjects for many artists.

• Studying the horse's muscle and bone structures will help you draw the animal from any point of view.

• Before beginning, it is essential that you observe the horse's proportions.

• Foreshortening a horse in a drawing requires anatomical knowledge of the animal. Certain true measurements will appear drastically reduced, whereas others will appear in their actual size.

• In any foreshortening, certain parts of the body appear closer to the viewer than others.

• Sketching horses is not easy, but if you practice diligently, even copying from other sketches, you will gradually gain confidence and speed.

• The dynamic quality of your drawings depends greatly on the agility of your stroke.

Chiaroscuro in the Still Life

Interpreting still life through shadow and light

Shadow represents the diminishment or absence of light on an object. When you're working on white paper, highlights are identified with the color of that ground. This exercise covers the various objectives of shading, beginning with a simple drawing of the subject and continuing on to study the complexities of modeling its forms as interpreted in terms of dark and light.

The term chiaroscuro – similar to simultaneous contrast – refers to the juxtaposition of light and dark tones, regardless of color, in such a way that white and light tones appear brighter when seen against darker tones. Such contrasts result in dramatic effects that can enhance the definition of form and dramatize composition. This fascinating topic provides some relief from the technical matters covered in previous chapters.

1. The first step is to draw the shapes of the objects in the composition, here a mortar and pestle. The drawing requires precision, especially with regard to perspective; otherwise the objects will look deformed once you try to model their forms in terms of shadow and light.

2. The first shadows are drawn with a brisk stroke – here, only the dark areas of the mortar and pestle. The shadows and outlines of the objects are made especially dark, so that the white areas appear more brightly illuminated. Indeed, making the darks so dark represents light.

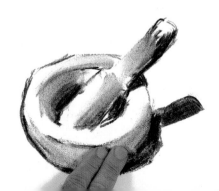

3. In this step, the relationship between dark and light is modified by blending the two extremes to produce gradations of gray. The deepest of these gray tones should, however, continue to provide a reference for the darkest shadows.

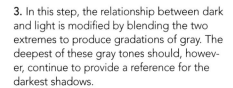

WORKING WITH MAXIMUM VALUES

Using the previous exercise as the basis for this one, we'll develop shadows further, though in a somewhat different manner. Here we'll use charcoal, as this medium's flexibility allows for rich and varied tonal results. We will concentrate on chiaroscuro, focusing on creating intense contrasts while keeping in mind the importance of the grays in making transitions between black and white.

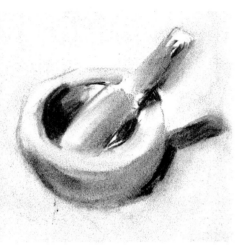

1. Starting from the previous drawing, we'll intensify some of the dark tones to set off the white areas. More color is applied to the inner area of the mortar, increasing the illusion of the vessel's depth and setting off the light areas of the pestle. Then the tonal values are modified until the appropriate balance is achieved.

2. The darkest blacks are lightened to correct the tonal balance. Then the background is shaded in lightly to strengthen the white areas and transform them into absolute values of light. The eraser is now used as a drawing tool on the grayish surface to clean up lines and forms and define edges of the illuminated areas, which serve as the basis for the final stage.

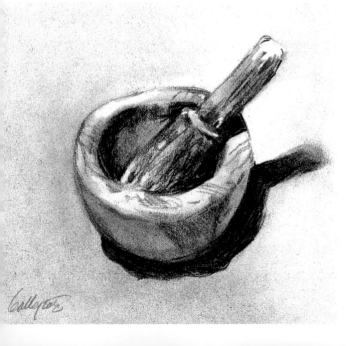

3. Once the highlights have opened up new possibilities, we can continue seeking the maximum values of light and shadow. The intensity of the shadows provides contrast for the intermediate tones. The grayish background of the subject, combined with the highlights, lends these two objects volume.

SOFT SHADING,
ACCENTUATED VOLUME

The volume of objects is represented by the way they are shaded, such that tonal gradations become progressively lighter until they unite with the areas of maximum illumination. The relation-ship of the various objects in a still life is established through the interchange of light between them. Tones shared between objects often arise through reflections. In the exercise shown below, done with Conté pencil and charcoal, the pot with tomatoes on the vine is rendered in chiaroscuro tones that create a highly realistic effect.

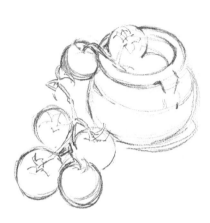

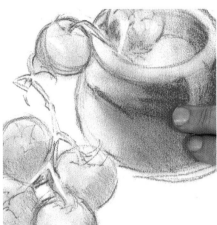

1. The perspective in this drawing is some-what challenging; the plane on which the still life rests should have the same slant as the mouth of the pot. The objects must be out-lined carefully before the shading process is begun to develop the volumes. Use a light touch as you apply the Conté pencil so you can make corrections easily with an eraser. Before doing so, clean the area with a cloth.

2. Once the initial drawing has been correct-ed, a fixative is applied to it to prevent it from becoming smudged. When it's dry, tones are applied and blending begins. Highlights are created with the eraser with-out any danger of damaging the preliminary drawing. The initial blending of tones should be gentle – a thin layer of color with which to progress from light to dark.

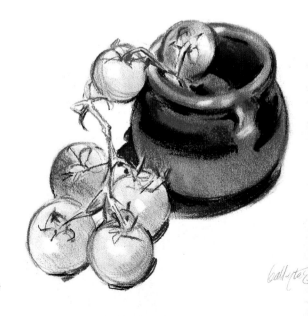

3. Since the tomatoes are the most luminous objects of this still life, they serve as a refer-ence for the maximum light value. Now more intense tones are applied to the pot, and charcoal is used to achieve deeper shadows and to darken the interior. Finally, the eraser is used to create highlights on the glazed lip of the pot.

DRAMA IN A DRAWING

When we mention drama, we are referring to the effect achieved by setting up tensions between light and shadows, which in this exercise are very important. In a drawing like this one, the chiaroscuro must be accentuated in the areas where contrasts are strongest, since these are what create the objects' volume and convey the intensity of light, and contribute to the drawing's overall atmosphere as well.

1. The most complex object in this composition is the plate. The ellipse of its form must be drawn precisely. The fruit is significantly easier to execute. After the initial blocking in, the tonal differences that will provide the fruit with volume and indicate the direction of the light source are sketched.

2. The drawing is treated with fixative to preserve the original outlines and provide a base for the development of tonal values. The first intense grays are applied, avoiding the areas of light, and the eraser is used to create the first highlights. After the entire background is lightly shaded, the remaining whites stand out.

3. The shadows on the fruit are darkened until the maximum tones are obtained. The highlights and most brightly illuminated fruit act as counterpoints. After studying the plate's form, we draw an intense shadow around it, softly integrating it into the background. The end result is highly dramatic. The forms are described by the tonal differences between the elements, that is, by the application of light to describe the objects.

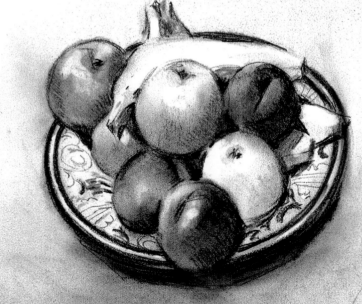

Classical Still Life

MATERIALS

Drawing paper
Graphite
Eraser, Cloth

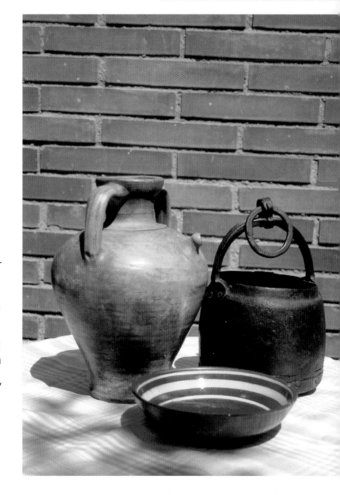

This still life setup includes objects with different surface qualities: two ceramic pieces and a metallic pot. Before beginning, we must observe the location of the shadows and keep in mind that each element can influence the object next to it. The objects' characteristics, the direction of the light, and the treatment of the drawing will be decisive factors in achieving realism.

Step 1. This is the most important step. Blocking in these handmade objects is not at all easy. We must pay attention to the relationship between the forms, their location from our chosen point of view, and the balance between their respective grounds. We should correct continually until we achieve a perfect drawing.

Step 2. Once the preliminary sketch is finished, we define each area of light, as well as the background and the plane on which the objects are situated. The background is drawn in a medium, somewhat darker gray, but without saturating the grain of the paper. Now that the main aspects of the still life are perfectly defined, we can begin to balance the light. The first lines are gentle as we draw the shape of the light striking the jug.

Step 3. The tonal evaluation will be progressive in all areas. The intensified tones of the background serve as a reference to define the more intense shadows on the three objects. When shading, we draw the lines more closely together now, intensifying the grays such that the whites appear as bright points of light. We begin darkening the iron pot as well, creating a second reference for the dark tones.

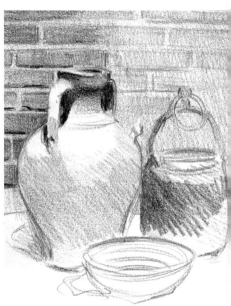

Step 4. We continue working on the background, defining the bricks. The grays of the wall provide a reference for judging the tones that describe the jug's spherical shape. On the side of the jug adjacent to the wall, a lighter area is allowed to remain, indicating its rounded form. We now apply close-knit, smoother shading, leaving no evidence of single lines on the jug, only a gradation that meets the illuminated area.

Step 5. The shape of the jug acquires volume as we apply tones. Every time we intensify the tone, it serves as a base for the next layer. The shading is now very dense, although it does not reach the absolute gray of the graphite or contrast strongly enough with the white of the paper. This makes the pot appear too light.

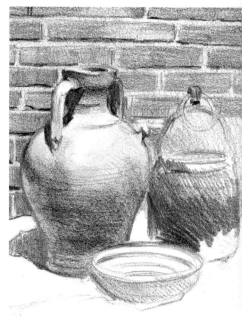

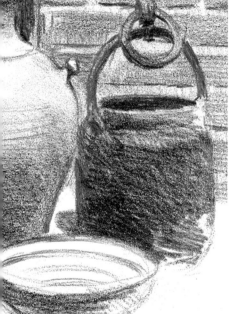

Step 6. To compensate for the previous darkened tones of the jug, we darken the pot, making sure to establish a tonal hierarchy here as well. Absolute black is applied in the darkest area. These dark tones provide a contrast for the bowl, to which we now apply gray as well, in a stroke that follows its form.

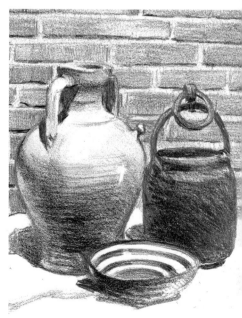

Step 7. All elements of the still life now have a series of tones that will serve as the basis for the final tonal evaluation. We intensify the dark areas of the jug to finish describing its form, the direction of the strokes following its shape and enhancing its texture. We darken the blacks on the iron pot, letting lighter gray areas serve as highlights. We then darken the bowl, defining its form through the areas of light.

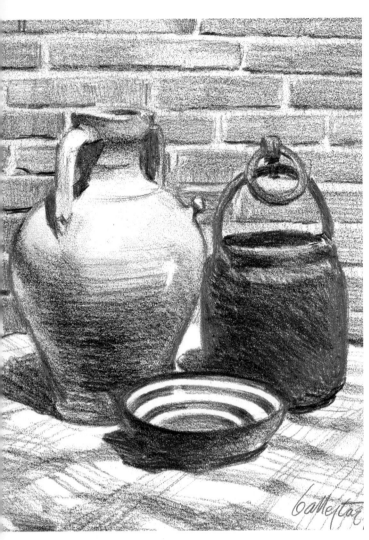

Step 8. We then intensify the dark tones of the objects, applying the graphite briskly on the iron pot and in the darker shadows. Finally, we draw the tablecloth, attempting to emulate its texture and softly shading in the folds.

SUMMARY

• The study of the most intense light is achieved through simultaneous contrast.

• White appears brighter if a darker tone is applied adjacent to it.

• Shadows are the absence of light.

• Objects in a still life are usually more difficult to draw if they are handmade.

• An object can be represented in chiaroscuro through either gradual tonal evaluation or radical contrasts.

• Intermediate gray tones are extremely important, as they provide a transition between white and black.

• The eraser is a drawing instrument as well as a correction tool.

• The volume of an object is depicted through shading, such that tonal gradations become progressively lighter toward the areas of maximum light.

• To make corrections to a drawing, it is best to brush off the area with a cloth before using the eraser.

• Drama in chiaroscuro can be understood as the interplay of resonances between light and dark areas.

EXPLORING LANDSCAPE THEMES WITH "HARD" TECHNIQUES

THE CLEAN DRAWING

This section deals with the "clean" landscape drawing, in which tonal values are dispensed with in favor of denser and purer contrasts. Unlike other drawing procedures, this one begins with a clear line, devoid of any ambiguity that can lead to confusion. This exercise is drawn with a precise and resolute stroke that plays with the capricious shapes of the landscape.

As its name indicates, the hard stroke yields a sharp, well-defined line. Hard techniques offer a wide range of possibilities and can be done with various drawing media, from unblended pencil to ink applied with a fountain pen, ballpoint pen, reed pen, or felt-tip pen or marker.

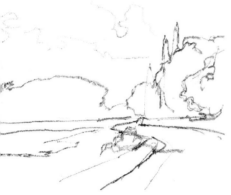

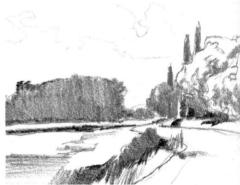

1. Because the landscape can be adapted in shape and style, it can be drafted with a loose, dynamic approach. The masses here have been reduced to several simple volumes understood solely by the line that encloses them.

2. The dark areas are shaded in with graphite, making sure there is a correct balance between the light areas and those in shadow. The gray shading is so definitive that it is done quickly.

3. With a reed pen dipped in ink, the darkest areas are established over the graphite. Drawing with ink demands great delicateness. When the pen has nearly run out of ink, it is used to draw the foreground where the texture of the grass requires subtler treatment in its contrasts.

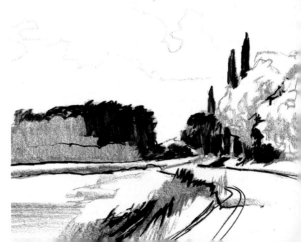

THE HARD FINISH

The finish of a drawing executed with these mediums will have a markedly hard appearance if hatching and halftones are avoided. Intermediate grays can be added, provided they don't diminish the prominence of the contrasts between black and white. Continuing on from the preceding exercise, the task now is to achieve a balance between the light and dark areas, the masses that must be blocked in completely, those in which the white must be left intact, and, finally, the areas that call for a softer treatment.

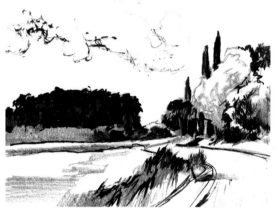

1. The most distant planes normally call for stronger contrast. Here, background areas of the landscape are drawn directly with the reed pen dipped in ink, applied with vertical strokes to ensure a uniform texture. During this phase of sketching, certain areas must be kept open, especially the base of the trees; therefore special care must be taken not to saturate this dark area.

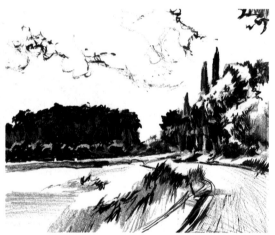

2. With the first tones established and the light areas separated from the dark ones, work on the details begins. These can be drawn as hatching or lines. In the trees on the right, the shading separates the areas of light. The dark areas of the base of the vegetation in the field are shaded in, while the entire top is left blank.

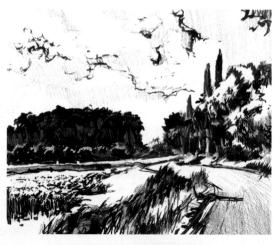

3. The dark areas are intensified, allowing the lightest areas to act as a counterpoint. The difference between the two dark areas results in alterations in both the terrain and its surface texture; note how the grassy area on the left has been represented as a dense mass.

Hard techniques
with graphite pencil

Graphite lets you achieve quite a wide range of gray tones, depending on the hardness of the pencil. From the preliminary sketch it's possible to include different pencil gradations in order to develop a number of tones and even create lines. This landscape exercise shows you each stage of the process using pencils of varying degrees of hardness.

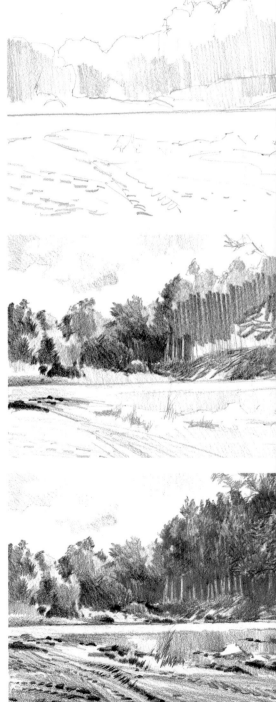

1. First a 2B pencil is used. Harder pencils are not appropriate for this type of drawing, as they leave impressed lines on the paper. Here, clean lines that define the masses of the landscape are sketched, and then a fast shading is executed in the area of the trees.

2. Now a 4B is used; it feels softer on the paper and creates a wealth of grays. Regardless of its degree of hardness, every type of pencil has a limit to both the darkest and lightest tone it can produce. After drawing the vertical lines on the right, which accentuate the verticality of the trees, the dark areas are intensified, lending depth to the woods. These dark areas are sustained by the ones elaborated in earlier phases. The grays that now separate them, through the effect of contrast, become halftones.

3. The final stage of the landscape is drawn with very soft pencils, such as a 6B or 9B, which are ideal for the most intense dark areas. When drawing with a softer pencil than the ones used previously, it's possible to obtain blacks that until now seemed impossible, such as the dark shadows of the mud and the intense black areas in the background woods.

FOUNTAIN PEN, REED PEN, AND BALLPOINT PEN

Mediums that produce a harder line let you create complete array of attractive gestural strokes; these include such familiar tools as the simple ballpoint pen or the fountain pen. As with any medium, you'll gain experience with these drawing implements through regular practice. No matter how commonplace, these drawing tools can prove invaluable.

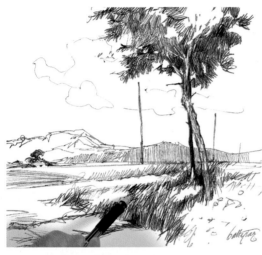

1. Drawings of exceeding beauty can be rendered with a ballpoint pen; its line, though uniform, allows subtle gradations according to how closely the lines are placed. In addition to allowing a wide range of textures, ballpoint pens can produce fresh and spontaneous effects. Here, the shading is executed in the same manner as with a pencil, although the blacks you get with pen can be very intense.

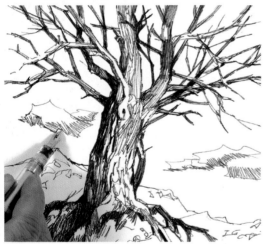

2. The fountain pen produces a uniform stroke that can be varied in intensity. As with ballpoint pen, grays are produced according to the spacing of the lines, which will be more or less prominent depending on how smoothly the pen runs over the paper. With this type of pen, because the ink is liquid, you can spread it in dense masses if you work fast, before it has time to dry.

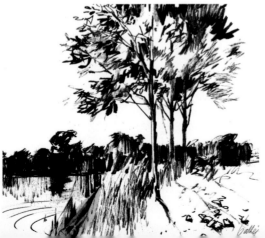

3. The reed pen yields a vigorous line that can range from black to intense gray. When the pen is heavily loaded with ink, you can use it to create a wash; when loaded with only a touch of ink, it yields faint lines. Reed pen drawings have a notably appealing finish, producing compact dark masses and textures impossible to obtain with any other medium.

Japanese-Style Landscape

MATERIALS

Drawing paper suitable for ink
India ink, Water
Reed pen, Soft-haired brush

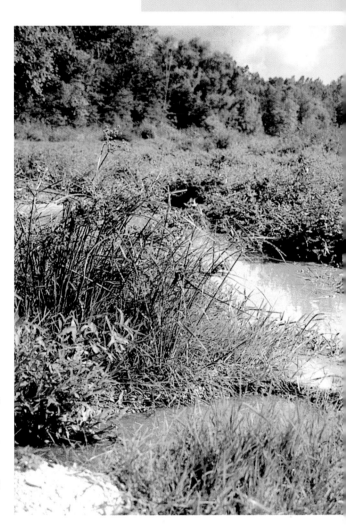

In this approach to landscape drawing, the balance between quiet, empty areas and lively, active ones is translated into the presence or absence of shading or contrast. In this seemingly simple way, the landscape can attain a dimension unlike any achieved through other methods. Here we'll see how the apparently complex shapes and textures of the subject can be adapted to a work of graceful simplicity. Interpreting the landscape in terms of shifts between light and dark is a drawing style reminiscent of Oriental art.

Step 1. The preliminary sketch is drawn directly, without a pencil, concentrating on just the barest of forms. The line in the background lends the trees volume, and over them the brighter area of the sky unfolds. Drawing with a fast technique, we sketch the grass in the foreground and thus create a division between the two planes.

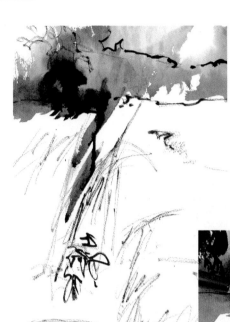

Step 2. Next, we concentrate on the gray of the background, the base tone for the sky, and the brightest area of the trees. We dip the brush into a very light wash mixed from ink and water and rough out the background. We go over this gray base in black, allowing the tone to blend with the still-wet grays. The ink blends in the wettest zones, sometimes even diffusing the contrast.

Step 3. Strong contrasts are established in the background, transforming the previous grays into light areas. With undiluted ink, we stain some areas to create the texture of the trees in the distance. Then, using the reed pen, we draw the first patches of grass in the foreground with spontaneous but resolute strokes.

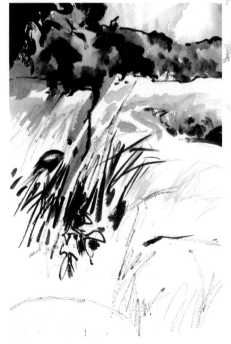

Step 4. We work with a new gray wash, but with only a hint added to the brush. The paper must be dry so that the ink won't run. With an even fainter stroke than that used previously, we continue drawing more grass in the foreground, leaving light areas to represent the brightest tufts of grass.

Step 5. The contrasts are increasingly accentuated and the landscape begins to come to life. For the moment, the paper is filled with numerous contrasts and everything appears confusing. Most of the tones applied are grays, which constitute the foundation for the next phase. As the most pronounced dark areas increase, the grays become more luminous thanks to complementary contrast.

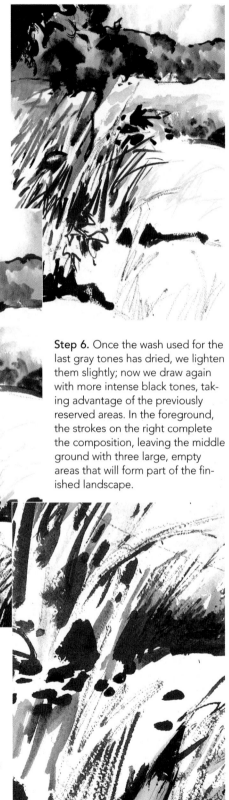

Step 6. Once the wash used for the last gray tones has dried, we lighten them slightly; now we draw again with more intense black tones, taking advantage of the previously reserved areas. In the foreground, the strokes on the right complete the composition, leaving the middle ground with three large, empty areas that will form part of the finished landscape.

Step 7. This stage of work is concerned with adding details and highlights that until now were somewhat dispersed. The reed pen lets us combine various tonal treatments and dark masses. Any dense patches of black that have remained on the paper can be turned into blades of grass by swiftly dragging over them with the tip of the pen.

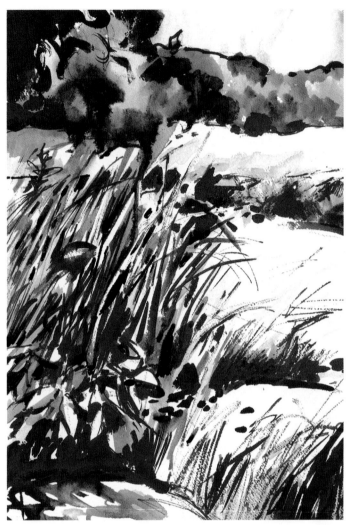

Step 8. In the last step, we considerably increase the contrast in the area of vegetation. The dark areas define new areas where before there were only grays; in this way, the grass appears to emerge from the void that is created between the dark areas.

SUMMARY

• So-called hard techniques do not allow the kind of tonal modeling charcoal permits.

• In a "hard" drawing, tonal values are abandoned in favor of pure, dense contrasts.

• Graphite is used to block in dense masses to weigh highlights against shadows.

• Working with ink demands great care, as the light areas must be worked with the utmost delicacy.

• Drawings executed with "hard" mediums will have a stark appearance if hatching or halftones are avoided.

• Graphite can produce a wide range of grays depending on the amount of pressure exerted on it.

• Ballpoint pen can yield beautiful drawings; despite its uniform line quality, you can create subtle gradations according to how closely you space the lines.

• A fountain pen produces a regular line, but also permits variations in intensity according to how you apply it.

• A reed pen allows countless tonal possibilities, which range from intense black to gray when used with wash techniques, as well as faint lines when it is loaded with only a touch of ink.

THE FACE: NOSE AND MOUTH

DRAWING THE NOSE

The nose is one of the most important parts of the face, and its prominence defines in great part the subject's personality. Inexperienced artists often draw the nose incorrectly, usually because its shape is not easy to discern when viewed from the front, and because it's difficult to adapt to the plane of the face. This anatomical study should help.

Little by little, feature by feature, this book is showing you how to draw a complete portrait, combining a realistic physical representation with a psychological interpretation of the subject. This chapter illustrates the relation of the nose and the mouth to the other parts of the face, and how to combine all the features as a whole.

1. When drawing the profile of the nose, pay special attention to the plane of the face so you can establish this feature's shape and size in proper relation to it. Here, the vertical plane is represented by a faint line; the tip of the nose is rendered as a circular shape.

2. The volume of the nose is brought out with a fine shading of the darkest areas, leaving the highlights reserved. Tones are softly blended with a fingertip; the result is a highly realistic volume. The profiles around the light areas are accentuated with an eraser.

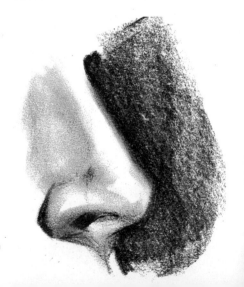

3. The principal contrasts are determined by separating the nose from the background with a dense shaded area that profiles its shape. The profile is not uniform; there's a slight gradation that integrates this tone with the highlight.

DRAWING THE MOUTH

The mouth also provides clues to the subject's personality. Inexperienced artists often try to draw the mouth with a horizontal line beginning from a simple vertical plane, which results in an amateurish and awkward look. The following exercise shows you how to deal with the technical difficulties entailed in drawing the mouth.

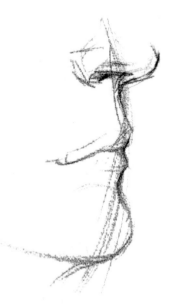

1. In the preceding exercise you saw how a vertical line was used to mark the distance of the nose with respect to the skull; by drawing a vertical line down the middle of the nose in profile, it's possible to gauge the nose's vertical relationship to the mouth. Note the curves that exist in the lips, as well as the shape used to draw the chin.

2. The curved lower part of the nose is accentuated and the uneven angles of the previously drawn chin are corrected. The lips are drawn very faintly, and they're shown as not completely closed.

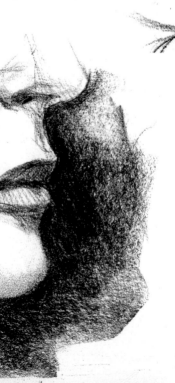

3. The mouth must be drawn as modeled forms. Note how the planes of the lips reflect light. Look for both the curvature of the shapes and the shadows the forms cast. The upper lip is drawn with an intense gray, highlighting the corner of the mouth with a darker line, and is made to protrude slightly over the lower lip, which is fleshier and lighter. The lower lip casts a gradated shadow over the chin.

RELATING FACIAL FEATURES

Before you attempt to bring together the various facial features of your subject to form a definitive portrait, it's important to know where each of them should be situated on the face. In this exercise, the face will be con-structed and developed according to a simple scheme on which each facial feature will be no more than a generalized supposition of reality. While not corresponding to any real person, this example provides you with some guidelines that show you how to draw a well-balanced face that can then be adapted to different faces by varying the proportions.

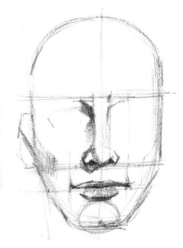

1. The drawing begins with an oval, which is corrected until the sides of the face and the shape of the chin are rendered. A vertical line down the center marks the axis of symmetry and horizontal lines locate the position of the eyebrows, nose, and mouth. These divisions help establish the verticality of the nose and situate the corner of the mouth.

2. The dark areas of the nose are drawn, leaving the highlights blank. The eye sockets, which define the breadth of the bridge of the nose, are an important element.

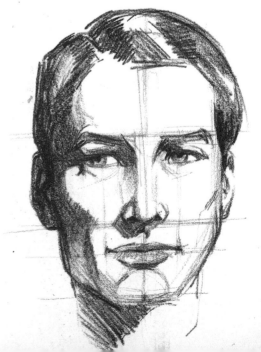

3. The addition of contrasts completes the placement of each feature. The dark area that describes the bridge of the nose marks the face's maximum degree of depth; this tone is used to depict the depth of the face, especially the cheekbone. The shadow cast by the nose on the upper lip describes its volume. Correctly drawn lips begin with a curved, rather than straight, line from one end to the other.

PARTIAL PORTRAIT

This exercise is concerned less with applying the ideal canon used on the previous page than with rendering the personality of the lower half of the face. This personalization of the subject will be sought through applications of highlights and shadows, a technique that requires the use of the eraser. This lesson is an excellent warm-up for the step-by-step exercise that begins on the next page.

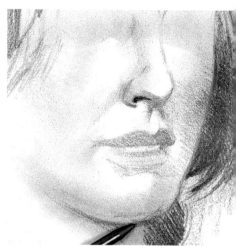

1. First an oval is sketched to establish the shape of the face. Then the tones are blended very softly to create a base for the highlights and the background. This type of sketching must be done fast and corrections made as often as necessary until the features are sufficiently well defined. The dark areas are softly accentuated and the eraser is used to draw the most prominent highlights.

2. This approach allows you to model the facial features gradually. But regardless of whether you're blending and extending tones, opening up white areas, and so on, it's essential not to lose sight of the curvature of the face. Here, since the model is looking directly at the viewer, there is a certain degree of foreshortening in the tip of the nose and on the left side of the lips. Once these shapes have been drawn correctly, the dark areas are redrawn with graphite.

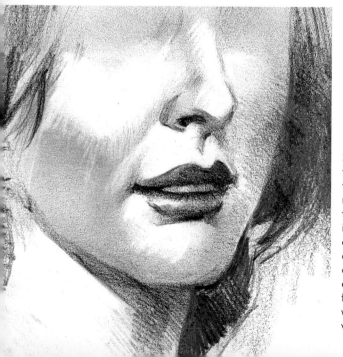

3. These dark areas form the foundation of the volumes of the nose, the mouth, and the face itself. Graphite is applied directly, ensuring that the darks describe specific parts of these features. The eraser is indispensable for creating highlights, which help define the various volumes.

MATERIALS

Drawing paper
Graphite, Fixative
Eraser

Female Face

This exercise is intended to give you practice in applying what you've learned so far about the principal shapes of the face, proportions, and details. The aim here is less about rendering ideal shapes than about drawing a portrait of this young woman. The structure of the face, the position of the features, and the reflection on paper of the subject's personality are the most important aspects to bear in mind. Pay special attention to how all the facial features interrelate.

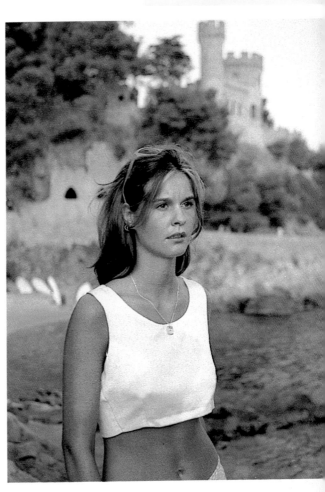

Step 1. Using a linear approach, we sketch the face beginning at the top. The head is based on an oval shape, supported by two parallel lines that form the neck on a squarish structure that will eventually become the torso. We situate the main facial features; because the face is turned slightly to one side, there is a reduction in the size of the shapes representing parts of the features that are seen in depth.

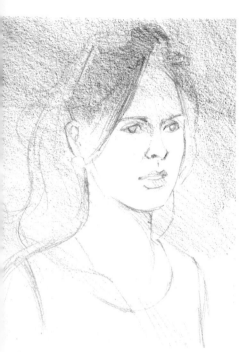

Step 2. Before proceeding, we apply fixative to the drawing to preserve the preliminary outline. This way, subsequent work won't affect the underlying linear sketch. A halftone gray is shaded over the surface to form the base on which we will open up areas of white and create dense areas of black. The dark areas that are added to the neck are faint, although they are clearly distinguishable from the rest of the tones of the drawing.

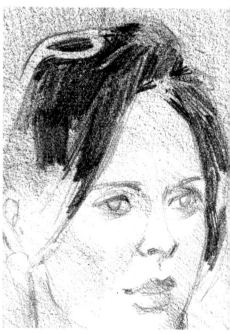

Step 3. The maximum dark tone, in the hair, is applied with graphite. This dark area provides us with a reference tone for the other dark areas, and it profiles the shape of the face. The hair delimits the forehead, eye, cheekbone, and the shape of the chin. We do some blending with our fingers on the face, accentuating a contrast in the cheekbone and on the chin.

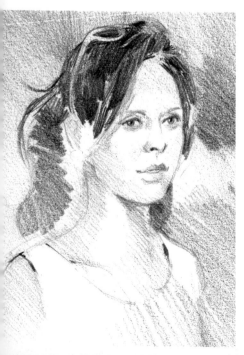

Step 4. The tones are gradually darkened. The hair is the darkest area of all; only the most prominent shapes of the face will share this intensity. We inject life into this developing portrait by drawing in the eyes and the pupils. With the eraser, we open the areas of white in the nose and the mouth. The background is darkened, making the highlights on the face "pop," thanks to the effect of simultaneous contrast.

Step 5. The face still needs more detail to capture the subject's personality. We define the depth of the eyes from the dark areas situated between the bridge of the nose and the eyelid; the result lends expression to the eyes and shape to the eyebrow. We intensify the tone of the cheekbone and open up highlights with the eraser, which is also used to clean up the shape of the nose. Finally, we softly shade the upper lip.

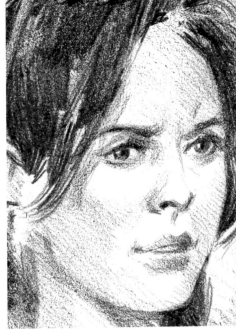

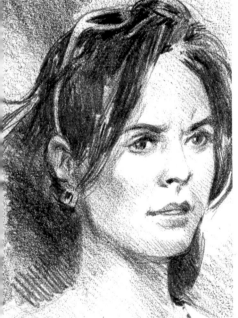

Step 6. We add tone to the dark areas of the face. A faint shading is applied over the face to model its depth, and highlights are accentuated with the eraser. Now we work more directly in the dark areas of the lower half of the nose and the mouth. The shading in the hair is intensified, and the bright areas are left in reserve.

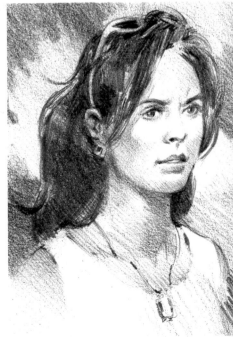

Step 7. The dark areas of the neck and the lower half of the face lend the portrait the necessary presence with respect to the body and the background. The torso is left in a barely defined state, since the focus here is on the woman's face. The hair is further intensified in the dark areas. The background is likewise darkened to form a counterpoint to the dark tones of the figure; hence, the face becomes brighter, thereby allowing some additional tonal modeling.

Step 8. To finish, we complete the dark areas of the portrait with intense but not uniform shading, as the idea is to create resonance between the different parts of the drawing. Finally, we use the eraser to eliminate any gray from the bright areas of the face.

SUMMARY

• In drawing a portrait, the success of your results depends on combining your subject's facial features correctly, and in a way that captures his or her character.

• As a prominent feature of the face, the nose is important in defining your subject's personality.

• The difference between the shape and size of the nose depends largely on the distances along the vertical plane, represented with a simple line.

• The volume of the nose can be defined by softly shading the darkest areas and leaving the highlights blank.

• The mouth is important in describing the personality of your subject.

• The planes of the lips reflect light, and their shapes must be modeled.

• You should begin a drawing of the face with an oval, and make as many corrections to its shape as needed until it looks right.

• When drawing the nose, it's extremely important to bear in mind the eye sockets, which delimit the breadth of the bridge of the nose.

• The lower half of the face is as important to the expression of personality and mood as the upper half.

Natural Textures

Vegetables

In general, vegetables don't have a uniform texture; some have rough leaves, while others have strange, irregular shapes. The following exercise is less concerned with shapes than it is with the rendering of light in ways that reveal texture, as well as with some techniques that give the drawing an almost photographic realism. Special attention should be paid to the shading and the technique of drawing with the eraser.

A still life can have as many levels of difficulty as you're willing to give it. It can be drawn in a rough style or an extremely realistic one, which involves an advanced study of texture. This section includes several exercises in which light is the most important feature.

1. This sketch of a cabbage is similar to that of a flower. The leaves open from the center, and the outermost ones are softer, with the leaves becoming gradually fresher and stiffer as we move toward the center. When sketching, combine the flat edge of the charcoal with the point. Here, some of the highlighted sections have already been distinguished from the shaded areas.

2. Here, a clear separation has been made between the light and dark areas, with the background darkened – especially at left – to establish a strong chiaroscuro effect with the brightly lit parts of the cabbage. The lighter background at right makes the shading of the vegetable stand out clearly.

3. To increase the effect of realism, we intensify the contrasts, almost completely eliminating any sketchiness so that the volumes appear almost photographic. The grays are modulated to provide a base on which we can open up pure white areas and sketch with precision the luminous lines that branch off on the cabbage's surface.

A PUMPKIN

The same spherical shape used to draw an apple can be used for a chiaroscuro drawing of a pumpkin. Here, the texture is the most impor-tant feature. The contrasts between light and dark areas are not limited to the sphere. The rough texture of the skin will be the main focus of this exercise, which combines various mediums: sepia and sanguine chalk, charcoal, and an eraser.

1. First we draw the shape of the pumpkin with a single line, correcting it until it's accu-rate. This is followed by the initial shading of gray, which transforms the flat shape into a sphere. The first strokes of shading are flat, followed by almost vertical lines that darken most of the left-hand side of the pumpkin, thus defining the most brightly illuminated area at right. Superimposing these dark, nearly vertical lines on the gray area creates a deep shadow that serves as the starting point for all subsequent work.

2. We fill in the background with sepia and define the pumpkin's outline with sanguine Conté crayon, then blend the tones with our fingers to create an opaque earth color. With pigment still on our fingers, we finish the gray in the lower section. Using the flat side of the Conté crayon and the point, we redraw all the shaded areas on the pumpkin.

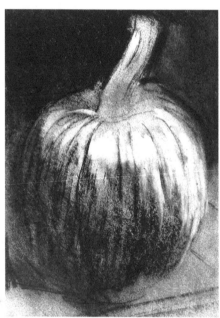

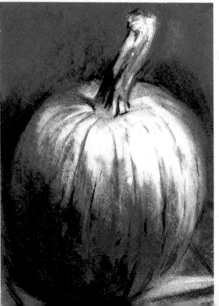

3. The final contrasts are created with char-coal. The area around the pumpkin is dark-ened to separate it from the background. We then apply black to the shadows on the pumpkin itself, blending these new tones with the ones underneath. Using the tip of the charcoal, we intensify the contrasts of some of the pumpkin's linear texture. Finally, we lift out the lightest areas with an eraser, removing the previously applied grays.

REFLECTIONS AND HIGHLIGHTS IN A STILL LIFE

Texture is the focal point of this two-part still life exercise. The subject is a platter of eggplants, vegetables that have an exceptionally glossy surface. The initial sketch and shading are essential factors in defining the shapes here. In this case we'll work on colored paper, which eventually will become an integral part of the atmosphere surrounding the composition.

1. The preliminary sketch is always important, since it's where we define the subject's shapes as accurately as possible, no matter how much time and effort is involved. Here, the first object drawn is the plate, followed by each of the vegetables on it. Spherical shapes are always the most difficult ones to render, so don't move on to the next stage until you're satisfied with your initial efforts.

2. A fixative is applied to the preliminary sketch so that the shapes of the objects are not lost in subsequent stages. We then shade the appropriate areas with charcoal, reserving the more brightly illuminated ones. Various gray tones are added first around the plate, building in value from the color of the paper itself to more intense applications of charcoal.

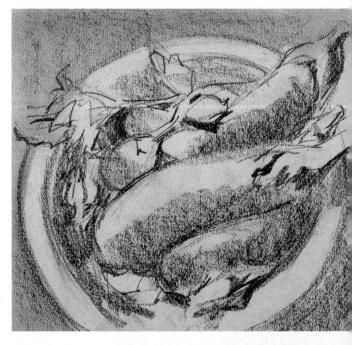

3. In this next step, all of the tones are darkened at the same time, which makes the light areas stand out clearly. Care should be taken not to block out the gray with lines that are too dark and intense. It's always best to darken tones section by section, leaving out areas that should be lighter.

VARIED TEXTURES

The previous stage of this exercise left the composition at a point where the subject's textures are ready to be articulated. Shadowed areas are darkened, so now, lights and highlights can be added with white chalk to create the shiny surfaces of the eggplants.

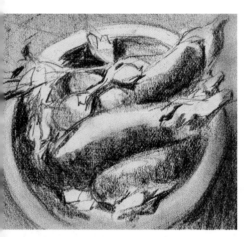

1. We start by darkening all of the gray areas. This dense shading makes the color of the paper look more luminous. The drawing has some areas of intense black and others where the various shades of gray scarcely alter the background color.

2. Once the grays have been applied, we lightly blend all areas with the fingers. It's essential to use a light touch so that the sketch doesn't become oily and the lines completely rubbed out. The fixative applied to the initial drawing should take care of this.

3. We now clean up some of the grays, although we're not creating high-lights with this technique; these will be added with white chalk in two stages, one in which tone is applied and subsequently blended, and another where the chalk is applied directly to create brilliant points of light.

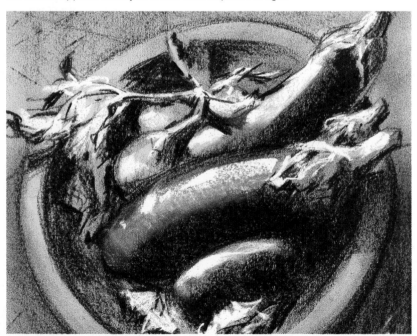

Still Life with Grapes, Tomatoes, and Lemons

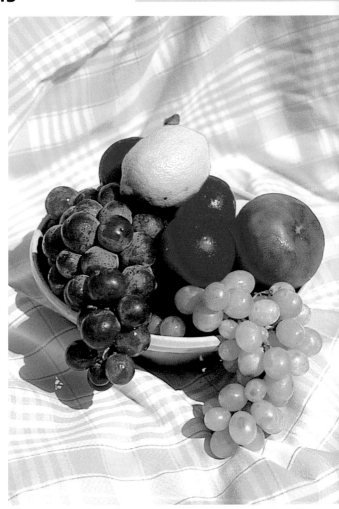

Careful observation of the photograph of this still life setup reveals that the subject can be reduced to a logical study of light. Various drawing mediums all have their own capabilities for rendering texture, and many of these will be used in this exercise. In the first stage, it's important to establish the composition correctly. Here, we've moved the pieces of fruit around until a good position for each of them has been determined. Light is another factor to keep in mind during this process.

Step 1. After studying the still life setup, we organize the composition by distributing the various masses of the objects in it, keeping in mind that the spaces between the subject as a whole and the edges of the paper are equally important. The preliminary sketch focuses on the basic forms, with no regard to details of the individual objects.

Step 2. After applying a fixative to the previous sketch, we add some of the dark areas that outline the shape of the lemon. Patches of warm, very intense color are applied to the tomatoes. This will also provide the base color for the darker grapes. We blend these tones with the fingers, reserving the spaces for the highlights. We also color in the tablecloth in the background.

Step 3. The previous base of warm colors is reinforced with intense darks and lines that redefine the still life's shapes. The main shading of the plate and the lighter grape is also added. With very delicate strokes, we increase the contrasts on the tomatoes and gradually redraw the grapes previously colored in with a shade of sanguine.

Step 4. We now use charcoal to create the main contrasts in the still life, starting with the area around the lemon, so that the light colors are isolated. We then move on to the darker grapes, redefining the shapes with shading and reserving the light areas. The tomatoes are given sharp contrast. This shading separates the planes and gives the objects volume.

Step 5. We begin drawing the folds in the tablecloth, using white as the main base and darker tones for the deeper parts of the folds. The tomatoes take on a shiny appearance, thanks to the use of white chalk for the highlights, a technique that is also applied to the grapes and the lemon.

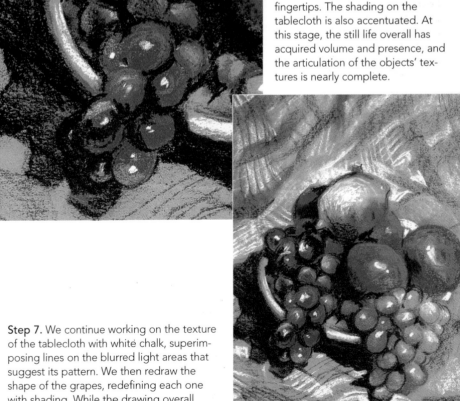

Step 6. We now concentrate on the contrasts and details on the grapes, coloring in the dark areas with black, and blending them with the fingertips. The shading on the tablecloth is also accentuated. At this stage, the still life overall has acquired volume and presence, and the articulation of the objects' textures is nearly complete.

Step 7. We continue working on the texture of the tablecloth with white chalk, superimposing lines on the blurred light areas that suggest its pattern. We then redraw the shape of the grapes, redefining each one with shading. While the drawing overall appears fresh and spontaneous, the textures of each element are rendered with precision.

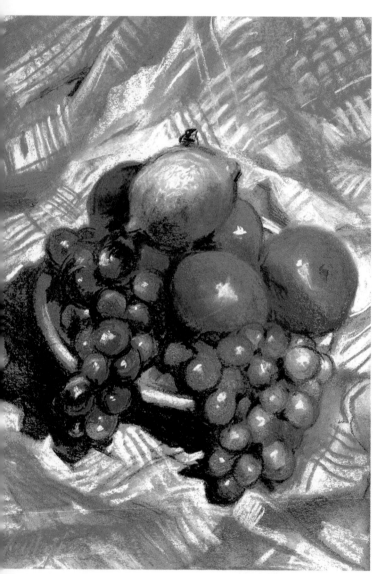

Step 8. With the same shade of red used previously, we complete the texture of the tablecloth. Using quick, decisive strokes, we fill in the pattern's lines. With the same tone, some final touches are added to the tomatoes and the lighter grapes.

SUMMARY

• Still lifes can be drawn in a rough style or an extremely realistic one.

• The most important aspect of any still life is the light.

• Vegetables do not have a uniform texture; organic forms are difficult to render.

• The outermost leaves of leafy vegetables are soft, and the leaves gradually become fresher and more rigid as we move toward the center.

• The first stage consists of separating the light areas from the dark ones.

• It is essential to completely separate the light and dark sections.

• An eraser can be used to clear out pure white areas and to draw textures precisely.

• When darkening the shaded areas, the areas of light should be respected; the highlights drawn with white chalk show the real texture of the surfaces.

Nature Study: Skies

Different skies

The sky can be interpreted in a variety of ways. The weather obviously plays a dominant role and can provide a scene with an air of drama. This section presents three very distinct skies executed with different techniques. Sky studies that focus mainly on cloud forms are known as cloudscapes.

Of all the themes connected with the landscape genre, the cloudscape has always been a favorite, due to the spectacular, seemingly limitless kinds of cloud formations and lighting effects the sky presents. The representation of clouds mainly involves executing interplays of tonal contrasts.

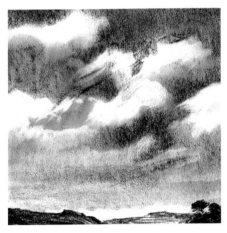

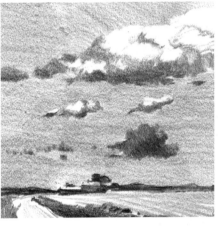

1. This stormy sky composition is based on very dense clouds that appear as immense, luminous masses against a dark background. Here, the sky was begun with a very dark application of charcoal, from which highlights were opened up with a kneadable eraser. Over this tonal base, the dark areas in the foreground and the volumes of the clouds were increased and blended with the fingers over the background.

2. This scene shows some dispersed clouds on a bright day. A graphite stick was used to darken the background, and highlights were opened up with the eraser. The dark areas of the clouds were drawn afterward with direct, though not linear, strokes.

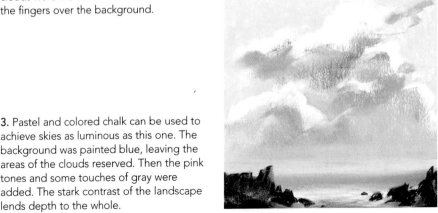

3. Pastel and colored chalk can be used to achieve skies as luminous as this one. The background was painted blue, leaving the areas of the clouds reserved. Then the pink tones and some touches of gray were added. The stark contrast of the landscape lends depth to the whole.

CLOUDS AND SKIES

This exercise deals with very thick clouds. This work has been drawn very quickly. It's important to learn how to draw skies in a kind of shorthand. Clouds can be sketched with a certain degree of agility, as they don't demand great precision.

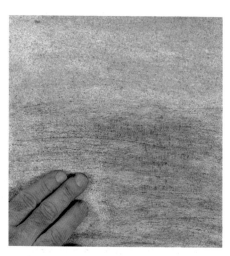

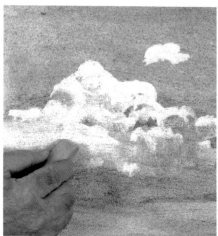

1. The background is filled in with a light layer of charcoal. Then the fingers are used to soften and integrate the shading. Some areas have been left dark for use as the background of the sky.

2. The eraser is indispensable for opening up very pure white areas, creating the definitive shapes of the clouds. The corresponding dark areas are left with the original gray shading.

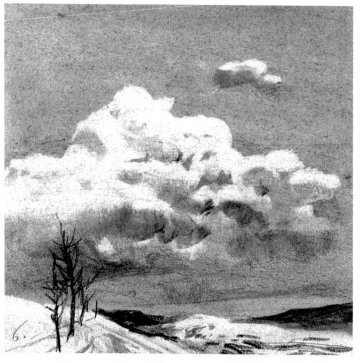

3. The eraser is used to open up the entire lower section of the landscape. After drawing the trees, which are seen in perspective, some of the contrasts in the clouds are increased and then blended with the fingertips. Finally, the last grays are cleaned up and the edges of the cloud forms refined with the tip of the eraser.

HOW TO SKETCH
CLOUDS

The preliminary sketch for a landscape, which in this case is a cloudscape, establishes the guidelines for its subsequent development. Before you start recording clouds on paper, study their formations carefully. And when sketching skies from nature, work quickly, as clouds constantly move and change shape. The quality and color of the sunlight changes, too.

1. This exercise is drawn on a sheet of gray paper. The main shapes of the clouds are sketched with a loose, clean line. There is no differentiating between the light and the dark areas for the time being. The area around the clouds is shaded with charcoal. The uppermost region contains very intense black shadings. Now the contrast in certain areas is increased with charcoal pencil.

2. This step of the work is drawn in compressed charcoal, which is applied with more pressure in certain areas to cover the color of the paper. Other areas are drawn more softly; this tonal difference allows the sky and the clouds to be situated on different planes, lending depth to the work. If the background appears to be too shaded, the kneadable eraser can be used as needed.

3. The strongest contrasts are drawn with compressed charcoal. The pressure exerted is a determining factor in the outcome of the work. Dark tones can be modeled to obtain subtle gradations by holding the stick between the fingers horizontally and dragging it over the paper. The dark areas within the clouds are drawn by dragging the stick flat over the paper while controlling the pressure exerted with the fingers.

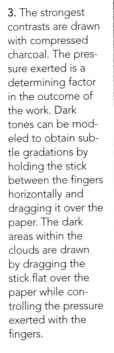

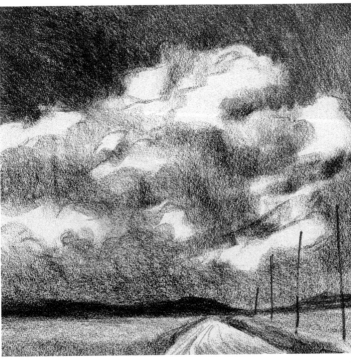

BLENDING, CREATING HIGHLIGHTS, AND OPENING UP WHITES

The preceding cloud study forming the first part of this exercise will now be developed further. Many of the tones applied previously constitute a base for the next ones. An improvised blending tool in the form of a cotton ball wrapped in cloth will be used in this process.

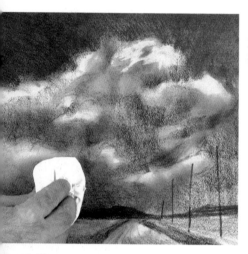

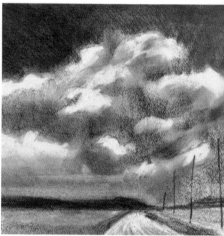

1. The strongest contrasts in the clouds are accentuated. Compressed charcoal is now used to darken areas that had previously been medium grays. Charcoal is also applied to areas designated for tonal blendings. Subtle touches of white are added to the lightest clouds. The cloth-wrapped cotton is used to blend certain areas of the drawing.

2. The brightest areas are brought out and some touches of white chalk are added to parts that were gray before. The blending must be selective; some areas will be more grayish, while others will continue to appear fresh. The areas nearest the horizon require the most blending.

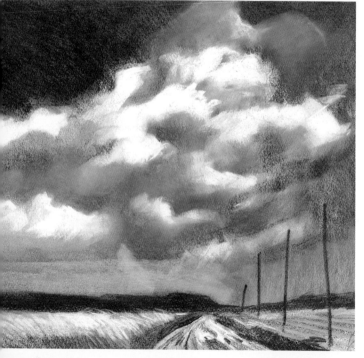

3. Here, dark areas are transformed into dense blacks that, through contrast, make the light areas appear even more luminous. The last phase of work on the clouds is executed in white chalk. The paper now contains a large amount of chalk, which will be blended over the underlying tones to create a range of beautiful grays.

Cloudy Sky

MATERIALS

Watercolor paper, Pencil, Brush
Watercolor paints: sepia, blue,
and sienna
Water, Mixing palette

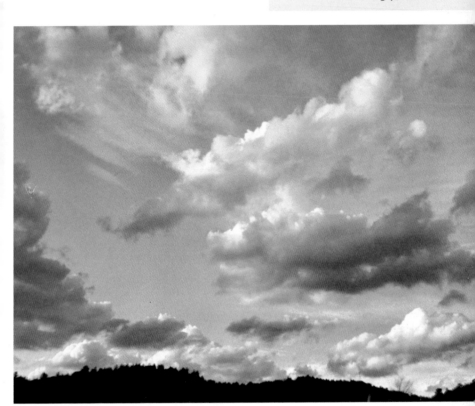

One way to draw skies is by copying them from photographs; most artists have an abundant collection of photos that they often use as a source of inspiration. This step-by-step exercise entails the use of watercolor washes; as you'll see, just two colors are enough to give you satisfactory results.

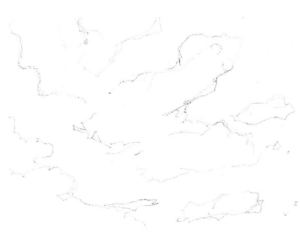

Step 1. We begin by sketching the outlines of the clouds in pencil. When you're making a preparatory drawing for a work to be executed in wash, you need to know exactly where the brightest areas will be. So, although this outline is schematic, it clearly defines the contours of each cloud mass.

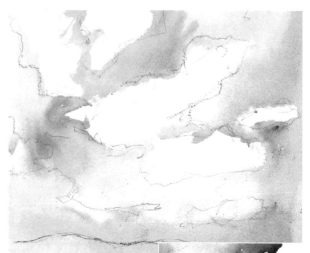

Step 2. To create the initial wash, with the brush we deposit a few drops of water on a palette or plate. Next, we load the brush with a touch of sepia and drop it on the plate, rinse the brush, and repeat the procedure with the blue, then rinse the brush again to clean it. Now we dip the brush in water and wet the entire sky area. Then we apply the wash over it. Tones blend easily when applied to a wet surface.

Step 3. In this step we apply blue, using the darkest tones in the uppermost areas and isolating those that will be lighter. The areas of the wash that will require a tonal gradation are dampened with water; the dark patch is "stretched" toward the lighter area and becomes ever more transparent due to the greater amount of water. The process of drawing with water allows two shades to be mixed. Note the effects obtained when a hint of color is added over areas previously dampened.

Step 4. We must increase the tones gradually. A dark blue is painted in the upper central region; this patch leaves the luminous shape of the cloud well defined. We use this blue to increase certain contrasts and outline their light areas. We prepare a mixture of sienna and blue and begin painting the dark area on the central right-hand side and obtain brown tones in the clouds.

Step 5. We wet the brush and load it with a small amount of grayish tone mixed from the two colors and stretch the previous dark tone downward to the lower area of the paper, keeping certain areas in reserve, which will eventually become the brightest areas. The entire lower half of the sky, with the exception of the reserved areas, is now covered by a transparent blue glaze, which forms the base for subsequent colors.

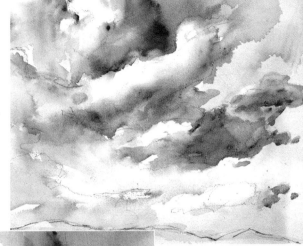

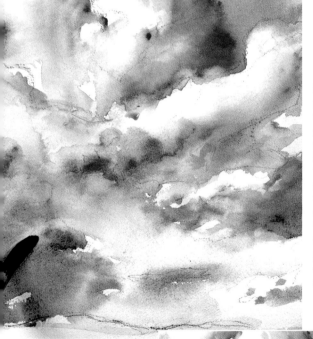

Step 6. We darken the tones gradually, starting at the bottom. We create a brownish-gray tone on the palette and use it to darken the lower half of the cloudscape. These contrasts significantly accentuate the light areas. We use a well-soaked brush to blend the previous tones. The dark areas outline new forms that appear very luminous. We must move on to the next step quickly, before the colors have time to dry.

Step 7. The mixture on the palette contains a larger proportion of blue and is very thick, unlike the previous transparent tones. Applying this color to the central right-hand area makes the light clouds very luminous through contrast. With the brush loaded with dense blue, we paint the horizon line. After rinsing the brush and loading it with clear water, we clean the base of the sky along the horizon.

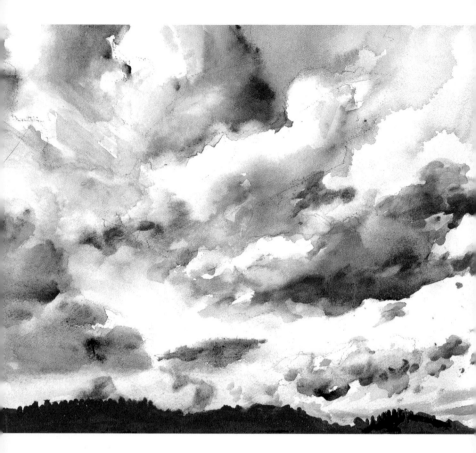

Step 8. In predetermined areas of the sky, we add more color, alternating the individual colors with their blendings. In the dark areas painted previously, we remove a significant amount of color with a wet brush, which must be rinsed continually. Finally, we finish the area of terrain below the horizon with a very dark tone.

Summary

- Because the sky changes constantly, it can be rendered freely, without much worry for capturing reality accurately.

- The sky can be interpreted in any number of ways, depending on the weather's influence.

- In many landscape renderings, clouds are often prominent elements that contribute much to the mood of the subject.

- An approaching storm can be represented by means of extremely dense clouds that are transformed into immense luminous masses against a dark sky.

- Pastel and chalk can be used to draw very luminous and exquisitely beautiful skies.

- The eraser is an indispensable drawing implement for rendering skies.

- The eraser is used to draw the clouds with lines of varying intensities.

- Because clouds are constantly changing, they must be sketched quickly so you can capture the landscape in the conditions you wish to represent.

- The most pronounced contrasts of the clouds can be emphasized with intense dark tones and white.

28

HANDS AND FEET

VERY SIMPLE SHAPES

Any object in nature, regardless of its complexity, can be reduced to a synthesis of basic shapes. This relatively easy exercise demonstrates how to draw a clenched first. The initial simple shapes will help you gradually define more complex forms.

This chapter presents a series of anatomical studies of the hands and feet. Because these extremities are the most difficult parts of the human body to draw, pay special attention to the first steps in establishing the basic shapes that will help you achieve a successful articulation of their forms.

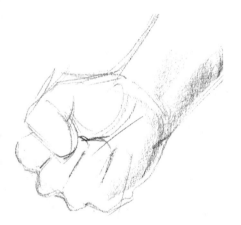

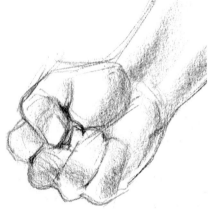

1. A clenched fist can be blocked in as an almost perfect circle and the wrist joined to the hand with a faint line. The fingers can be drawn with almost straight lines, working from the center of the circle. Capturing the way the thumb bends requires special attention to its size and anatomical proportions.

2. Note the joint between the hand and wrist and the curves that arise from it. Within the hand, the fingers are finished with a description of the knuckles, and the volumes of the hand are accentuated. The main dark areas are shaded faintly to achieve an anatomically correct rendering of the bent fingers.

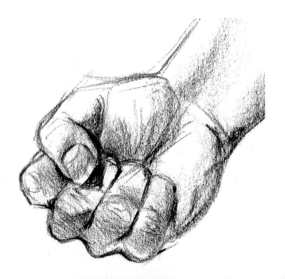

3. Finally, the dark areas are accentuated; the tendons and main anatomical features of the hand are drawn. The knuckles are drawn with gray shadings and the light areas are left blank.

ANATOMICAL STRUCTURE

This exercise involves drawing the back of the hand, relaxed and open.

The anatomical structure will also be the main focus of this drawing. The proportions as so critical that the slightest disproportionate variation in size between the fingers will disfigure the entire drawing.

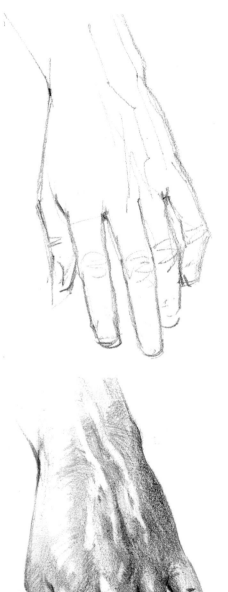

1. Pay special attention to the proportions between the hand, fingers, and the divisions between the different sections of the fingers. It's helpful to draw a simple scheme to ascertain the correct sizes of the fingers, as well as their curvature and length.

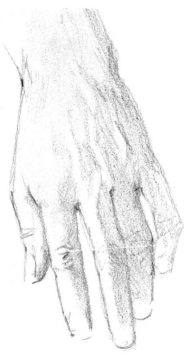

2. The way light articulates the anatomy is studied; then the sketch is reinforced with faintly executed halftone shadings that define the volume, with the eraser used to open the lightest areas.

3. The gray applied in the preceding step provides an excellent starting point for articulating this hand's anatomy. Note how light and shadow interact here to describe the hand's topography. Dark shadows on the fingers help describe their cylindrical forms. Definitive highlights are opened up with the tip of the eraser. Finally, the darkest contrasts are added to define the skin texture.

Hands in a contemplative pose

The hands are very expressive parts of the body. A realistic rendering of the hands requires study and continuous practice. They can be drawn from nature or from photographs, or from works by other artists. This exercise describes how to draw hands in what could be a pose of meditation or patient waiting.

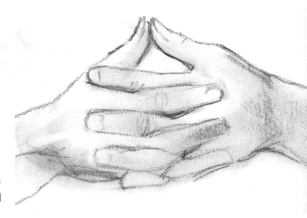

1. The basic shape of these hands can be drawn within an oval. The sizes of the fingers are based on the backs of the hands, although the crossed fingers conceal their source. These shapes are sketched according to their proportions from the back of the hand to the fingers. Anatomical accuracy is called for in rendering both the visible and hidden areas of the fingers.

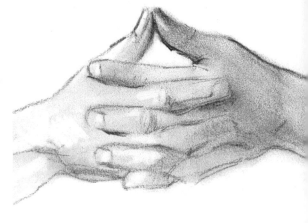

2. Based on the the preceding drawing, a preliminary evaluation is made of the tones that lend volume to the hands and fingers and that separate the areas of light and shadow. Whereas in the last step the hands seemed flat, now they have acquired volume thanks to the differentiation between the light and shadows that fall on them.

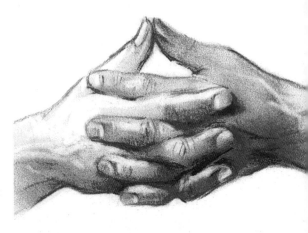

3. The aim now is to achieve the absolute contrasts that will result in a highly realistic rendering. To that end, the dark tones are intensified and highlights are added with white chalk.

THE FOOT

The foot is probably the part of the body that receives the least attention in artistic drawing. Even in anatomical studies it's frequently omitted. More often than not, drawings of the figure are framed above this area. To draw a foot correctly, you must closely observe the joints and the internal anatomy, and the areas where the skin rests directly on the bone and the muscular masses.

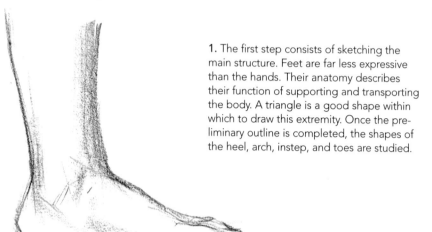

1. The first step consists of sketching the main structure. Feet are far less expressive than the hands. Their anatomy describes their function of supporting and transporting the body. A triangle is a good shape within which to draw this extremity. Once the preliminary outline is completed, the shapes of the heel, arch, instep, and toes are studied.

2. Once the shape of the foot has been outlined, its volumes are defined gradually by modeling the light and dark areas. To define the principal anatomical features, the shadows on the ankle and foot must be drawn with the utmost care.

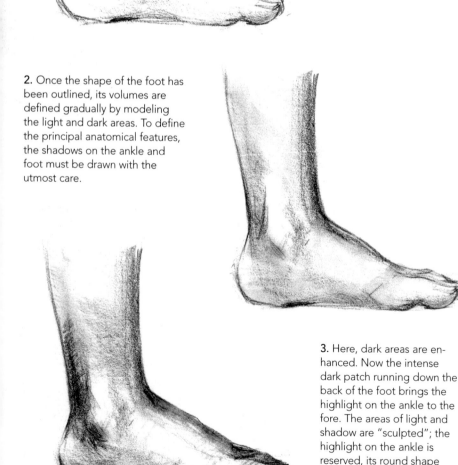

3. Here, dark areas are enhanced. Now the intense dark patch running down the back of the foot brings the highlight on the ankle to the fore. The areas of light and shadow are "sculpted"; the highlight on the ankle is reserved, its round shape now very prominent. The inner volume is drawn with the utmost care.

Woman Fastening Her Shoe

MATERIALS
Blue drawing paper
Sienna, orange, white, and black pastels
White chalk
Cloth, Eraser

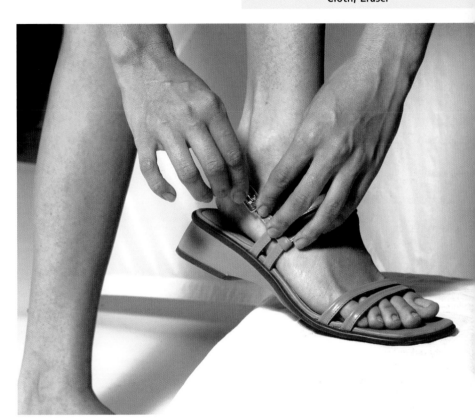

The anatomy of the feet and the hands is so complex that drawing these features can be mastered only with constant practice. This challenging exercise is based on a subject comprising both extremities in positions viewed from different angles, requiring a careful study of their anatomical shapes and the way the interplay of light and shadow defines their forms in space.

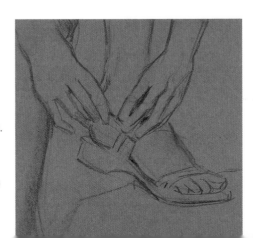

Step 1. Each body part must be understood as a separate unit. To begin, we sketch the hands and foot with basic lines. We also draw the shapes of the fingers and their joints, whose foreshortening lend them a curved appearance. After correcting the shapes, we begin to define the anatomy in orange, a color that contrasts sharply with the blue paper.

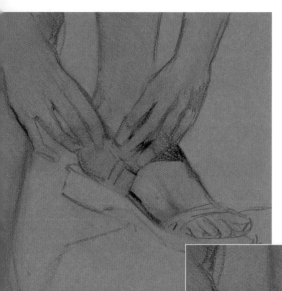

Step 2. The preliminary shading is concerned with defining the areas of light. This shading, executed briskly, facilitates our understanding of the main forms of the hands and the foot. Although these areas are drawn in positive, others are left in reserve (or in "negative"). The background – the color of the paper itself – describes certain parts of the anatomy, such as the gaps between the fingers and their shadows.

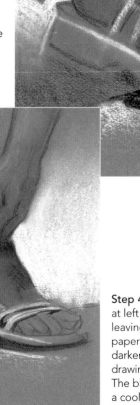

Step 3. In this step we draw the fingers of the right hand and apply color to the calf. We then add tone to the background immediately surrounding the contour of the fingers and the shape of the hands; the color of the paper is merged with the tones of the drawing. We add white to other areas, such as the instep. The light flesh color is arrived at by softening the first tonal values.

Step 4. Now we enhance the tones at left and soften the pastel stroke, leaving the underlying color of the paper partially visible. With black, we darken part of the leg and begin drawing the dark areas of the shoe. The blue color of the paper provides a cool environment that counterbalances the warm tones of the flesh.

Step 5. The highlights blended over the flesh tone help refine the modeling and anatomical accuracy. Even though we are working with a very limited palette of colors, a rich effect results. Using the background blue of the paper as a base on which to bring out halftones makes it easier to interpret the dark areas of the hands with hardly any black. After blending some tones, we highlight them with the white chalk, avoiding excessively strident contrasts.

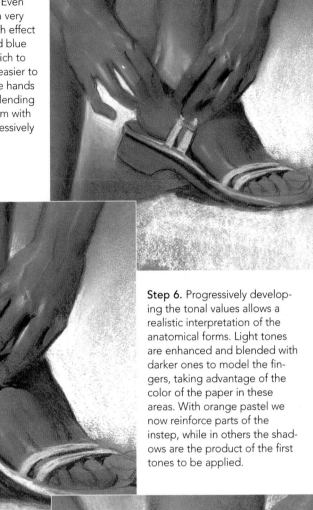

Step 6. Progressively developing the tonal values allows a realistic interpretation of the anatomical forms. Light tones are enhanced and blended with darker ones to model the fingers, taking advantage of the color of the paper in these areas. With orange pastel we now reinforce parts of the instep, while in others the shadows are the product of the first tones to be applied.

Step 7. Now we focus on modeling the fingers. The use of black here is essential for defining the hand's profile. After softening the tones in this area, we accentuate the finger bones with orange (note the close-up of the right hand). The index finger of the left hand is barely touched; it appears to fade into shadow.

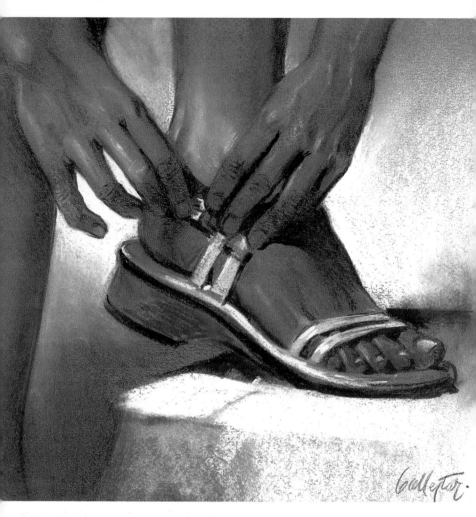

Step 8. We add the last highlights in orange, and a few hints of white blended with the fingers indicate the presence of veins in the left hand. The fingers are drawn with orange. We intensify their shape with black and add some white to the fingernails. Finally, the white background is lightened, which makes the contrasts even stronger.

SUMMARY

• The hands and feet are the most difficult parts of the body to draw.

• Establishing the basic shapes of these complex body parts is extremely important in drawing their anatomical forms correctly.

• A clenched fist can be blocked in using a circle.

• When drawing hands and feet, it's important that you to establish their correct anatomical structures and proportions.

• It's recommended that you begin any drawing of these features with simple schemes.

• Rendering anatomical structure relies both on outline and on modeling shadow and light.

• The hand is one of the most expressive parts of the human body.

• Study the interplay of light and shadow on the hands and fingers to interpret poses and foreshortening of these features in drawing.

29

FLOWERS

UNDERSTANDING COMPLEX SHAPES

Although the main characteristics that define flowers must be respected, it's not necessary to draw their every detail. What is important is that you convey the textures correctly and treat the different angles of the petals and leaves like geometric planes. In the following exercise, the first two steps are the crucial building blocks that will allow you to proceed to more complicated phases.

Flowers can be considered an almost independent genre, as they are very specific elements of nature. But they're not easy to render realistically. This chapter provides solutions to some of the technical difficulties entailed in drawing flowers of varying degrees of complexity.

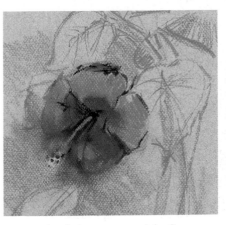

1. To understand an object, study its internal structure. This is especially important with flowers because sometimes their texture or their position in relation to the viewer can cause confusion. This flower's basic shape can be sketched within a circle, from which the petals can be drawn in detail. After a line drawing is executed, the precise shapes of the petals, leaves, and branches around the flower are drawn with the eraser.

2. Here, the dark areas around the flower are shaded in, leaving the shapes of the leaves clearly defined. The flower is drawn in sanguine and the first contrasts are intensified with an earth tone. These dark areas convey the depth and curvature of the petals. Tones in the lower part are blended; then some of the petal's tone is dragged toward this area. Thus, the flower is integrated with its surroundings.

3. The strongest contrasts in the flower and in the lower part of its surroundings are drawn with black pastel. The fingertips are used to merge the dark tones with the lightest ones. The brightest highlights are drawn with white chalk and are softened in the background; in this way the paper becomes an intermediate value between the tones of the drawing.

FROM STRUCTURE TO DETAIL

Since it's easy to get lost among the multiple details of a floral subject, it is useful to divide the process of draw-ing it into specific phases. The first thing you should concentrate on is the drawing's basic structure. Only after you've established this framework can you begin to develop the drawing further, filling in the details and, at last, adding the finishing touches.

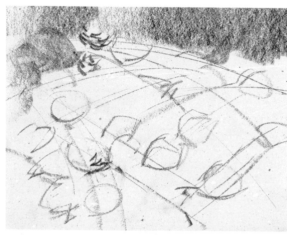

1. The most important thing to remember when drawing a large bunch of flowers is to forget about the details. The main shape must be captured as an almost linear scheme. You can adapt your subject to the most suitable composition. Here, each flower is represented by an oval shape. The background is shaded with the Conté crayon held between the fingers and applied flat over the paper; then a first appraisal of the tones is made.

2. The volumes of the main flowers are drawn with the tip of the Conté crayon. The dark areas of the background are shaded in, leaving the mass of flowers reserved as the color of the paper. Then the strongest contrasts are drawn in the upper area.

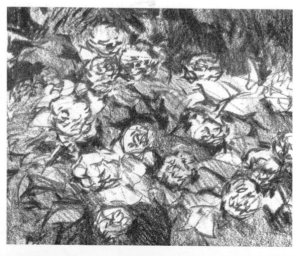

3. The background is shaded with sanguine. Note the gradation of the dark tones: the light color of the paper is left intact in the areas of the flowers; the background is shaded with a halftone, and the densest shadows are indicated with an intense dark tone. These dark areas isolate the flowers and integrate the halftones with the whole. The most prominent contrasts between the closely woven petals are shaded with very intense strokes.

THE IMPORTANCE OF TEXTURE

Once you've resolved the main structure and the first contrasts that set off the flowers, you now must establish the visual priorities in the drawing, areas in which there is a marked difference between the flowers and the background foliage. Textures are what define each ground. In this phase, contrasts are added by combining blended areas with patches of direct color to complete this floral motif.

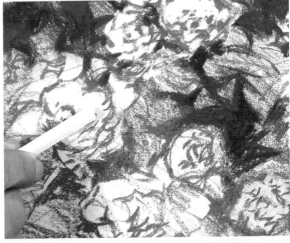

1. Sienna is used to selectively darken the deepest-toned areas of the work. The tonal values of the background are assessed; the two flowers at the top are now brighter and more prominent due to the effect of simultaneous contrast. Work on the details starts with the highlights, which are drawn with white chalk; this intensifies the light color of the paper, which becomes integrated as a very luminous gray.

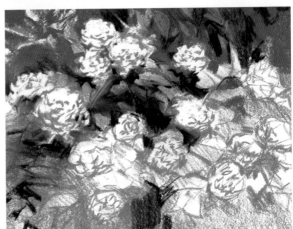

2. Work on the highlights continues and the flowers acquire significant presence. Dense dark tones are applied in the background to segregate and outline areas that were originally dark. The progression of the dark tones forms a good base that can be softened and blended with the fingertips. The leaves in the background are drawn slightly blurred, which makes the flowers radiate intensely and reveals their texture.

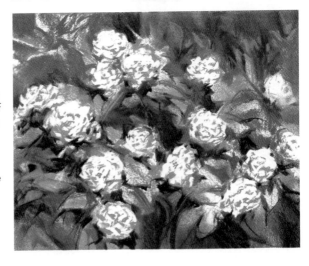

3. The background is darkened in a way that allows glimpses of the shapes of the branches and leaves. Many of these tones are blended with the fingertips, while taking care that the drawing is not covered over completely. Some areas of the flowers are retouched with the white chalk to make their texture more luminous and contrast the blossoms against the background tones.

CONTRASTS
BETWEEN LEAVES

The subject for this exercise is a group of sunflowers set against a dense, closely woven background. The most brightly lit petals will be represented solely by the color of the paper, while the various gray tones applied to them will define the placement of the flowers within their setting, as well as the composition's light source. Note here how the flowers' dark centers are exploited to heighten the interest of the work.

1. The sketch of the sunflowers, drawn softly with the tip of a charcoal stick, has been kept simple. The main flower has a very precise circular shape, with a well-defined center. Just above this sunflower, two more are drawn; the one directly above the main flower is oval and the other is triangular.

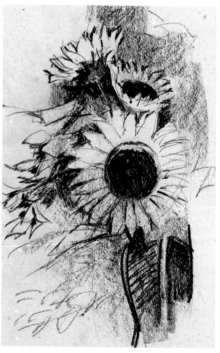

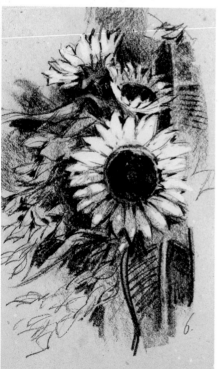

2. The space around the sunflowers is shaded with different degrees of intensity, as if it were being drawn in negative. These contrasts leave both the sunflowers and their surroundings almost completely defined.

3. Contrasts between the leaves reveal their texture. The dark areas are drawn with intense tones; the petals are outlined and a few lines are added between them. The variety of dark areas here helps to define certain details. White chalk is used to highlight the brightest areas as the picture's focal point.

Roses

MATERIALS

Green drawing paper
Sanguine Contè crayon and dust
White and sepia chalk
Bristle brush, Eraser, Cloth, Fixative

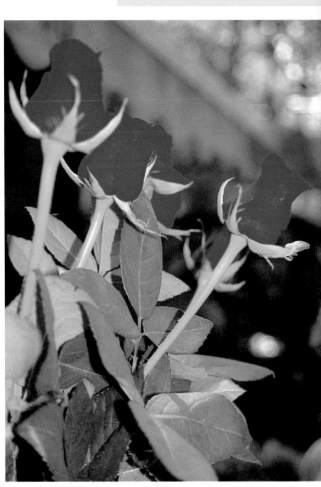

Roses are among the most beautiful flowers to draw. This demonstration involves all the techniques that have been covered in this chapter, although the main focus here is on rendering the flowers' texture, and on integrating the subject with its surroundings. The exercise requires the use of a paintbrush (one with hog's hair bristles) and powdered sanguine. The preliminary sketch needn't be elaborate, although it should capture the essence of the subject as a whole.

Step 1. If you look closely at the photograph, you'll see that these flowers can be blocked within a single form. Using the Conté crayon, we draw several basic lines that determine their separation and slant. With the bunch blocked in, we draw the basic shape of each rose and its leaves. Once the preliminary forms are completed we can begin to draw the structure of each flower.

Step 2. We load the brush with sanguine dust and proceed to darken the buds and the main dark areas between the leaves. The bristle (hog's hair) brush lets us create very faint tones and reduce the prominence of the darkest lines. We apply a very soft tone in the center of the rose, which sets off a light area that is left open and appears to indicate the flower's volume.

Step 3. In the same way we began the work, we now use the brush to accentuate the dark areas and the tip of the Conté crayon to reinforce the lines of the stalk. With the eraser, we open up and correct areas that must remain light.

Step 4. We draw the areas of maximum contrast in the roses with the tip of the Conté crayon. The base of the flower is described with these tones, while the sepals are left in reserve. The work executed with the brush lends an interesting atmospheric quality to the flowers. We again draw with the eraser, opening up the lines that define the stalks and some of the most important highlights.

Step 5. The entire work has been drawn with sanguine up to this point. With the tones throughout the composition well defined by now, we can begin to add the most pronounced shadows and highlights. We apply the sanguine directly, profiling the leaves and letting the green hue of the paper serve as their color.

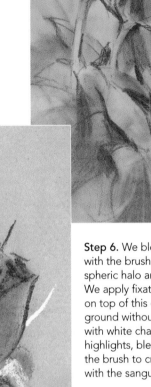

Step 6. We blend the new tones with the brush, leaving an atmospheric halo around the flowers. We apply fixative so we can work on top of this ethereal background without damaging it. Now with white chalk we draw the first highlights, blending them with the brush to create a gradation with the sanguine.

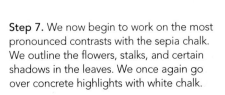

Step 7. We now begin to work on the most pronounced contrasts with the sepia chalk. We outline the flowers, stalks, and certain shadows in the leaves. We once again go over concrete highlights with white chalk.

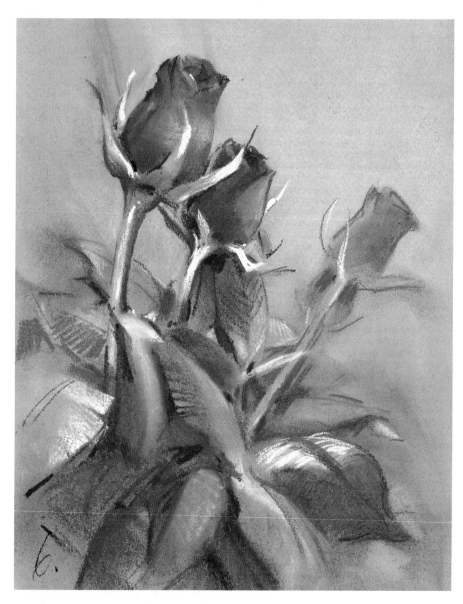

Step 8. The last phase involves reinforcing specific contrasts. Some of the dark areas model the volume of the two roses on the left, while the third rose is left very soft to achieve a perfect atmospheric effect. Finally, the contrasts are elaborated in the lower half of the composition, leaving the upper half much freer and more open.

SUMMARY

• Flowers can be drawn with a certain degree of freedom in terms of composition and detail, although the main characteristics that define them must be respected.

• Any floral form, regardless of its complexity, can be reduced to basic shapes.

• A realistic rendering of a flower depends on the lights and darks that surround it.

• In a floral motif, view the angles of petals and leaves as geometric planes.

• The texture of flowers varies widely, with simple or complex shapes.

• Priority must be given to the principal shapes of the flower.

STUDYING TERRAIN IN THE LANDSCAPE

DIFFERENT POINTS OF VIEW

The viewer's position with respect to the land determines the composition of a landscape. Depending on the vantage point, the sky may take precedence over the ground, or vice versa. The following three examples have been drawn with felt-tip pens, a medium that will be used throughout this chapter.

The landscape has any number of features – trees, grass, rocks, mountains, clouds, bodies of water, architectural elements – and of course, the ground itself, the terrain. The variety is almost endless, from a flat, windswept plain to a sere, sandy desert, to rolling green hills or a muddy field. Let's study a few of the terrain's possibilities for artistic expression.

1. The horizon line here is very high; only a small portion of sky is visible, so that the land dominates the scene. Note the perspective here: the rushes in the foreground appear tall, whereas the rest of the elements decrease in size as they recede into the distance.

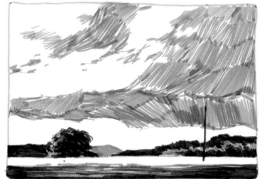

2. In this example, the horizon line is very low. The terrain is relatively unimportant with respect to the sky. Note how the terrain has been resolved. There is barely any difference in tone between the foreground and the background. With the sky so important here, the clouds have been rendered as somewhat spectacular forms.

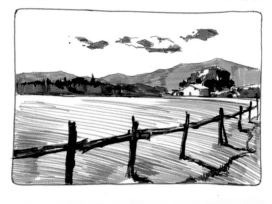

3. In this landscape the position of the horizon line gives equal importance to foreground and background alike. Of the three examples reproduced here, this is the least dramatic and the most objective. The perspective does not appear overly pronounced even though it is evident.

Different terrains

Land can be drawn in a number of ways, depending on how wet it is, the type of vegetation that grows there, and the effect of the intervening atmosphere. The appealing features of a desert landscape will differ significantly from those of a muddy or rainy landscape. To develop your understanding of a given terrain, try to draw it during different seasons and under various weather conditions.

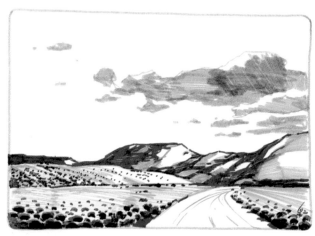

1. This is a semi-desert landscape, an arid terrain with rocky mountains and scrubby vegetation. Here, drawing directly with a felt-tip pen, the first shading was applied with a faint gray, then the darker tones of the shadows on the mountains were added. The vegetation in the foreground and middle ground was drawn with simple patches of dark green.

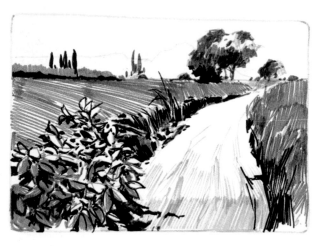

2. The lush, wild vegetation of this terrain is characteristic of a rainy season. The hatchlike shading leaves no doubt as to the surface of the land in the middle ground; emphasis has been placed on the thick vegetation growing along the roadside.

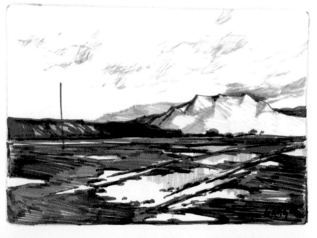

3. This is possibly the most spectacular type of landscape. A muddy, waterlogged field offers a number of approaches and a wide range of possibilities in terms of surface textures and treatments. The pools of water were first reserved; sap green was then applied all over the terrain with a brisk stroke, and was subsequently enhanced with shadings of sienna.

RAIN-DRENCHED TEXTURES AND MUD

A muddy terrain is the subject of this exercise, which involves combining a point of view with a pronounced perspective. The main aim is to render the surface of the land correctly and create a suitably dramatic atmosphere. Pay special attention to the process of gradually adding tones.

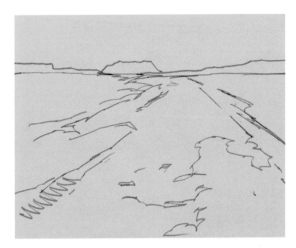

1. With a gray felt-tip pen, the motif is sketched with a clean line that describes the high horizon and a somewhat abrupt relief. A clear distinction is established between the different levels of the terrain. The line separates the waterlogged area from the drier muddy surface. The direction of the trail, whose faint sketch lines are based on the puddles, is drawn with a somewhat pronounced linear perspective.

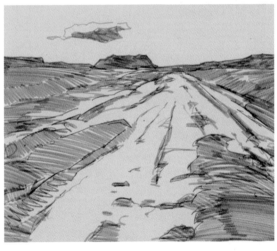

2. With the same gray felt-tip pen, the land is shaded, leaving the most luminous areas of the pools of water blank. The direction of the stroke describes each type of terrain. This base tone is essential for the subsequent work. Like other transparent mediums, felt-tip pens must always be worked from light to dark, so that superimposed tones darken underlying ones.

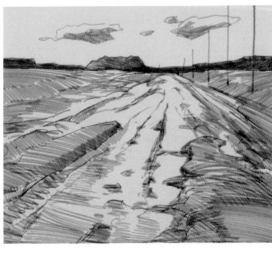

3. The varying levels of the terrain are indicated through an intensification of tones. The same pen is used as before, although new strokes applied over ones of the same color noticeably intensify the tones. In this way the silhouette of the mountains is darkened.

THE TEXTURE OF MUDDY GROUND

When drawing muddy surfaces, pay attention to the contrasts corresponding to the different heights of the terrain, as molded by nature (and here, tire tracks) in which water and earth are combined. The darkest tones express such contrasts.

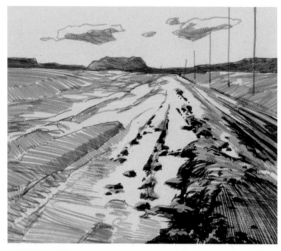

1. A black felt-tip pen is used to establish the most important contrasts that allow the direction of the light and the height of the land to be differentiated. The stroke, applied over the previous gray tone, is rapid and gestural. Next to it, several contrasts are added that define the areas of ground above the level of the pools of water. The direction of the strokes enhances the perspective.

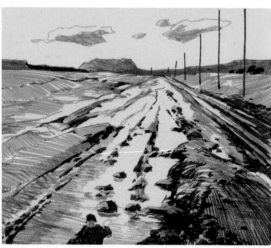

2. Still drawing with the black felt-tip pen, the main contrasts are applied over the terrain, so that the mounds give rise to a luminous area that is understood as being wet. To look convincing, the light must fall from a specific direction. The tiny black patches clearly define the small furrows and irregularities in the terrain in the lower left-hand corner.

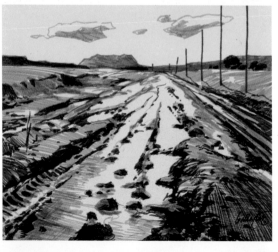

3. In the same way the gray tones were layered in the first step to bring out the masses of earth, so the black is now employed, leaving many areas in reserve that were previously gray and are now understood as light. Without saturating the surface of the paper, the vertical walls of the terrain are represented as dense dark patches.

Muddy Landscape

MATERIALS

Satin-textured drawing paper
Felt-tip pens

Throughout this chapter, we have explored various ways to draw the surface textures of the land. The subject selected for this exercise is a muddy field with deep, waterlogged furrows. Rendering it entails some degree of difficulty, and drawing with felt-tip pens is not the easiest of techniques, since you have to start with the lightest tones and superimpose darker ones on top to obtain the darkest contrasts. Keep in mind that a dark tone applied at the start of the drawing can't be altered throughout the rest of the process.

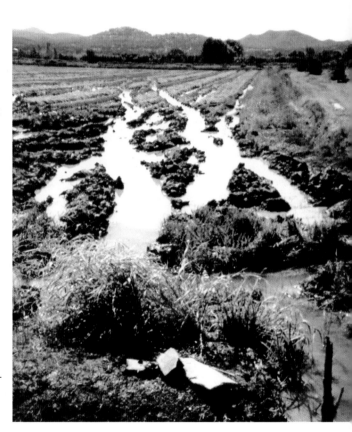

Step 1. We sketch the landscape with a brownish gray color, including the horizon line and the outline of the mountains. A vanishing point to which the main vanishing lines will converge is indicated on the horizon line. We draw the entire foreground as a series of lines indicating the areas to be left in reserve.

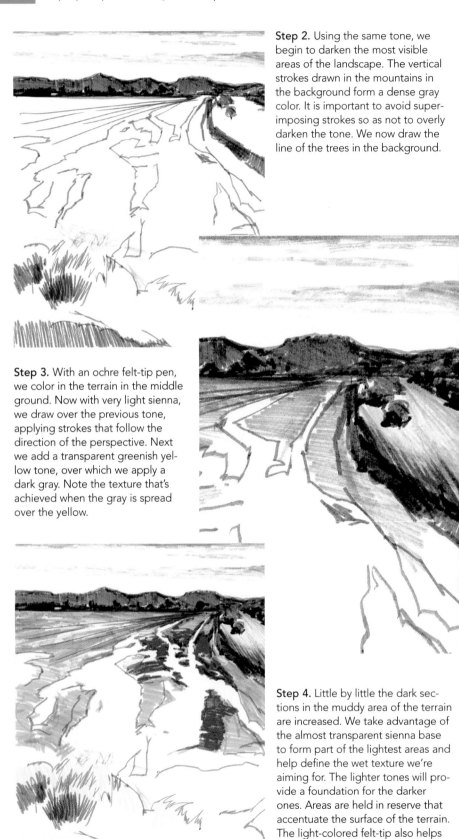

Step 2. Using the same tone, we begin to darken the most visible areas of the landscape. The vertical strokes drawn in the mountains in the background form a dense gray color. It is important to avoid superimposing strokes so as not to overly darken the tone. We now draw the line of the trees in the background.

Step 3. With an ochre felt-tip pen, we color in the terrain in the middle ground. Now with very light sienna, we draw over the previous tone, applying strokes that follow the direction of the perspective. Next we add a transparent greenish yellow tone, over which we apply a dark gray. Note the texture that's achieved when the gray is spread over the yellow.

Step 4. Little by little the dark sections in the muddy area of the terrain are increased. We take advantage of the almost transparent sienna base to form part of the lightest areas and help define the wet texture we're aiming for. The lighter tones will provide a foundation for the darker ones. Areas are held in reserve that accentuate the surface of the terrain. The light-colored felt-tip also helps to soften the dark tone and create a gradation.

Step 5. With the dark sienna felt-tip pen, we draw the entire foreground and enhance the perspective of the terrain as it recedes toward the background. The areas left blank form part of the surface texture of the muddy mass. The grass in the foreground is drawn with direct strokes of green that blend with the underlying yellow. Then to these direct mixtures we add some luminous orange tones.

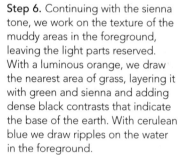

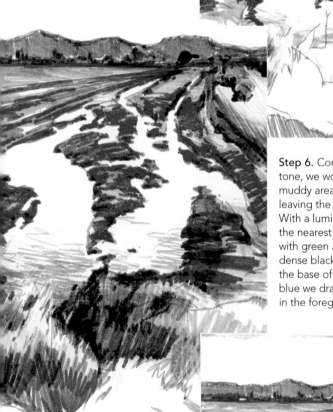

Step 6. Continuing with the sienna tone, we work on the texture of the muddy areas in the foreground, leaving the light parts reserved. With a luminous orange, we draw the nearest area of grass, layering it with green and sienna and adding dense black contrasts that indicate the base of the earth. With cerulean blue we draw ripples on the water in the foreground.

Step 7. Now we turn our attention to the most intense contrasts. We add sienna to complete several areas in the background and brown tones in the middle ground that indicate a variation in the light, using black in discrete areas to render the appropriate texture there. Some gray and sienna are added to the grass, executed with loose directional strokes in accordance with the texture of the vegetation.

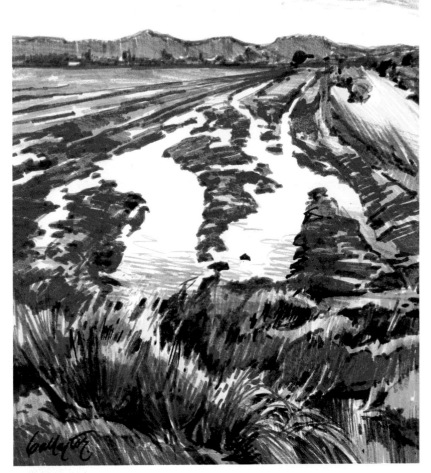

Step 8. The last step involves using black to denote the darkest areas of the vegetation and the most intense contrasts in the grass. A gray felt-tip pen is used to blend these blacks and create halftones that offset the yellow tones.

SUMMARY

• The viewer's position with respect to a landscape can result in truly original approaches to the drawing's composition.

• Even a slight variation in the location of the viewer's vantage point can result in an entirely different landscape perspective.

• With a very high horizon line, only a small portion of the sky is visible.

• With a very low horizon line, the terrain loses compositional prominence in relation to the sky.

• A horizon line that divides the paper in half creates a balance between the two planes of sky and earth.

• Terrain can be drawn in a number of ways, depending on how wet or dry it is, the vegetation, and even the intervening atmosphere.

• Muddy terrain can offer some especially striking artistic results.

• The texture of muddy ground is made interesting through contrasts that indicate the variations in height of terrain that combine both earth and water.

CATS AND DOGS

THE PROPORTIONS AND ANATOMY OF THE LEGS

The legs can be one of the most complicated parts of an animal to draw. Because cats and dogs are two separate species, naturally their anatomies differ. But the various breeds within each species also differ in terms of the leg's anatomy, sometimes with marked contrasts in shape and size, as you can see in the examples shown below.

As you've seen in two previous chapters devoted to them, animals are popular artistic subjects. Common pets like cats and dogs deserve special attention, since so many of us draw them frequently. This chapter is devoted to studying the unique characteristics of their anatomies and illustrating our household friends on paper.

1. These are the legs of a large dog. The front legs are straight, with a pronounced joint at the paw. The basic forms of these legs are based on a slight curve, with the angles becoming more acute at the joints. In the hind legs, the muscles are more powerful and the joints combine half of the leg and the paw. Shading plays an important role in rendering these parts of the body, since they define the muscles, especially in shorthaired animals.

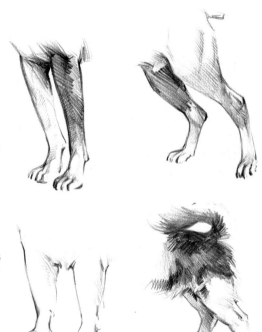

2. Small dogs have more compact joints. The shapes are less straight, and the animals' smaller size makes the legs look thicker. The hind legs are similar in their reduced shapes and the volume of their muscles. This picture shows a longer-haired dog, so the muscles are covered up by the fur.

3. A cat's legs are sinuous and delicate. A comparison of the leg anatomies of cats and dogs reveals marked differences in their structures. Drawing them from basic schemes helps you appreciate the bending points of each joint.

OUTLINE AND SKETCH
OF A CAT

In its movements, the position of its legs, and the way it reclines, a small domestic cat is anatomically similar to its larger relatives. As with any drawing of an animal, the initial sketch is of prime importance, since the drawing will have to be very precise from this point on.

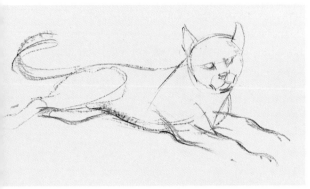

1. Always begin a sketch from the general to the specific, leaving out details and summarizing the main volumes with basic shapes. We start the head with a circle, then gradually develop it into an almost triangular shape as we sketch in all of the cat's features. Once these shapes have been established, we proceed to the rest of the anatomy.

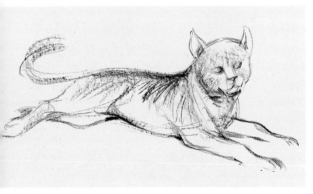

2. The shapes become more specific with the addition of more intense lines. The upper contour of the body is drawn with the flat side of the charcoal, while the lower contour is sketched with the point. The first dark areas are drawn by pressing lightly to avoid saturating the pores of the paper.

3. The lines are reinforced by increasing the shading without losing sight of the anatomical shapes. In this example, only the front of the cat is completely finished. The texture of the skin is added and the facial features are enhanced using various light, loose lines. The lighter areas are colored in with white chalk.

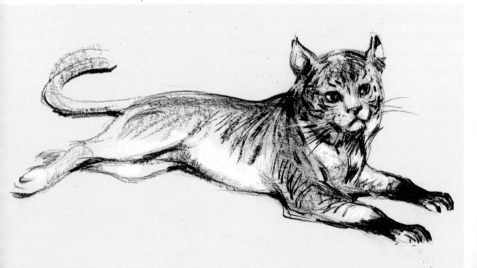

THE HARMONY AND PROPORTION OF A DOG'S BODY

Drawing a dog isn't easy, and drawing a puppy even less so. Since it's almost impossible to keep a puppy still long enough to draw it, it is gener- ally advisable to draw puppies from a photograph in order to learn the basics of their anatomy. Distinguishing a fully grown dog from a puppy is mainly a question of proportion. In this drawing of a puppy, the legs, ears, and facial features are proportionally larger than those of an adult dog.

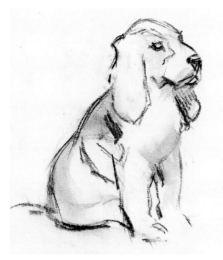

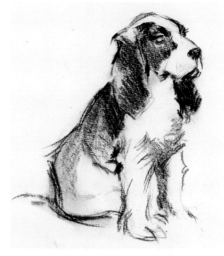

1. After making a sketch that outlines the dog's basic forms, we redefine the animal's anatomy with lines that are progressively more sure and precise. The basic volumes should include the fur. The eyes, ears, and muzzle are proportionally larger than those of an adult dog. This set of basic forms will become more refined as work progresses.

2. The first contrasts start to breathe life into the drawing, the dark areas delimiting the lighter ones, even though in general the lines remain soft. Certain dark areas are added in the rear areas of the dog with the flat side of the charcoal.

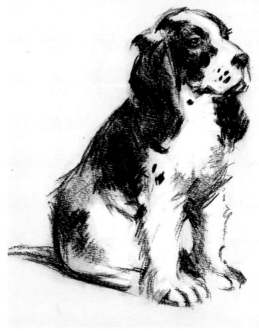

3. We now intensify the dark areas by applying more pressure. Rather than lines, this drawing is based on tonal patches that define the animal's shape. The fur on the legs is drawn with very light lines to suggest the texture. The lightest areas are colored in with white chalk, whereas other sections merely allow the color of the paper to show through.

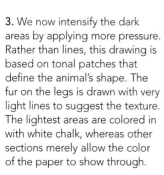

A DOG'S HEAD

A dog's head is a very attractive subject that has undeniable appeal for canine lovers. This exercise uses very light lines to obtain an almost photographic result, and illustrates the importance of the initial sketch as a basis for later shading.

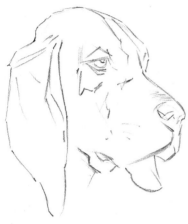

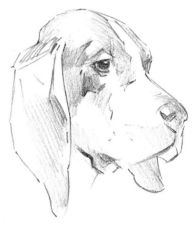

1. The barely discernible lines of the initial sketch have been enhanced here by firmer strokes. The skull was sketched as a circle and the muzzle as an oval. The contour of the skull forms a sharp angle with respect to the eye, which intersects with the line delimiting the muzzle's upper edge. This process involved numerous corrections until each feature was perfectly placed.

2. The previous outline allows us to distinguish between the light and dark areas that will define the shading and texture of the head. The lines are soft and should be drawn in the same direction and with uniform intensity in each section. The ear is drawn with one long line. The lines are more intense around the eye; in contrast, the nose is barely visible at this stage.

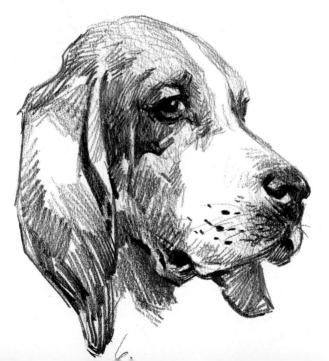

3. Working from the previous base, the shades become more intense thanks to stronger strokes that darken each feature on the head. The lines are especially clear on the ear, where the strokes of graphite are clearly visible. In contrast, the strokes in the front area are so light that the lines are barely noticeable. They become increasingly intense near the eye to show the texture of the skin. This interplay of different lines and strokes helps define the textures of the head.

A German Shepherd

MATERIALS
Vine and compressed charcoal
White chalk
Drawing paper
Fixative, Eraser

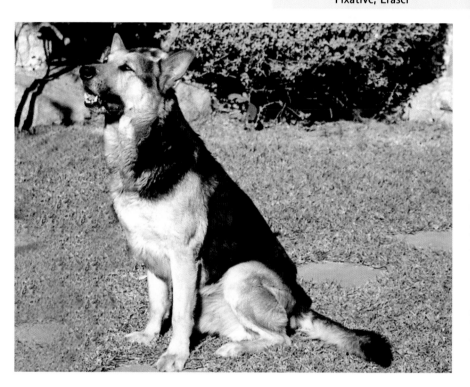

Drawing animals is always a gratifying experience, especially for animal lovers. Many artists have a dog as a pet, an ideal subject for exercises like the one suggested here. In this case, the model is a German shepherd, an exceedingly noble and elegant animal. Base the dog's contours on observation, and avoid concentrating on only the external appearance. The studies of legs illustrated previously should provide a basis for understanding their posture and organizing the entire drawing.

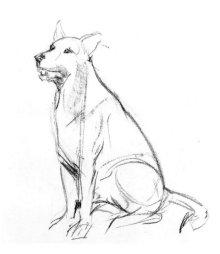

Step 1. Carefully observe the model and reduce its basic forms to simple geometric shapes. Here, with soft vine charcoal, the entire body is sketched inside a right-angled triangle, with the front legs along a vertical axis, the hindquarters shaped as two circles and the head as an oval. Once these shapes have been established, we redraw the entire subject with lines that connect the extremities and integrate them with the body. The head should be drawn with great attention to detail. Note especially the proportions of the elements that make up the body.

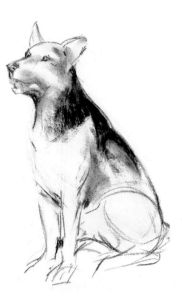

Step 2. After applying fixative to the initial sketch, we intensify the dark areas with compressed charcoal, especially on the back of the dog, where the color should be applied densely, since there are no light patches in this area. We blend the color with our fingers in the area of the abdomen near the leg. At this point we can erase the preliminary lines that helped establish the shape of the legs, since they are now visually distracting.

Step 3. We now darken the dog's back, working gradually so as to study the animal's volume. Compressed charcoal doesn't blend as easily as vine charcoal, but it's ideal for creating dense tones that are rich in contrasts. We then darken the dog's chest and add fine lines to suggest the texture of the fur. On the head, we blur the area around the mouth and add some darks.

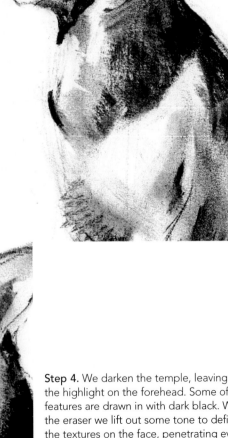

Step 4. We darken the temple, leaving out the highlight on the forehead. Some of the features are drawn in with dark black. With the eraser we lift out some tone to define the textures on the face, penetrating even the darker grays around the mouth. We now go over the mouth, defining the muzzle with shading but leaving the highlights clean.

Step 5. The dark areas are given more intensity by pressing hard on the compressed charcoal to create almost opaque tones, allowing some of the softer grays created by the vine charcoal and a few of the highlights to come through. Be careful in applying compressed charcoal with maximum pressure, because the very dark marks that result are difficult to erase.

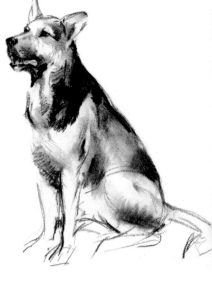

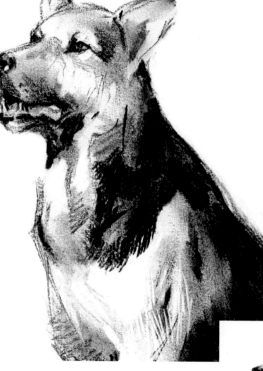

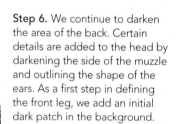

Step 6. We continue to darken the area of the back. Certain details are added to the head by darkening the side of the muzzle and outlining the shape of the ears. As a first step in defining the front leg, we add an initial dark patch in the background.

Step 7. We add a sharp contrast to the background of the front legs, which makes their light color stand out and clearly defines their shape. An intense, slightly blended dark shading is applied to the abdomen on top of the shading applied previously. Finally, we clearly define the animal's right foreleg (here, the one to the viewer's left), which recedes in the picture plane.

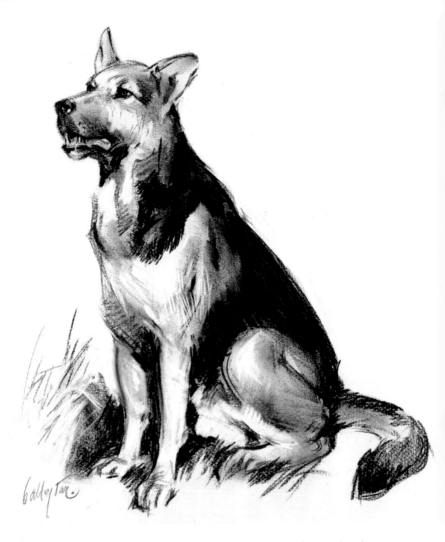

Step 8. We finish drawing the legs and the tail and refine the background to delimit the lower part of the hind legs. The front legs are outlined by the dark areas surrounding them, and a few lines are added to articulate the paws as well. Finally, we blur the tail and then add some contrasts to suggest the texture of the fur.

SUMMARY

- A good drawing of an animal should always be based on careful observation and analysis of the model.

- An animal's legs are the most complicated parts to draw.

- The anatomy of a domestic cat is very similar to that of the great felines.

- A dog's front legs are straight. Special attention should be paid to the joint of the paw.

- The angle of the legs becomes sharper at the joints.

- Puppies have a more compact structure than fully grown dogs do.

- As with any subject, the initial sketch should be based on simple geometric shapes.

- When drawing a dog, it is essential to find the correct proportions of the basic elements, which apply to both puppies and adult canines.

- The initial sketch of a dog's head is of prime importance, since it constitutes the basis for later shading.

THE FACE: COMBINING FEATURES

SKETCHING THE FACE

Once you've determined the proportions and positions of the facial features, the portrait can be treated in a direct and spontaneous manner. This approach lets you record the features of your subject easily. Vertical and horizontal axis lines create a basic structure on which the you can flesh out the definitive shape and characteristics of the face. This exercise is drawn with sienna and black pastels.

Various chapters throughout this book have been dedicated to different parts of the face. This chapter focuses on combining all the facial features and articulating your subject's expression. There are various ways to draw the face, some of which are covered here. Here, regular pastels and pastel pencils will be used.

2. *Right*: The lines and tonal patches of the first step are softened with the fingertips, blurring many forms that now must be re-defined. The lightest areas are opened up with the eraser, describing the most evident shapes, while one side of the face is in shadow. The darkest areas are drawn with black pastel.

1. *Above*: The head is sketched with the flat side of the sienna pastel to quickly establish its general volumes; axis lines are added so you can position the features accurately.

3. *Right*: The dark areas that define some of the main features, such as the eyes, are enhanced and the contrasts in the shadowed areas are increased. Applying the pastel flat on the paper facilitates all manner of strokes and produces blacks that can be subtly integrated with the rest of the tones. Finally, the eraser is used to open up highlights that will lend the appropriate shape to the face.

SIZES AND PROPORTIONS

The portrait is by far the most challenging and complex of genres, as it calls for a knowledge of the face and an interpretation of the subject's inner self. No matter what technique or medium you use, the objective is always the same: to obtain a likeness and interpret the personality of your subject. This exercise presents a procedure for drawing a portrait with pastel pencils, and focuses on attaining accuracy in the measurements and proportions.

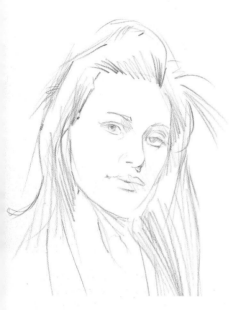

1. A sketch is drafted with a sienna pastel pencil. Pastel is ideal for this task, given that incorrect lines can be erased easily with a cloth or an eraser. The lead should not be too sharp, and it's important not to exert too much pressure on the pencil. This first phase requires a study of the sizes and proportions of the face; the distance between the eyes and forehead, the fullness of the lips, the shape of the nose, and the dimensions of the face must all be correctly calculated.

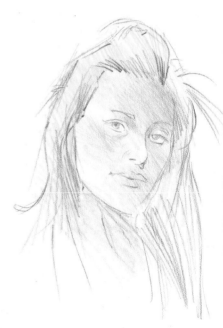

2. With the shape and main characteristics of the face resolved, the entire right half of the face is shaded faintly to make the left half appear brighter. The hair also forms part of the portrait, and here it is interpreted with yellow shading.

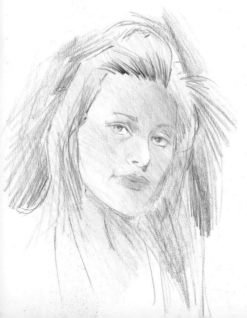

3. Pastel is an extremely versatile medium that allows all tones to be layered one over another. Light colors can be painted over dark ones, and vice versa. Here, the main dark areas that comprise the facial features are defined with a gray. Blue and gray are added around the head to separate it from the background.

VOLUME AND RELATIONSHIPS BETWEEN THE FEATURES

Establishing the volume of the face should be approached very carefully, since one badly situated tone can destroy the harmony of the features. Continuing on from the previous stage of this exercise, the task now is to relate the volumes generated between the light and dark areas and correctly balance each feature with all of the others in the composition.

1. The fingers are used to soften the layer of color on the paper's surface. Be sure to do this with clean fingers; oil or sweat can prevent subsequent colors from being applied on top. With this tonal layer gradated, it is easier to increase the contrasts progressively. The volumes are now better situated.

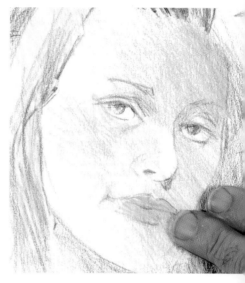

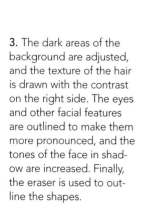

2. The texture of the hair frames the face, with dark strokes defining the roots and some stray hairs included. The dark area of the flowing hair profiles the right half of the face in semidarkness. After intensifying the dark areas of the face, the eraser is used to accentuate the highlights.

3. The dark areas of the background are adjusted, and the texture of the hair is drawn with the contrast on the right side. The eyes and other facial features are outlined to make them more pronounced, and the tones of the face in shadow are increased. Finally, the eraser is used to outline the shapes.

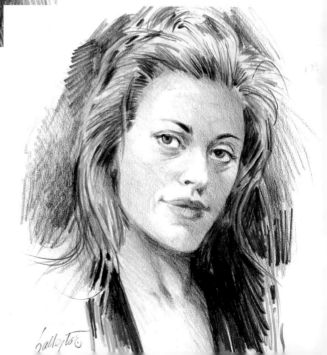

HIGHLIGHTS AND TONES

Executing a portrait on colored paper can be very gratifying, as it gives you an extra hue to work with. It's especially important when you're drawing with a limited range of colors. This exercise demonstrates how to create a composition based on highlighting and reserved areas. The subject, a child, is a bit difficult and requires you to muster all your skills to capture his innocent expression.

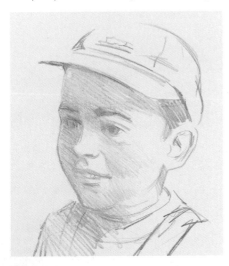

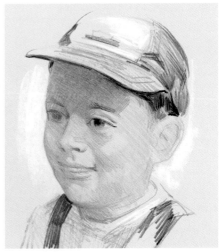

1. A light shade of sanguine is used to sketch the face. The proportions of a child's face are not the same as those of an adult. Children's features are more rounded, and the expression reflects innocence. Once the features have been situated, the main shadow is indicated with a faint tone. The first highlight is opened up on the nose.

2. The shadows on the face are drawn, with careful attention paid to the one on the right side of the forehead. The nose and mouth are now redrawn. The more the contrast in the face is adjusted, the more the other elements can be increased; here, the brightest areas of the face are lightened simultaneously. The right side still retains a tone akin to the color of the paper.

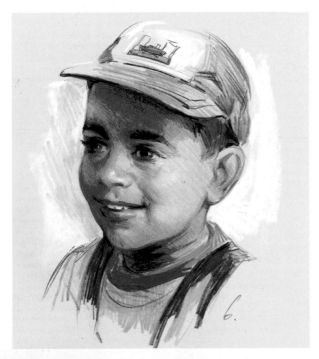

3. In this step the definitive contrasts are resolved. Red tones are applied in the shadow of the cheek and the forehead. Much more intense tones are obtained with burnt umber and black. Values added to the mouth bring out the child's lips and smile. The white highlights indicate the direction of the light source and enhance the expressive quality of the portrait.

Portrait of a Young Woman

MATERIALS
Cream-colored paper
Pastel pencils, Eraser
Fixative, Cloth

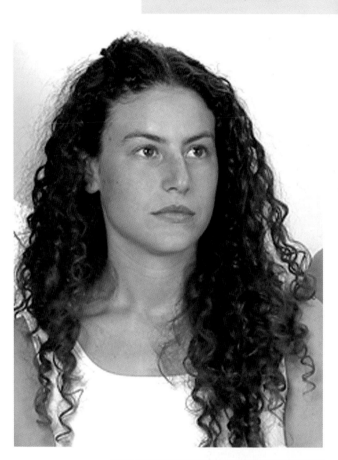

Portraiture is a difficult genre, even for the experienced artist. A good portrait requires you to achieve both a likeness of the model and a reflection of the subject's personality insofar as you and your sitter know each other. The model we've used for this demonstration has a number of unique characteristics that reveal something of her personality, like the depth of her gaze and a slight smile that will be interpreted here as a contained seriousness.

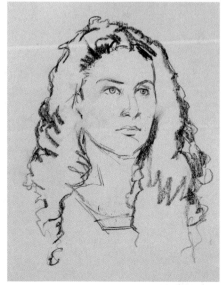

Step 1. Two important aspects must be taken into account in order to draw this portrait: the space occupied by the oval of the model's face and her hair, and the space that exists between the image and the borders of the paper. The features should always be situated in a preliminary drawing. For the moment, we concentrate only on the line of the eyes, the dark areas of the nose, and the shape of the mouth.

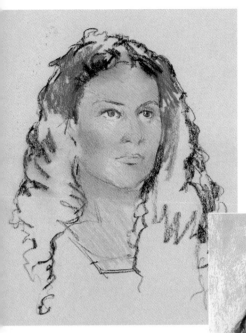

Step 2. Once all the excess lines of the preliminary sketch have been erased, we apply a fixative to it so that subsequent work can progress without losing the basic structure already established. We shade in the tones of the face with a very luminous orangy pink and enhance the area of the cheek with carmine. Without exerting too much pressure, we blend these tones with our fingers. In spite of this, the underlying drawing remains visible.

Step 3. We paint the hair with an orangy ochre, creating a foundation for subsequent dark tones. Next, we apply yellow ochre and several touches of violet. We add some white shading around the head to bring it to the fore. After blending the face with our fingers, we increase the dark areas near the nose and upper parts of the face, and begin to refine the eyes.

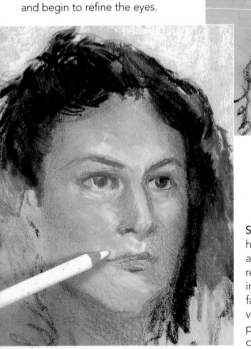

Step 4. We render the texture of the curly hair with a pronounced darkening, while allowing some of the underlying tones to remain visible. The addition of these darks is intense, contrasting with the tones of the face. In this way we accentuate the original volumes of the face and, with white pastel pencil, retouch areas like the nose, forehead, cheek, and lips that require more luminosity.

Step 5. Now we intensify the contrast between the white and the cream-colored background, thereby making the dark hair appear darker. Having softened the tones of the face, the white we added in the last step merges with them, achieving a somewhat luminous flesh color. After integrating these tones, we draw the nose and the eyes with precision and add red to the mouth, which in this stage appears too intense.

Step 6. Now we're concerned less with creating an exact likeness of the photo than with capturing the model's facial expression. Until now, the tones in the eyes were light; by adjusting the dark tones, we lend them greater depth. We draw over the lips to lighten the intensity of the previously applied red and soften the tones of the face and neck with our fingers to bring out more important anatomical volumes.

Step 7. The hair is finished with intense tones of black, then enhanced with lighter earth hues. We lengthen the eyelid by making the oval of the eye larger, and add some highlighting to the lip and the lower eyelid. We softly merge the shadows but maintain some of the more sharply defined areas, such as the shadowing on the nose and its highlight.

Step 8. There is little difference between this and the previous step, though many features have been retouched. Very specific reflections are added that help to bring out the corner of the lips and the chin. Finally, we add several contrasts to the neck and enhance the dark tones of the hair.

SUMMARY

• In portraiture it is essential to keep in mind the relation between the features and the expression of the face.

• Once the features have been situated correctly, the portrait can be drawn directly and spontaneously.

• Applying the pastel stick flat against the paper allows you to create all manner of strokes; this medium is ideal for obtaining dark tones that can be softly merged with the rest of the tones.

• The aim of a portrait is to render both the face and, more importantly, the personality of the subject.

• Each drawing medium has its own particular advantages in interpreting and representing a subject.

• A volume incorrectly situated on the face can destroy the overall harmony of the features.

• Working on colored paper adds another hue to your palette.

TRANSPARENT GLASS SURFACES

REFLECTIONS

Drawing the transparent glass objects shown below, while simple in terms of concept, requires a careful study of the shapes involved. In fact, all of the objects presented in this chapter are quite difficult to draw because they are symmetrical and must be rendered in precise perspective.

Rendering highlights and reflections is a challenge that many artists prefer to avoid. This chapter presents a number of examples that will help give you the know-how required to draw the beautiful transparent and reflective qualities of glass.

2. *Right*: The contents of the jars are represented as blurred forms, rendered in a slightly fuzzy manner. The eraser is used to open up the brightest reflections.

1. *Above*: No object takes center stage in this composition, and the volumes are arranged in accordance with their visual weight within the frame. The vertical planes of the jars and the curve of the base, neck, and lid are drawn with charcoal. Any incorrectly rendered lines must be immediately corrected before work can proceed.

3. *Right*: The values are adjusted and extremely dense blacks added. The folded cloth is reinforced with a very dark tone that brings the foreground closer. The food inside the jars is darkened and the reflections on and around the lid are drawn with discontinuous lines. The jar in the background is brought out a little more through the shadows that envelop it, but it is left as a very faint gray tone. Finally, the eraser is used to open highlights and reflections.

GLASS CONTAINING LIQUID

Liquid is a common feature in still lifes that include glass vessels. Liquid isn't easy to draw, as its transparency often makes it difficult to observe.

This exercise shows how to draw two glasses filled with wine. The light acts both on the liquid and through the glass that contains it. The saturation of tone in certain areas and the addition of highlights in others will lend realism to the finished drawing.

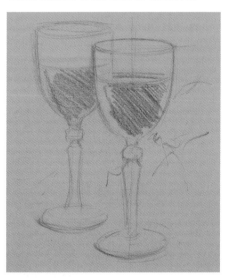

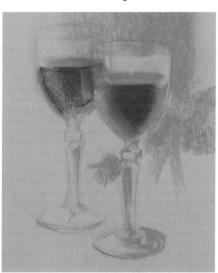

1. The perspective of the two glasses is observed by focusing on only one of them. A line of symmetry makes it easier to draft the oval shape of the base of each glass, the surface of the wine, and the rim of the wineglass. A diagonal line is traced at the top to indicate the center of the uppermost oval. From here this and the body of the glass can be sketched.

2. Fixative is applied to the drawing to preserve the preliminary lines. Part of the background is darkened to counterbalance the light areas. The darkness of the liquid helps convey the volume of the glass. Shadows are drawn on the base of the glass, while the lightest areas are left in reserve.

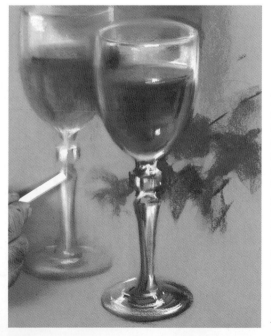

3. Some major blending is carried out on the background tones that overlap into the interior of the wine-glasses. Here, a touch of burnt umber is added to adjust the homogeneous tone of the sanguine base. The same is done inside the glasses; the liquid is blended with a combination of dark and light areas, leaving the profile of the surface in reserve. The same color is used to obtain a precise rendering of the dark reflections on the base of the glass. Finally, white chalk is used to draw the most brilliant lights and to redraw the external shapes and reinforce the reflections.

REFLECTION AND REFRACTION

The optical qualities of liquids present unique artistic challenges. This exercise shows you how to draw the effect of light on liquid in any still life.

Water's transparency is relative to the glass vessel containing it. When an object, such as a spoon, is submerged in water, it appears deformed because the water in the glass acts like a lens; it's essential to convey this effect in a drawing of the subject.

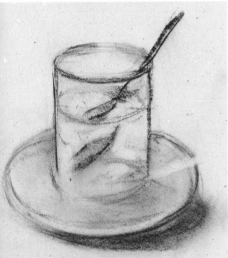

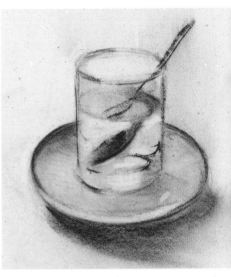

1. In the preliminary sketch, the shape of the glass is based on a cylinder and the plate on an oval. The same shape is drawn inside the glass to represent its bottom and the surface of the water. Here, the shape of the plate is still not altogether right. The part of the spoon that is submerged in water is drawn with its corresponding distortion.

2. The perspective of the shapes is perfected and the ellipse on each oval plane is drawn more precisely. The drawing is rubbed lightly to create an atmospheric effect, and the most important lines of the glass, spoon, and plate are highlighted. Note the visual distortion of the spoon in the water, its concave shape expressed as a dense dark patch.

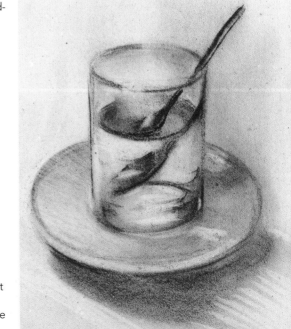

3. The area around the subject is blended once again. The light tone of the paper is now tinted with a subtle blue haze, from which light areas and highlights can be opened up. The plate's shape is corrected by erasing part of the previous dense blue tone. A few highlights are created in the spoon and body of the glass.

SHARP CONTRASTS
IN THE HIGHLIGHTS

The effects of the light rendered in the first part of this exercise will now be adjusted to their maximum values by refining the highlights and strongest contrasts and bringing out the brightest reflections in specific areas. Think of this as a warm-up for the step-by-step exercise that follows.

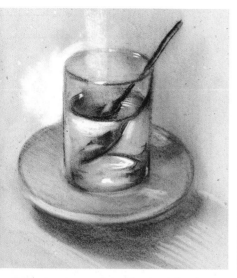

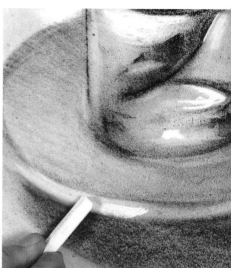

1. The area around the glass and the shape of the plate are gently drawn with white chalk. The fingers then are used to blend the white in the background. The white subtly penetrates the interior of the glass to the edge. Using the tip of the charcoal, some subtle highlights are drawn on the side and bottom of the glass and on the surface of the water.

2. The luminosity of the cylindrical area of the water is increased. This white tone is softened around the shape of the spoon. The tip of the chalk is used to refine the rim of the plate.

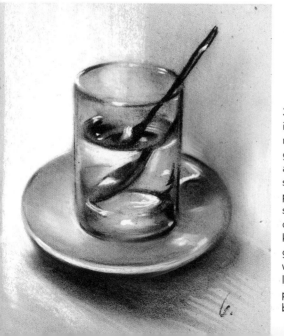

3. Sharp contrasts are achieved by intensifying the white around the main objects. The shape of the glass can be accentuated further by adding some highlighting. The densest shadows are painted with blue pastel. Now the fingers are used to soften the surface texture of the china plate. The background is darkened with the blue left on the fingertips. The foreground is shaded with white chalk, allowing it to overlap into the shadow cast by the plate. A few touches of bright light bring this exercise to its conclusion.

Beer Steins and Mug

MATERIALS

Gray drawing paper
Sanguine pencil, Black pastel
White chalk, Eraser
Cloth, Fixative

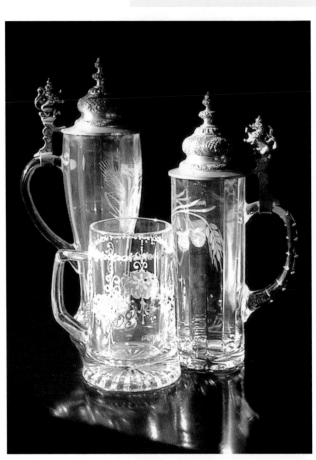

This still life exercise is as difficult as it is beautiful. The subject comprises two beer steins and a beer mug set against a dark background, illuminated so as to maximize the qualities of the glass and create dramatic contrasts.

When composing a still life, it's important to carefully study the arrangement of the objects, the quality of their surface textures, and, in this case, the properties of the lighting. This step-by-step demonstration places special emphasis on highlights and reflections.

Step 1. We execute the preliminary sketch with white chalk, making an accurate study of the objects' shapes, especially their contours. We also aim to draw the steins and beer mug in perspective. We apply the stick of chalk flat on the surface of the paper, first sketching straight lines, then defining the densest areas with thick patches of white. Then, applying the chalk by its tip, we draw the curve of the stein at left, and the two lids. We reinforce the drawing with sanguine pencil.

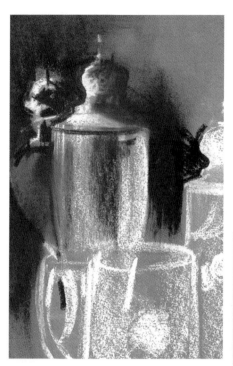

Step 2. We begin the harshest contrast, which will allow us to elaborate the highlights on the objects. We stain the area of background around the left stein with black pastel, taking care not to overlap into the brightest areas. With the pastel stick, we caress the interior of the stein, darkening this area of highlighting.

Step 3. Now we finish the background with black, adapting it to the areas of white on each glass vessel. Holding the stick of black pastel between our fingers, we fill in the background area between the two steins in order to make the shiny surfaces glow.

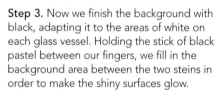

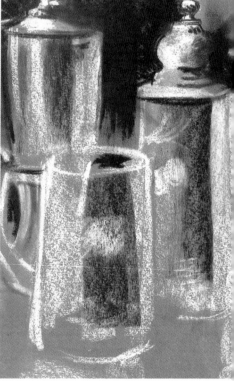

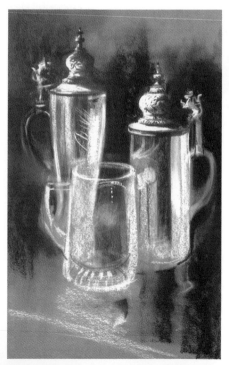

Step 4. The dark areas continue to dominate the background, in a way that these blacks lend shape to some of the highlights on the steins. The black stroke is completely vertical in the stein on the right; the light tones produced by contrast with the darks correspond to the color of the paper itself and to the highlights applied. The black in the beer mug in the center is softly blended. We apply several very luminous touches in areas such as the base of the mug.

Step 5. Note the difference between the dark and the light areas. The black tones precisely punctuate the highlights, causing these to divide into many subtler tones. We reinforce certain contours with white and, by alternating blended areas with others more sharply rendered, draw the engraved decorations on the objects' surfaces.

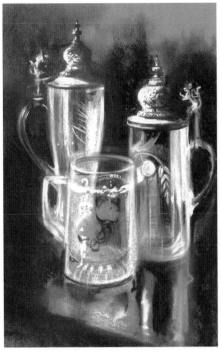

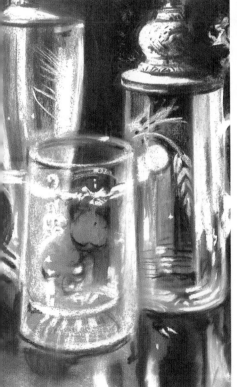

Step 6. Now the work becomes more meticulous, almost a study of each individual luster and reflection. By alternating light and dark areas, we obtain a very rich effect, incorporating the halftones; certain warm notes are added with the sanguine. Now we outline the base of the beer mug with the tip of the chalk.

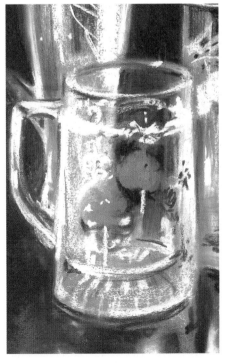

Step 7. The handle of the beer mug is represented through very strong contrasts between black and white. The shape is outlined with white against the black background. We carefully shade in the interior of the handle until we achieve what in the next step will become the flat interior surface. The tiny details in the base of the mug are drawn with black, which is also used to accentuate the decorative engraving on it.

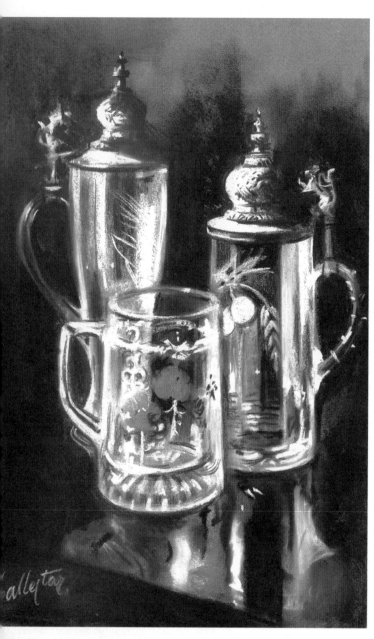

Step 8. We finish drawing the handle of the beer mug, a task that calls for the utmost precision. We add some black and white to refine its interior wall. Finally, we draw several highlights on the handle of the beer stein at right, which now displays a very beautiful highlight.

SUMMARY

• Reflections can be difficult to draw if you don't understand the physics of light on glass.

• Representing highlights on glass surfaces requires special attention to their shapes.

• An eraser can be used to open up the main reflections in the brightest areas.

• Light acts on the liquid and through the glass containing it.

• Tonal saturation and highlights allow great realism.

• The transparency of water is relative to the glass vessel containing it.

• An object submerged in a glass of water appears deformed because the water acts like a lens.

• Shiny surfaces and reflections can be rendered directly by applying white and by opening up light areas with an eraser.

ATMOSPHERE IN THE LANDSCAPE

SUGGESTING DISTANCE WITH TONAL GRADATION

The foreground, middle ground, and background in a landscape can be represented through linear or atmospheric perspective. Expressing depth involves gradually lightening and softening the tones and colors of objects and planes as they recede into the distance. The simple exercise below explores some basic questions concerning depth in the landscape.

The way we perceive depth in a landscape depends in part on the intervening atmosphere – the air itself, and the way its density differs according to climatic and environmental factors such as moisture content, dust particles, and pollution. In general, the atmosphere causes elements as they recede into space to appear both lighter and blurred, with progressively less contrast between the edges of shapes, colors, and tones.

2. Right: We soften background tones with the fingertips to create a faint mist that contrasts with the foreground. A range of grays describes the various planes of the landscape. In an atmospheric treatment of the landscape, it's essential to create reference points in relation to distances between planes.

1. *Above*: We draw the main foreground plane, the darkest in the composition, with a stick of charcoal applied to the paper lengthwise, filling in the darker areas that eventually will be backlit. Some dark patches are drawn in the background using the charcoal flat against the surface to emphasize the atmospheric separation of planes. These soft tones are clearly differentiated from those of the foreground.

3. Here, the eraser is used to open up the lightest areas, thereby giving importance to the grays. The darkness of the foreground separates this plane clearly from the background. Some very intense darks are added here, while a few of the previous grays are retained to represent the texture of the rock's craggy surface.

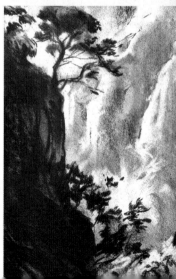

ATMOSPHERIC EFFECTS

The atmosphere – the air in all its climatic varieties and effects on the environment – can be represented through well-differentiated planes. In this subject, a wooded landscape, we'll make use of the pronounced contrasts between foreground and background as defined by atmospheric and light conditions. The trees and mist filter the light, which saturates and distorts the most distant shapes.

1. The dense undergrowth in the foreground is fairly well articulated, while the shapes of the trees in the background are barely suggested. The foreground is shaded in with a stick of charcoal held flat against the paper. Here the drawing is kept simple, mainly to establish a distinction between the fore- and background. The charcoal crumbles and leaves tiny particles on the paper.

2. The tiny particles of charcoal deposited in the previous step are now dragged across the surface of the paper with the fingertips to create blurred shapes. The vegetation in the foreground is yet to be drawn. With the eraser, the dense forms of the main tree trunks are carefully profiled; the vegetation in the far distance is merely suggested.

3. Certain elements are erased further, leaving the trees expressed in only minimal terms. Their forms, determined by the light source, will appear sharper once the contrasts in the foreground are added. The tree trunks are drawn with a more intense stroke to render the texture of the bark. Adding darks to the undergrowth helps complete the stark contrast between the backlit foreground and the background.

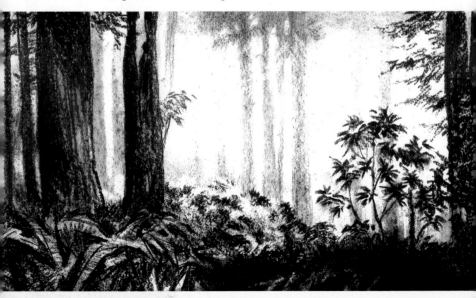

ALTERNATING AREAS
OF ATMOSPHERE

This exercise is not only fun to do, but also explains how to understand the atmosphere and interpret it in the landscape. Light sometimes envelops a scene; other times it saturates tones and distorts elements to such an extent that they merge with the atmosphere. Here you'll see how an object in nature, in this case a tree, can be merged into the atmosphere.

1. The background is sketched softly with charcoal and then blended. Some shadings are added to and then dragged over the surface to expand the contour. This preliminary blending provides an excellent base to which the eraser can be applied.

2. The strongest contrasts of the dark areas are intensified without reaching the blended contour. Now the eraser is used to open the light areas where the leaves will be situated.

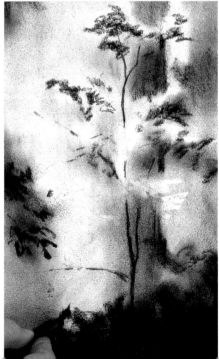

3. In this step compressed charcoal is used. The density of the black tones produced by this medium permits extremely subtle linear development. New dark areas are drawn over the black masses with the tip of the charcoal stick. The dark areas of the foliage are drawn in the white areas.

DEFINING GROUNDS
AND DISTANCE

In the second part of this exercise, we'll study the effects of the light on the tree shapes. These effects help you see how, even in a subject whose main feature is relatively close to the front of the picture plane, the different grounds can be defined through interplays of light. The contrasts applied to each branch link the tree with the surrounding atmosphere and the light, which reflects the humidity of the environment.

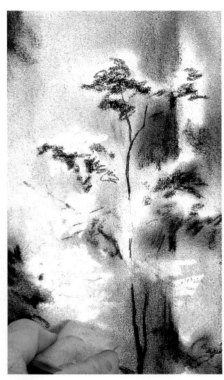

1. *Left*: Because it can be molded into any shape, a kneaded eraser lets you draw with greater precision. When it becomes dirty, you can use it to blend previously shaded areas. In this step, the eraser is used to outline the shrubbery; to open up lights against the background; and to convert previously shaded areas into bushes distorted by the effect of the intervening atmosphere.

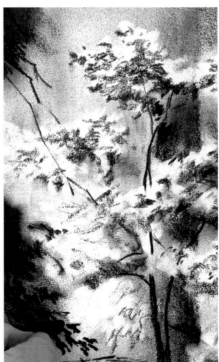

2. *Above*: Details are drawn with compressed charcoal. Highlights are saturated by the filtering effect of the humid atmosphere enveloping the scene. The foliage in the foreground has enough detail to produce a contrast between it, the middle ground, and the background, which still appears blurred.

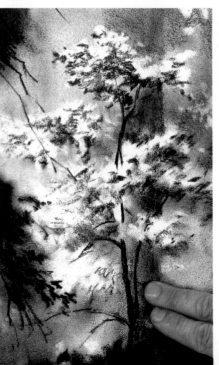

3. *Left*: We continue outlining various forms with the compressed charcoal. Areas blended with the fingertips are alternated with newly opened up whites and concrete strokes that enhance the leaves.

Atmospheric Landscape

MATERIALS
Cream-colored paper
Soft and compressed charcoal
Eraser, Cloth

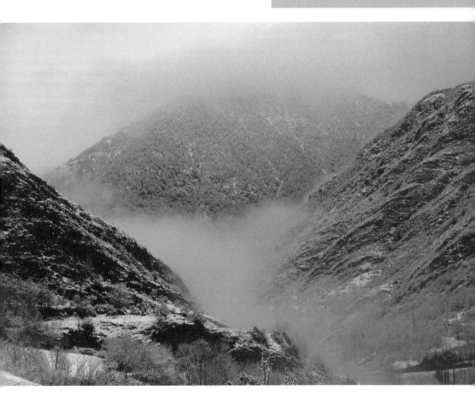

The light in the foreground of this densely atmospheric landscape must be more opaque in comparison with the middle ground and background. The atmosphere acts as a filter for defining the different planes of the landscape. Here, a monochromatic rendering is ideal for interpreting the atmospheric aspects of this scene.

Step 1. With soft charcoal we execute a rapid sketch; just a few lines are sufficient to establish the four principal volumes of this scene. The foreground is shaded with a flat stroke, creating a base for later light areas. Since this is an atmospheric landscape, we are aiming to suggest distances through blendings rather than through perfectly outlined forms.

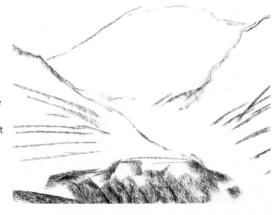

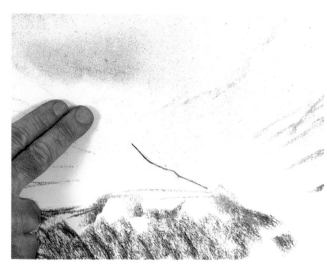

Step 2. We softly shade in the area behind the mountains with charcoal, using a light touch to avoid saturating the grain of the paper. With our fingertips, we rough out the background area except for the large mass in the center and the mountain in the foreground. Fixative is not required because this type of atmosphere calls for a continuous drawing process.

Step 3. The disappearance of the most distant mountain does not pose a problem; we simply redraw it with the stick of charcoal, which we also use to sketch a very faint outline in certain areas. We play down the importance of the mountain's contour by merging it into the gray sky. Using the eraser, we go over the misty central section to open up an important area of light. Then we draw the mountain in the foreground with a direct line to convey a sense of spatial depth in relation to the other planes.

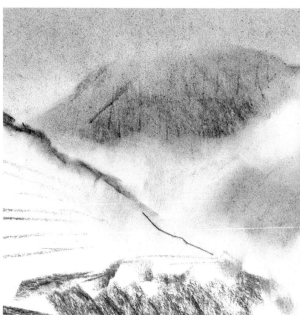

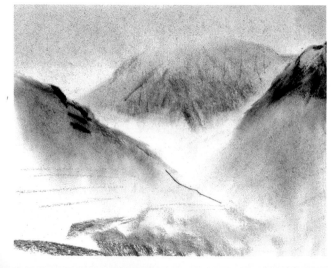

Step 4. We rough out the mountain in the foreground and the one on the left with a charcoal blending that provides the basis for the dark areas to follow. The charcoal intensifies the contrast in the base of the most distant mountain, thus making the luminosity of the mist even more manifest.

Step 5. Intense black patches that represent the surface of the foreground mountain are superimposed over the original layers of gray, articulating the craggy texture of its rocky face. With the eraser, we open up several points of light that emphasize the presence of these rocks. Now we apply a stick of compressed charcoal flat against the paper and execute a dense patch halfway down this mountain.

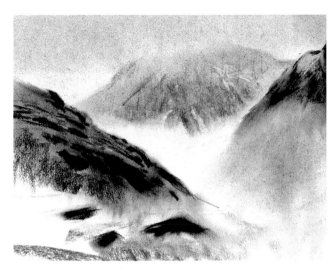

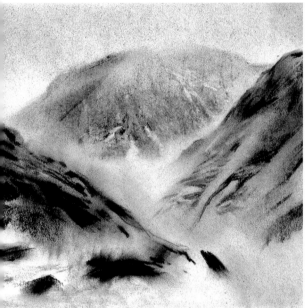

Step 6. With compressed charcoal, we draw faint lines and then blend them with our fingertips. Some highlighting is added here in the form of tiny white areas opened up with the eraser. At left, after carrying out various blendings with the compressed charcoal, we add several dense patches and, with the corner of the eraser, open up some lines that seem to gradate into the background. Now we blend the outlines of the dark foreground patches.

Step 7. We also use compressed charcoal to define the texture of the mountain at left. We apply several intense black patches in the foreground, which gradually reduce in intensity as the mountain recedes into the distance. Still with the compressed charcoal, we add some details to the mountain at right and blend them, then open up some light areas in the foreground using the eraser.

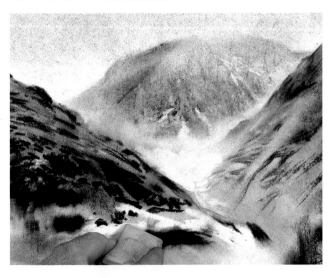

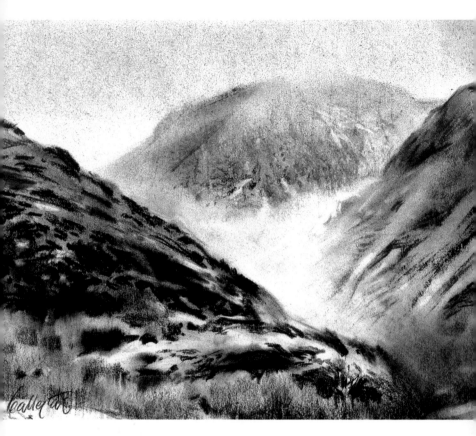

Step 8. The final step consists of finishing the foreground. We draw the vegetation in this area with a number of smudged patches. Several contrasts represent the clumps of grass. At right, we add a number of gray areas that we blend with our fingertips. Finally, we clean up the area of mist in the center of the picture.

SUMMARY

- Atmosphere is represented by drawing a number of planes in depth.

- The planes of the landscape can be drawn according to linear or atmospheric perspective.

- Atmospheric perspective facilitates a convincing interpretation of depth.

- In the landscape, atmosphere is indispensable for establishing points of reference with respect to the distance between the planes.

- Atmosphere can also be rendered through a number of successive planes that vary in contrast.

- Strong lighting does not necessarily imply an absence of shapes.

- The light can envelop or saturate the tones that distort the elements until they are integrated within atmosphere itself.

- The lightest area can be left open and totally integrated into the background.

THE CARICATURE

ESTABLISHING PROPORTION TO UNDERSTAND FORM

A good caricaturist is first and foremost a good draftsman, although the caricature does allow certain flexibility in the interpretation of the shapes of the body. Features, movement, dynamics, and their application to the anatomy are also considerations in caricature. The example on this page gives an idea of what is involved in drawing a caricature.

The caricature, a variation on the portrait, is a subject that enjoys widespread popularity. A caricature is far more difficult to draw than at first it may seem. Furthermore, there's no end to the ways in which a caricature subject can be interpreted, and every artist has his or her own particular style and technique. This chapter covers some of the more interesting aspects of this subject.

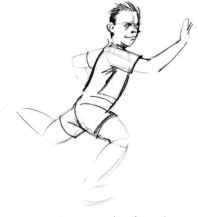

1. It's best to understand the body as a mannequin that can adopt a wide range of postures, each limb capable of making a movement that can be represented in an exaggerated way. Volumes must be reduced to simple shapes that can be played around with on the paper. Here, the anatomy is drawn in somewhat rounded fashion, with an emphasis on the figure's movement.

2. Rather than illustrate reality, the caricature focuses on a specific aspect of that reality. In this linear example, the face is drawn with very few lines, exaggerating the features and ignoring details of value.

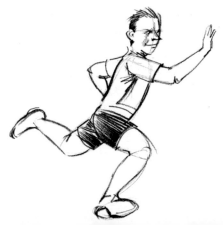

3. The gesture must surprise the viewer. Although the movement here is exaggerated, care has been taken to draw the joints and position the facial features correctly. In this type of drawing, the direction of the line and the calligraphy are decisive.

EXAGGERATING
THE FEATURES

The face can reveal the subject's traits by accentuating the most prominent

features and establishing dynamism between them. The aim is to differentiate the concept of the drawing from the subject's personality, something that can be mastered only through constant practice.

1. This caricature of Beethoven begins with a triangle; the head's shape has been altered to emphasize the skull. The proportions of the face have also been altered, with the features bunched together in the center under the line of the eyebrows, which clearly divides the scheme of the head. The chin ends with a very wide horizontal line that's even wider than the mouth.

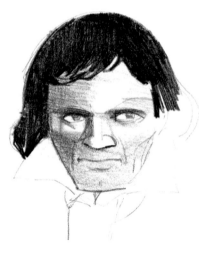

2. In caricature drawing, the first step is always the most important, since this is the moment to represent the subject's most distinguishing traits, such as personality, sense of humor, and expression of character. Here, the straightness of the eyebrows conveys a sense of intense concentration. The other fundamental feature is the subject's gloomy expression, underscored by soft violet tones.

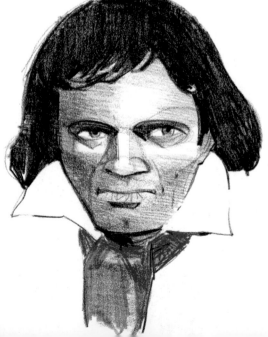

3. The highlights are also factors taken into account here; note how the volumes of the face have been rendered by leaving the cheekbones, nose, and eyes in reserve. These highlights facilitate the modeling of the forms, and the volumes emphasize the depth of the subject's gaze, the focal point of the portrait.

SATIRE IN THE PORTRAIT

Satire is essential to any caricature. Finding the right degree of roguishness is not easy, since it requires the ability to convey personality through physical features in the artist's personal style. Drawing a truly good caricature can be achieved only through perseverance. But with regular practice, you'll develop a characteristic style that will gradually become ever more natural to you.

1. The volumes of the head are interpreted in a very free sketch, and forms are developed to exaggerate the most obvious ones. The exaggerated proportions of the nose allow the rest of the features to be drawn likewise; the bridge of the nose disappears, while the tip clearly exceeds its real proportions. The mouth extends across almost the entire breadth of the face.

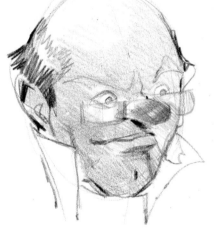

2. Working from the general to the particular, the face is drawn with a sienna pencil; subsequent tones will allow the lightest shapes to be corrected. As this caricature is being drawn with colored pencils, it's necessary to work from light to dark. The soft shading produces very faint contrasts; the main tones of the nose and cheeks and the blue of the stubble can now be brought out.

3. The tones are intensified in the face, leaving the highlight in the forehead in reserve without any attempt to render real flesh tones. The reds and oranges in the temple are emphasized by leaving the brightest area with soft tones The nose is drawn with an intense red and with a highlight. Finally, the chin is drawn with tones of blue.

Different options

The caricature can be drawn in a wide variety of styles. A simple line is enough to render the subject's face and personality. A number of techniques can be used to emphasize the subject's personality and most characteristic features. The three caricatures reproduced here are of famous painters. Nowadays, there are many more types of caricature than these examples, but all styles are perfectly valid.

1. During the 19th century caricature artists were often well-known painters who collaborated on newspapers and magazines. The caricature was based directly on a portrait of the subject, whose features were exaggerated, although with less irony than in today's caricatures. In other words, despite the caricaturized features, the work was still fundamentally a portrait. As you can see in this example by Claude Monet, the nose and eyes have been distorted slightly and the body reduced in size, lending the subject a grotesque appearance. (*Léon Manchon*, 1856; charcoal, 23.6 x 17.7 in.; Carter H. Harrison Collection, Art Institute of Chicago.)

2. Avant-garde artists and intellectuals of the 19th-century Paris café scene often poked fun at one another through caricature. One master of the genre at the time was Henri de Toulouse-Lautrec, as illustrated by this witty portrait of a contemporary. Note how the distorted face and body have been executed in simple, basic strokes. (*Gabriel Tapie de Celeyran*, c. 1891; black ink; Musée Toulouse-Lautrec, Albi.)

3. Another type of very gestural caricature plays up the subject's most grotesque aspects. Certain features and physical attributes make the identity of the subject clear, as do elements such as objects associated with the person's profession. This self-caricature by Toulouse-Lautrec shows the artist riding a drawing pencil; no attempt has been made to finish the drawing or to render correctly defined lines. (*Self-Portrait*, c. 1890; black ink; Musée Toulouse-Lautrec, Albi.)

Richard Wagner

MATERIALS

Cream-colored paper
Colored pencils
Eraser

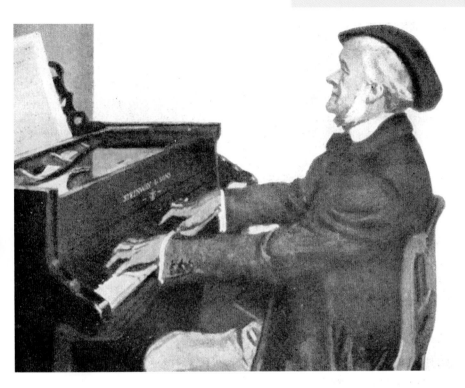

As a type of portrait, caricature is perhaps most often applied to well-known people. Caricature has almost always involved techniques associated more with drawing than painting, partly because originally this of type of representation was destined primarily for publication in newspapers and magazines. Here, a photograph of the celebrated German composer Richard Wagner is the subject for this step-by-step exercise. In addition to linking the composer to music, the photo offers enough details to draw his features and capture his personality traits. It is important to know how to identify the elements that will best caricaturize the subject. In this case, the main features that need to be represented are the nose, chin, and sideburns. Far from reflecting on paper the composer's strong character, this drawing aims to be an ironic rendering.

Step 1. We draw the preliminary sketch with a dark pencil, blocking in the shape of the head and defining the position of the hands on the piano keys. Rather than respect the musician's static pose in the photo, we add dynamism to his arms. We draw the right hand poised above the keys, a similar position to that in the photograph, by slightly raising the little finger to exaggerate the movement.

Step 2. We begin by shading the face with orange. Taking care not to exert undue pressure on the pencil, we define the main volumes: the light area of the cheek and dark area of the nose. The tones must be faint to prepare for the next steps of the process. We also begin shading the back with a dark stroke that will serve as a base for establishing the first contrast.

Step 3. We increase the contrasts of the face until they are practically finished. The dark areas are drawn according to narrative rather than academic criteria. Hence, the angles of the face are jagged and clearly define the features. Now we add gradations from dark to light, such as the area that defines the cheek, where the reddish tone sets off a very bright contour. We draw the hair with long strokes of gray, leaving white to represent the lightest areas. Then we bring out the chin.

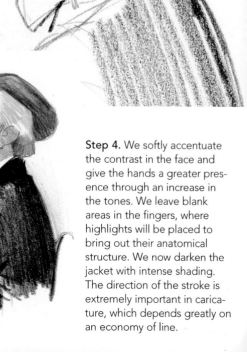

Step 4. We softly accentuate the contrast in the face and give the hands a greater presence through an increase in the tones. We leave blank areas in the fingers, where highlights will be placed to bring out their anatomical structure. We now darken the jacket with intense shading. The direction of the stroke is extremely important in caricature, which depends greatly on an economy of line.

Step 5. We intensify the tones in the face, going around the bright areas that have been left in reserve from the beginning. The deepening of the tone in the temple helps describe the volume of the skull. We then darken the area in the back of the neck and ear. The darkest areas of the hair are drawn with gray, and an intense gray is applied to the cap. We shade in the cravat with a brisk stroke, leaving the most brightly lit area reserved.

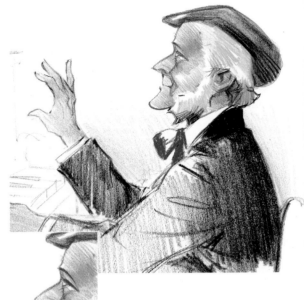

Step 6. We now shade the jacket with intense vertical strokes and reinforce the shadows in the folds, while respecting the lines of the drawing. We intensify the red of the cravat and do likewise with the tones in the hands to make the anatomical characteristics stand out.

Step 7. Next, we work on the detail of the hands by darkening them and creating a range of tones there. To lend greater depth to the body, we darken the area where the right arm bends, and reinforce several of the folds of the jacket. We now draw the piano, achieving a good balance between the tones of the subject and his surroundings.

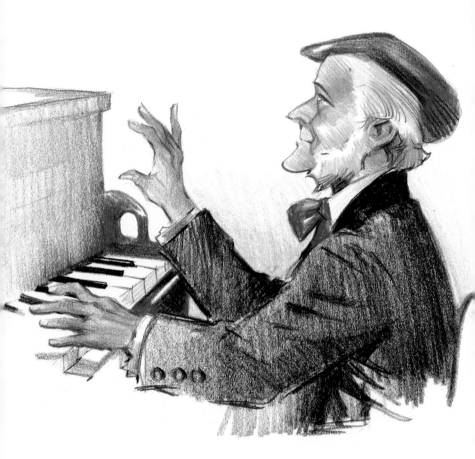

Step 8. Finally, we add several intense contrasts in the jacket, below the arm, and in the hands, leaving the figure finished but at the same time fresh and spontaneous. The tones of the piano are also darkened, above all in the area adjacent to the keys.

SUMMARY

• The caricature is one of the most enjoyable variants of the portrait, and it allows artists to develop their own particular style.

• The caricature lets you interpret forms with great freedom.

• The caricature is an intentional exaggeration of the subject's main characteristics.

• The lines must summarize the forms; rather than illustrate reality, the caricature focuses on a specific aspect of that reality.

• The subject's gesture and movements must be dynamic enough to capture the viewer's attention.

• One of the main characteristics of a caricature is the exaggeration of the facial features.

• The illumination of the face is one of the most important aspects to have in mind. Irony is one of the most quintessential features of any caricature.

• A simple line can define a face or an attitude, or accentuate the subject's personality and traits.

COMPOSING STILL LIFES

THEMATIC COMBINATIONS

The still life normally consists of elements that can be considered characteristic of certain subgenres, such as fruit, gadgets, game, and so on, but with closer study you'll discover more sophisticated possibilities that give rise to all manner of appealing combinations of objects.

As a genre, still life is excellent for trying out new styles and interpretations, lighting effects, and so forth. This chapter examines facets of still life that will greatly contribute to your experience with various drawing techniques and compositional concepts, such as how to arrange objects and distribute their weights and textures.

1. The distribution of still life objects in space must be based on their volumes and relative weights. In the following example, the surroundings – that is, the room within which the still life has been set up – form an important part of the composition. Here, the vase, flowers, fruit, the surface on which they have been placed, the wall, and the painting in the background are all key elements.

2. Relationships among all the elements are important. If a single object is removed, the entire still life will have to be recomposed. The initial sketch is based on a synthesis of forms; here, shading doesn't represent a real tonal value, but rather, a simple distribution of the areas of light and shadow.

3. Once the main areas of light and shadow that relate and balance all the elements have been established, the drawing now has the necessary base for elaborating the work further. The setup is scrutinized and appropriate contrasts are sought.

CONTRASTS BETWEEN ELEMENTS

Each object of a still life relates in a certain way to all the other elements in the setup. The light source is an important aspect to take into account from the outset; in this exercise, various techniques are combined to lend the composition a rhythmic quality through the handling of light.

1. The space is divided with a horizontal line that separates the edge of the table from the wall in the background. The lower half is broader that the top half. The dark strip running along the bottom of the paper indicates the thickness of the table and marks a rhythm between the horizontal areas. The composition forms a V shape described by the bottles and the onions.

2. The background is shaded with a dense but not opaque tone using two colors, sepia and sanguine. The background is blended with the fingertips; then, the highlights in the nearest bottle are opened up with the eraser, making this object stand out. But now the composition appears to have lost the rhythm of the initial sketch; the combination of tones has left the weights badly distributed and the drawing appears lopsided.

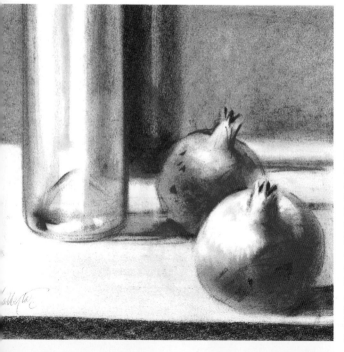

3. The bottle in the foreground is corrected. After erasing a little, its shape is elongated until it coincides with the bottom of the onion at the back. Then the more distant bottle is darkened and the rest of the highlights are finished. After this correction, the whole has gained equilibrium between the masses and tones.

INTERPRETING A SUBJECT WITH A CLEAN LINE

The exercise illustrated on this page requires you to put all of your skills to the test. It consists of drawing solely with lines. Although the apples are easy enough to draw, the pitcher is more complicated. Its shape must be correct, since the slightest error will ruin the result.

1. The objects are first outlined. It's important to avoid a symmetrical composition and to show the most interesting aspects of the whole. The apples, situated in front of the pitcher, indicate the viewer's position in relation to the table. The pitcher must be drawn in accordance with the perspective of the setting, which in this case, while not seen, can be sensed.

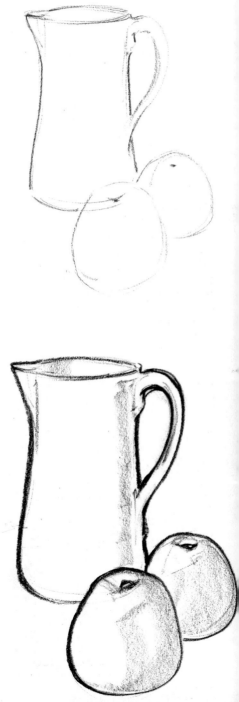

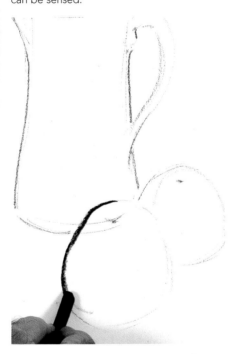

2. The drawing should be corrected and adjusted as many times as needed until the best possible result is attained. Once the contours have been rendered correctly, they are gone over with a dark line applied with the tip of the charcoal; the line must be continuous and precise, without lifting the charcoal off the paper until the outline of each element has been completed.

3. Once finished, the drawing may appear simple, although it will almost certainly require some correction with the eraser. Exercises of this nature can be used to practice drawing freehand and to master the technique of synthesis.

INTERPRETING WITH SHADOWS

This still life will be executed with an approach that differs entirely from that used in the last exercise. Line is used only in the initial sketch, as it's essential to constructing the composition. Here, the main interest is the shadows, following a technique that recalls the tenebrist style of Ribera (1591–1652) and Caravaggio (1573–1610).

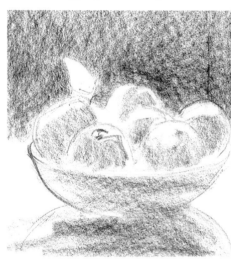

1. A common error in this approach is applying shading before the preliminary structure of the subject has been established. Nothing must take precedence over a correctly drawn sketch. The oval describing the rim of the bowl must accord with the base that supports it. After the bowl has been sketched, the fruits inside it are drawn.

2. Now the dark areas of the picture are drawn. The background, shaded with the charcoal held flat against the paper, delimits the brightest areas of the fruit, while highlights are reserved. The dark areas prevail in this picture; for the moment everything is shaded flat, without volume.

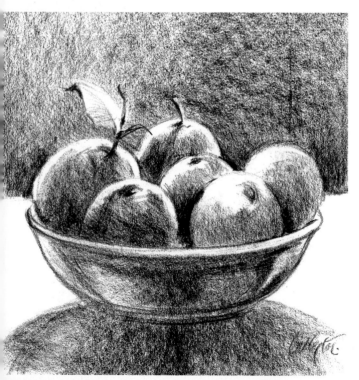

3. Tones are intensified and gradations are established between them to suggest volume and depth. The intense darks make the white areas appear brighter. The eraser is used to clean up the highlights, thus bringing out the most brilliant areas.

Majestic Still Life

MATERIALS
Cream-colored paper
Sanguine and sepia pencils
Black pastel, White chalk, Fixative
Blending stump, Eraser, Cloth

For this demonstration, we chose a painting by the Dutch artist Willem Claesz Heda (1593/4–1680/82), **Breakfast with a Lobster** (dated 1648; Hermitage Museum, Saint Petersburg), because it's perfect for practicing one of the best methods of learning: copying work by great masters. The merits of this still life are indisputable – outstanding composition characterized by an overall dynamism achieved through harmony and variety in the distribution of objects, the diagonal that divides the work, the triangle within which all the objects are enclosed, and a rectangle in the lower half where a brilliantly executed tablecloth is situated.

Step 1. We draw the horizontal lines of the subject and distribute the main masses. The work is asymmetrical; objects are blocked in as simple geometric shapes within a general triangular scheme. Another element to take into account is the large shadow on the left. Once the preliminary drawing is finished we apply a fixative to it.

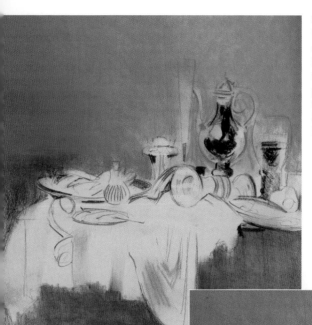

Step 2. Next, we shade the background with sanguine, then apply sepia in the lower part. Now we blend the two tones with our fingertips until they are perfectly integrated in a gradation. With black, we shade the brass pitcher and the wineglass, leaving highlights in reserve.

Step 3. The shapes must be rendered accurately. We draw only the shadow of the spout, leaving the highlight blank. Black is also used to shade the wineglass on the right. Then, with a stump, we blend the tone and draw the folds of the tablecloth.

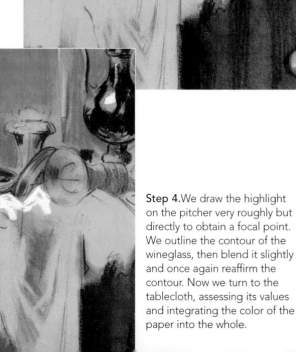

Step 4. We draw the highlight on the pitcher very roughly but directly to obtain a focal point. We outline the contour of the wineglass, then blend it slightly and once again reaffirm the contour. Now we turn to the tablecloth, assessing its values and integrating the color of the paper into the whole.

Step 5. Working in cycles, we return to the pitcher, where we draw the luminous area of the spout; we sketch the handle with a fine black line and blend the central highlight with our fingertip, taking care not to dirty the area immediately surrounding it while leaving the color of the paper visible there. We complete the wineglass on the right with black, softening some areas and outlining others with white that is merged into the dark areas. Then we continue with the folds of the tablecloth and indicate several highlights.

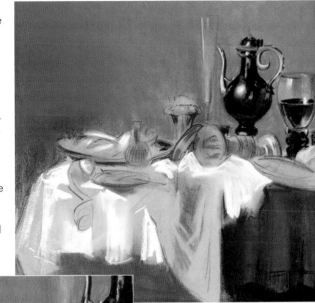

Step 6. Next, we articulate the metal surfaces, which are drawn based on the dark areas as well as the touches of white for the contour. Once drawn, we blend these white areas with our fingertips to create gray tones. The contrasts are outlined with direct applications of black and white. The surface of the metal is rendered with touches of white. Now we soften the different areas of white to lend shape to the folds of the tablecloth.

Step 7. White touches on the metallic objects highlight the presence of blacks and grays. We first draw the small pitcher with black and then add the highlights on top. We sketch the lobster in the background. The paper's color forms part of the interplay of reflections on the vessel lying on its side. The realism achieved is truly astonishing. We draw the tall wineglass with a precise yet subtle white line.

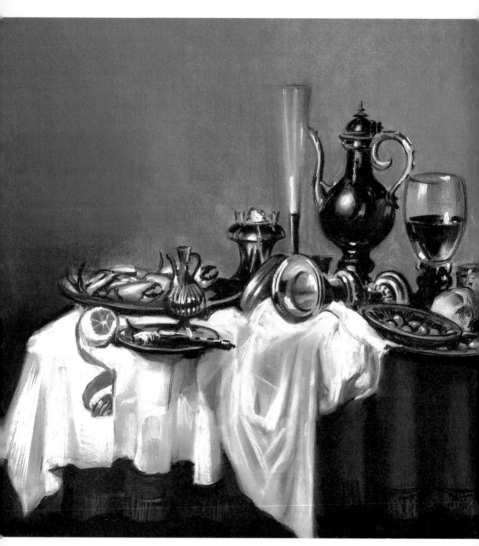

Step 8. We intensify the contrasts and heighten the reflections of all the elements of the composition. We finish the lemon peel with a touch of white. Finally, we add several intense, well-modeled areas of white and darken the background until completely opaque blacks are achieved.

SUMMARY

• As a sort of testing ground, still life offers the artist multiple options in terms of technique and composition, whether your approach is linear or in a more tenebristic style.

• The key to a perfect still life composition lies in a correct distribution of the objects included in the setup.

• To draw a successful still life, balance and a certain dynamism must exist among the various elements of the subject.

• One of the best ways to grasp the importance of proportion is to draw your subject with a clean, precise line, as this approach will make even the slightest error stand out.

• Rendering a still life in chiaroscuro is one possible way to represent your subject; assiduous practice here will help you understand how the interplay of light and shadow on objects helps define them in terms of three-dimensional space.

SENSUALITY IN THE NUDE

THE SOURCE OF SENSUALITY

As an artist, your model, whether male or female, must be appealing to you personally. The model need not have a body that conforms to some artistic canon; in fact, a body that approximates such perfection can appear very cold, and thus can be difficult to draw. Sensuality doesn't reside in any ideal of beauty; rather, it emanates from a demeanor that projects human warmth, no matter what the pose.

Making anatomical studies of the nude to develop your understanding of the human body is important, but you shouldn't confuse that endeavor with reflecting the beauty of physical reality that only an artistic interpretation can allow. This chapter shows you some techniques for doing just that: transforming anatomical studies into artistic drawings of the nude.

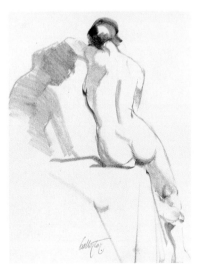

1. *Left*: This example of a woman's back emphasizes the curves of her body in a casual pose that focuses attention on her shapely hips and rounded buttocks. Increasing the sensuality of this drawing is the treatment of the shadow, which enhances the model's curvaceous shapes.

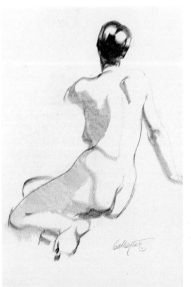

2. *Left*: This drawing captures the model's rounded shapes and sensual pose. The contour is drawn so faintly that it vanishes entirely in some areas, the shadows enhancing her rounded attributes.

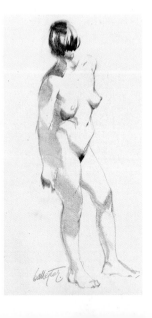

3. *Right*: This drawing, almost sculptural in nature, describes the sensual S-shaped curve of the model's body.

INTERPRETING A MODEL'S POSE

This exercise shows how the most sensual aspects of a model's pose can be extracted from an anatomical study. Very often such sensuality lies less in the model than in your interpretation of his pose, and the angle of view from which you choose to draw it.

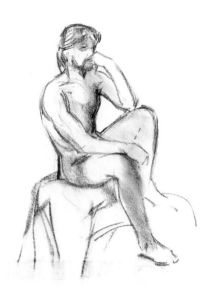

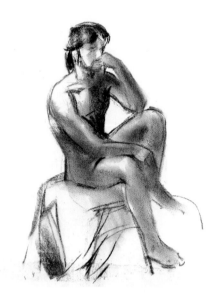

1. Before beginning to draw, we study the model's proportions. Here, we render the right shoulder and knee as foreshortened shapes. For the moment the drawing lacks any sensuality. The pose adopted by the sitter provides an interesting starting point; his left leg is raised slightly, conveying a pensive and distant demeanor.

2. An appropriate distribution of the highlights on the model's anatomy will determine the degree of sensuality conveyed. At this stage, we establish the shadows on the body, which set off the highlights.

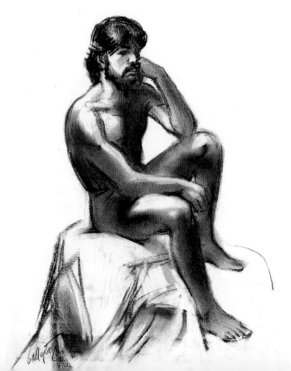

3. Intensifying the dark areas further articulates the figure. Note these details: the chest, shoulder. and biceps have been notably highlighted, and the thigh has acquired great expressive force. These stark highlights are what make this nude much more than a simple anatomical study.

THE IMPORTANCE OF LINE IN EXPRESSING SENSUALITY

If your model has a seemingly perfect body, the development of your drawing will be gratifying, but the process can be even more interesting if the model is not so ideal in her or his proportions and features. The preliminary sketch of this nude is expressionistic; as the drawing is developed, several aspects will be explored to imbue the subject with sensuality.

1. The model's pose denotes a certain timid modesty. With hands crossed over each other at the wrist, her torso gains compositional prominence. This is a good example of how a nude can appear sensual even when covered. A preliminary drawing, with any unnecessary lines erased, establishes the model's contours.

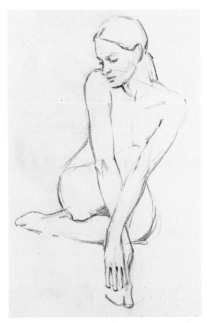

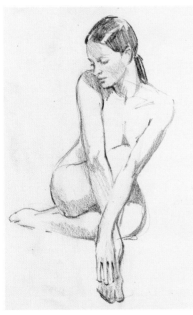

2. Line lends each area of the body its own particular interest. The right arm is clearly outlined, although some internal lines are barely sketched. Another interesting area of line is the visible part of the thigh, which later will be intensified with dark shading.

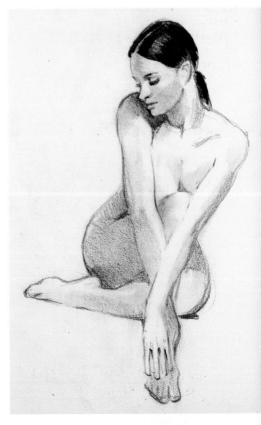

3. The lack of definition of certain lines makes the viewer pay more attention, thereby increasing the figure's erotic quality. Certain parts of the body are afforded rhythm, enhancing some of the dark areas and reducing the importance of others. However, care must be taken with this procedure, since excessive precision will diminish the sensuality.

EROTICISM AND SUGGESTION

In this continuation of the exercise begun on the preceding page, the techniques applied will transform what until now has been a mere anatomical study into something more artistic. A correct treatment of contrast and line quality with respect to the model's various anatomical features will give the figure a more sensual appearance.

1. White chalk on light-toned paper makes it possible to create highlights that help define the figure with a distinctively sensual luminosity. The enveloping quality of the light is particularly attractive to the eye. Note the foreshortening.

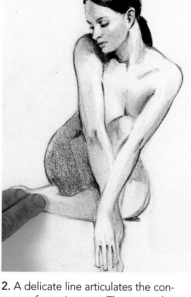

2. A delicate line articulates the contours of certain areas. The crossed arms appear to merge at one point; the line is so subtle that the differentiation is established through a subtle cutoff between shadows. By shading in the inner part of the leg, the foreshortening is made more attractive and the lines appear more tenuous. This results in the need to redraw some details (the dark area of the left arm). The darkest shadows are softened with the fingertips.

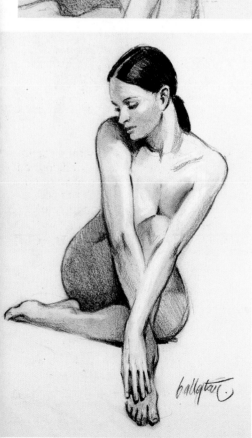

3. The contrast in certain areas of the body is intensified, through which the brightest areas acquire a special luminosity due to the effect of complementary contrast. Finally, reinforcing a few contours noticeably enhances the figure's sensuality.

Female Nude

MATERIALS

Cream-colored drawing paper
Graphite
Eraser

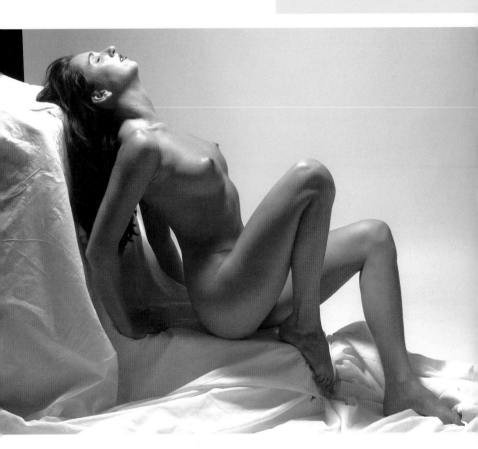

The nude can be used to express a wide variety of artistic facets that transcend mere anatomical representation. Through lighting, the model can be transformed into a very sensual figure. Regardless of whether you are drawing a model from nature or from a photograph, special attention must be given to both the pose and the illumination. In this case, the pose in itself conveys a great degree of eroticism, and the overhead lighting, which highlights the breast, the line that describes the top part of the thigh, and the luminosity of the inside of the right leg, is excellent for bringing out the beauty of this woman's body.

Step 1. After the figure has been sketched and all the excess lines erased, the drawing is clean and ready. The drawing must be done very faintly, so that you can correct without dirtying light areas of the paper. First we indicate the shadows and then add some shading, working all in the same direction.

Step 2. Since the treatment of the dark areas is very important, we must establish the darkest part of the drawing from the outset; in this case it's the hair, and that's where we start, working from top to bottom with different phases of shading. We begin with the softest tones and, with them, gradually bring out the contrasts. The features are drawn with great care and subtlety of line.

Step 3. The contrasts are very subtle; note here how the tonal gradations work. The graphite is applied with minimum pressure, just enough to create tonal differences. This effect can be seen between the torso and the arm. The dark areas adjacent to the face begin to establish the point of reference for the the strongest contrasts.

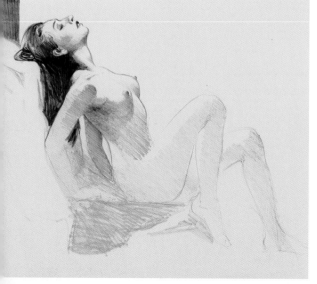

Step 4. A faint shading brings out the most evident features. With the addition of tonal variations, the face and its light areas acquire volume. We darken the shoulder and the ribs, starting from the armpit, and outline the breast. This sensual modeling lends presence to the most important highlights and suggests the roundness of the breast. We darken this area and then add tone to the model's left (more distant) arm. We then draw the hair, with which the shape of the model's right arm is defined.

Step 5. The darkening must always start from the areas that require the most intensity. We draw a dense shadow in the area of the ribs that models the breast, paying special attention to the distribution of the shadows and to how the darks set off the luminous area indicating the shape of the breast. Adding some dark areas in the abdomen gives the light areas greater prominence; the dark shading on the left increases the volume of the body.

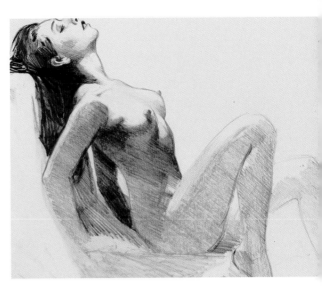

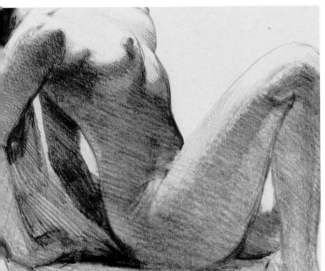

Step 6. The contrasts are added gradually over the body. The tone of the hip is lightened to create a subtle highlight in the area behind it. This highlight makes the curved shape of the body appear more sinuous. We also begin to darken the leg, holding the highlight on the upper part in reserve.

Step 7. We conserve all the existing tones of the body to facilitate the modeling of its volume. The first gray tones to be applied are the intermediate ones, those between the darkest darks and the lightest lights of the background. We draw a very light tone on the model's left leg, separating it from the background and also differentiating it in relation to the right leg. This increase in contrasts leaves the figure almost finished.

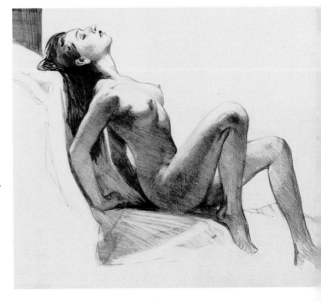

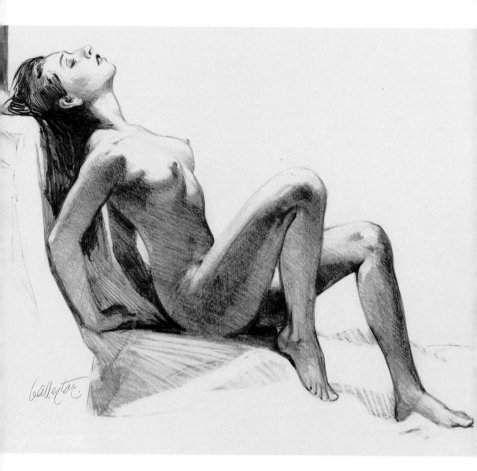

Step 8. We heighten the contrasts while preserving the lightest, brightest areas, which now appear to be almost integrated into the background. In this way, the figure conveys significant sensuality.

SUMMARY

• As an artistic subject, the nude should not be confused with a simple anatomical study; the latter is merely a means to learning how to draw the figure, rather than an end.

• Strive not only to capture the physical reality of a figure, but also to render an artistic expression of it.

• A mastery of the anatomical study will help you draw the figure from a more sensual standpoint.

• It's not necessary that your model have a perfect body; sensuality doesn't reside in any absolute ideal of beauty, which is often cold. But it is important that your model appeal to you.

• A specific treatment of the shadows is one way to increase the sensuality of a nude in a drawing.

• A correct distribution of lights can heighten the nude's persona.

• The light that envelops the figure guides and determines the viewer's vantage point.

• Line quality is indispensable for achieving certain effects that contribute to creating expressive nudes.

• Emphasizing some parts of the body while reducing the importance of others through tone creates a desirable visual rhythm.

LARGE MAMMALS

MOVEMENT AND RHYTHM OF THE JOINTS

Animals have a completely different appearance depending on whether they are moving or still. Studying certain animals can give you a completely different view of them. In this exercise, we will see how the shapes you think you know often do not coincide with reality.

This chapter focuses on large animals, such as the elephant and lion. Learning how to show the anatomy of any animal correctly requires a great deal of practice, observation, and comparison. To help enrich your knowledge of this subject, collect photographs and drawings of various animals.

1. In drawing an animal – here, an elephant – indicate that the body isn't static; pay close attention to the bends in the joints and the extension of the limbs. In your initial sketch, use line, executed with the flat edge of a stick of charcoal, to suggest only the animal's major shapes, while at the same time establishing the subject's general overall structure. After sketching the body, draw the head.

2. Using both the flat edge and the point, we now use sanguine Conté crayon to add the folds in the skin and certain details on the body that require lines. No sanguine should be used on the hindquarters of the elephant; leave some areas of the animal's anatomy only suggested.

3. Now the lines are enhanced with compressed charcoal, giving them more intensity and adding contrasts. Patches of color and tone added at this stage are applied by alternating sanguine Conté crayon and compressed charcoal. We also clean up some light areas with the eraser.

CONNECTING LINES

The outlines defining the shape of an animal can be connected by continuity, cutoffs, or by a method of creating form using the imagination. This exercise involves a series of progressive constructions that allow you to analyze the various facets of drawing an animal, building up its anatomical forms in increments.

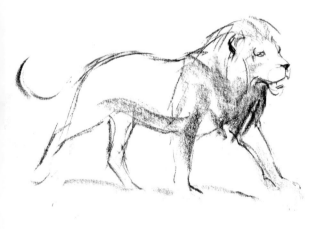

1. After the lion's basic geometric forms have been sketched, more precise lines are added to give the animal its characteristic shape. Some areas are so roughly sketched that the contours are merely suggested by empty space. As the work progresses, gradually this sketchiness will be replaced by more detail. Yet the information provided in this initial stage is just as rich as that of the completed exercise.

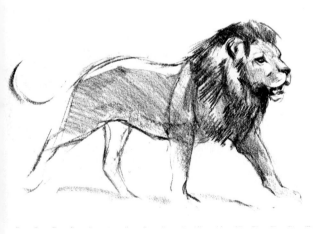

2. We now reaffirm what was previously only suggested. The basic dark areas are filled in, and the volume of the lion is defined. After coloring in the body with homogeneous lines, a bright highlight is added to the top of the body. Using a precise, detailed drawing style, we connect and reaffirm some of the lighter lines.

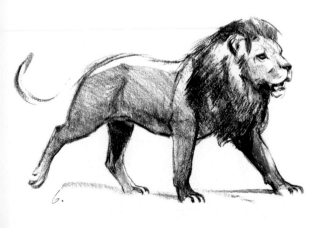

3. The lines that were previously missing are now completed. The color and tonal variations in each area bring the work closer to its final form. What the lines suggest is now perfectly clear, since everything that might have caused doubt has now been defined. The contrasts are now drawn firmly so that the shape becomes more sculptural and the drawing takes on a narrative quality.

SUMMARIZING SHAPES

The initial sketch can give insight into the deepest traits and attitudes of the animal. It's essential to understand the animal's volumes from the lines and shaded areas that define its figure. Both drawing approaches require a sparse, sketchy style.

1. This subject, a bear, has been reduced to circular shapes using very light lines. By separating the shapes, we understand the proportions of the various parts of the animal. We can suggest the shapes by imagining that the rear and front ends fit inside two circles. The point where the two circles meet is the center of the bear.

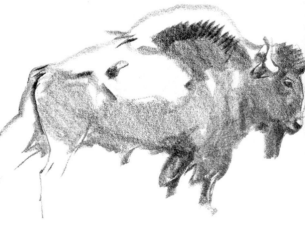

2. This American buffalo makes an especially interesting subject for drawing. It could be drawn inside a trapezoid, with the head blocked within an equilateral triangle and the body within a right-angled triangle. The legs are drawn with only a few lines that define the most important areas.

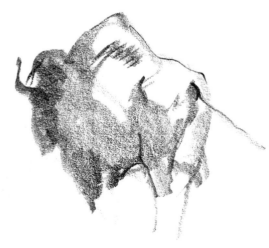

3. If you study the same animal from behind, you'll see that you can establish its overall shape within a triangle whose apex defines the uppermost part of the body. In both drawings of the buffalo, the dark areas are essential, since, along with the highlights, they define the shape of the animal and the main characteristics of its anatomy.

WHERE TO PLACE THE DETAILS

Careful study of the animal's anatomy can reveal the areas that require more highlighting and detail. This exercise is based on the observation of an animal at the zoo, in this case, a boar. Sketching from nature is, of course, preferable, but it's also extremely useful to make drawings based on photographs or completed works like the ones shown here.

1. The head has certain characteristic traits, such as the curve of the snout or the straight area of the forehead. The top part of the back and the rear area are also characteristic. The dense shading shows the volume and shape of the body. In this case, the details to be accentuated in the animal are the face and the mass of its body.

2. This interpretation, rendered from a different angle, gives priority to the shape of the head, which is drawn with foreshortening with respect to the body. The detail is shown by not sketching the body. This technique is especially useful, since it allows you to concentrate on just one section of the animal.

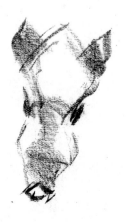

3. This is a detail of the animal's face. The drawing has been rendered in such a suggestive style that some of the lines of the face have been left out. This sketch concentrates on one area, showing only the main features.

A Leopard

MATERIALS
Colored paper, Charcoal
Sanguine Conté crayon
White chalk
Eraser, cloth

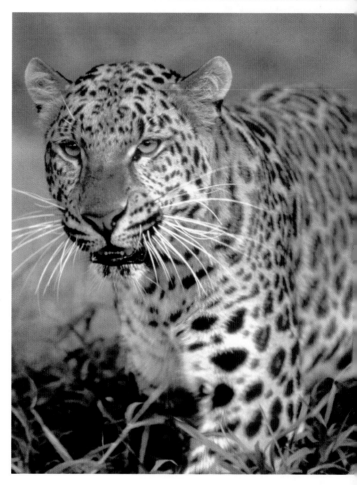

Just as with drawing a human figure, rendering a large feline often calls for more than a study of its shape in a mere sketch, although this can sometimes be an option. A possibly more advanced approach could be making a portrait or an artistic interpretation of the whole figure, rather than a simple anatomical study. In this case, the drawing does not include the entire animal. Rather, it focuses on one area of the body, with the head as the focal point.

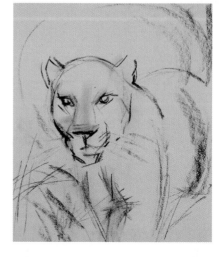

Step 1. Using charcoal, we study two main areas: the head, sketched within an inverted triangle, with the vertices at the ears and the chin, and the body, drawn from two ovals, one for the front area and another for the rear. The contours of the head are corrected and given shape with the point of the charcoal.

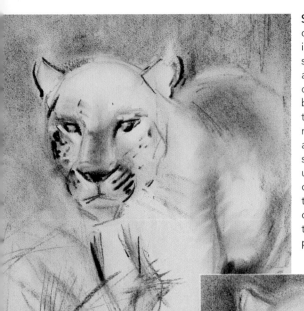

Step 2. Using the flat edge of the charcoal, we blur the surroundings to silhouette the animal's shape. We then blend the tones and the lines marking the contour of the head. The lines should not be completely eliminated, but they should be very light. The next step is reaffirming the ears and drawing the face. The upper section of the muzzle is darkened using a finger smudged with charcoal; the nose is drawn using the tip of the charcoal. After clearing out the front of the mouth with the eraser, we draw a triangular patch on the tip of the nose.

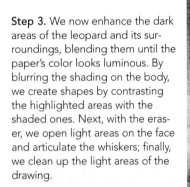

Step 3. We now enhance the dark areas of the leopard and its surroundings, blending them until the paper's color looks luminous. By blurring the shading on the body, we create shapes by contrasting the highlighted areas with the shaded ones. Next, with the eraser, we open light areas on the face and articulate the whiskers; finally, we clean up the light areas of the drawing.

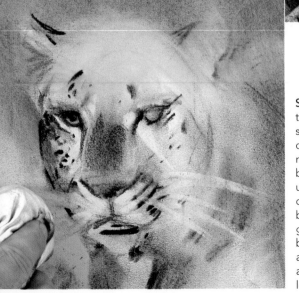

Step 4. The areas surrounding the animal are colored in with sanguine Conté crayon. Using a cloth, we soften the lines, eliminating some that previously had been emphasized. Before continuing, we check the tones and color in the background and the body with highly blended sanguine. These tones will provide a base for contrasts that will be added later. Using the eraser, we accentuate the light area in the lower part of the eye.

Step 5. We now color in the background with sanguine Conté crayon, applying firm strokes with the flat edge of the stick onto the base created previously. The background tone should show through the new, darker tonal patches in some areas. We blur the forehead to create a shade of gray that gives shape to the skull. The spots on the fur are added with charcoal and the shape of the nose is retouched. Using the eraser, we clear out light patches on the dark areas of the muzzle. We then apply patches of white chalk to the face, creating a wide range of tones.

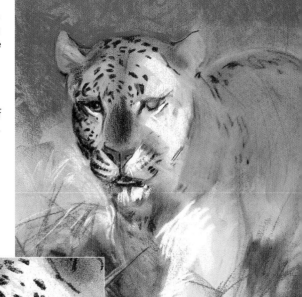

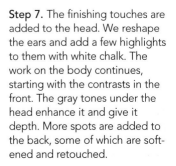

Step 6. With fingers we soften the white patches, blending them with the paper's color, then finish the eyes, leaving the highlights clean. We blend the dark contrasts on the nose and give it shape with a dark line, then blend the charcoal with the sanguine. Then we blend tones on the body and open light areas with the eraser. With white chalk, we draw the whiskers and add small highlights to the skin.

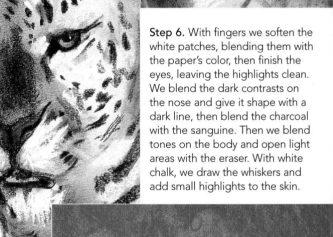

Step 7. The finishing touches are added to the head. We reshape the ears and add a few highlights to them with white chalk. The work on the body continues, starting with the contrasts in the front. The gray tones under the head enhance it and give it depth. More spots are added to the back, some of which are softened and retouched.

Step 8. To complete the drawing, we accentuate the small dark areas around the neck. Intense dark shading in the lower area integrates the leopard with the foreground brush. Patches are added to the fur with charcoal and sanguine to create a wide range of tones. A black line accentuates the shape of the leopard's back.

SUMMARY

• Since it is difficult to study large mammals from nature, photographs can be used for reference.

• A large collection of pictures can enhance our understanding of these animals.

• Animals have a completely different appearance depending on whether they are moving or still.

• The initial sketch of the basic shapes should take the position of the animal into account.

• Sketches can facilitate the study of the different positions of animals.

• Although each species has its own anatomical characteristics, several features are common to all drawings of animals.

• Drawing animals is complicated, since there are features of their anatomy that we do not usually notice.

• When drawing an animal, it is advisable to sketch it from different angles.

PORTRAITURE

FRAMING THE FIGURE

This exercise shows you how to frame a portrait subject. The first sketch on this page shows the whole figure, while the two succeeding illustrations focus in on details that can help you appreciate what might constitute a compelling close-up portrait.

It goes without saying that there are any number of ways you can approach portraiture. The procedures covered in this chapter offer you just a few more possibilities for creating credible and appealing portraits. As always, constant practice always pays off in the end.

1. *Right*: The pose is one way to establish your subject's personality. In a full-length portrait, it's unnecessary to concentrate on details: the subject's face and posture are more important than the perfect rendering of all the other elements.

2. *Below*: Note the dramatic difference between this half-length view and the previous one: here, the figure gains emotional intensity, even though some of the more anecdotal elements have been lost.

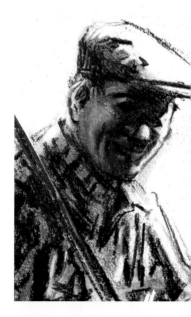

3. *Right*: In a head portrait, all your skills as an artist are put to the test. The body is no longer important; you can even omit it altogether to focus your attention on the face, using just a few judiciously placed patches of color and tone to create an impact. In this example, the shading on the face is intense, perfectly reflecting the subject's personality.

CREATING A WELL-PROPORTIONED STRUCTURE

Getting the proportions of the face right in a drawing are essential if you hope to capture the subject's personality and make the portrait easily recognizable. In this frontal close-up, the position of the face's shapes and the relationship between the features should be carefully studied. Working from a photograph is convenient, although it's always better to draw from life whenever possible. The medium used here is graphite, plus an eraser.

1. The preliminary sketch is drawn with very light lines. If you're working from a photograph, the features and their positions on the face can be measured and transferred to the paper. In this step, no element should be left out, and all necessary corrections should be made until the basic features of the subject have been correctly sketched.

2. The first reference point for subsequent tones is the darkest black area; this makes it easier to grade subsesquent tones of gray. Here, a light blur indicates some parts of the forehead, nose, cheekbone, and upper lip. The eraser can be used to adjust the intensity of these highlights.

3. Contrasts are blended to show the depth of the features; the softness of the graphite medium used makes it easy to clear out small highlights in the face with the eraser.

CONTRASTS AND BLENDINGS

Another way to approach a portrait is by applying a series of shadings, which allow constant correction and tonal layering. Once the first shadings have been established, the figure is retouched with a more malleable medium than the one used previously. This example shows how to sketch a model from nature.

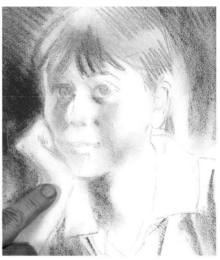

1. To accurately portray your subject's personality, you need to make a thorough study of his or her pose. The initial sketch should describe the basic figure, which will be gradually enhanced as work progresses. Here, with sanguine Conté crayon, the first volumes are very lightly shaded in.

2. The surrounding area is darkened to silhouette the figure against the background, with the color of the paper left as the lightest tone. The lines of sanguine are then blended, and the shaded areas of the face are enhanced. The eraser is used to correct the highlights. The best way to blend charcoal or Conté is to use the fingers.

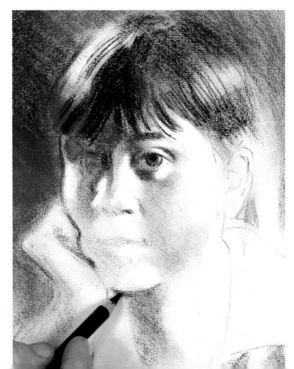

3. The contrasts of the hair are created using direct strokes and opening up highlights with the eraser. The focal point now moves to the eyes, an extremely important area in any portrait. Using gentle strokes, the main contrasts in the upper section of the face are enhanced and retouched.

HIGHLIGHTS

Let's continue from the exercise begun on the preceding page. A sanguine-colored base makes an ideal guide for the most intense shadings and light areas. In this work, the paper's color acts as an additional tone. What will give the drawing a feeling of depth and volume and, ultimately, a semblance of three-dimensional reality, depends on the contrasts established between light and shadow.

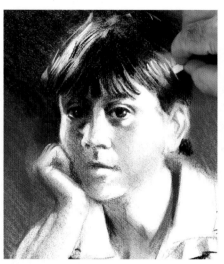

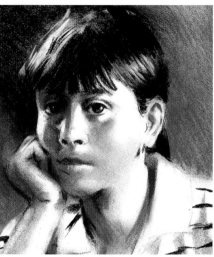

1. The background is darkened and the tones of the subject are intensified. This creates the profile of the side of the face, which is now illuminated. The right eye is drawn with sufficient contrast to outline the shape of the nose. We now use our fingers to blend and lighten the dark tone used in this section of the face, integrating it with the sanguine tone below.

2. Contrasts on the darker side of the face are gradually intensified, and features that were until now only hinted at are completed. Some highlights are created with the eraser, whereas others are drawn with chalk, then blended on the paper. Finally, some points of light are created. Some of the unfinished areas of the face, such as the ear, are further articulated with the sanguine Conté crayon.

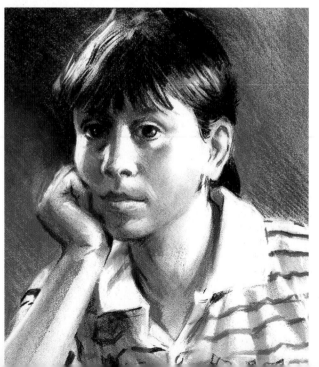

3. The shading on the chin is darkened, leaving a few highlights that don't reveal the color of the paper. Once the strongest contrasts have been completed, the final touches are added to the drawing with a few highlights created with white chalk. Special attention is paid to the highlights on the nose, the lips, and the areas around the eyes, which give the portrait realism and life.

Portrait of a Woman

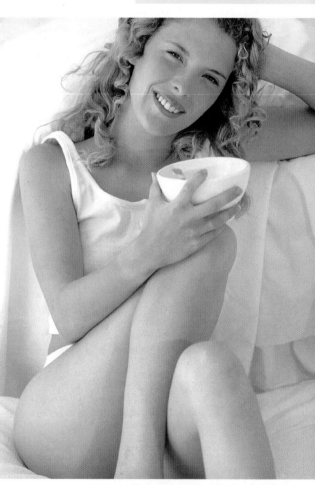

The main objective of this step-by-step exercise is to combine a portrait with an anatomical study. The soft shadows of this figure are ideal for blendings and highlights. This portrait focuses on the model's pose and her attitude toward the viewer. The mood or intention of the subject is one of the most important aspects to be taken into account when you're drawing a portrait. In this example the most notable features are the model's direct gaze and her somewhat flirtatious expression.

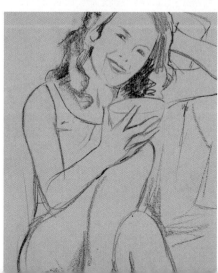

Step 1. A charcoal sketch allows us to construct the figure quickly and accurately. At this point, the foreshortened shapes of the legs are established without any shading. In drawing, foreshortening is not completely evident until the highlights and shading are well integrated into the sketch. We now situate the main features on the face, paying special attention to the position of the eyes, the smile, and the location of the nose in relation to the dark areas.

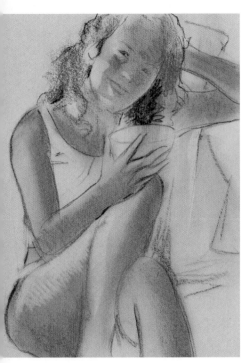

Step 2. Using sanguine Conté crayon, we establish a clear distinction between the dark and light areas. This distinction between the color of the paper and the sanguine blendings constitutes our first approximation of the general volume. It is always important to work from the general to the particular, leaving the details for last. When necessary, light areas can be opened up using our fingers, the cloth, or the eraser.

Step 3. Using the tip of the charcoal, we begin to work on the strongest contrasts in the hair. Using this as a reference point, we can evaluate the tones used on the face. We then open up some light areas on the face to give shape to the features. Finally, using soft strokes we complete the smile and indicate the position of the eyes.

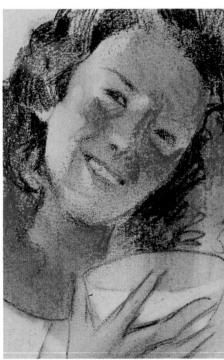

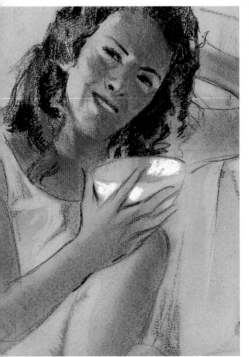

Step 4. Contrasts on the head are enhanced; we intensify the tones, some of which we blend with the flesh tones on the face using our fingertips. By darkening the hair, we reinforce the contours of the face. With the eraser, we open up some highlights, which give shape to the illuminated area of the face.

Step 5. Some of the tones of the hair are enhanced with sanguine, giving it a warmer appearance. Using the tip of the charcoal, we darken some of the lines on the arm and then partially blend them to create volume and depth. White patches are added around the figure using chalk, a procedure that gives the figure volume and separates it from the gray color of the paper background. A few patches of white complete the tone of the woman's clothing.

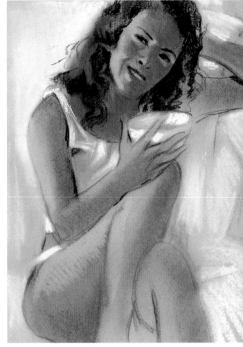

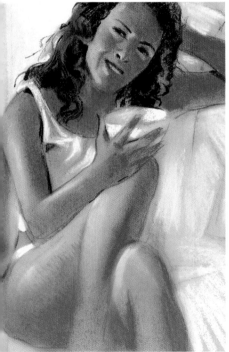

Step 6. The highlights on the face are softened by gently passing our fingers over them. This makes the highlights less sharply defined in relation to the surrounding tones. The shape of the nose depends entirely on the highlights we open up on it. Finally, we sketch in the shadow in the background.

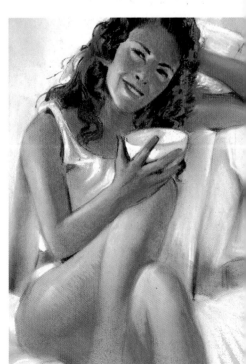

Step 7. A soft blending of charcoal accentuates the contrasts on the forehead and the other dark areas. Using the eraser, we shape the light areas without defining the highlights too sharply against the shaded areas. The increased contrast between light and dark gives the face a more realistic appearance. The main light/dark contrasts on the hand are also intensified.

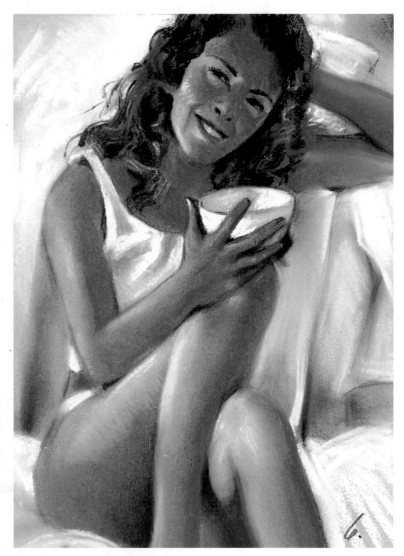

Step 8. The intense shadings on the legs allow us to show the foreshortening realistically. Using white chalk, we brighten the light areas around the figure and add some highlights to the face and chin. This completes this portrait and anatomical study, which has been sketched with great economy of means.

SUMMARY

- A full-length portrait allows us to show the complete subject, and this kind of framing shows an attitude as well as certain features.

- The half-length portrait shows only half of the subject's body.

- The head portrait focuses attention on the face, which becomes the center of attention.

- It is possible to create a good portrait using only a few patches of color.

- In a head portrait, it is essential to render the proportions of the features correctly.

- A good portrait drawn from nature can be created using several progressive shadings.

- To a great degree, achieving a good resemblance of your model on paper depends on the contrasts between light and shadow, which are what give the drawing a feeling of depth and volume.